YOUSUF KARSH
REGARDING HEROES

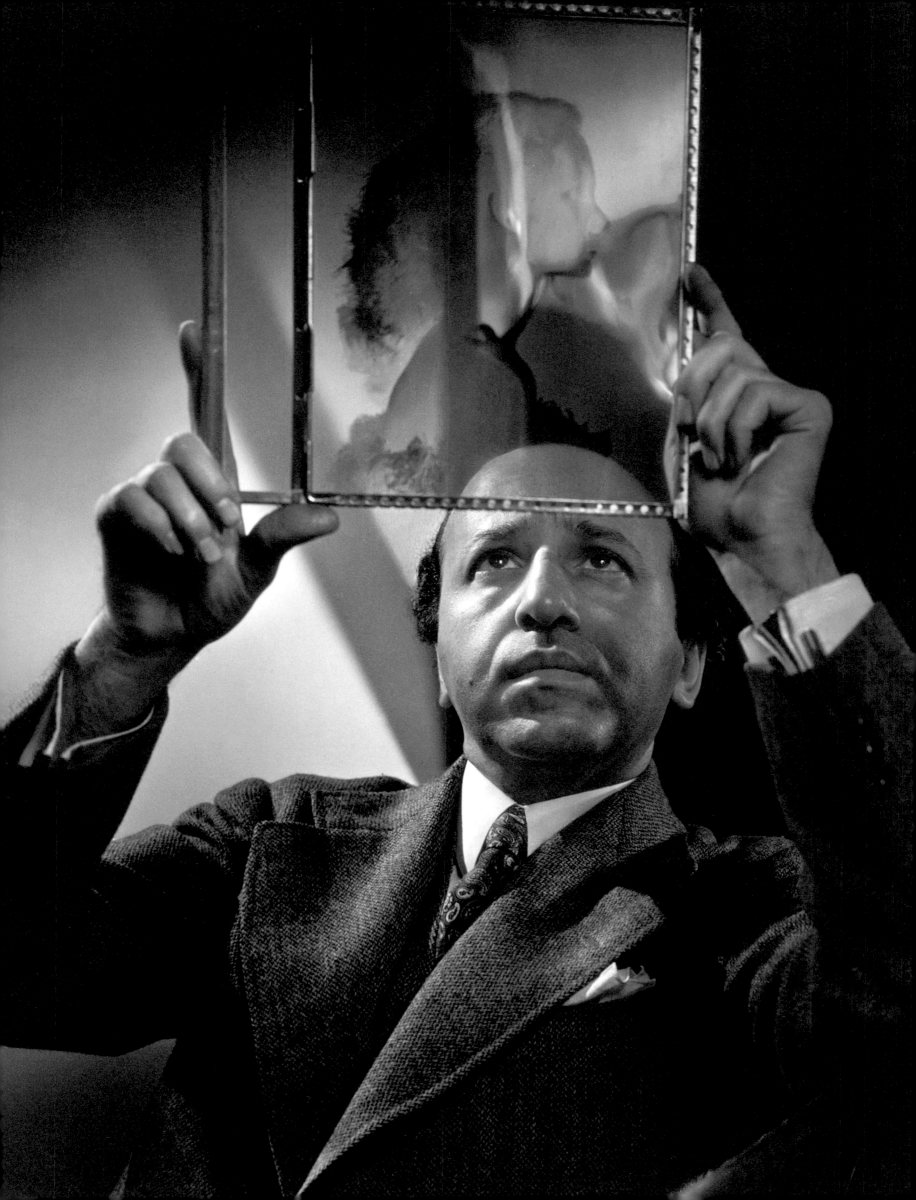

YOUSUF KARSH
REGARDING HEROES

SELECTED, WITH AN ESSAY, BY DAVID TRAVIS

AND BIOGRAPHICAL SKETCHES BY PATRICIA KOUBA

DAVID R. GODINE · *PUBLISHER*

BOSTON

Published in 2009 by
DAVID R. GODINE · *Publisher*
Post Office Box 450
Jaffrey, New Hampshire 03452
www.godine.com

LIBRARY OF CONGRESS CATALOGING-IN-PUBLICATION DATA

Karsh, Yousuf, 1908-2002.
Regarding heros / Yousuf Karsh ; selected, with an essay,
by David Travis and biographical sketches by Patricia Kouba. — 1st ed.
p. cm.
Includes bibliographical references and index.
ISBN 978-1-56792-359-9
1. Celebrities—Portraits. 2. Portrait photography. 3. Karsh, Yousuf, 1908-2002.
I. Travis, David, 1948- II. Title.
TR681.F3K3828 2009
779´.2—dc22
2008041864

FRONTISPIECE: *YOUSUF KARSH, 1952*

FIRST EDITION
PRINTED IN SWITZERLAND BY
ENTREPRISE D'ARTS GRAPHIQUES JEAN GENOUD SA

YOUSUF KARSH
REGARDING HEROES

PROLOGUE: THE WAITING ROOM

THE WAITING ROOM for surgery at the Brigham and Women's Hospital in Boston is a room for hopes, often desperate hopes. Estrellita Karsh had led me there to show how the photographs of one of her husband's portfolios were being displayed. Before she could give me the tour she had planned, a woman politely addressed her, saying: "Mrs. Karsh, it's me, again." Estrellita turned to her and recognized the woman as the wife of a heart patient. The woman's self-maintained calm broke as she said with tears, "He's too young to be having a bypass." Estrellita tenderly reassured her that her husband was in the best place and under the care of the best doctors.

What I witnessed next, however, made the scene indelible for me. Regaining her composure, the woman thanked Mrs. Karsh for all of her many contributions to the hospital and especially for the Karsh portraits in the waiting room. "They are a great comfort to me." Unlike anyone else in the room, I had entered as an art historian. But, because of what the woman said, I was instantly shaken out of that sheltered world into another consciousness. Indeed, as I looked around again, the portraits were reassuring. They inhabited a moment of the past when the rightness of light, pose, and temperament coincided long enough to be captured on film. I had never quite thought of Karsh portraits purely as moments of rightness, as I usually could not dissociate the celebrity of his subjects from the picture. But no matter who the sitters in his photographs were, they had each seemingly reached an utmost expression of charm, seriousness, or serenity. I recognized in them something other than the immobility created by beautiful studio lighting, precise hand placement, and stilled emotion. Emanating from them was not just a notion of their inner heroic being, but also a simple, inherent goodness. It occurred to me that Karsh sought for and tried to bring out these qualities in every sitter.

Such an attitude has almost become a forbidden territory for artists today, as it is thought to cloy the imagination and stifle judgment, preventing us from our addiction to exploring the unsavory recesses of the human psyche. But at the raw edge of emotion in hospital waiting rooms, well-reasoned critical attitudes or daring exploratory strategies break down. We are often confused in the conflict between rising to be more than ourselves and not quite holding on to ourselves at all. In that place and under such stress, our minds no longer relish the playful, ingenious ideas that once stimulated us with curiosities and questions, or the solemn ones that gave us doubts about our society and ourselves. We dismiss everything of that sort and welcome only what can help us to restore the peace and equilibrium that we had taken for granted most of our lives.

It occurred to me at that moment that there was something unexamined about the work of Yousuf Karsh that was important to know, something that was fundamentally outside art theory or the record of the history of photographic styles and accomplishments, something that mattered deeply to the non-professionals, something that millions of people could feel and that experts kept dismissing. Now I felt I had a way to enter the world of this master of the photographic portrait and find in it a story that all parties could understand.

Once this hint was given to me, I began to see clues everywhere as I looked into fields as far apart as philosophy, poetry, and popular music. Ralph Waldo Emerson or Wallace Stevens could now be linked in real human terms to the likes of John Lennon or Paul Simon. In our contemporary habit of choosing to pay more attention to what is wrong than what we feel is right, our thoughts crave, and likely need, to know the darker dimensions of our existence and relationship with others and the world. Paul Simon recognized the borderline as a young songwriter in the lyrics of his refrain to "Something So Right:"

When something goes wrong
I'm the first to admit it
I'm the first to admit it
And the last one to know
When something goes right
Well it's likely to lose me,
It's apt to confuse me
Because it's such an unusual sight
I swear, I can't, I can't get used to something so right
Something so right.

As an older man, Wallace Stevens in his late sixties had developed deeper thoughts. He had resolved more with regard to what he felt about change, spirituality, reality, and the human condition. Experienced and accomplished as a poet, he was able to capture some of them in his poem "Credences of Summer" with just a few words, almost like a photograph fixes a fleeting moment.

Things stop in that direction and since they stop
The direction stops and we accept what is
As good. The utmost must be good and is. . . .[1]

Or so we hope.

I. ESTRELLITA'S STORY: *A Presidential Request*

ESTRELLITA KARSH can relate numerous stories of the portrait sessions and of the personalities who sat for her husband over their thirty-nine years of marriage. She was involved in many of them, and, like the photographer's first wife, Solange, she insisted that he make notes of each sitting with his famous clients, and she helped him to edit his essays about them. She remembers, as well, one photograph he did not take.

Yousuf Karsh had made formal portraits of all of the American presidents since Herbert Hoover, twelve in all. Now, early in the year 2001, at age ninety-two, he was frail and long retired when the staff of George W. Bush approached him. They wanted to fly the president to Boston, where Karsh had resided since closing his Ottawa studio nine years before. The newly elected leader would be at the photographer's disposal, they promised, more so than was usual. Mrs. Karsh recounts that the president's staff said to Jerry Fielder, the twenty-five-year primary assistant to Karsh who was handling the urgent request, that they would even be satisfied with a perfunctory portrait set up by the studio staff if Karsh would just release the shutter. This last effort at accommodation made them seem not only overly eager but also uninformed about what a Karsh portrait entailed.

Before any session with an important client, Karsh's first order of business was to research as many facts as possible about the sitter. He also studied his or her appearance in existing photographs. His own appearance was significant as well. His suit, silk tie, occasional pocket square, and cufflinks made of ancient Greek coins were indispensable, and when he worked away from his home studio they were often complemented by a Borsalino hat. From early in his career, this dapper and urbane outfit had become his standard attire, whether photographing dignitaries in his studio, an artist in a messy atelier, or a milling company executive on the Kansas prairie. Wherever he made a portrait, his primary goal at the beginning of a session was to engage his subject in a cordial and personal way, putting him or her at ease as he determined the number of lights and their exact positions. As a small man, Karsh was not an imposing or threatening figure to nervous subjects. Also a graciously mannered conversationalist, he could listen and respond while concentrating on the sitter's facial expressions, constantly watching and intermittently imagining, rejecting, and reconstituting ideas for poses, then pausing and searching again for some unique, tell-tale visual trait that would trigger the start of the actual shooting session. When lights were set, this verbal and silent interaction would continue as he scrutinized precisely where and how the illumination fell, all the while maintaining an intense verbal interplay that brought out subtle, fleeting movements across facial muscles that might reveal the sitter's settled or momentary character. After all that, perhaps there would be an exposure. Or, maybe a new idea would suggest itself. A session could take a whole morning or afternoon and could be exhausting, especially for the photographer.[3]

But that was just the half of it. Later in the darkroom, each sheet of 8 × 10-inch film was painstakingly developed by inspection, a laborious and old-fashioned procedure. Selectively desensitizing the emulsion so the tonally reversed image could

For, dear me, why abandon a belief
Merely because it ceases to be true.
Cling to it long enough, and not a doubt
It will turn true again, for so it goes.
Most of the change we think we see in life
Is due to truths being in and out of favor.[2]

ROBERT FROST

be examined by a special safelight as it developed further was easy enough. But to evaluate the densities as they built up in the emulsion and to still leave them thin enough so highlights were not inelegantly clotted required a familiarity with the exact opacities that would correspond to the tones Karsh envisioned on a particular photographic paper. It took not only training but also stamina and finesse. Only after years of apprenticeship would Karsh entrust the development of the less-challenging exposures to an assistant. After that there would come the arduous printing of the final image to his high standard. It was never a matter of assistants preparing the subject in the studio or of Karsh just holding the shutter release.

It is understandable that Bush's staff was anxious about not getting a sitting with the one photographer who had become a legend by recording those he personally considered to be the shapers of history and culture. To be among those Karsh included in his photographic pantheon and publications was an honor that dignitaries, political figures, and celebrities sought of him to the last days of his career. An additional attraction for Bush's people must have been that Karsh was not a partisan portraitist, and thus there was an expectation that he would not infuse the image with a personal political judgment, even subliminally.

At the beginning of his career, Karsh would have been the one hoping for such a sitting, but for more than four decades it had been the other way around. He had become an institution in his own right, someone who was expected to participate in what had grown to be one of the many cultural expectations of the ritual of passage to the presidency. But even though Karsh had made an exception by taking a portrait of William Jefferson Clinton in 1993, a year after the studio had officially closed, he was not making a political statement by declining the request from Bush's staff. If there was any inner conflict concerning either his eagerness or reluctance to make yet another presidential portrait, it did not show. Although Karsh relished the status he had created for himself, he was not arbitrary. Ever fair and unbiased, he always felt duty bound to fulfill the role he had created for himself with impartiality. Nevertheless, he was too weak to grant the request. In just over a year, on July 13, 2002, he would die, bringing to an end one of the longest and most fruitful careers in the history of portrait photography.

II. THE POWER OF THE IMAGE

Could a simple photograph possess as much presence as a real person? Certainly: Proust believed a photograph to be a sort of ideal double, instinct with all the potentialities of a living person, even preserving a soul.[4]

BRASSAÏ

THROUGHOUT THE twentieth century, American presidents have become increasingly conscious of their photographic image. It is one way the electorate becomes familiar with them, sympathizes with their predicaments, judges them, and remembers their character. Therefore, presidents and their handlers have tried to control, as best they can, the kinds of photographs of them that reach the public. Performed now with increasing sophistication by press agents and staff photographers, this practice had its beginnings when photography was little more than two decades old.

The first president to gain an inkling of the political power of photography was Abraham Lincoln, who was photographed as many times in one term as all of his predecessors combined. After his election in 1860, Lincoln remarked that the speech he gave at Cooper Union in February of that year, in conjunction with the portrait

Mathew Brady took of him a measure of hours before that stirring address, had made him president. Certainly, the speech was the fundamental element of the two, as it proved him to be no backwoods political stumper. Its content and his delivery awakened the new Republican Party to Lincoln's viability as a candidate who could rally the country to the Party's causes and win.

But Brady's portrait played a role as well; a wood engraving of it was often mated to printings of the speech that circulated through the country. The veteran photographer of the portfolio "Illustrious Americans" realized that Lincoln's gangly physique, tousled hair, and gawky neck spoke too severely of his rough-hewn, Midwestern origins and needed a bit of taming for East Coast powerbrokers and voters. Before boarding the train to New York, Lincoln was mildly aware of the discrepancy and had tried on his own to prepare for a more style-conscious audience by buying a new suit for his upcoming speech. He was, however, a sartorial challenge. The fit of suit and shirt was less perfect on his frame than the image that Brady was about to make would require. The photographer did Lincoln the kindness of raising his collar to hide his long neck and had him stand with statesmanlike deportment, exhibiting the solemn yet human air that would become his trademark. Even if these do not seem today like bold adjustments, Lincoln, and especially Brady, knew a slight cosmetic tuning could make a huge difference in the minutely detailed record that a photograph produced.

The need to acquire such a calculated photograph as a campaign prerequisite was still uncommon among politicians at the time. Although wood engravings from drawings or photographs commonly illustrated publications such as *Harper's Weekly*, politicians were more used to appearing in caucuses and before voters in person, where their bodily carriage, gestures, and oratory style could do much in persuading others of both the truth of their printed messages and their personal integrity. Beginning with Lincoln, gradual steps were taken toward providing – through the photographic medium – a visual representation of the politician's face to those who wished to scrutinize an image for clues to a candidate's character and worth.

In person and in photographs, Lincoln's face expressed everything. So it seemed to the poet Walt Whitman, as revealed in a letter sent from Washington, D.C., to his mother in Brooklyn, New York. The letter, dated June 30, 1863, one day before the colossal and decisive battle at Gettysburg, lovingly described the young soldiers he had ministered to. Then Whitman voiced another concern. "Mr Lincoln passes here (14th St.) every evening on his way out. . . . I had a good view of the President last evening – he looks more careworn even than usual – his face with deep cut lines, seams, and his complexion gray, through very dark skin, a curious looking man, very sad – I said to a lady who was looking with me, 'Who can see that man without losing all wish to be sharp with him personally? Who can say he has not a good soul?'"[5] Whitman's lines certainly tally with the grave face in all of the portraits and photographs made of Lincoln in those perilous times. Clearly Lincoln's despondent visage had impressed itself upon the emotional framework of the poet when Whitman later eulogized him: "With the lustrous and drooping star with the countenance full of woe."[6]

We might think witnessing Lincoln's expression in a private moment a few days after he had abruptly replaced generals leading the Army of the Potomac at the

most critical moment in the war to date was a privilege afforded to the admiring and poetic observer. After all, Whitman had been able to set his own eyes, unhindered, on the living face of the great man, and thus his compassion was not formed by decoding a static photographic reproduction of its features that would have been intended for some other purpose at another time. It was, instead, a sight, as Whitman indicated, available to anyone who chose to stand along the route Lincoln took every summer evening to his country home. From the right vantage point, anyone could see the President directly, glimpsing his face well enough to compare his unmasked, personal mood to one's previous observations.

What Whitman experienced on 14th Street – the private, drawn face of a president beleaguered by an arduous war – is now rarely available to the public. Among other things, photographs have changed that forever. Every president in the last seventy-five years has had to become a kind of actor portraying his ideal self. Public appearances are now purposefully orchestrated and scripted by advisors and public-relations experts. Photographic images of statesmen and women are produced for our consumption by experts who concoct or manipulate photo opportunities and press conferences meant to generate a favorable response to the way a leader is handling critical issues or momentous situations. Even though we know that politicians, like movie stars, have a heightened sense of their visual identity and know how to carry a host of useful camera faces with them at all times, we are nevertheless left with the quandary of whether any photographic image of them, portrait or reportage, demands our suspicion or merits our trust.

III. TRUTHFUL FICTIONS

I have often made up stories, but very rarely told lies.[7]

JEAN-JACQUES ROUSSEAU

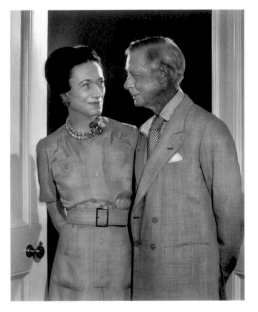

Yousuf Karsh, *The Duke and Duchess of Windsor, 1971* [p. 131]

WHETHER OR NOT one suspects or trusts a given portrait of a politician or celebrity, the fact remains that the image produced in the photographer's studio is an artificial one. No one actually looks like their portrait once they leave the studio. Sitters are not followed by lighting crews, nor are the poses they devised during the session sustainable in daily life. Beyond that, we must ask whether even candid photographs of a subject allow us to be any more certain in making assessments of the person's character. Long before surveillance and cell phone cameras became ubiquitous, T. S. Eliot wrote, "There will be time, there will be time / To prepare a face to meet the faces that you meet."[8] In addition to portraits being artificial visual expressions, our judgment of subjects depends as much on the knowledge we bring to images of them – especially in the case of celebrities – as on what facts or rumors about them are in circulation.

No matter how renowned his clients were, Karsh was always fascinated with discovering more about the mystery of human beings through their facial expressions. Without fawning over them or pandering to the vision they had of themselves, he was enthralled. "While I am a hero-worshipper," Karsh wrote, "I do not expect my heroes not to show signs of the humanity that they share with us all."[9] Nevertheless, he would have to bring those traits to the surface and, at the same time, try to reveal something unique that distinguished his sitter from anyone else. He knew, however, that he could not attend to every aspect of such complicated subjects or fit them all

into one image. For instance, in his 1971 portrait of the Duke and Duchess of Windsor, Karsh chose to take a semiformal photograph that spoke of their long, unwavering love for each other. After all, many romantics cherished the fact that it was for this woman that Edward had given up the throne.

The unmarried duke had been crowned Edward VIII, King of Great Britain, on January 20, 1936. At the time, he had already broken ties with former consorts in favor of an American divorcée, Wallis Warfield Simpson, who was still married to her second husband. The royal family refused to receive Mrs. Simpson at court and deemed her unsuitable to be queen. On December 11, 1936, Edward abdicated, declaring, "I have found it impossible to carry the heavy burden of responsibility and to discharge my duties as king as I would wish to do without the help and support of the woman I love."[10] He married Mrs. Simpson, who had by then divorced her second husband, in France six months later. It was a scandal and at the same time a popular love story. Their devotion to each other is the aspect of their relationship that Karsh chose to emphasize in his portrait.

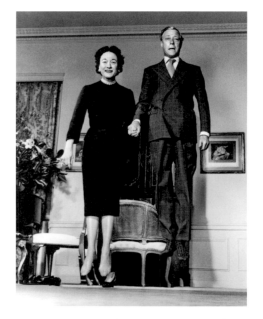

Philippe Halsman, *The Duke and Duchess of Windsor*, 1956

The romantic charm of the Karsh portrait was one aspect of the couple's image that they were eager to display in public. Other photographers, however, drew out different expressions from them. The photograph Philippe Halsman made of the duke and duchess in 1956 suggests that they had a sense of humor. To break through the formality expected when making portraits of famous sitters, Halsman often asked them to allow him to photograph them jumping. "When you ask a person to jump," he stated, "his attention is mostly directed toward the act of jumping and the mask falls so that the real person appears."[11] Or, at least, one sees the real *jumping* person. The couple was game for the innocent, lighthearted trick, devised as a method of getting rid of either a feeling of self-consciousness or a deliberately imposed camera face.

A year later, in 1957, when the duke and duchess were portrayed in their suite at the Waldorf Astoria in New York City by Richard Avedon, the photographer was motivated to convey another known aspect of the couple's history. They lived not only with their extraordinary love story but with certain suspicions as to their former political sympathies. British Intelligence had suspected that the pair (and especially the duchess) had held pro-German sympathies before and during the Second World War. FBI files contain briefings to J. Edgar Hoover of a similar nature.[12]

Avedon later recalled encountering the immovable royal façade at the sitting. In order not to capture the same look that countless other photographers had been forced to record, Avedon concocted a story, telling the couple, who were known to be dog fanciers, that he had seen a dog killed by a taxi. Their faces drooped and, in a split second, he captured the unguarded moment. This is the portrait that succeeded like no other in illustrating Avedon's personal opinion that they loved dogs more than they loved Jews.[13]

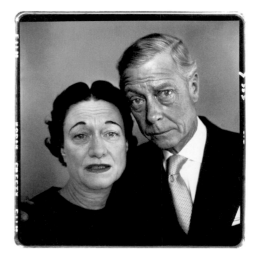

Richard Avedon, *The Duke and Duchess of Windsor, Waldorf Astoria, suite 28A, New York, April 16, 1957*

Thus, viewers need to be aware that the idea of a truthful photographic portrait, capturing the "real" person, is an impossible concept. As mentioned above, sitters change during the session or as soon as it is over, and then change further with time. Depending on the purpose of the portrait, photographers have different goals, and they refine their approaches accordingly. Viewers learn various facts about the

personages they encounter in photographs, and they change like everyone else over the years. To judge a portrait, one must discern the role it plays in response to several possibilities: Was it a commission by the sitter, an editorial statement by a photographer working for the media, an aesthetic or psychological study by an artist, or something else?

What the best studio and editorial portrait photographers have in common, even if their work displays radically different opinions of the same sitter, is that beyond their technical lighting prowess or creative approach to posing, they must acquire the skill of unmasking the face that confronts them. How they do this depends on the purpose of the portrait and the photographer's philosophic attitude toward the world and his or her art.

To understand why a Karsh portrait might differ from one taken by Halsman or Avedon, or, for that matter, Arnold Newman or Irving Penn, one needs to know about the tradition each photographer followed, challenged, or augmented, as well as why and for whom the portrait was made. Emerging technologies are also important to consider. But the most crucial factor is the character of the artist behind the camera, which may be understood better if we know something of his or her life and beliefs.

On the last day of 1923, the sixteen-year-old Karsh arrived alone in Halifax, Canada, as an immigrant escaping the poverty and ethnic cleansing that had devastated his village, Mardin, along with much of Turkish Armenia. His family had fled to Syria after Turkish authorities murdered two of his uncles in prison, his older sister died of starvation, and his aunt survived being thrown down a well, where the Turks expected her to die. The youth, who spoke only Arabic, some French, and a smattering of English, was taken in by his uncle, George Nakash, who operated a photography studio in Sherbrooke, the only major town in the Eastern Townships of the province of Quebec. While Karsh assisted his uncle, he also attended school and improved his English. At the age of twenty, he was sent to Boston for two years to be an apprentice to John Garo, a fellow Armenian who ran a fashionable portrait studio catering to the city's theatrical, musical, and artistic community, as well as to visiting celebrities. When Karsh returned to Canada in 1931, it was to assist his uncle. But he soon felt the need to be in a major city, so he relocated and became an assistant in the John Powis Studio in Ottawa, where he carried on after Powis retired in 1932 by establishing, at age twenty-four, his own fledgling business in the unpromising days of the Great Depression. It was a typical portrait studio business, like thousands of others past and present: Karsh had to please his clients, who otherwise would not return for other portraits or recommend him to friends and family.

Certainly, most professional portraitists need to flatter their subjects in one way or another. In the case of accomplished master photographers, however, this overly simple statement, along with its negative connotations, obscures how the stimulating relationship between photographer and sitter can give rise to spontaneous and innovative ideas that come from working in partnership. It also dismisses the innovative urges particular to pose and lighting with which the photographer may be experimenting. And, most importantly, it ignores the essential ingredients for even

modest success: a gift for interpersonal exchange and an inquisitive temperament.[14] Robert Hughes addressed this subject in his study of the seventeenth-century court painter Anthony van Dyck:

> *Flattery* is not a word that can quickly be defined, at least in portraiture. How it is used, what it means depends on how the sitter feels about himself and how posterity will feel about the sitter. Our own bias, in a post-Freudian age, is toward portraits that show a "truth" about the sitter that the sitter was not willing to admit. But that is not how the portraitists of the sixteenth, seventeenth, and eighteenth centuries saw their work. . . . In Van Dyck or Reynolds, portraiture is a diplomatic agreement between truth and etiquette, between private opinion and public mask. Since the Self is the sacred cow of today's culture we are apt to find this less "interesting" than fictions of interrogation and disclosure. But that is our problem, not Van Dyck's. It is also, of course, why we have no formal portraiture of any value.[15]

Except, one might claim, in the work of a photographer like Karsh.

The compassion Karsh had for others and maintained throughout his sixty-year professional career, coupled with his superb technique and traditional aesthetic training, made him successful. His mother had taught him not to be vengeful or bitter, and so he did not allow the horrors he had witnessed in his youth to be part of his fundamental artistic makeup. Like the eminent society portrait painters Van Dyck, Joshua Reynolds, and John Singer Sargent, Karsh felt it was not his business to uncover or advertise aspects of the flawed or tortured self. In this regard, he was also following a tradition in professional photographic studio portraiture that remained largely unchallenged through the 1940s.

The approach Karsh assumed to portray others was affected by his early religious rearing in Armenia. Reminiscing on his mother's influence, he wrote, "I was brought up to feel that all the world was right as long as one believed in God and in Christ."[16] Among the more revealing statements in his 1962 autobiography, this avowal of devotion helps to explain why his sitters always trusted him so completely. He was hopeful and optimistic by nature, believing that each person had unique, positive values to offer the world. This attitude toward life, although less prevalent in art and photography today, might now be understood as an alleviant for enduring atrocities in childhood or in having been spared the widespread societal upheaval and destruction of the Second World War. The trust that Karsh's positive attitude inspired in his sitters explains why Henry Kissinger did not say to Karsh before their session what he would later say to Avedon before theirs: "Please be kind to me."[17]

IV. ARTIFICIAL LIGHTS

ALTHOUGH KARSH's optimistic attitude and respect for the sitter – seasoned with a dash of hero worship – ultimately determined the overall character of his work, his virtuosity in lighting and posing his subjects is what astounded viewers most when seeing his portraits for the first time. One may say that his methods were

Rather these things express a world where the image, more interesting than its original, has become the original. The shadow has become the substance.[18]

DANIEL J. BOORSTIN

appropriate to his results, but technique is often remote from both subject and meaning, and can occasionally be borrowed from another discipline.

All through the history of photography, achievements in both lighting and pose in portraiture were limited by contemporary technology. As photographic emulsions became more sensitive to light, shorter exposures were possible and it was no longer necessary to immobilize sitters with the mechanical restraints like nineteenth-century studio head braces. By the turn of the century, split-second shutter speeds permitted photographers to capture poses they had once only imagined. On the other side of the lens, subjects could more easily assume postures as natural or exaggerated as they wished. But it was artificial lighting that provided the studio photographer with the promise of a completely new visual territory, offering possibilities previously unimagined.

Prior to the use of electricity, photographers relied upon natural light or magnesium flash powder for their exposures. Both sources were generally flat or unidirectional, although one could combine or adjust them by using reflectors to redirect illumination, usually for the purpose of lightening or softening shadows. Photographers who made hand-manipulated prints with techniques such as the gum-bichromate process could modulate the sense of light and its direction in the same way that an artist might sketch a scene, face, or figure. Artificial illumination, however, allowed photographers to create the entire lighting scheme themselves: the picture's composition need no longer be determined by a dominant, immobile light source or by pyrotechnics.

In the early years of electricity, photographers generally followed habits that had been established through the use of natural light or skylit studios. Most of the innovative applications of artificial lighting in professional photographic portraiture originated in the theater and were then applied or further enhanced in motion pictures, where artificial light had become a necessity. Theaters had employed candles as early as the seventeenth century and oil lamps in the following century. But it was not until the 1830s, with the perfection of the limelight – a glowing cylinder of calcium heated to incandescence by burning streams of oxygen and hydrogen – that a beam of light much more powerful than the general illumination on stage could be focused on a small area or on a single actor.[19] Beyond the isolated drama of spotlights, the general mood and atmosphere of scenes were also enhanced by a variety of lighting methods.[20] It was not until the early 1920s, however, that theaters and photographic portrait studios commonly had at their disposal a safe, odorless, quiet, and reliable spotlight for their productions and portraits.[21] For photographers, the introduction in around 1913 of the commercially produced tungsten-filament lamps and portable fixtures signaled the advent of an era of practical artificial lighting.

Conventional studio portraits of individual actors only began to give way to innovative compositions created on the set after 1919, when John Barrymore refused to sit for his portrait in the studio the New York photographer James Abbe had temporarily set up in Los Angeles. Instead, the actor summoned the photographer to the set, and a new genre of stage photography was born.[22] To avoid the flatness that natural light or floodlighting often produced, Abbe developed techniques that backlit the subject with multiple artificial lights, in various positions, to

create an outlining halo. Additionally, he used mirrors to control dark shadows, sometimes giving a sense that his stars were glowing on their own.

The luminous fantasies of the film industry, pioneered in still photography in the 1920s by Abbe, Ruth Harriet Louise, and Karl Struss, led to the highly recognizable Hollywood style of the 1930s and 1940s made famous by Clarence Sinclair Bull and George Hurrell.[23] Bull and Hurrell were particularly adept at glorifying sensual beauty in close-ups by delineating the face with deep, dramatic shadows and giving the skin a smoldering luminosity. As David Fahey and Linda Rich observed in their book *Masters of Starlight*, "The creature in a George Hurrell portrait epitomizes perfection of face and form as his photographs themselves epitomize Hollywood allure. Hurrell's inventive lighting style is immediately identifiable: his dramatic use of light allows the shadow areas to play an important design element within the picture's frame. His use of Rembrandt and butterfly lighting (the latter using a spotlight to produce a butterfly-shaped shadow under the subject's nose) in coordination with his own invention, the portable boom light, produced 'the Hurrell style.'"[24]

At much the same time as the early developments in Hollywood, one of the most talented photographers to use artificial light, Edward Steichen, was working on the East Coast. After stints as a young protégé of Alfred Stieglitz in the emerging field of fine-art photography, Steichen, an aspiring painter in France and a member of a photographic reconnaissance unit in the United States Army during the First World War returned to New York. There, after trying to paint a few modernist abstractions, he became intent on becoming a professional photographer. In 1923, he was hired by Condé Nast publications to take fashion photographs for *Vogue* and celebrity portraits for *Vanity Fair*. He had no experience up to that point with artificial illumination. "I realized that electric light would be my greatest ally in getting variety into fashion pictures. For one whole year, I used daylight plus one light. Then, gradually, I added lights, one at a time, until, in the later years of my work for *Vogue* and *Vanity Fair*, there were lights going all over the place."[25]

Karsh, of course, knew about fashion photographs and celebrity and movie star portraits primarily through magazines when he established his portrait studio in Ottawa. He did not immediately begin developing the style for which his work is easily recognized today, simply because he was very young. He adopted both the use of artificial light his uncle had used and the traditional approach and preferences he had learned as an assistant for Garo (who championed the use of natural light). Furthermore, his early clients were neither dressed in the latest Parisian fashions that designers were eager to promote, nor were they established or emerging talents in the motion picture industry. In general, their needs for portraits were more humble and everyday.

Karsh later remembered that, during his apprenticeship in Boston, his employer and mentor would send him off to examine the reproductions of works by Rembrandt and Velázquez in the public library and the Museum of Fine Arts, Boston. From these examples, and from what went on during a Garo portrait session, he concluded, "It was a question not only of studying where the light fell but where the artist allowed it to fall, how he used it to bring out his composition."[26] Once he began

mastering artificial light, Karsh enjoyed nearly the same freedom of any portrait painter of the past or present in being able to place light exactly where he wanted it.

The lessons Karsh learned in Boston did more than determine his technical habits and disposition toward his subjects: he also discovered a cultural world beyond the daily photographic sessions through the many soirées Garo hosted in his studio for the city's social and cultural elite, including artists, actors, and classical musicians. At Garo's parties, Karsh, who was still learning to speak English fluently, acquired a fascination with personalities involved in the spheres of culture and politics.

Karsh's studies of light and his interest in theater came together in 1932, several years after he had left Boston for Canada. He met and fell in love with his future wife, Solange Gauthier, an actress. Through her, he became involved with the Little Theatre group in Ottawa. In the following year, he was appointed official photographer for the inauguration of the Dominion Drama Festival. This assignment led to the first publication of his work, which appeared in *Saturday Night*, a Toronto magazine issued in a large, luxurious format with excellent reproductions. This hands-on experience in the theater enabled Karsh to grasp the creative potential of artificial light in making photographic portraits and to comprehend the range of feelings that facial expressions can communicate.

Although Karsh's experience with new theatrical lighting techniques was a revelation, he knew that without change and growth in the basic technology of the field, photographers can improve their functional skills only up to a point; he also knew that virtuosity in the making of photographs is limited by the physical nature of the process. Excellence in art, of course, is not achieved by technology alone; it requires imagination and conceptual input. Every aspect of the materials and equipment of the medium must be at the photographer's command at a suitable level, if nontechnical ideas are to succeed and spur further aesthetic development.

One technical skill every photographer needs to master is the relation of timing to vision. Photography is fundamentally a record of how the subject before the lens is experienced during a moment in time. This way of considering the medium shifts the emphasis from reproducing an object to perceiving the grace and meaning revealed as the photographer's visual reflexes capture what has come to be known as "the decisive moment." A nonliteral translation of the title of Henri Cartier-Bresson's 1952 book, *L'Image à la sauvette*,[27] this phrase has been applied almost exclusively to the practice of photojournalism and documentary photography. In general, the work of professional portrait photographers has been ignored by the critical discussion that developed around this idea. Rather, the term has been constantly applied to highly mobile photographers armed with hand cameras who composed pictures by threading together the unanticipated pieces of concurrent events.

Although professional portrait photographers are not out on the street looking for chance encounters with contingent objects of a world in flux, the best of them recognize the advantage of employing the decisive moment in other ways. They share with street photographers and photojournalists the sense that the significance of an exposure depends not only on their attitude toward the subject and how light defines it, but also on when to release the shutter. When one examines Karsh's photographs, one sees only a few pictures that emphasize the timing of the exposure

instead of the personality of the subject. In general, his compositions describe a moment of repose. That, after all, was part of the tradition of portraiture he learned from Garo and from his study of painters. But a moment of repose is itself a definite moment, even if it is not always one of split-second drama. This was exactly what Karsh tried to do, as he explained: "Only in a space of time far too short for measurement does a man fully express himself, and then unconsciously – by the glint of an eye, a sudden change of mood, a casual but deeply significant gesture of the hand. Except in such magic interludes, the mask of daily life conceals; the curtain we all wear before the world is rolled down." [28] Karsh was able to capture a decisively dramatic moment within the face itself because his awareness of the value of the photographic instant had been refined as part of his overall photographic and aesthetic consciousness, as some of his non-portrait photographs testify.

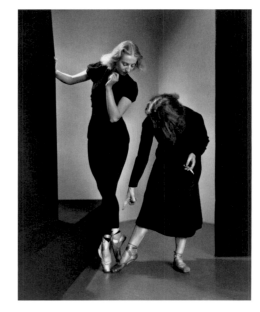

Yousuf Karsh, *The Ballet Lesson*, 1935 [*p. 49*]

For example, in a 1935 study entitled *The Ballet Lesson*, Solange points to Betty Low's *en pointe* position. Primarily a studio experiment in composition using artificial light and a graceful geometry of figures, it was a constructed moment rather than a discovered one. In it Karsh tested whether he could depict the passing instant of a pose with his bulky 8 × 10-inch view camera. Thirteen years later, in his dramatic portrait of the dancer Martha Graham, one sees that his skills remained in place and well honed. Between the ballet study and his stunning portrait of Graham, there are several other indications of Karsh employing a sense of timing in capturing the character of his subject. In 1943, he caught the mischievous side of the Irish playwright George Bernard Shaw in what one might call the twinkling of an eye. Another example is his unconventional 1946 portrait of Boris Karloff. In this case, it is hard to know whether the innovative composition was intentionally crafted or chanced upon during what was likely an instant in which the sitter relaxed by leaning back and resting his hands on his forehead. As it turned out, the transitory pose is balanced by the mysterious tensions of lighting, all of which serves to reveal the character of an actor best known for his leading roles in Hollywood horror films. In each of these examples, the element of time is concentrated in the corporeality of posing, not unlike the way the decisive moment captured by a photojournalist focuses on the physical positions that objects assume in the viewfinder. The sense of timing that Karsh achieved in the ephemeral and psychological expressions on a face was subtle to such a degree that it is only the engaging character of his mastery of lighting that brings it into visibility.

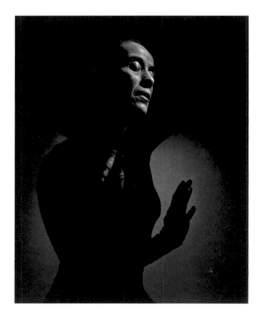

Yousuf Karsh, *Martha Graham*, 1948 [*p. 81*]

Karsh's awareness of how to exploit artificial lighting developed gradually in the 1930s. By the 1940s, he had become so adept that he could move his lighting paraphernalia and set up a studio environment on location if necessary. Leaving the studio to portray statesmen, artists, and celebrities in various settings required him to rely upon his skill at improvising lighting schemes on the spot. Thus, he was able to make most of the photographs taken on the road look like finely tuned studio products. [29] Sometimes he left a hint as to what was involved. In an extended caption in the 1947 *U.S. Camera Annual*, he stated that he used six floodlights and a spotlight for his sensitive portrait of Marian Anderson, taken in 1945 at her Connecticut home. [30] On the facing page, he stated that he later used the same lighting arrangement for the Karloff portrait.

Although both of the portraits can be considered psychological studies, the one of Karloff shows a significant advance in Karsh's inventive use of artificial light. Perhaps he dared to be more playful with an actor as his subject than the political or military dignitaries with whom he would first make his international fame, or a revered singer of spirituals. Actors, after all, are the epitome of changeable character and meaning. They are not supposed to be as steadfast in personality or persona as political and military figures. They work well as partners who bring to life the image that others create. And the portraits of other actors, especially that of Peter Lorre, illustrate Karsh's compulsion to find a new avenue for his expressive lighting ideas.

Not unlike Hurrell or Steichen before him, Karsh created a scheme with the Karloff portrait in which the strongest beam light is balanced by others – coming from various directions – in such a way that it becomes more of a glancing highlight than a dominant source. The Karloff portrait illustrates another breakthrough, achieved by Karsh beginning in the mid-1940s. He determined the position and intensity of his lights to cast most of the face in a range of gray a tone or two darker than was common in the practice of the time. "In lighting a composition," he stated, "my preference is for a gradation of illumination from light to shadow everywhere, because it is the middle tones that contribute most to the third dimension of a face in a photograph."[31] The light he spread across Karloff's face did not produce a two-dimensional geometry or the extreme contrast of highlight and shadow that Hollywood loved, but rather a sense of sculptured definition as it skimmed or even chafed across the surface to uncover an otherwise undetected topography. Within this interconnected landscape of facial textures, the photographer created passages from one region to another in almost the same way that chisel work in stone or the brushwork of the Old Masters had done. Through his sharp eye and sense of timing, Karsh knew when an exposure would make the pose fit with the light that he had placed on his subject so that a certain character that he had intuited from his interaction with the sitter emerged and could be captured in its momentary immobility.

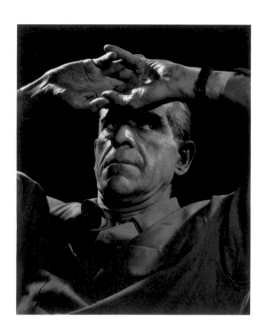

Yousuf Karsh, *Boris Karloff*, 1946 [p. 65]

My quest in making a photograph is for a quality that I know exists in the personality before me, for what I sometimes call the "inward power."[32]

YOUSUF KARSH

V. PSYCHOLOGICAL AND DOCUMENTARY PORTRAITS

ALTHOUGH THE lighting style exemplified by Karsh's portraits of Boris Karloff and Martha Graham had a technological foundation in the advances made in equipment and film, the way they found their particular form and power was through Karsh's understanding of the psychological moment that is essential to theatrical performance. Actors on a stage project the state of a character's inner self through vocal, gestural, and facial expression. Actors in a motion picture do the same, but have the advantage of the edits and close-ups that the director integrates into the storyline. And dancers work entirely with motion, pose, and music. Because a sitter for a still portrait does not have voice, motion, or music to support the registration of mood, the portrait photographer must concentrate either on the face (often with figure and hands) or else on the place a person occupies within a given environment. And although this analytic separation of face and place seems clear, when Karsh distinguished himself in his profession in the 1940s it was an era in which one approach began to incorporate the qualities of the other. Part of that change was

due to a shift in the way photographers understood and practiced their medium.

In 1930, when Karsh was apprenticing in Garo's studio in Boston, the aesthetic premise of the photographic field was in the final phases of a fundamental change. The practice of inducing an atmosphere through soft-focus lenses and hand-manipulated prints was nearly extinct as a new emphasis on sharp-edged, "unrelieved, bare-faced, revelatory fact"[33] established itself as the proper way a photographic subject should look. In writing of the documentary photographs of Walker Evans in 1938, Lincoln Kirstein proposed an extreme corrective for a field that he felt had lost its way in artiness. "The view is clinical. . . . The pictures of men and portraits of houses have only that 'expression' which the experience of their society and times has imposed on them."[34] But to redeem the photographs from a mindless recording of objects, Kirstein added, "Evans is less concerned with the majesty of machinery than with the psychology, manners and looks of the men who make it work."[35]

The psychological element that had been an essential part of photographic portraiture, especially from the turn of the century, was now beginning to make itself part of documentary photographs. In both portraiture and documentary photography, it was no longer to be achieved by simply overlaying a subject with an artificial atmospheric mood or printing technique, but rather to be divined from within the subject itself. It would have a crucial role to play in the portraiture of the 1940s, to which Karsh was a significant contributor.

Mixed with the psychological disquiet and apprehension that photographs were beginning to express was the mounting fear of fascism. Although many in Canada and the United States wished to remain isolated from the trouble, all of Europe was uneasy, and a conflict there seemed inevitable. Canada declared war on Germany on September 10, 1939, nine days after Hitler invaded Poland and one week after Britain and France had entered the war. This lapse indicated Canada's independence from Britain, and revealed, perhaps, that the former colony was not prepared for war. The Permanent Active Militia of full-time officers and enlisted men was minuscule, numbering less than five thousand, backed up by fifty-one thousand partially trained and poorly equipped reservists. Prime Minister William Lyon Mackenzie King guided Canada toward a policy of "limited liability," according to which the nation would contribute primarily economic and production assistance rather than military manpower. Consequently, sixty percent of Canadian men between the ages of eighteen and forty-five did not join or were not drafted into the armed forces, and half of the assembled army never left the country during the entire six years of conflict. Thus, Karsh, like most Canadians, did not become a soldier fighting in either the European or Pacific theaters, as did many American photographers and artists. Nonetheless, like W. Eugene Smith and Margaret Bourke-White, who served as war correspondents for *Life* magazine, Karsh did find two roles suitable to his talents: he made portraits of any soldier in Ottawa leaving for the war without charge, and he also took on commissions to portray the war leaders, the success of which established his international renown.

Karsh had become the photographer of choice to make wartime portraits of

important leaders through his connection years before with the Little Theatre productions. In 1932, he had befriended Lord Duncannon, who was starring as Romeo, and through him was introduced to his father, Lord Bessborough, the governor general of Canada. Although Karsh's first attempt at a portrait of the representative of the British Crown was a technical failure, a second attempt proved successful and appeared in 1935 in double-page layouts in the *Illustrated London News* and other British and Canadian publications. The portrait of Lord Bessborough led to other introductions, other portraits of political figures, and, eventually, to friendship with Mackenzie King. By 1941, his career and connections in the Canadian government were so well established that he was the logical choice to photograph Winston Churchill when the British prime minister arrived in Ottawa for an official and urgent state visit.

On December 30, 1941, Winston Churchill addressed a joint session of the Canadian Parliament after a trip to Washington, D.C., where he had also spoken to both houses of Congress. Among the phrases of his momentous "Preparation-Liberation-Assault" speech were four words that etched the tenacity of this brilliant orator into the collective cultural memory. Referring to certain French generals who he felt had misled their country, he said, "When I warned them that Britain would fight on alone whatever they did, their generals told their Prime Minister and his divided Cabinet, 'In three weeks England will have her neck wrung like a chicken.' Some chicken, some neck."[36]

The story of the Churchill portrait was relayed countless times by the photographer himself and his circle of admirers. A nervous Karsh had prepared for what he knew would be a rare opportunity by positioning and adjusting his lights the night before Churchill's address in a makeshift studio set up in the spacious Speaker's Chamber. Using a model who looked like Churchill from the neck down, Karsh readied everything for the encounter by determining position and pose and a lighting arrangement that would portray strength and assertiveness. After the speech, Churchill arrived attired in a three-piece suit complemented with watch fob and pocket square. He was handed a snifter of brandy and a cigar. Not having been told of the portrait sitting, he was surprised by seeing the floodlights turned on, and had to be coaxed into granting even a few minutes for the session. But Karsh was ready. Thanks to the good habits he had acquired by observing Garo's thoroughness in preparing all he could ahead of time, Karsh knew he could be certain of his results, at least technically. The rest would depend on what happened with Churchill himself.

The famous portrait was, however, achieved in a way that neither photographer nor subject would have predicted. In the instant that Karsh released the shutter, he captured not the image of a persuasive diplomat, but rather of an uncompromising, defiant individual. Churchill's stern expression was in response not to facing the Nazis, but rather in reaction to an unknown Canadian photographer who, a second before the first exposure, had politely but deliberately removed the cigar from Churchill's mouth. To assuage the prime minister, Karsh dutifully took another exposure that properly recorded an official, smiling face, an expression with which the prime minister and his family were more comfortable. But, for the public eye, the second version pales in comparison to the first, which is a masterpiece technically,

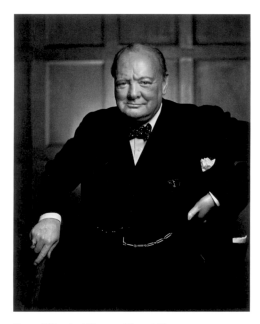

Yousuf Karsh, *Winston Churchill, 1941*

aesthetically, psychologically, and symbolically. In fact, the striking image was destined in a very short time to be reproduced throughout Britain, Canada, and, later, the United States.[37] It became a symbol of Churchill's personal resolve and the intransigence of his nation's resistance.

In the fall of 1943, just over a year after Karsh's galvanizing portrait of Churchill, Mackenzie King convinced the Canadian government to send Karsh to Britain for two months to photograph forty-two political, military, cultural, and royal leaders. These portraits were meant to be respectful studies expressing the sense of purpose and resolve of those actively opposing the forces of fascism. It was hoped that this suite of images would inspire Canadians to keep their support efforts alive. The style that Karsh had developed from his traditional training and practical experience in the 1930s proved to be an excellent foundation for what was required. The war, with its daily bombings, had become a grim and prolonged life-and-death reality for millions of British citizens. Thus, an innovative style – one based on an avant-garde aesthetic geared to art-world mavens, critics, or practitioners – would have been unsuited to the gravity of the situation. Rather, a psychological approach was appropriate, and was exactly what Karsh was now qualified to do.

For Karsh, the sittings with these military, political, and cultural leaders were both stimulating and humbling. He emerged from the experience with a sense of hope for a world that was tearing itself apart. In addition to contributing to the moral support of the war effort, Karsh was more than eager, for other reasons, to portray those who were shaping the destiny of Western civilization. His appetite to meet eminent people may have had its roots in Garo's soirées, but he realized that these opportunities to photograph men and women of accomplishment could lead to other commissions and a career that extended beyond Ottawa. This, in fact, had been his long-term goal and the reason he had left his uncle's studio in Sherbrooke for a second time.[38]

The portraits of Churchill and the war leaders demonstrate that Karsh was not looking to invigorate portrait photography by overlaying his compositions with the quaint, painterly atmosphere of past styles, nor to garnish it with a novel avant-garde aura. His method was strictly straight and traditional, concentrating primarily on what the face, figure, and hands expressed and relying on his remarkable facility with light to make the resulting image indelible. But elsewhere, a few portrait photographers in the 1940s were probing in two new directions. One was a cross-pollination between portraiture and documentary photography, and the other between portraiture and Surrealism.

The invigoration of photographic portraiture in the 1940s by incorporating a documentary mindset was not an entirely new idea. It had its precedents. One outstanding example is August Sander, a trained professional portrait photographer in Germany who had run his own studio business since 1904. In order to supplement a dwindling income during the severe inflationary period in the midst of the economic recession in Germany that followed the First World War, he became an itinerant portraitist. Bicycling around the Siebengebirge region outside of Cologne, he found customers in peasant families who posed formally for him in their farm-yards. Later in the 1920s, he expanded this work into a wide-ranging photographic

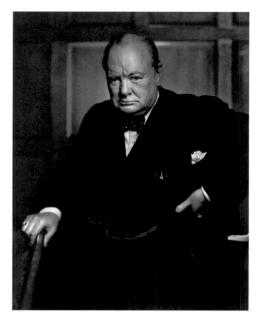

Yousuf Karsh, *Winston Churchill, 1941* [*p. 53*]

study of members of various professions seen in their surroundings, recalling the documentary-style *cartes-de-visite* bearing images of merchants and tradesmen of Paris and other European cities in the nineteenth century. Sander's renown ultimately rests on this extraordinary series and its documentary excellence.

Another example of a photographer who depicted people in their environments was Brassaï. Although the Hungarian immigrant's photographs of the Parisian demimonde in the 1930s are primarily documentary in nature, he applied his approach and style to the portraits he made of artists, writers, and art-world personalities, from Salvador Dalí and Pablo Picasso to Alberto Giacometti and Jean Genet. Likewise, portraits by photographers such as Bill Brandt, Walker Evans, and Lisette Model can also be understood as related to a documentary mode of seeing the world.

The photographer who brought this documentary lineage to a new level in the mid-twentieth century was Arnold Newman. Newman considered himself to be primarily a portraitist who used the sitter's surroundings to echo, complement, and amplify his or her identity. "The physical image of the subject and the personality traits that image reflects are the most important aspects, but alone they are not enough. . . . We must also show the subject's relationship to his world either by fact or by graphic symbolism."[39] This approach freed Newman from the restriction of working with just face, figure, and hands. At each site, new possibilities constantly suggested themselves. His approach appealed to those magazine editors and art directors who liked to tell stories with photographs either by sequencing them or by selecting those images that provided enough information to suggest a narrative. Not surprisingly, Newman, who had been influenced by photographs he had seen in *Vanity Fair*, found ready employers when he moved from Miami to New York in 1941.

The other influence that invigorated some portrait photography in the 1940s – but not Karsh's work – did not have its origins in the photographic past, but came to the medium from poetry and painting and brought with it a pronounced psychological element. Surrealism, which based itself on the workings of the creative mind and its inherent irrationality, especially in unconscious thought, dreams, memories, perception, and odd juxtapositions, operated completely in the psychological realm. It had no interest in pictorial photographs that exhibited a romanticized view of the world experienced through an individual's temperament. Documentary photographs, especially anonymous images, were what the Surrealists preferred. Such visual slices of time could be selectively pressed into service as realistically devised pieces of evidence testifying to the irrationality of the world. The new aesthetic mindset leaped from poetry to painting to photography and soon achieved a popularization that tinged everything around it, changing the meaning of concepts and pervading the artistic and intellectual milieu so thoroughly that in a 1936 lecture at Harvard University, the American poet Wallace Stevens had to qualify what he meant by the irrational element in poetry so as not to have his own work confused with it. "Certainly they [the Surrealists] exemplify one aspect of it [irrationality]. Primarily, however, what I have in mind when I speak of the irrational element in poetry is the transaction between reality and the sensibility of the poet from which poetry springs."[40]

The best example of the new life that Surrealism gave to professional portrait

photography in America is found in the career of Philippe Halsman. Unlike New-man, Halsman did not have a background in traditional studio portrait photography. Originally from Latvia, he worked in Paris until the Nazi takeover of France forced him to flee in 1940. He took with him an important notion he had absorbed from Surrealism: ever after, he considered the studio to be a place of artifice and fantasy. He was a versatile photographic illustrator who would eventually have more *Life* covers to his credit than anyone else. He had a proclivity for whimsical experiments, creating new photographic situations that framed life as a human comedy, as his extended work with Salvador Dalí and his series of jumping portraits illustrate.[41]

Karsh's respect for the traditional way of making photographic studio portraits was not the only aspect of his development that separated him from those photographers in the 1940s who brought something to the practice from outside the strict genealogy of the discipline. Although Karsh's inventive use of lighting owed much to the theater, to motion pictures, and to fashion magazines, his sense of his subject, his feeling of purpose, and his idealistic belief that hope was worth maintaining were the primary elements that formed and reinforced his portraits of the political and military leaders of the war. Thus, he brings to his viewers a feeling of solemnity that is grounded in more than his shadowed backgrounds and deep gray skin tones. His admiration for those he felt were heroes was different from most other photographers who did not base their work on those who had rescued Western civilization from the threat of fascism and genocide. Neither did his art depend on the hybrid character of a merger of two photographic approaches or on the application of a new conceptual style. It was firmly rooted in a tradition of portraiture to which it was making significant contributions.

VI. IMPOSING FIGURES

THE DARK GRAY tones that Karsh achieved in his portraits of the 1940s and 1950s lend dimension and texture to a sitter's face, as well as an air of gravitas. They also infuse the photographic atmosphere with a sensational perceptual experience and the shock of recognition that moves between the mystery of film noir characters and the hyper-reality of wax-museum models. A similar mode of expression had emerged earlier, with the publication in 1931 of Helmar Lerski's *Köpfer des Alltages* (Ordinary heads).[43] Not surprisingly, Lerski's radical light experiments were also the result of a connection first with theater and later with cinema.[44] In 1915, French-born Lerski returned to Europe after having spent time in the U.S. as an actor and portrait photographer. In Europe he became a cinematographer, creating novel lighting effects for the avant-garde films being made in Berlin, chief among them Fritz Lang's highly stylized *Metropolis* (1926–27). By the end of the 1920s, Lerski was taking photographic portraits again. Despite the title of his book, the portraits reproduced there were not the ordinary output of a standard professional photographic studio. Nor were his likenesses related to their surroundings of his subjects. His most engaging photographs at the time were close-ups of faces of anonymous members of Berlin's working class. To emphasize his notion of social equality, Lerski only photographed faces, and he identified a subject only as a laundry woman, fruit merchant, revolu-

I am convinced that a portrait which reveals a man's character and inner qualities possesses a far greater beauty than one which merely reproduces his face and physical appearance.[42]

PLUTARCH

23

tionary worker, beggar, seamstress, porter, and so on, in a list at the back of his book.

Unlike Sander and Lerski, Karsh used his skills not for sociological studies, but rather to set his famous sitters apart from the ordinary citizen. By the time he made a portrait of Jean Sibelius in 1949, he had perfected his theatrical lighting schemes to such a degree that they allowed him to meet the challenge of the serious and imposing figure before him. In the Sibelius composition, Karsh added a second highlight, cascading down the right side of the sitter's face, a touch that had not been quite as pronounced in his study of Karloff. Moreover, he was still able to finesse containing the composer's face within the shadowed, undulant grays.

But for Sibelius, Karsh took a bold and different step. Contrary to every tradition of portraiture that the photographer had learned in his apprenticeship, he made one of his exposures showing the Finnish composer with his eyes closed. Although one can see this motif in a few of Lerski's works, Karsh did not intend it as an avant-garde exercise or a compositional exercise (as in his experiment with timing in *The Ballet Lesson*), but rather as a way to obtain a genuine portrait of the musician's psyche, or even, he might claim, his soul. Sibelius's closed eyes allow one to guess what his thoughts may have been at that moment. One can imagine the composer struggling with the fact that his once boundless talent has been dormant for almost four decades. Or perhaps that he is finally drawing out a new composition from his subconscious equal to his acclaimed 1899/1900 tone poem, *Finlandia*. But that is all speculation, which is the point of many of Karsh's portraits of famous people.

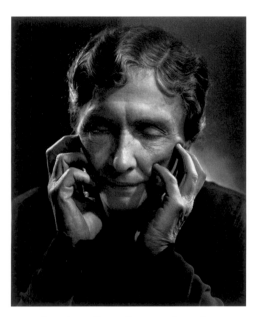

Yousuf Karsh, *Hellen Keller*, 1948 [p. 76]

This was not the first time Karsh had depicted a sitter with closed eyes. The year before, he had photographed the deaf and blind writer Helen Keller.[45] One of his portraits of her shows her full face framed by her expressive hands. But Keller's closed eyes and those of Sibelius suggest entirely disparate meanings. Expressive as the portrait of Keller is, her eyes are closed for physiological reasons. Sibelius was another matter. For Karsh, observing a sitter closing his or her eyes during a session as a portrait option or asking him or her to do so was, so to speak, a deliberate set up for a pose, as bold as any he had concocted with hands, torsos, or entire bodies. But as something to add to his standard repertory, it was too melodramatic to be used indiscriminately.[46]

When Sibelius shut his eyes, Karsh did not see a blind man, someone sleeping, or a death mask.[47] Instead, before him was an artist in a self-reflective pose of intense imagining. Rare as it was, the motif not only occurred in Lerski's work but also in a curious work by Salvador Dalí published in the first issue of the Surrealist magazine *Minotaure* in 1933. Composed of a grid of somnolent faces of women by Brassaï and various photographers *Le Phénomène de l'extase* (The phenomenon of ecstasy) symbolized states of the mind that the Surrealists poets had explored in hypnotic trances. There is also something trancelike in the image of Sibelius, and something mysteriously haunting and secretive. But that was Karsh's response to his encounter with Sibelius. Other sitters would be different. Five years later, in 1954, when Albert Schweitzer obliged the photographer in the same way, the result evoked something altogether different.

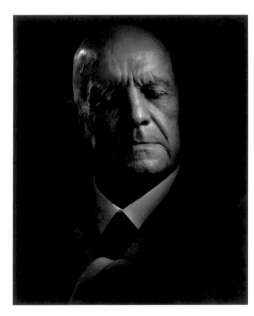

Yousuf Karsh, *Jean Sibelius*, 1949 [p. 75]

Schweitzer, the self-sacrificing activist and missionary surgeon, is seen not in a stage of aesthetic rapture but rather in what appears to be a moment of troubling

meditation, as his furrowed brow suggests. Depictions of him by other photographers capture a similar introspection and mental gravity. For instance, also in 1954, for an assignment for *Life*, W. Eugene Smith portrayed Schweitzer adding a leper colony to his hospital complex in Lambaréné, in what was French Equatorial Africa (now Gabon). The trademark moustache and shock of hair, as well as the sense of overbearing determination, were for the photojournalist essential elements of the humanitarian's identity and aura. But for Karsh, all that Schweitzer had achieved – as a medical doctor, Calvinist minister, musician, scholar, writer, proponent of disarmament, and winner of the Nobel Peace Prize – could only serve as an invisible background to the face of the man himself. Transcending the artificiality of a studio set up in Schweitzer's home in Gunsbach, Germany, Karsh not only inventively recorded a likeness but also created an image of monumental strength and focus, qualities necessary to the weary few who can carry the burden of being keeper to so many brothers.

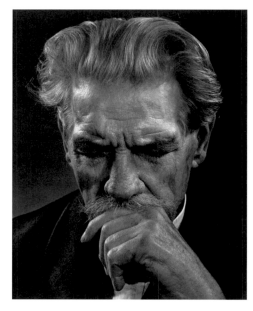

Yousuf Karsh, *Albert Schweitzer*, 1954 [*p. 89*]

While it is easy to connect the overt act of closing one's eyelids for histrionic effect to Karsh's early work with actors, this seems far too simple an answer in view of his success in illuminating the profundities he saw in his subjects. More likely, the appearance of the innovation in the late 1940s was partly due to Karsh's own daring in applying his vision, his techniques, and his abundant interpersonal skills to the pressure of creating newer and bolder images. With each year, he became more adept at finding ways to strip away his sitters' camera faces and coax them into forging with him a dramatic and sometimes audacious facial expression that he hoped would reveal something deeper of themselves, even some universal emotion, during the concentrated time that each session allowed.

In lighting Schweitzer, Karsh reduced the potential of any single highlight to command the composition. He created a new condition in which various kinds of light from several sources swept over the doctor's meditative forehead in one direction and then another, crisscrossing, grazing, and scouring every pore, and articulating the grainy quality of the skin. The viewer is trapped somewhere in the composition in an erratic continuum, tumbling from one place to another through tonal passages glanced by highlights that course the eye across the face over and over. This was a sensibility different from the sinuous lines and patterns of shadows formed by the perfect complexions that those invested in the slithery Hollywood style would have preferred.

The Schweitzer portrait was a triumph for Karsh. It demonstrated how, like his contemporaries Newman and Halsman, he could invent indelible visual idioms that matched the personalities of his sitters, relying on nothing but face, figure, and hands. But unlike those remarkable freelance magazine photographers, Karsh did not interact every day with editors and art directors in New York. For his famous subjects, he worked mostly on site, traveling worldwide. Moreover, he saw himself as an established artist respectful of tradition, and, although he was a skillful innovator, he did not claim to be the revolutionary upstart that the art world glorified. He was comforted by the moral imperatives of his basic optimistic philosophy, which grounded him in hope.

Although his striking innovations of lighting and pose equaled or surpassed

those of his contemporaries, the results are not as witty as Newman's work or as lighthearted as Halsman's. In his quest for what often seems like a personal catharsis on the part of his famous subjects, Karsh risked pushing his vision and style too far, making his portraits potentially too ponderous, pious, melodramatic, or static. This is a chance artists take when testing their freshly developed powers or when breaking new ground. Excess is tolerable in periods of innovation because nothing good usually comes from being cautious or neutral, at least not for Karsh in an era in which moral values and democratic freedoms had just been rescued from tyranny and fascism. For Karsh it was still a time to proclaim the nobility in individuals, the selfless acts of public mercy, and the celebration of old-fashioned heroes.

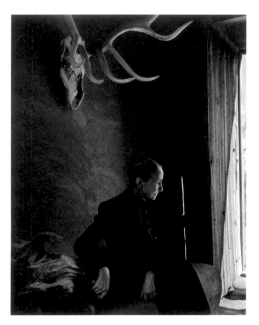

Yousuf Karsh, *Georgia O'Keeffe*, 1956 [p. 108]

What Karsh achieved in the Schweitzer portrait would not have served other subjects in the same way. For the most part this was his limit, as he did not venture further in suggesting any demons, real or imagined, that might be troubling his subjects. Thus, considering the way he worked and his optimistic outlook, he had to be satisfied with the extent to which the Sibelius and Schweitzer portraits touched on the darker, moodier side of the human psyche. The photographer refused to fabricate anything sensational, whether serious or playful, in the studio or on location that he felt was not part of his sitter's character. However, using tonality and light to find the dimension of the face and the texture of the skin that formed it would remain one of his most powerful tools, and he had not yet exhausted all of its possibilities.

Karsh's portraits were not always intended to pique the dramatic imagination of the viewer. His serene 1956 portrait of Georgia O'Keeffe shows the painter in profile and relaxed in her Abiquiu, New Mexico home and studio. Although she is seated in a darkish interior, the sense of the photograph is of the bright, natural Southwestern light, unlike many of the famous mood studies her husband, Alfred Stieglitz, made of her between 1918 and 1934 in New York.

In another famous portrait of the period, Karsh chose artificial rather than the natural light of tropical Cuba as the source of illumination in his 1957 portrait of Ernest Hemingway. This allowed him to define the outline of the head with subtle backlighting while more forcefully scrutinizing the texture and topography of the writer's face with the flat light of floodlamps. Here the passages of the face are not so much directed by the flow of highlights brushing across it, but rather by the details of the physical surface. As in the O'Keeffe portrait, calm reigns – no straining cogitation of a Schweitzer, no inner dialogue between a memory of a long-ago artistic glory and the fruitless present of a Sibelius, no clever placement of hands of a Karloff or Keller. We see simply a head, magnificently stoic and at ease. Knowingly but with some resignation, the eyes look not inward but out onto the world from a wealth of life experience.

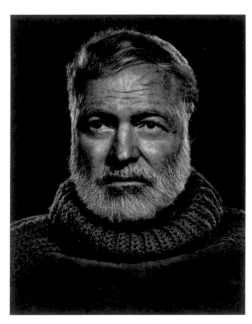

Yousuf Karsh, *Ernest Hemingway*, 1957 [p. 115]

Because Karsh found a moment of equilibrium free of dramatic flair, viewers are able to place all the information they know about the celebrated author into the accommodating receptacle of his countenance. It becomes a composite image of a well-known life. One can imagine that his injuries driving ambulances in the First World War or the more recent lacerations and burns of a 1954 airplane crash left their mark both physically and psychologically. Four marriages, decades of heavy drinking, the exhilaration of the blood sports of bullfighting and hunting, winning

26

the Pulitzer Prize (1953), and later being named a Nobel Laureate for Literature (1954) all may be registered there as well. And in this one still, unaffected moment of repose, we can simultaneously empathize with the writer as a wounded survivor and honor him as a impassive, self-assured hero. Hemingway's nearly emotionless gaze allows these opposite interpretations and contributes to the monumentality of the work. His is a head made for contemplation in a way that Agnolo Bronzino in the Italian Renaissance or Van Dyck in aristocratic England could have appreciated.

VI. PHOTOGRAPHY IN THE FINE ARTS

DESPITE THE public's comfort with photography in twentieth-century culture as a method for making portraits, reporting news, measuring scientific experiments, recording history, and documenting daily lives, the May 16, 1959 issue of the *Saturday Review* addressed the role of photography as an art form. The editors were trying to accomplish in a public forum a feat that scores of critically minded individuals had only partly achieved. The issue was put to the test by an exhibition instigated by Ivan Dmitri, a professional photographer and former artist. Held at the Metropolitan Museum of Art in New York, the show was a response, the editors wrote, to the "place earned by photography in the national culture" and to the "increasing number of books dealing with creative photography."[49] Dmitri felt that, unlike painters, who had dealers and galleries promoting their art and actively searching for new talent, photographers had only editors and publishers, as there was no comparable art market for their work. Except for permanent exhibition programs at the Museum of Modern Art in New York, the George Eastman House in Rochester, New York, the Art Institute of Chicago, and a few scattered museums around the country, photographs that were not snapshots or professional portraits were not commonly valued as original prints at the time, but were seen as images primarily for reproduction in books, magazines, and newspapers. As long as this remained the case, Dmitri felt the general public would never consider photography to be art.

To choose prints for the exhibition, a jury of fourteen museum directors, curators, critics, art directors, editors, and business people voted without debate on which of the assembled 438 photographs appealed to them. The jurors chose eighty-five prints that were exhibited in New York for four months and then traveled around the country for two years. The following year, another touring exhibition, also initiated at the Metropolitan, was arranged. In 1965, the third and final version was created for the New York World's Fair with eleven prominent museum directors comprising the jury. In this six-year period, scores of museums without photography experts on staff felt confident to exhibit the selections endorsed by those who were in a position to judge the merit of photographs as works of art.

Edward Steichen, as director of the department of photography at the Museum of Modern Art, New York,[50] and later as a member of Dmitri's first jury, had by the mid-1950s come to understand another mission for photography beyond its worthiness as an art form. "I now believe that the major important function of photography is as a direct communications medium, but with this, I stress the importance of the photographer as an artist as a prerequisite in the further and

Perhaps when people deny that photography is an art, we should throw our caps in the air because it keeps photography in our daily living along with soup and sunlight.[48]

A. HYATT MAYOR
Curator of Prints,
The Metropolitan Museum of Art

greater development of photography in this function."[51] He had demonstrated this point of view in 1955 by assembling *The Family of Man*, one of the most popular displays ever presented at the Museum of Modern Art.[52] He did not design the exhibition as a discourse in how photographs can be excellent pictures (his selection of them assumed that), nor did he want to illustrate how the world is seen through an individual temperament (he accomplished this in organizing one- and two-person shows). *The Family of Man* was instead a long photo-essay of 503 photographs of anonymous people around the world that Steichen melded into an optimistic statement about a shared humanity. His attitude, forged from his experiences of two world wars, reflected what the younger French writer Albert Camus wrote during the second of those conflicts. "If the words justice, goodness, beauty have no meaning, then men can tear one another to pieces."[53]

Although Karsh had no photographs in *The Family of Man*, as only ordinary people were shown, he had already played an important role in demonstrating that photography is capable of more than making likenesses and reports. His work was chosen for each of the touring exhibitions Dmitri organized. Karsh was already well known, and his participation, along with that of Avedon and Irving Penn, helped as much to sanction the enterprise as to publicize his own talents. Karsh's photographs had been featured in both popular and trade magazines in the 1940s, such as *Life*, *U.S. Camera Annual* (1947), and *American Annual of Photography* (1949) in the United States, as well as in a similar publication of Britain's Royal Photographic Society, *Photograms of the Year* (1950, 1953). In 1952, the Art Institute of Chicago organized Karsh's first one-person museum exhibition, which was part of a continuous series of shows of photographs as art begun the year before by Peter Pollack, the museum's public-relations counsel.[54]

In the same year as the first Dmitri exhibition, Karsh published his fourth book. His first, *Faces of Destiny* (1946), contains dull, half-tone reproductions, as do two later books, *This is Newfoundland* (1949) and *This is the Mass* (1958). In contrast, *Portraits of Greatness* (1959) is larger and more lavish, a quarto-sized volume with dark, rich, full-page, sheet-fed gravure reproductions of his portraits of famous artists, musicians, philosophers, and writers.[55] It includes only a few images of politicians and military leaders from his first volume. Facing each portrait is a short anecdotal essay detailing the photographer's recollections of the sitter and the session. Because he wished to focus on his sitters rather than on his own aesthetic criteria or development as an artist, he arranged the portraits in alphabetical, not chronological, order. After all, the famous sitters were what mattered and were the reason the book would sell. *Portraits of Greatness* joined a historical line of similar collections featuring images of praiseworthy or famous people. Among them can be mentioned Mathew Brady's portfolio, "Illustrious Americans" (1850), *Galerie contemporain* (published in Paris between 1876 and 1884), and Alvin Langdon Coburn's *Men of Mark* (which reproduces portraits taken between 1904 and 1913). In 1959, few of Karsh's contemporaries were making personal compilations of portraits with similar diligence. His obsession was fueled by his esteem for accomplished individuals and the hope they provided for the world, coupled with the desire common to most professional portraitists to achieve fame and fortune through an association with

a subject's renown. It was also his ambition to satisfy the passion many photographers have for collecting in photographs what they hope will be a study that is more than the sum of its parts. And it should be remembered that, as an immigrant, Karsh was eager to prove his worth and contribute to his adoptive society.

Three other books by major photographic talents date to 1959. By considering these alongside *Portraits of Greatness*, one can complete an accurate sketch of the creative and intellectual landscape of contemporary photography at the time. The first of these, Richard Avedon's *Observations*, another book of celebrity portraits, differs from Karsh's volume in several ways. Beyond the absence of political personalities, *Observations* distinguishes itself through its bright, bold, oversized design[56] by Alexey Brodovitch, the legendary art director of *Harper's Bazaar*, as well as through the running commentary provided by the young literary star Truman Capote. Capote's text does not relate stories about specific sessions as Karsh's does, but rambles through the book touching on one character after another, painting them with adjectives and invented terms to spark the reader's imagination. Capote's writing style was an appropriate complement to Avedon's concept of photography, which combined the latter's acute sense of timing, his personal opinion of the subject, and something less tangible: the integration of his own involvement in the photo shoot as part of the meaning of the picture.

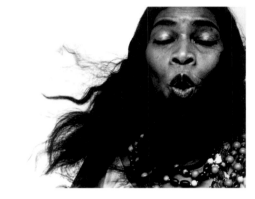

Richard Avedon, *Marian Anderson, contralto, New York, June 30, 1955*

Unlike Karsh's portrait business, the fashion industry in which Avedon worked demanded a monthly stream of fresh ideas and outright novelty. Avedon experimented with non-traditional portrait techniques such as high contrast and blurred or grainy prints. He, like Penn, had been mentored and encouraged by Brodovitch to seek new ideas that the medium had to offer (the design director's generic instruction to photographers was "Astonish me!"). Thus, in Avedon's 1955 portrait of singer Marian Anderson, she does not appear as Karsh portrayed her, as a sublime saintly statue, but instead as a vivacious contralto, with closed eyes and flying hair, who is engulfed in the ecstasy of song. Avedon's portrait of Ezra Pound, taken three years later, also shows him with his eyes closed, but lost in another world. If the profound but mentally unstable poet seems self-absorbed, it is in a different way than Karsh portrayed Schweitzer. Schweitzer posed for Karsh, but in Avedon's photograph, Pound seems caught unaware, or merely unconcerned that he appears half-dressed, disconnected from reality, and exquisitely hurt. In 1977, Roland Barthes, the French literary theorist, noticed this aspect of Avedon's work and wrote: "Look at an Avedon portrait: in it you will see, in action, the paradox of all great art, of all high art: the extreme finish of the image opens onto the extreme infinity of contemplation."[57]

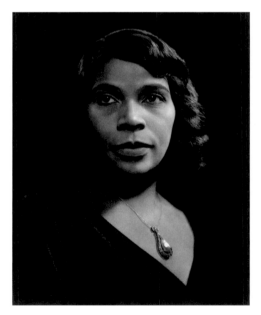

Yousuf Karsh, *Marian Anderson, 1945* [p. 63]

Also in 1959, Robert Frank's *The Americans* was scheduled for release by Grove Press in the United States.[58] It proved to be less popular than either Karsh's or Avedon's volumes but more controversial, agitating critics and other photographers alike.[59] It had been published by Robert Delpire in Paris in 1958 as *Les Américains*, with the photographs accompanied by an assortment of quotes from figures such as Simone de Beauvoir, Abraham Lincoln, Alexis de Tocqueville, and others. The English-language version, actually released in January 1960, had no accompanying literary citations. Instead, it featured a preface by the Beat novelist Jack Kerouac.

Photography enthusiasts previewed what was coming in a special insert section of the 1958 *U.S. Camera Annual*. In an introduction for that selection, Walker Evans wrote, "This bracing, almost stinging manner is seldom seen in a sustained collection of photographs. It is a far cry from all the woolly, successful 'photo-sentiments' about human familyhood; from the mindless pictorial sales talk around fashionable, guilty and therefore bogus heartfeeling."[60]

In contrast to Karsh's *Portraits of Greatness*, no one in Frank's revolutionary book is honored or glorified. If anything, *The Americans* showcases the anti-hero on nearly every other page. The photographer Gotthard Schuh wrote to his Swiss compatriot Frank after seeing a maquette of the French edition: "Your new pictures, just received, have left us shocked and haunted. . . . Never have I seen so overpowering an image of humanity become mass, devoid of individuality, each man hardly distinguishable from his neighbor, hopelessly lost in airless space."[61] In his book, Frank neither sought to discover nor to create grandiose Whitmanesque statements about America, make Emersonian appeals to the hidden unity of nature, or commemorate heroes. His photographs spoke to the viewer who was alienated by America's materialistic culture, distrusted the establishment, and had abandoned religious faith. As Kerouac wrote, "After seeing these pictures you end up finally not knowing any more whether a jukebox is sadder than a coffin."[62] *The Americans* was the book that widened critical discussion about photography and also demonstrated what photographers could achieve independent of the books and magazines issued by major publishing houses.

The fourth and final 1959 publication to be considered here is *Aaron Siskind: Photographs*. If Frank represented a radical approach to documentary photography and brought photography back to the subjects of soup and sunshine but in a dark, emotional way, Aaron Siskind's approach represented the means by which the nominal subject became something else. For Siskind, a picture, in its formal aspect, was not a visual chart of where things happened to be, that is, as a journalist might perceive them, but rather a diagram of where things were placed by the artist. In other words, photographs – like paintings – were not haphazard arrangements of forms, but rather determined ones, even if chanced upon by a photographer. After 1941, Siskind became obsessed with observing and controlling aesthetically what one might call the life of shapes. As he followed his new interests, he gave up taking documentary photographs to concentrate on making "abstract" compositions with his camera. The animated play of geometry in his images suggests a motion or interaction that defines the spirit of Abstract Expressionism, the post-war American style with which several of his painter friends were associated. The introduction to Siskind's book by one of the movement's leading proponents, Harold Rosenberg, speaks not of likenesses or accuracies of rendition but of a conceptual situation: "Unlike a painting, which we get into deeper the more we look at it, finding the artist himself in the hue, line, rhythm of paint strokes, the photograph, within whose areas of light and darkness the hand does not intervene, can catch and hold us only through its overall effect, that is, its idea."[63]

While revealing and commenting upon their time, as well as expanding our notions of what photography is, the visions of Karsh, Avedon, Frank, and Siskind

can be understood in a more timeless assessment articulated a century before by the poet, essayist, and philosopher Ralph Waldo Emerson: "For the Universe has three children, born at one time, which appear under different names, in every system of thought, whether they be called cause, operation, and effect; or more poetically, Jove, Pluto, Neptune; or theologically, the Father, the Spirit, and the Son, but which we call here, the Knower, the Doer, and the Sayer. These stand respectively for the love of truth, the love of good, and the love of beauty."[64]

Had Emerson lived a century later, he might have seen Frank's work as primarily addressing a love of truth; Karsh's, of goodness; and Avedon's and Siskind's, of beauty (although it would not be surprising to learn that each photographer might have claimed all three traits for his own work). Emerson's vision did not become obsolete with the new century and its modernist revolution that came with it. In fact, Camus presented something similar in his deity-free, triadic sense of what he felt to be essential to humanity: justice, goodness, and beauty.[65]

Karsh (along with Steichen in his later years) was one of the very few major photographic figures whose manner as well as his work derived from his belief in goodness. Goodness as a philosophical and theological subject has a grand and ancient history. But as the 1950s progressed, the idea that artists would pursue a notion of goodness, which was the main goal of very few, began to diminish further in the progressive arts with the rise of cynicism, doubt, and irony.

After the Second World War, the darker side of the imagination, whether it was in film noir or Beat poetry, found voice in exploring new freedoms that popular imagination, alternative lifestyles, or a sense of individual liberties allowed. One description of how this darker side stimulates artistic thought had been offered by Federico García Lorca in 1933. The Spanish poet believed that the animating force known as the *duende* was most easily transmitted through "music, dance, and spoken poetry,"[66] but he also felt it was available to visual artists and other creators. "Every man and every artist, whether he is Nietzsche or Cézanne, climbs each step in the tower of his perfection by fighting his *duende*, not his angel as has been said, nor his muse. . . . The angel and the muse come from outside us: the angel gives lights, and the muse gives forms (Hesiod learned from her). Leaf of gold or tunic fold: the poet receives norms in his grove of laurel. But one must awaken the *duende* in the remotest mansions of the blood. . . . The true fight is with the *duende*."[67] He also wrote, "The *duende* is a momentary burst of inspiration, the blush of all that is truly alive, that the performer is creating at a certain moment. The *duende* resembles what Goethe called the 'demonical.'"[68]

Here another trinity of truth, goodness, and beauty emerges, as the *duende*, angel, and muse. The new troika again aligns with the work of Frank (*duende*), Karsh (angel), and Siskind (muse). Perhaps his religious background or his devotion to seeking what is good and leaving all else behind kept Karsh – Lorca's angel – from striking a demonic tone or giving himself over to fantasy. While he may have been essentially alone among prominent photographers in building on this foundation, he shared his vision with artists in other media. A similar view is woven into the beautiful score Aaron Copland composed for *Appalachian Spring*, Martha Graham's 1944 modern ballet about values of piety and simplicity on the western

Pennsylvania frontier. For that music, Copland borrowed a Shaker hymn, "Simple Gifts," to express angelic benevolence. The lyrics to the hymn, which is also thought to have been a dance, address the idea that rightness is a blessing to be treasured rather than ridiculed.

> 'Tis the gift to be simple, 'tis the gift to be free,
> 'Tis the gift to come down where we ought to be,
> And when we find ourselves in the place just right,
> 'Twill be in the valley of love and delight.
> When true simplicity is gain'd,
> To bow and to bend we shan't be asham'd,
> To turn, turn will be our delight,
> Till by turning, turning we come round right.[69]

Had Karsh published his book as *Portraits of Goodness*, it would not have succeeded. In transposing the idea of goodness into the idea of greatness, Karsh was measuring one idea against the other. And as he was more religious than philosophic, we are left to assume that behind his admiration for individuals of accomplishment was a judgment that took into consideration their moral character. This idea is reinforced by the fact that Karsh admired the leaders in what has recently been called "the good war,"[70] whom he met in England in 1943. In his first book, *Faces of Destiny* (1946), based primarily on those portraits, he wrote that his goal was to portray his subjects "both as they appear to me and as they impressed themselves on their generation."[71]

Curiously, Karsh's low-key sets and dramatic use of shadow and raking lights that he developed fully after the war years has a parallel in the style that Hollywood directors were producing in the film-noir period of the 1940s and 1950s. Employing techniques similar to those used to describe anti-heroes or the flawed but skilled characters of detectives in the popular culture of the movies gives Karsh's work a perplexity that belies the simple notion that great is good. Perhaps airing this contradiction to his attitude of hope is an acknowledgement of a repressed human desire to look upon, contemplate, and play with evil. Perhaps, too, it is an expression of doubt and depression that he did not allow himself during the war. During his months in war-torn Britain, he could not say, as Wallace Stevens had written earlier during the First World War in "Domination of Black":

> I saw how the night came,
> Came striding like the color of the heavy hemlocks.
> I felt afraid.
> And I remembered the cry of the peacocks.[72]

Now such doubts could mimic Hollywood's fictional fascinations and thus could exist safely as a theatrical experiment that brought a different dimension and depth to his subjects and to his own work as well.

Part of the artistic attraction his portraits had at the time is that they evolved more and more toward his own creative vision of what a picture could be and not toward a representation of the sitter's view of themselves or how they thought they

impressed themselves on their generation. It is only a mild exaggeration to say that Karsh's career owns many of our collective, permanent visual memories of the political, social, scientific, and cultural personalities of the last sixty years. *Portraits of Greatness* succeeded for the public at large not just because the people portrayed in it were photographed so creatively or they themselves had "come round right," but, paradoxically, because they were famous. The German philosopher Arthur Schopenhauer wrote presciently in 1850, "People are always anxious to see anyone who has made himself famous. . . . [P]hotography . . . affords the most complete satisfaction of our curiosity."[73] While he was right about photography being a perfect vehicle for this curiosity, Schopenhauer had little notion of the magnitude of the cult of celebrities that would exist in popular culture 150 years later.

VII. HEROES AND CELEBRITIES

IN MAY 1958, *Popular Photography* asked its readers who they thought were the world's greatest living photographers. Karsh made the list, as did Avedon, Penn, and Halsman. Also elected were Ansel Adams, Henri Cartier-Bresson, Alfred Eisenstadt, Ernst Haas, Gjon Mili, and W. Eugene Smith, all of whom, except for Adams, were known primarily through reproductions of their photographs in magazines. The list garnered some celebrity for the photographers who had helped give celebrity to their subjects, especially in the cases of Karsh, Avedon, and Penn. This was inevitable, because much of the machinery of creating celebrity was (and continues to be) based on photography in the form of movies, photographic portraits, magazine stories, news events, television, advertising, and so forth.

Our age has produced a new kind of eminence. . . . All older forms of greatness now survive only in the shadow of this new form. This new kind of eminence is "celebrity."[74]

DANIEL J. BOORSTIN

To counter the new demands magazines had for fresh faces and would-be idols, Karsh, Avedon, and Penn all included in their first books only those photographs of subjects that they deemed worthy.[75] But with the surge of celebrities, anti-heroes, and stars of underground culture in the 1950s and 1960s, the traditional hero, whom Karsh so admired, was becoming harder and harder to find. The historian Daniel J. Boorstin observed in 1961, "The heroes of the past, then, are dissolved before our eyes or buried from our view. Except perhaps in wartime, we find it hard to produce new heroes to replace the old."[76] Perhaps the fact that Karsh's fame as a portraitist was established during the Second World War separated him from much of his field. After all, his subjects had included Churchill, Charles de Gaulle, Dwight D. Eisenhower, Field Marshal Viscount Montgomery, and Lord Louis Mountbatten. Through his connections with the Canadian prime minister, he had photographed or would photograph the royal personages of Great Britain, the Netherlands, Norway, and Saudi Arabia. He was the *de facto* portraitist of the establishment in Canada, Europe, and the United States. His sense of what constituted a noble leader (as opposed to a mere celebrity) and greatness was formed in a political and military environment during the apprehensive, yet resolute, years of the war.

After the war, Karsh continued to admire certain statesmen, but he also felt freer to further express his kinship with artistic talents. Magazine editors liked his serious style, as well as his innovative lighting, which amazed readers. A commission from *Life* magazine took him to Hollywood to make portraits of popular actors. In 1946

alone, he photographed Lionel Barrymore, Ingrid Bergman, Humphrey Bogart, Joseph Cotton, Judy Garland, Greer Garson, Sidney Greenstreet, José Iturbi, Boris Karloff, Peter Lorre, Gregory Peck, Tyrone Power, and Elizabeth Taylor. In addition to movie stars, he sought or was commissioned to photograph musicians, playwrights, novelists, scientists, doctors, artists, poets, filmmakers, journalists, and popes, almost anyone of significant accomplishment in his estimation or in the public eye. The list of subjects is a bewildering array, blurring the lines between hero, talent, and celebrity. In Karsh's mind, however, he was keeping an honor roll. Those he admired reappeared constantly in the many portrait anthologies he published over the years.

Reviewing the nine anthologies that Karsh published from 1946 to 1992, one finds that the portraits from the 1940s and 1950s form a foundation for the selections of all but the last book. In those decades, his talent led him to an attitude, procedure, and style so singularly recognizable that, even as early as 1943, Field Marshal Montgomery, after seeing his portrait, declared that he had been "Karshed." In some regards, this stylish and powerful manner of portrayal made the photographer a victim of his own success. He found it impossible to turn away from what his subjects and editors who commissioned work liked about his portraits. Sometimes sitters even wanted or expected something from him that they had admired in other portraits. Karsh constantly had to talk his subjects out of donning sweaters because Einstein and Hemingway had worn them in their portraits. More importantly, they were attracted to Karsh's heroic, monumental-sculpture style, as well as the compassion they sensed in his manner. For instance, Karsh was considerate and kind to all his subjects, always looking for positive values, even in such unyielding communist adversaries as Nikita Khrushchev and Fidel Castro, both of whom cooperated on the basis of their trust of Karsh, something no other photographer managed to achieve.

If it was difficult for Karsh to keep ahead of his own spectacular success, he did, however, manage on certain occasions to find new ways or at least fresh variations on past successes to express himself through his sitters. In the 1960s, he made a series of portraits of artists and architects whom he depicted with something of their surroundings or their work. The placement and appearance of the sitter's hands remained important, but there were now other things to help express character and identity. In the case of architect Ludwig Mies van der Rohe, instead of situating him next to or inside of one of his elegantly designed spaces, Karsh interposed a characteristic material of Mies's trade: a transparent drafting triangle that looks like the corners of two pieces of glass. For his 1965 portrait of French President Georges Pompidou, Karsh incorporated the dazzling elegance of the sun-struck interior of the Elysée Palace in Paris much as he had used the natural light of O'Keeffe's Abiquiu home nine years earlier to suggest a sense of place or immediate surrounding.

Even though the late 1960s witnessed the emergence of a generation that challenged the establishment, Karsh adapted as best an artist wrapped in and promoting tradition could to these profound cultural and political changes. In 1968, Pierre Elliott Trudeau was elected prime minister of Canada. Coming from Quebec, the left-leaning Trudeau considered his predecessor, Mackenzie King (who had helped to launch Karsh's career), as a betrayer of French-Canadian interests. But, as leader of the entire nation, Trudeau reversed his separatist stance to become a proponent

Yousuf Karsh, *Pierre Elliott Trudeau, 1968*

[*p. 136*]

of national unity. He also led the Liberal Party to rescind or relax Canadian laws
restricting abortion and divorce. To portray this young, agile, progressive but elusive
statesman, Karsh drew on an old compositional motif that he had occasionally used
in the 1930s for more romantic, intimate effects. He fitted Trudeau's face into the
vertical portrait format so that it dominated the upper left third of the frame. No
longer did the lighting bathe the subject in a soft, sensual caress of a distant decade.
Neither was the subject presented as a mannequin with fashionable allure or a cin-
ematic object of desire. Karsh offered instead a lucid view of the searing, feisty stare
that exemplified Trudeau's will and unyielding mind. Importantly, the close-up
composition does not leave out the shoulder and lapels of the leather jacket the
politician wore as a symbol of his flamboyance. As Karsh reminisced toward the end
of his life, "His youthful dynamism and intelligence occasioned waves of 'Trudeau-
mania' and comparison with John F. Kennedy. . . . The leather coat, the symbol of the
swinger – his then-popular image – is almost belied by the introspective, cerebral
qualities of his features. . . . In later years, he still retained his ability to deflate polit-
ical pomposity with his devastating rapier wit."[77]

Yousuf Karsh, *Fidel Castro, 1971* [*p. 137*]

Karsh employed a similar close-up composition in 1971 in portraying Trudeau's
friend, Fidel Castro. This opportunity called for a different handling than Karsh
had devised for kings, queens, and sheiks, presidents, prime ministers (other than
Trudeau), and senators. In one of the most striking but least-known photographs
from the session in Cuba, Karsh concentrates on Castro's introspective mood – some-
thing absent in any other public photographs of him. This rarely published portrait
shows the radical leader with bare shoulders instead of his customary military
fatigues, signaling Castro's certainty that Karsh would not take unfair advantage of
an opportunity that the Cuban head of state would never offer an American pho-
tographer. On the occasion of this portrait, Karsh wrote about another side of the
revolutionary, "Castro's range of literary and cultural interests recalled the middle-
class Cuban youth who read widely and studied law. He wanted to know about my
experiences with Helen Keller, Churchill, Camus, Cocteau, and most of all about
Hemingway, whose home near Havana is a shrine. I was impressed that Castro –
now a revolutionary – should still have room in his life for these humanitarians."[78]

In 1989, several volumes were published to commemorate the sesquicentennial of
the announcement of photography's invention in 1839. These comprehensive cat-
alogues retelling the history of the medium were accompanied by large exhibitions
that traveled to major museums in the United States, Great Britain, and France.
The field of photography had acquired its own celebrity, a respectable status in the
art world, a market for its prints, an impressive volume of critical thought and the-
ory, and a technical and aesthetic history. The practice of photography itself had
progressed from a method of recording subjects in front of the camera, to a medium
that incorporated its own self-awareness into the meaning of its pictures, to some-
thing that Harold Rosenberg forecast in 1959 "can catch and hold us only through
its overall effect, that is, its idea."[79] These three elements – subject, medium, and idea
– separated the approaches to photography as an art and at times made defensive
camps of their respective adherents.

Although the catalogues included these three developments in their histories of photography, they did so without a single photograph by Yousuf Karsh. His presence was only visible at a celebratory exhibition organized by curator James Borocoman of the National Gallery of Canada in collaboration with the National Archives of Canada, and had as its catalogue *Yousuf Karsh, The Art of the Portrait*, an illustrated book with critical essays on portraiture. The photographer did not seem to mind having been excluded from the other reviews of the field, even though, thirty years before, he had been voted one of the top ten photographers by amateurs and professionals. With the success of his long career and the profitable business he had built over the decades, he was comfortably independent of the new status of photography as an art. The lessons his mother taught him about not being bitter or vengeful were still in place. Karsh's friends and supporters, and likely his many subjects, were, however, not so happy with the turn of events. It was certainly his due to be included, but since he had adhered so strictly and so long to tradition in an age of experimental and conceptual approaches and because he had no protégés to catch the attention of later generations (and thus no ongoing influence), none of the curators remembered his remarkable innovations of the 1940s and 1950s.

The way Karsh came to occupy a world of his own is a story that can be told of few other photographers. It is an instructive example of how, unlike the history of art in Asia, where tradition is valued, Western culture worships the idea of innovation in defining what is worthy in a work of art.

VIII. THE LAST OF HIS KIND

Over here summer is coming to an end and one is never able to tell which touches us most deeply:
the end of an old season or the beginning of a new one.[80]

WALLACE STEVENS

THE YEAR 1962 was one of both personal triumph and devastation for Karsh. His autobiography, *In Search of Greatness*, appeared under the imprint of the esteemed publishing house Alfred A. Knopf. He was, however, living with a personal tragedy: his first wife, Solange, had died in 1961 of cancer. She had introduced him to the theater world, from which he evolved his signature dramatic lighting. Solange had helped him to write about his interactions with the leaders, creators, and celebrities he photographed, and had assisted in completing his autobiography. Her advice and his own compulsion to succeed made Karsh as well known as many of his sitters. He had every right to retire and mourn, to count his blessings, and to be proud of having transformed himself from a poor immigrant to one of the most celebrated and well-paid photographers of his time. But he loved his work and retained his fascination with meeting and photographing new heroes. When he was on assignment in Chicago in 1962 photographing an eminent physician, he met Estrellita Nachbar, a medical writer who would shortly afterwards become his second wife. Fortunately, he found in her a new partner for his photographic quests.

Karsh was comfortable writing in his autobiography, "I believe that it is the artist's job to accomplish at least two things – to stir the emotions of the viewer and to lay bare the soul of his subject."[81] If the contemporary reader finds such a proclamation somewhat grandiose, it may reflect the degree to which the photographer was emboldened by past successes and by the adulation of his sitters. Although portrait photographers may believe that in unmasking their sitters they

find an unvarnished truth or lay bare a soul, it may be that they instead enter into a photographic situation that stimulates their imagination, a situation in which they are able to explore a subject that they alone witness and that can be shaped by their vision of the world. Photographers are not the only people who convince themselves that truth has to do with the discovery or molding of the exterior world into a form that parallels their own experience or ideas. Scientists and mathematicians such as Isaac Newton and Albert Einstein used observation and discovery in achieving their claims to truth, just as Michelangelo and Picasso used personal experience and the molding of physical materials to establish theirs. If Karsh thought he was glimpsing the soul itself, it was at least honest to say so. But, of course, much has changed over the past forty-five years. From our current and less trusting point of view, we no longer maintain a faith in expression just because of the kind of professed sincerity that Karsh gave to his. And if we do not find later portrait photographers working toward Karsh's way of regarding heroes, it may simply be because he was the last of his kind.

In fact, one more often finds enlightenment about Karsh in looking back to the philosophies of previous generations rather than looking forward. In an 1844 essay entitled "The Poet,"[82] Emerson wrote somewhat disparagingly, "Men seem to have lost the perception of the instant dependence of form upon soul," a sentiment in perfect consonance with Karsh's ideas.[83] There are other parallels. As a photographer, Karsh was obliged to work from the surface appearances of forms toward what he termed a sitter's "inward power."[84] Emerson the philosopher assumed that despite its varied external forms, nature contains a unity at its core that is knowable. Karsh shared this belief in the bond between the external and internal, between the physical and spiritual. This concept is crucial to understanding the vitality and seriousness of these two observers, both of them were men whom faith had touched. Emerson the Unitarian minister described it: "Here we find ourselves, suddenly, not in a critical speculation, but in a holy place, and should go very warily and reverently. We stand before the secret of the world, there where Being passes into Appearance, and Unity into Variety."[85]

Emerson was a man of artistic profundity as well: "For all men live by truth, and stand in need of expression. In love, in art, in avarice, in politics, in labor, in games, we study to utter our painful secret. The man is only half himself, the other half is expression."[86] This credo also lay behind Karsh's approach to portraying his subjects. Like Karsh, Emerson the writer also wanted to stir his readers' emotions. He accurately described his experience with the imagination in a way that many artists refer to the importance of intuition and the irrational in their creative process: "The poet knows that he speaks adequately, then, only when he speaks somewhat wildly, or, 'with the flower of the mind,' not with the intellect, used as an organ, but with the intellect released from all service, and suffered to take its direction from its celestial life. . . ."[87] If Karsh was not exactly "wild," at least he was dramatically adventurous in creating his own style of lighting and pose. Emerson knew firsthand what Karsh would experience with many sitters. The writer described the stimulating but perplexing situation of isolated moments of suspended time during which artists try to free themselves from the larger world and concentrate on the matter

at hand, but instead find one stray idea quizzically lapping over their original response, often morphing into a third, and then feeding the results back into another iteration to produce something even farther from its impetus with either a ridiculous or a new and powerful meaning: "The inaccessibleness," he wrote, "of every thought but that we are in, is wonderful. What if you come near to it, – you are as remote, when you are nearest, as when you are farthest. Every thought is also a prison; every heaven is also a prison. Therefore we love the poet, the inventor, who in any form, whether in an ode, or in an action, or in looks and behavior, has yielded us a new thought." [88]

The sequence of portraits from Karloff to Keller and Hemingway and O'Keeffe to Trudeau and Castro demonstrates Karsh's need to explore how form and meaning relate to each other, how they can be manipulated, and how they can switch roles. His lighting experiments with Karloff yielded a mood at once playful and haunting. When transferred to Sibelius and Schweitzer, they created a heavy aura of self-reflection. But when necessary, Karsh could dismantle the intricate way the patchwork of light fell, lessen the dark grays, and allow an expression of placid sublimity to enhance the viewer's scrutiny of O'Keeffe's profile or Hemingway's head. And on occasion Karsh was even able to discard his habitual dark backgrounds to make a portrait of a maverick politician like Trudeau or a revolutionary like Castro seem at once innovative and classical.

The sequence of portraits from Karloff to Castro also demonstrates that Karsh, like other artists, was pestered and blessed with an incessant curiosity and inability to be content with the permanence of one or two excellent results. He had when necessary the ability to break out of the stylistic routine that was necessary for making the 15,312 portraits of his career. This may come from not wanting to remain trapped in the prison of a thought or a past success. It may come from wanting to make an eminent subject different from other known renditions. Or it may be the upshot of a greater fascination with questions than with answers. Wallace Stevens suggested a more straightforward explanation: "As a man becomes familiar with his own poetry, it becomes as obsolete for himself as for anyone else. From this it follows that one of the motives in writing is renewal." [89] Stevens's idea of the renewal of the self is basically the solution that a psychological age gave to the problem of mental intransigence caused by the satisfaction of temporary success. For an artist like Karsh, who by the 1940s was no longer searching for selfhood through his art, renewal was not signaled by a novel, audacious approach with each decade. Thus, he displays a greater stability of style since he did not discard completely what served him well throughout his long career.

The overpowering consistency that many curators, critics, and historians see in Karsh's style is only superficially associated with his dark backgrounds, gray tones, and innovative lighting. What holds it all together is his attitude. For the most part, Karsh's life-long task as a photographer became the search for a form in which he could evoke a symbol of a person whose essence was directed toward making life seem purposeful and good. "I speak with some experience when I say that I have rarely left the company of accomplished men and women without feeling that they had in them real sincerity, integrity – yes, and sometimes vanity of course – and

always a sense of high purpose."[90] And if one portrait after another exudes a deep-rooted sense of self-importance, that was another risk Karsh was willing to take regarding heroes in order to dramatize and put on full display what he felt were admirable traits of character.

When Karsh was in Europe in 1954, he made several of his most innovative and startling portraits: that of Schweitzer with his eyes closed; Pablo Casals playing his cello with his back turned to the camera; Christian Dior, whose rather normally placid face is cut in half by a mysterious, noirish shadow; and Pablo Picasso in a compelling unpublished image directing a riveting eye that pierces into the viewer's space.[91] He also made a portrait of Albert Camus in his Paris study showing a seemingly mild man illuminated by a gentle window light and looking back at the viewer. Karsh admired Camus, who in three years would win the Nobel Prize for Literature. Spot and flood lamps did not strike Karsh as appropriate for Camus's temperate face and manner, nor did these suggest to the photographer the brilliant sunlight that Camus described so powerfully in his writings about his native Algeria. No turbulence or gloom marks the author's face, even after he had spent years in the French Resistance and had written a philosophical treatise on suicide (*The Myth of Sisyphus*) asking during the darkest days of the war if life was worth living. At the time the photograph was taken, Camus was preoccupied by the crisis of France's colonial presence in Indo-China, which he believed was bleeding the nation dry. We perceive none of this activism in Karsh's rendering of the writer. Rather, we see a man who appears resolved to accepting a world that he had declared to be absurd.

Yousuf Karsh, *Albert Camus, 1954*

The photographer and the writer held a few views about art that were similar. For instance, when asked by an interviewer what moment in his work the writer preferred, Camus answered, as Karsh would have, "the moment of conception."[92] But in so many other attitudes they diverged. Karsh's notion of optimism was conventional. For Camus, any remnant of a positive outlook that made a life complicated by struggles worth living is revealed by his quotation of the German philosopher Friedrich Nietzsche, who answered when asked what wish he would make for himself: "Within the superabundance of life-giving and restoring forces, even misfortunes have a sun-like glow and engender their own consolation."[93] Their outlooks on existence and society in general were nearly opposite. Perhaps this is why Karsh found Camus difficult to fathom, and perhaps the reason that his portrait of Camus is not one of his most memorable. While, as we have seen, Karsh believed in God and in the power of men to improve the world, Camus was a resolute atheist who did not see any reward in the idea of hope. He declared, "Comfortable optimism surely seems like a bad joke in today's world."[94] For Camus there was no rational way to make sense of the world, and he felt that without faith he was completely on his own in coming to terms with life. In addition, he believed he was "living by and for a community that nothing in history has so far been able to touch."[95] Camus rejected the past, faith, and hope and struggled to find the terms for living without them. Karsh's worldview, on the other hand, was built upon these very foundations.

Camus's views were well considered but often more flexible. On the other hand, because Karsh's moral beliefs were unchanging, his work has a solidity of meaning that would find itself at odds with the attitudes of artists of future generations. If

the work of other artists and writers survived better in a future period, it may be due in part to the fact that an inherent ambiguity in the exact meaning in a work of art is one of the ways pictures live beyond the first intentions of their makers and beyond the generation in which they were made. The changing meaning of form with the evolution of culture is another way. In Karsh's work, the role ambiguity plays is small, as his intention is always present, clear, and constant. Although the techniques he devised and his formal constructions changed somewhat, the identity and character of his subject always emerge as the primary purpose for the portrait. Karsh's goal in making a portrait was never to have the viewer sense the artist's own personality or temperament as the primacy of expression. No matter how his portraits were achieved, even through Karsh's trademark style, Schweitzer remained Schweitzer, O'Keeffe remained O'Keeffe, and Trudeau remained Trudeau. When respect for a subject dominates so thoroughly, it can make the artist's work seem out of fashion as it ages. Still, Karsh believed the permanence of intention was a virtue. He did not want a future generation mistaking his meaning for one of its own devising, which is why we can sense an almost religious or scriptural quality inhabiting certain photographs.

In a world passionate about novelty and the latest fashion of style and thought, consistency can still survive for those whose stability comes from tradition or for those who have discovered who they are in essence. Another sequence of Karsh's portraits illustrates not only the virtue of this emotional equilibrium but also the inner power that Karsh felt created accomplished individuals, especially heroes.

Karsh's 1945 portrait of Marian Anderson is one of the most compelling images of his sixty-year career. Here he did not address her passion for singing, as Avedon would, but rather the solemnity of virtuousness and beauty. Karsh also responded to two other deep-seated qualities. First, Anderson was a devout Christian, best known at the time for her richly moving interpretations of spirituals. Listening to her sing "Nobody Knows the Trouble I've Seen" could bring her audiences to tears. Second, she played a crucial role in the fight for equal rights for people of all races. In 1939, the Daughters of the American Revolution refused to allow Anderson to sing in Constitution Hall because of her race. This policy had been established seven years earlier because of objections to mixed-race seating at performances by black artists. On learning of the situation, First Lady Eleanor Roosevelt immediately resigned her membership and encouraged Harold Ickes, secretary of the interior, to organize an outdoor concert for Easter Sunday (April 9, 1939) on the steps of the Lincoln Memorial, where Anderson sang for 75,000 admirers.[96]

Karsh wanted to present these elements of Anderson's character in his portrait. When he arrived at Mariana Farm, her home in Danbury, Connecticut, he was not sure how to accomplish it. "She was gracious and most cooperative, but yet it [was] not quite what I wanted." After the session, he revealed how he had succeeded: "Then her accompanist came and played. I whispered to my wife to ask him to play, very softly, 'The Crucifixion,' and while he played, in undertones, Marian Anderson sang the words to herself. . . . All the pathos, tragedy and greatness of the woman came to the fore, quite unconsciously, but, I do hope, forever recorded."[97] The lyrics, including the line "They pierced him in the side / And he never said a mumblin'

word," help to explain the poignancy of the portrait. The hymn reflects the racial prejudice Anderson endured with the restrained, saintly dignity that Karsh captured in his exposure.

Too often such heartfelt statements as Karsh's portrait of Anderson are ridiculed or dismissed as maudlin or schmaltzy because they do not speak primarily to the aesthetic intervention of the artist with the subject. Heartfelt statements should not, however, be simply dismissed; they deal with real feeling, which cannot be sub-jugated. For example, musicians searching for the authenticity that true emotions offer have embraced hymns (Aaron Copland), folk music (Bob Dylan), blues (The Rolling Stones), and spirituals (Patti Smith), because such music has a genuine pur-pose for being and is untainted by the commercial demands of popular culture or aesthetic theory.

Harry Callahan, *Eleanor and Barbara, 1953*

The quality of spirituality and goodness that the Anderson portrait exemplifies is difficult to find in the work of many other photographers. Nevertheless, it does exist, sometimes in careers that, although familiar, have not been thoroughly under-stood. This quality is subtly, yet fundamentally, integral to the work of Harry Calla-han. His photographs of weeds in snow have a Shaker-like simplicity, and his portraits of his wife, Eleanor, as well as the series of Eleanor and their daughter, Barbara, are all generated by a wholesome domestic happiness. Although Callahan was not known to be religious, he indicated otherwise in an interview conducted at the end of his life. He admitted, "I was religious. . . . My friends talked me out of it. I have a religious outlook because of my early days."[98] Callahan's "religious" out-look is the hidden foundation upon which his art rests, although this aspect has never been investigated thoroughly by the many scholars who have focused on his work, concentrating instead on his creative process. This essential element is con-cealed by the photographer's diligent and playful experimentation with the medium. Unlike Karsh, but like most other artists, he wanted his subjects, as well as his under-lying attitudes toward them, to be secondary to the way they are expressed.

Callahan recalled later in his career how his creative process worked: "Photog-raphy's wonderful because you can start with one idea but get lost on something else, and that's where the big thing happens. It's in the drifting off that you find something unique."[99] Keeping this "drifting off" fresh, so it could act as a renewing stimulus, is perhaps the reason Callahan felt it necessary to try out so many ideas and series, as well as so many photographic formats and techniques. Karsh did not experiment as freely as Callahan. Any drifting off on the part of Karsh had to hap-pen in the presence of his subjects. Because Karsh had a partner in his sitter, with whom he wanted to create a collaborative image, his kindness towards the sitter caused him to be more cautious in his own personal aesthetic innovations. He also felt that he had to maintain a certain stylistic stability to satisfy his respect for tra-dition and maintain the look that had made him famous.

In 1990, two years before closing his Ottawa studio, Karsh made a portrait of Jessye Norman, a soprano who, as a child, sang in a church choir and studied the recordings of Marian Anderson and Leontyne Price. When she sat for Karsh, Nor-man was forty-seven years old, just a year younger than Anderson had been when the photographer made his moving portrait of her forty-five years before. Much

41

had changed since Anderson broke the color barrier in America's classical music world, and because of it Norman had been welcomed by American audiences and as an international star in great opera houses for well over two decades.[100] Like Anderson, Norman was more than a celebrity. Her voice, too, had range and richness, but in the higher register of a soprano. When she recorded Richard Strauss's *Four Last Songs* in 1982, listeners who had been satisfied by a long line of stellar sopranos – Kirsten Flagstad, Birgit Nilsson, Leontyne Price, Elisabeth Schwarzkopf, and Kiri Te Kanawa – were overwhelmed by the power and sensuality that matched the rich, sublime orchestration. Even Norman's slower tempo in the last song seemed to magnify the gorgeous profundity of the romantic masterpiece.

By 1990, Norman had been photographed by many talented portraitists. The image Annie Liebovitz made of her was, like Avedon's of Anderson, a spirited moment in the midst of song. Karsh wanted something calmer and less glamorous. He was not interested in the singer's expressive hair. He did not want to freeze a moment of ecstasy. And he knew that he could also not make of her another saint, as Norman had not had to suffer what Anderson had endured. In his recollections of the session, he indicated that there were several aspects of the singer to capture: "One moment she was a disciplined goddess and diva adept at creating before my camera the illusion of imposing majesty befitting the operatic heroines she portrays. The next, relaxed and at rest between photographs, she was disarmingly girlish, enthusiastic, and free of prima donna pretense."[101]

Borrowing the composition he had used for Trudeau, Karsh concentrated on Norman's face. The dark gray tones were now entirely natural and were not there for some artificially devised drama, but rather to suggest a warm, inner glow. Norman's magnetic and exquisite face is all the more evocative for being solemn and peaceful. Thus, the sentiment of the photograph makes her seem every bit as self-possessed as the one Karsh made of Anderson almost a half a century before. Perhaps only small things needed to change, even over decades. Now the background is light, and now, instead of the words of "The Crucifixion," one can imagine Norman recalling the last two elegiac stanzas of the Herman Hesse poem "September," which constitutes the text of the third of Strauss's *Four Last Songs*.[102]

Yousuf Karsh, *Jessye Norman, 1990* [*p. 151*]

> *Leaf after golden leaf drops*
> * down from the high acacia tree.*
> *Summer smiles, surprised and weary*
> * upon the dying dream of this garden.*
> *Yet still it lingers by the roses,*
> * longing for rest.*
> *Then slowly closes its great weary eyes.*

Strauss composed the suite, his last great opus, in 1948, when he was eighty-four. He meant it to be a calm meditation on the inevitability of his own death, especially the last song, "Im Abendrot" (In evening's glow). For all their musicianship and the sumptuousness of their voices, young sopranos have had to stretch in order to give expression to something in these songs that they could only partly compre-

42

hend. On the other hand, how easy it would have been at the time for the aging Karsh to understand the words of Josef von Eichendorf, which Strauss used as a text for the fourth song. Its last lines are:

O broad, contented peace!
So deep in the sunset glow,
How exhausted we are with our wanderings –
Can this then be death?

In this portrait, Karsh, at age eighty-two, was the experienced partner guiding Norman to an expression in a way that few photographers could have achieved. The occasion required an older artist and a subject worthy of his gifts. The photographer meditating on the solemnity of the face had long ago become comfortable in leaving the chase after animated poses to younger talents. For her part, Norman could summon her experience as a performer and draw upon the depths of her artistry to communicate something integral to her true self. As ever, Karsh brought his charm and respect to the encounter. Knowing of his legendary kindness, Norman brought her trust. This was still not enough to create a genuine portrait, in the photographer's eyes. Karsh needed something more: not luck, which, since the Churchill portrait, had only been an incidental and unreliable factor; nor novelty, finding a clever compositional or conceptual solution of the kind the contemporary art world relished. Fortunately, what Karsh required was something he had brought to his work throughout his career, something he had gained by his deep kinship with tradition: his old-fashioned belief that goodness remains a virtue essential not only to making portraits substantial and enduring but also to making life worth living.

DAVID TRAVIS
Chicago, Illinois, 2008

1 Wallace Stevens, "Credences of Summer," in Wallace Stevens, *Collected Poetry & Prose* (New York: The Library of America, 1997) 324.

2 Robert Frost, "The Black Cottage," in Robert Frost, *Collected Poems, Prose, & Plays* (New York: The Library of America, 1995) 61.

3 When Karsh photographed Artur Rubinstein, the pianist asked how long the sitting would take and Karsh replied that it would continue until they were both exhausted. Recorded in Yousuf Karsh, "Portraits of Famous Musicians," in *The American Annual of Photography* 1949, vol. 63 (Boston: American Photographic Publishing Co., 1948) 75.

4 Brassaï, *Proust in the Power of Photography*, trans. Richard Howard (Chicago: The University of Chicago Press, 2001) 82.

5 Walt Whitman, *Walt Whitman: The Correspondence*, vol. I, ed. Edwin Haviland Miller (New York: New York University Press, 1961) 113.

6 Walt Whitman, "When Lilacs Last in the Dooryard Bloom'd," in Walt Whitman, *Leaves of Grass*, comprehensive reader's edition, ed. Harold W. Blodgett and Sculley Bradley (New York: New York University Press, 1965) 337.

7 Jean-Jacques Rousseau, "Fourth Walk," in *Reveries of the Solitary Walker*, trans. Peter France (London: Penguin Books, 1979) 79.

8 T. S. Eliot, "The Love Song of J. Alfred Prufrock," in *The Oxford Book of Twentieth Century Verse*, ed. Philip Larkin (Oxford: Oxford University Press, 1973) 229.

9 Yousuf Karsh, *In Search of Greatness: Reflections of Yousuf Karsh* (New York: Alfred A. Knopf, 1962) 155.

10 King Edward VIII [Abdication speech, 1937].

11 Philippe Halsman, *Philippe Halsman: A Retrospective*, with an introduction by Mary Panzner (Boston: Little, Brown and Company, 1998) 11.

12 "Windsor, Duke and Duchess," Federal Bureau of Investigation, http://foia.fbi.gov/foiaindex/windsor.htm.

13 Peter Howe, "An American Legend," http://www.digitaljournalist.org/issue0410/howe_avedon.html

14 Howard Garner counts interpersonal relationships as one of the seven main categories of his definition of intelligence in his book *Frames of Mind: The Theory of Multiple Intelligences* (New York: Basic Books, 1993).

15 Robert Hughes, "Anthony Van Dyck," in *Nothing If Not Critical: Selected Essays on Art and Artists* (New York: Alfred A. Knopf, 1990) 41.

16 Yousuf Karsh, *Portraits of Greatness* (London and New York: Thomas Nelson and Sons, Ltd., 1959) 8.

17 Avedon recounted this encounter on the Avedon Studio website at: http://www.richardavedon.com/conversation/kissinger.php and explains his point of view about favors and kindnesses in making portraits.

18 Daniel J. Boorstin, *The Image: A Guide to Pseudo-Events in America* (New York: Atheneum, 1978) 204. (Originally published by Atheneum in 1961 under the title *The Image, or What Happened to the American Dream*.)

19 The limelight (also known as the Drummond light) was first used theatrically in London in Covent Garden Theatre in 1837.

20 For example, in 1900, David Belasco used backlighting for a wall of shoji screens in *Madama Butterfly* and devised a colored silk roll that covered a lamp housing. As the silk was scrolled, the color changed from orange for daylight to blue for night and then pink for morning as Cio-Cio-San waited for her American lover, Pinkerton, to debark from his battleship and arrive at her house.

21 Electric carbon-arc lights of the late nineteenth century were the brightest lights available and were inexpensive to maintain and use. They were cumbersome and often noisy and threw a harsher light than the limelight.

22 For a more thorough discussion of the history and development of Hollywood still photography and the Barrymore incident see: David Fahey and Linda Rich, *Masters of Starlight: Photographers in Hollywood* (New York: Ballantine Books, 1987) 17.

23 Hollywood executives knew the value of good still photographs of their stars in promoting their motion picture investments and controlled the production of publicity stills by hiring their own staff photographers rather than leaving the stars to find their own portraitists as had been the custom. For special productions they also hired famous names, such as William Sheriff Curtis for Cecil B. DeMille's 1923 *Adam's Rib* and *The Ten Commandments*, and William Mortensen for DeMille's 1927 *King of Kings*.

24 Fahey and Rich, *Masters of Starlight*, 19.

25 Edward Steichen, "Fashion Photography and Fabric Designs," in *A Life in Photography* (New York: Doubleday & Company, Inc., 1963), unpaginated, chapter 7.

26 Karsh, *In Search of Greatness*, 33.

27 The French phrase *à la sauvette* translates more literally as "image taken on the run."

28 Yousuf Karsh, *Portraits of Greatness*, 11.

29 When Karsh arrived to photograph Mauriac, the electricity was out in the building due to rationing energy. Mauriac's top-floor apartment, however, provided enough daylight through one of his windows to accomplish the photograph.

30 Tom Maloney, ed., *U.S. Camera Annual* 1947 (New York: U.S. Camera Publishers, 1947) 214.

31 Karsh, *In Search of Greatness*, 114.

32 Ibid., 94.

33 Lincoln Kirstein, "Photographs of America: Walker Evans" in Walker Evans, *American Photographs* (The Museum of Modern Art, New York: 1938), 197.

34 Ibid., 196.

35 Ibid., 196.

36 Winston Churchill, *Unrelenting Struggle* (Boston: Little, Brown and Company, 1942) 367. The dust jacket of the original edition reproduced a close cropping of Karsh's portrait.

37 Karsh's famous portrait of Churchill was later used on the cover of *Life* magazine's May 21, 1945 issue.

38 Karsh's first attempt to enter into the world of the famous had not been the success he had dreamed of. In 1932, while working in John Powis's studio, the young Karsh convinced his employer to invite Commonwealth leaders who were assembling in Ottawa for the Imperial Economic Conference to be photographed. Whether out of a sense of publicity, history, or vanity, several important attendees – including Prime Minister Neville Chamberlain of Britain and the Irish dramatist and political activist Sean O'Casey – were willing to spend some of their visit on the second floor of a dilapidated building at 130 Sparks Street, just one block from the Parliament building. While the resulting portraits are flat and routine and did not provide the sensational results that Karsh had envisioned, he was encouraged to make the best of the next opportunity afforded to him.

39 Arnold Newman, *One Mind's Eye*, with an introduction by Robert Sobieszek (Boston: David R. Godine, 1974) vii.

40 Wallace Stevens, "The Irrational Element in Poetry," in Stevens, *Collected Poetry and Prose*, 781.

41 He loved working with Salvador Dalí, and after thirteen years of collaborating published *Dalí's Mustache* in 1954.

42 Plutarch, "Cimon," in *The Rise and Fall of Athens: Nine Greek Lives* (London: Penguin Books, 1960) 143.

43 Lerski's book circulated in Europe, and it is highly unlikely that Karsh knew of it.

44 Lerski married an actress in the United States whose family was professionally involved in photography. A short biography of Lerski can been seen at http://www.fotostiftung.ch/index.php?id=31&L=3. His work was included in the 1929 exhibition *Film und Foto*, which was a statement about the role of photography in the world of the artistic avant-garde in Europe and the United States.

45 A childhood experience in Armenia could have increased Karsh's sensitivity to people with their eyes closed. In his hometown of Mardin, his mother took in a young Armenian girl whose eyes had been torn out by Turks.

46 Karsh used this motif in his one of his 1958 portraits of the psychiatrist Carl Jung.

47 In the nineteenth century, the only portraits made of subjects with their eyes closed were postmortems, usually of children, which had the effect of suggesting both peace and suffering.

48 A. Hyatt Mayor, "The Greeks Had No Word for It," *Saturday Review*, May 28, 1960, 40.

49 *Saturday Review*, May 16, 1959, 35.

50 In 1947, the trustees of the museum replaced Beaumont Newhall, the leading historian of the field, with Steichen, who had the eminence of accomplishment as a pioneering artist-photographer and name recognition through his commercial work at *Vanity Fair* and *Vogue*. Steichen would hold the position from 1947 to 1962. Newhall later became the founding Director of the George Eastman House in Rochester, New York.

51 *Saturday Review*, May 16, 1959, 42.

52 *The Family of Man* was presented at the Museum of Modern Art from January 24 to May 8, 1955. It comprised 503 photographs grouped thematically around subjects pertinent to all cultures, such as love, children, and death. After its initial showing at the Museum of Modern Art in 1955, the exhibition toured the world for eight years, making stops in thirty-seven countries on six continents.

53 Albert Camus, "On a Philosophy of Expression by Brice Parain," in Albert Camus, *Lyrical and Critical Essays* (New York: Vintage Books, 1968), 360.

54 The first exhibition in 1951 was devoted to the work of Harry Callahan: it was his first museum exhibition, as it would be for Karsh. Peter Pollack had the support of Francis Stuyvesant Peabody, a commercial portrait photographer and admirer of Karsh, who contributed funds toward the purchase of photographs by Karsh, Edward Weston, and others for the collection.

55 The page size of the book measures 9 × 12 inches.

56 It measures 10½ × 14¼ inches. No other photography books at the time were larger.

57 Roland Barthes, French photo quoted on the Avedon website, http://www.richardavedon.com/

reviews/ from an article published in *Photo* magazine 1977.

58 Grove Press scheduled the book for 1959 but it was not released until January 15, 1960. Grove Press through their book list and their magazine, *Evergreen Review*, published many works by contemporary French intellectuals including Camus, Samuel Beckett, Jean Genet, and Eugène Ionesco, as well as authors and poets in English: Arthur Miller, D.H. Lawrence, and the American Beats: Allen Ginsberg, Jack Kerouac, and William Burroughs.

59 Although Frank's photographs were powerful and compelling, the book was not generally well received. Some objected to the title, others to the despondent tone that infused its dark images. Minor White, photographer, critic, and influential editor of *Aperture* disliked it, as did much of the photographic trade press. There were only a few supporters who instantly saw through the controversy, such as Hugh Edwards, curator of photography at The Art Institute of Chicago, who wrote to Frank four months after the book appeared to ask for an exhibition: "It pleases me a great deal because no other book, except Walker Evans's *American Photographs*, has given me so much stimulation and reassurance as to what I feel the camera was created for. . . . I feel your work is the most sincere and truthful attention paid to the American people for a long time. . . . Someday they will spread to everyone and even the most sterile and analytical of intellectuals will accept them at last."

60 Walker Evans, "Robert Frank," in *U.S. Camera Annual* 1958, 1957, 90.

61 Gotthard Schuh to Robert Frank, 1957, *Robert Frank: New York to Nova Scotia*, ed. Anne Wilkes Tucker (Houston: Museum of Fine Arts Houston, 1986) 32.

62 Jack Kerouac, introduction to Robert Frank, *The Americans* (New York: Grove Press, 1959) i.

63 Harold Rosenberg, introduction to *Aaron Siskind: Photographs* (New York: Horizon Press, 1959).

64 Ralph Waldo Emerson, "The Poet," in Ralph Waldo Emerson, *Essays & Lectures* (New York: Library of America, 1983) 449.

65 The discussion of truth, goodness, and beauty (as well as justice, equality, and freedom) were furthered in a popular book authored by Mortimer Adler in 1984, *Six Great Ideas* (Macmillan Publishing Co., New York). Initiated by Robert Maynard Hutchins, Adler was instrumental in establishing the Great Books series at the University of Chicago published in 1952.

66 Federico García Lorca, "Play and Theory of the *Duende*" in *In Search of* Duende (New York: New Direction Bibelot, 1998) 54.

67 Ibid., 50–51.

68 Ibid., viii.

69 Shaker visual forms and sense of the minimal also influence the photographic work of Charles Sheeler from 1915 to the end of his career in 1965.

70 Studs Terkel, *The Good War: An Oral History of The Second World War* (Random House, New York: 1984).

71 Yousuf Karsh, *Faces of Destiny* (London: Harrap, 1946) 5–6.

72 Wallace Stevens, "Domination of Black" in Stevens, *Collected Poetry & Prose*, 7.

73 Arthur Schopenhauer, *Parerga and Paralipomena*, vol. 2, ch. 29, sct. 377 (1851).

74 Boorstin, *The Image: A Guide to Pseudo-Events in America*, 57.

75 After Avedon's first book, he no longer only included portraits of those he admired.

76 Boorstin, op. cit., 54.

77 Yousuf Karsh, *Karsh: A Biography in Images*, with commentary by Jerry Fielder (Boston: Museum of Fine Arts, 2003) 82.

78 Yousuf Karsh, *Karsh: A Fifty-Year Retrospective* (Boston: Little Brown and Company, 1983) 55.

79 Rosenberg, introduction to *Aaron Siskind: Photographs*.

80 Wallace Stevens to Thomas McGreevy, September 9, 1949, Wallace Stevens, *Letters of Wallace Stevens*, ed. Holly Stevens (Berkeley: University of California Press, 1966) 647.

81 Karsh, *In Search of Greatness*, 94.

82 Emerson wrote this essay between 1841 and 1843. Soon after it was published, it became an inspiration for Walt Whitman, who felt he had to answer the call that Emerson made for an American poet.

83 Ralph Waldo Emerson, "The Poet," in Ralph Waldo Emerson, *Essays & Lectures* (New York: Library of America, 1983).

84 Karsh, *In Search of Greatness*, 94.

85 Emerson, "The Poet," 453.

86 Ibid., 448.

87 Ibid., 495.

88 Ibid., 463.

89 Stevens, "The Irrational Element in Poetry," 784.

90 Karsh, *Portraits of Greatness*, 12.

91 One can speculate that this streak of inspired work in Europe was a result of Karsh having spent more than a year (1952–53) on assignment traveling across Canada recording a documentary of the virtues of the country's workers.

92 Albert Camus, "Replies to Jean-Claude Brisville," in *Lyrical and Critical Essays*, 360.

93 Camus's remarks are recorded in a 1959 interview with Jean-Claude Brisville, published in Albert Camus, "Replies to Jean-Claude Brisville," in *Lyrical and Critical Essays*, 365.

94 Albert Camus, "Encounter with Albert Camus," in *Lyrical and Critical Essays*, 353.

95 Albert Camus, "Letter to Roland Barthes on *The Plague*," in *Lyrical and Critical Essays*, 341.

96 In 1943, the Daughters of the American Revolution invited Anderson to sing in a benefit concert in Constitution Hall to aid the American Red Cross. Anderson accepted.

97 Karsh, *Portraits of Greatness*, 13.

98 Harry Callahan, "Harry Callahan, 1912–1999: An Interview with John Paul Caponigro," *Camera Arts*, Vol. III, No. III, June/July 1999, 8.

99 Harry Callahan, "Harry Callahan, a Life in Photography," edited from an eight-hour video interview made in 1977 by Harold Jones and Terrence Pitts, in Keith Davis and *Harry Callahan, Photographs: An Exhibition from the Hallmark Photographic Collection* (Kansas City, MO: Hallmark Cards, 1981) 55.

100 Anderson was the first African-American to be cast in a major role at the Metropolitan Opera in New York, singing the role of Ulrica in Giuseppe Verdi's *Un Ballo in maschera* on January 7, 1955.

101 Karsh, *Karsh: A Biography in Images*, 139.

102 The four songs were originally not considered a group by the composer. "Im Abendrot" (lyrics by Josef von Eichendorff) was written first but now performed as the final song in the sequence: "Frühling" ("Spring" by Herman Hesse), "September" ("September" by Herman Hesse), "Beim Schlafengehen" ("On Going to Sleep" by Herman Hesse), and "Im Abendrot."

ACKNOWLEDGEMENTS

I AM INDEBTED to Estrellita Karsh for her untiring efforts to keep the accomplishment of her husband's career alive and to her support of my research. Seldom have I worked with a widow or a family member of an artist who had such a clear-sighted and balanced understanding of the strengths and shortcomings of creative individuals in both the sciences and the arts. Her own career as a medical writer may have contributed to this, but in working with her for the past two years on my celebratory, but judicious, assessment of Yousuf Karsh as a man and photographer, I came to feel that it has a deep-seated place in her ethical view of both society and individuals.

Jerry Fielder, Karsh's long-time assistant and present Director and Curator of the Estate of Yousuf Karsh, was equally fair in helping me to reach an informed view of Karsh's attitude toward his work and sitters. His fine critical sense for language more than once kept me from errors of false emphasis or the flights of fancy that writers often fail to notice. He was also indispensable in stepping into the role of diplomat when small annoyances threatened my concentration.

Writers who work without readers forget that the text is only complete when it is fully comprehensible. Thus, I am grateful to my many guides, readers, and editors who have both encouraged me and rescued me from my own visionary enthusiasms with their responses, in particular: Tom Bamberger, Katherine A. Bussard, Gregory Conniff, Terry Evans, Jerry Fielder, Estrellita Karsh, Anstiss Krueck, Susan Rossen, Carl W. Scarbrough, Elizabeth Siegel, Irene Siegel, Linda K. Smith, Martha and Jorge Sneider, and my wife Leslie Travis.

All readers of this book will join me in my gratitude to Patricia Kouba for her sketch biographies of Karsh's sitters. Without them few would be able to identify the characters or bring to their appreciation of the work the necessary knowledge that must accompany pleasure and judgment of the resulting portrait. I am grateful to those who edited these biographies to their fitting expression and length: David R. Godine, Jennifer Levine, Daniel E. Pritchard, Emma Thesenvitz, and Leslie Travis.

Jean Genoud, long-time friend and admirer of Karsh, and the printer who most profoundly understands the crucial role of the exact placement of tone and contrast in Karsh's work, brought to bear decades of knowledge from an illustrious career and attended to the supervision of the production of this book with the support of his remarkable staff and company. If his results are nothing short of astounding, it is in part due to Karsh's own superb prints and to the skill of Jamie Stukenberg who made the camera scans of them and Patrick Goley of Professional Graphics, Inc. who checked each of the scan proofs against the originals.

Lastly, the ideas and feelings that a writer may bring to light will only survive in a book if experienced in a visual and tactile way. Sara Eisenman, with her exquisite sense of typography and imposition has made the book a reader's delight, as well as one that can be celebrated for its visual grace. Jennifer Delaney deftly and cheerfully guided the book from its piecemeal components to its lasting form as a complete book. This loving attention to the qualities of appearance and substance is a hallmark of all the books that David R. Godine, friend and supporter of photographers, artists, designers, writers, and in particular this curator, has published. I am grateful to him for his attention to and augmentation of my passions for calligraphy, typography, book design, photography, poetry, even nautical rapture that we both share.

DT

PLATES

48 *above:* ELIXIR, *1938*
 opposite: THE BALLET LESSON, *1940*

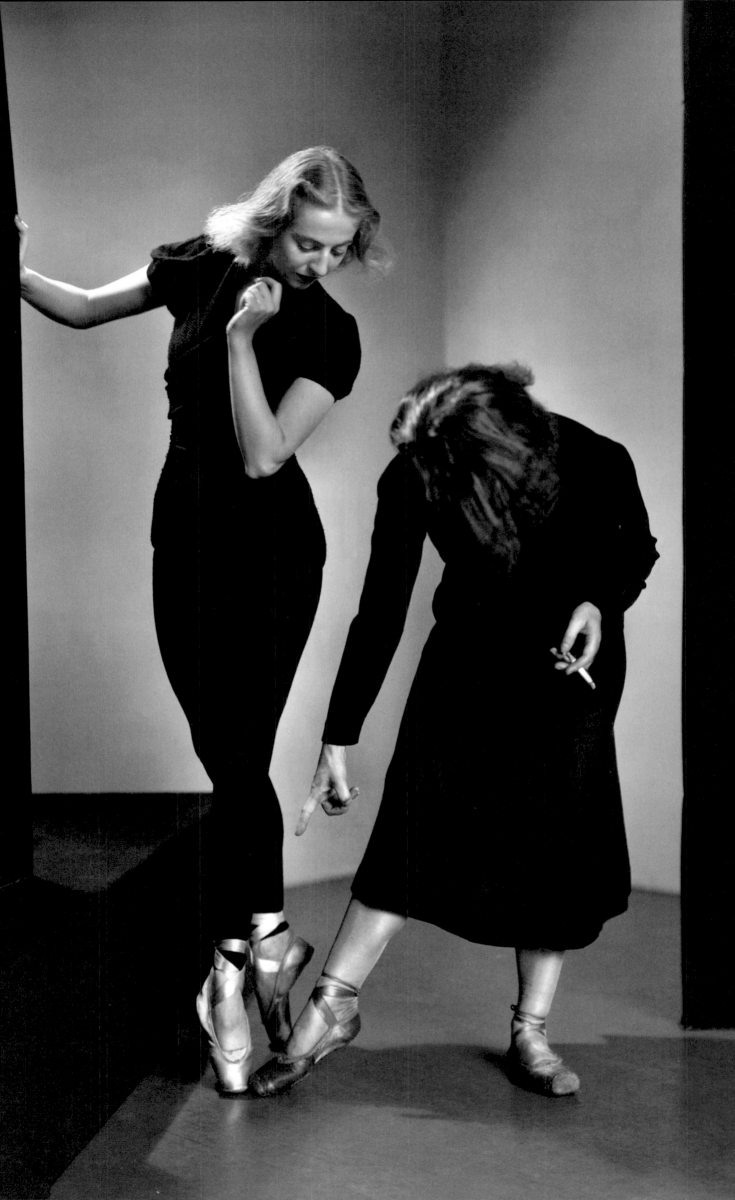

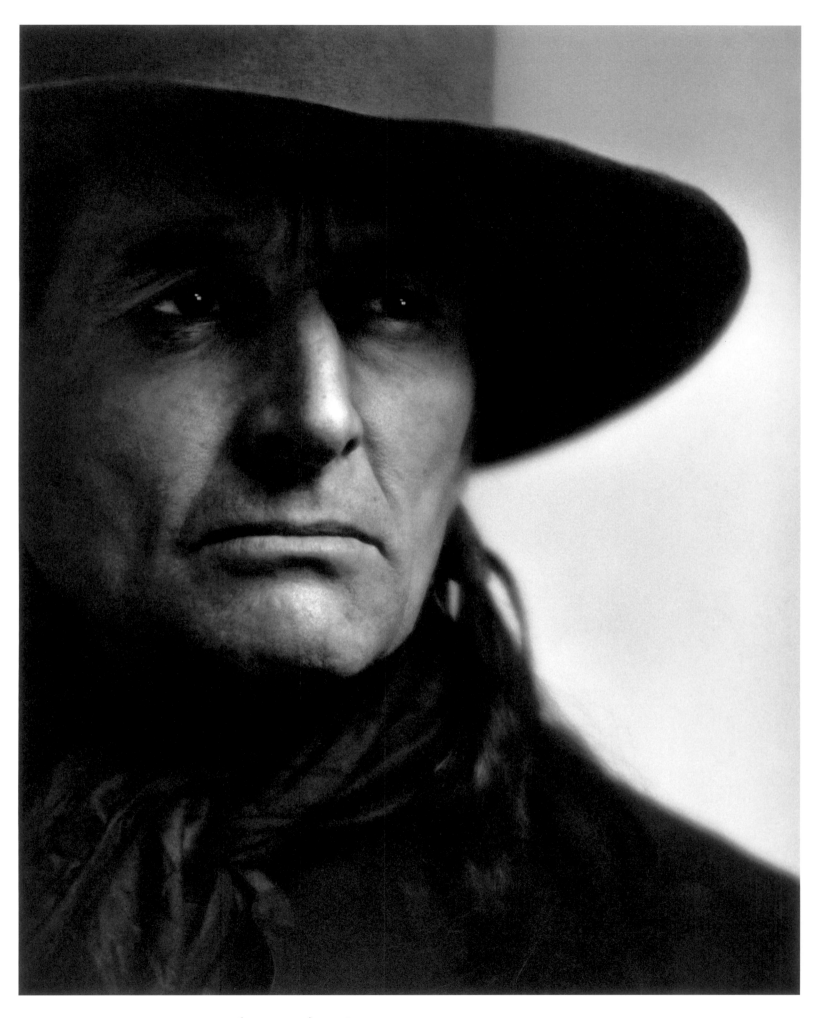

50 ARCHIBALD BELANEY (GREY OWL), *1936*

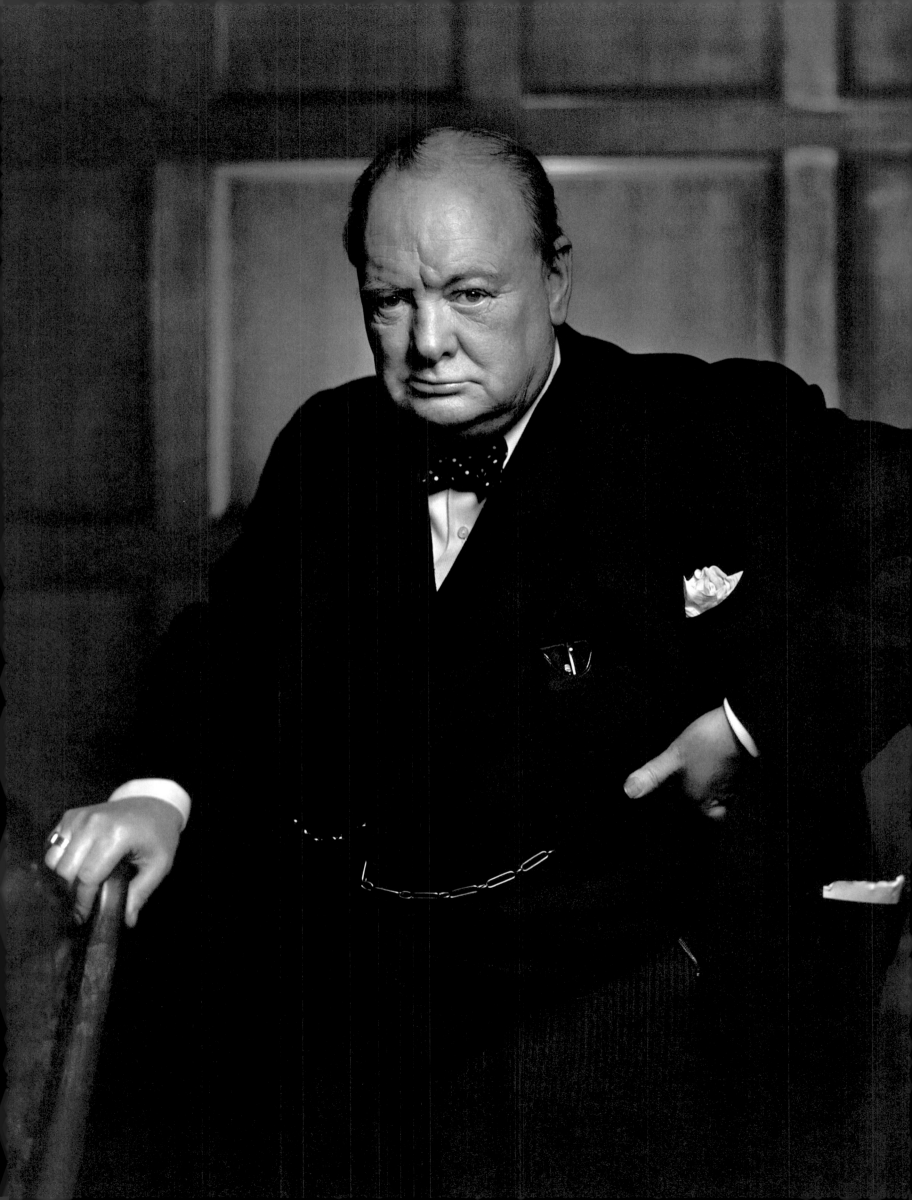

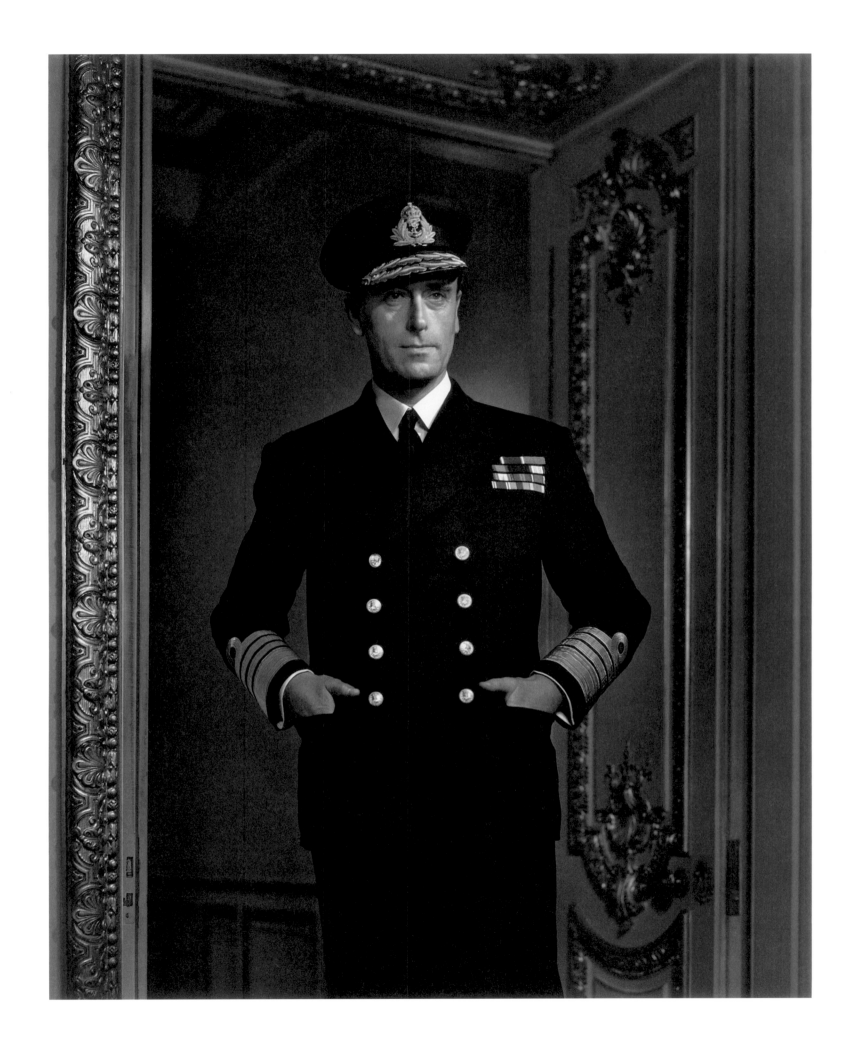

54 LORD LOUIS MOUNTBATTEN, *1943*

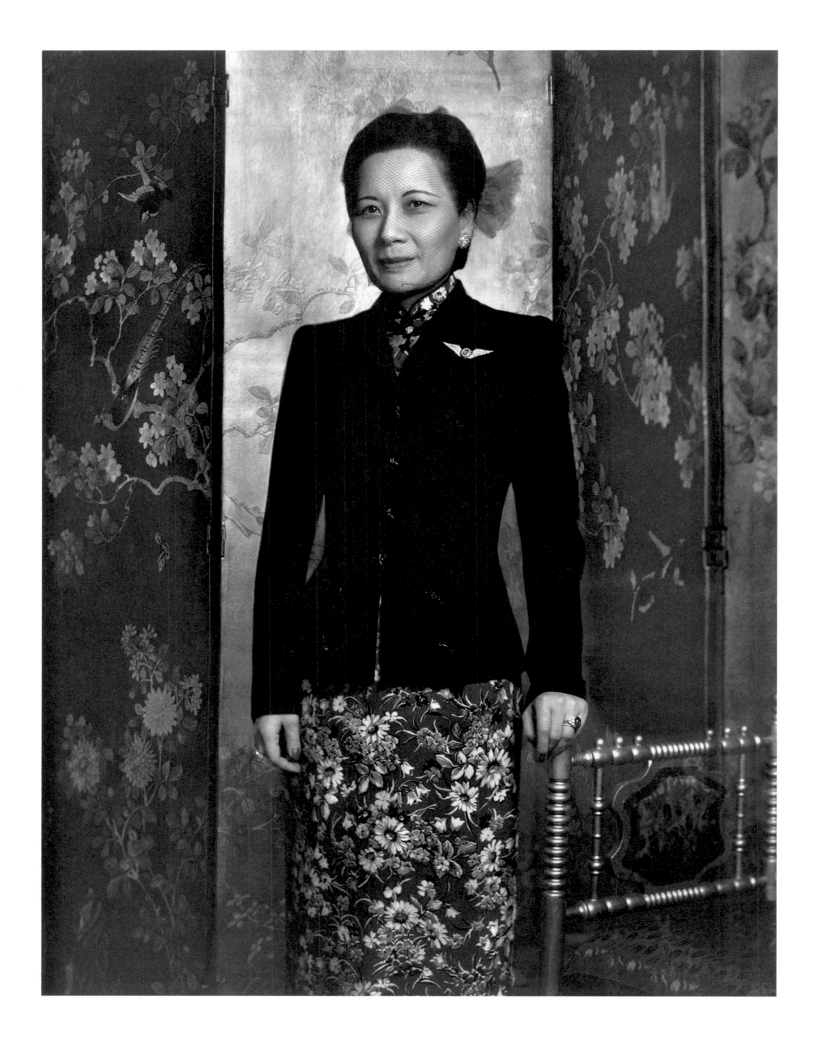

MADAME CHIANG KAI-SHEK, *1943* 55

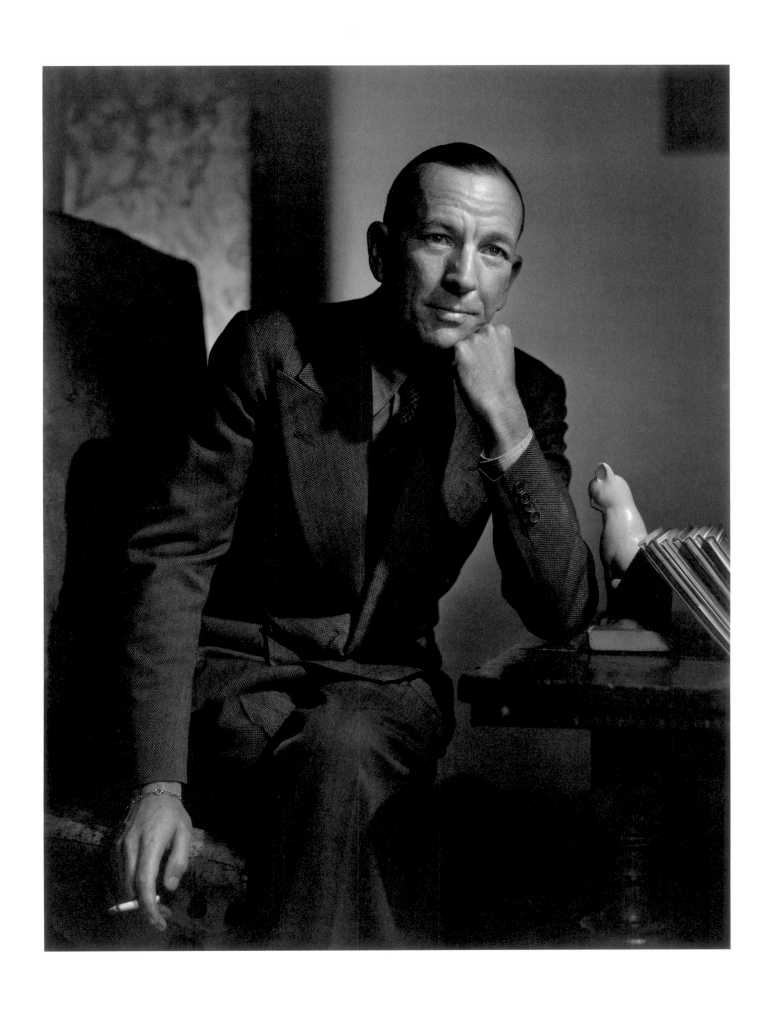

56 *above:* NOËL COWARD, *1943*
opposite: GEORGE BERNARD SHAW, *1943*

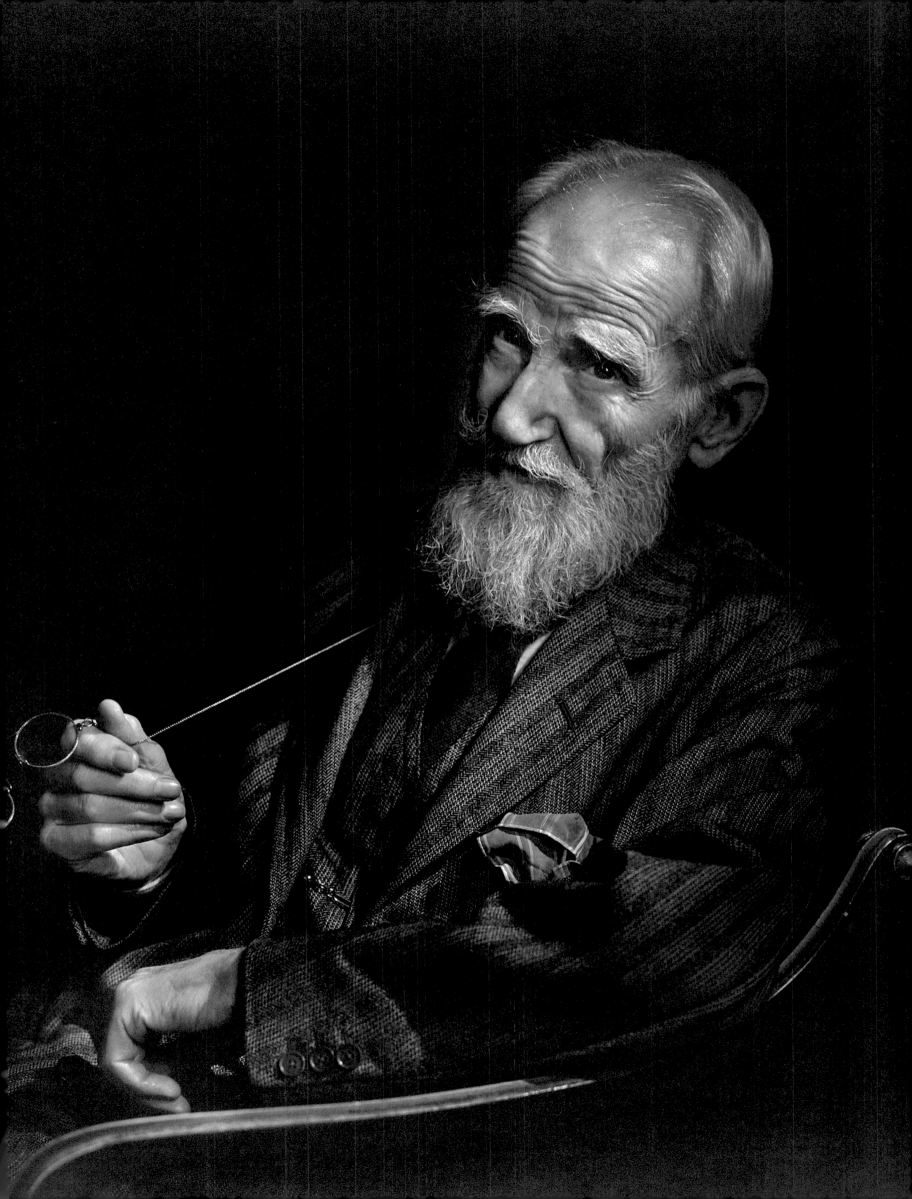

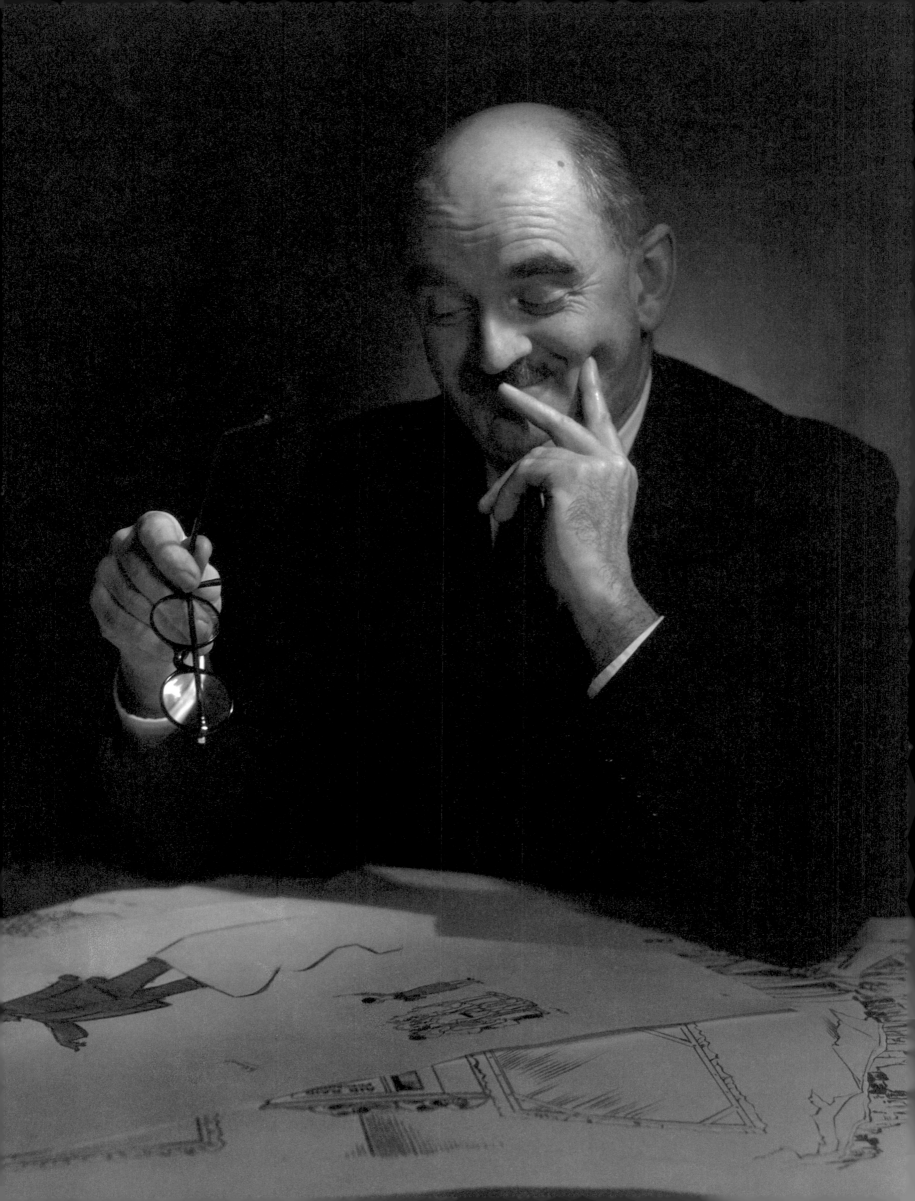

above: H. G. WELLS, *1943* 59
opposite: DAVID LOW, *1943*

60 *above:* RUSSEL WRIGHT, *1944*
 opposite: DWIGHT D. EISENHOWER, *1946*

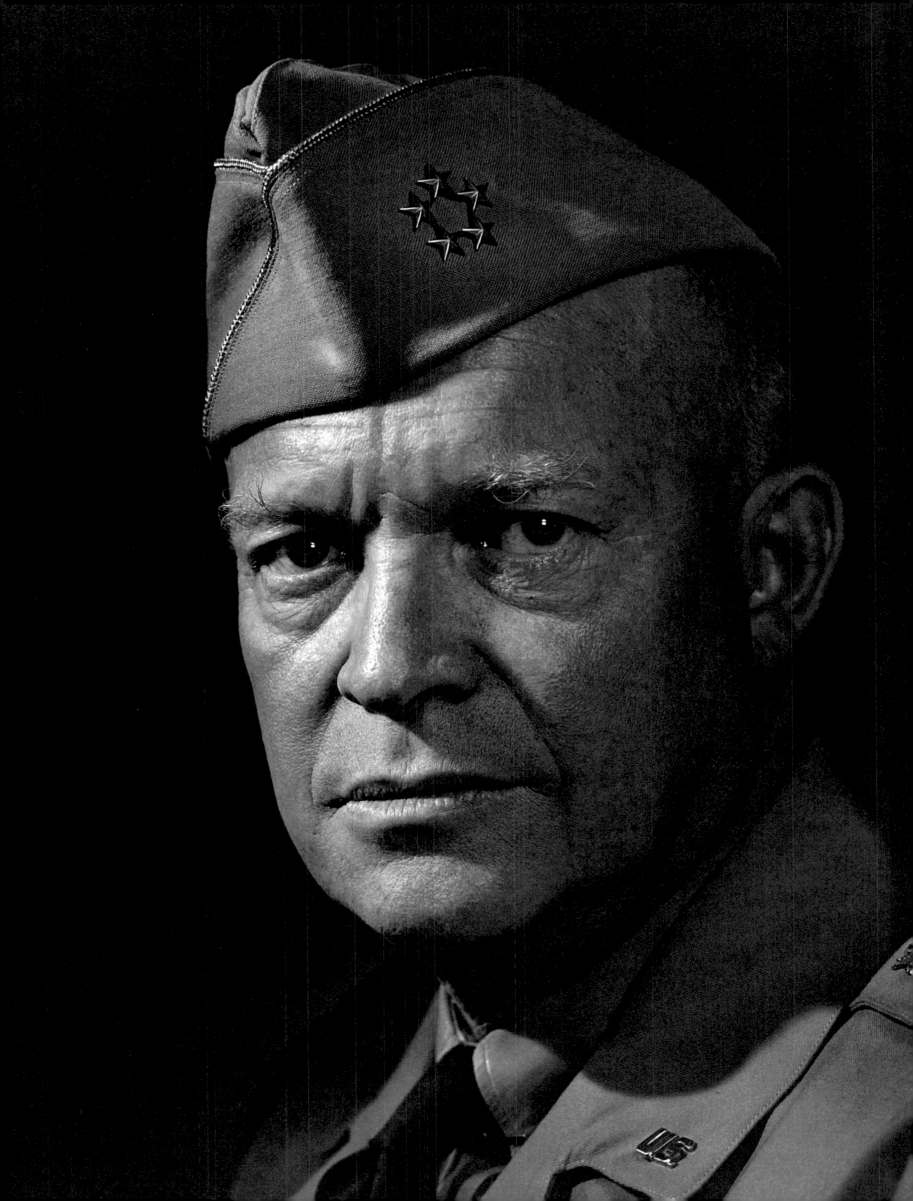

MARIAN ANDERSON, *1945*

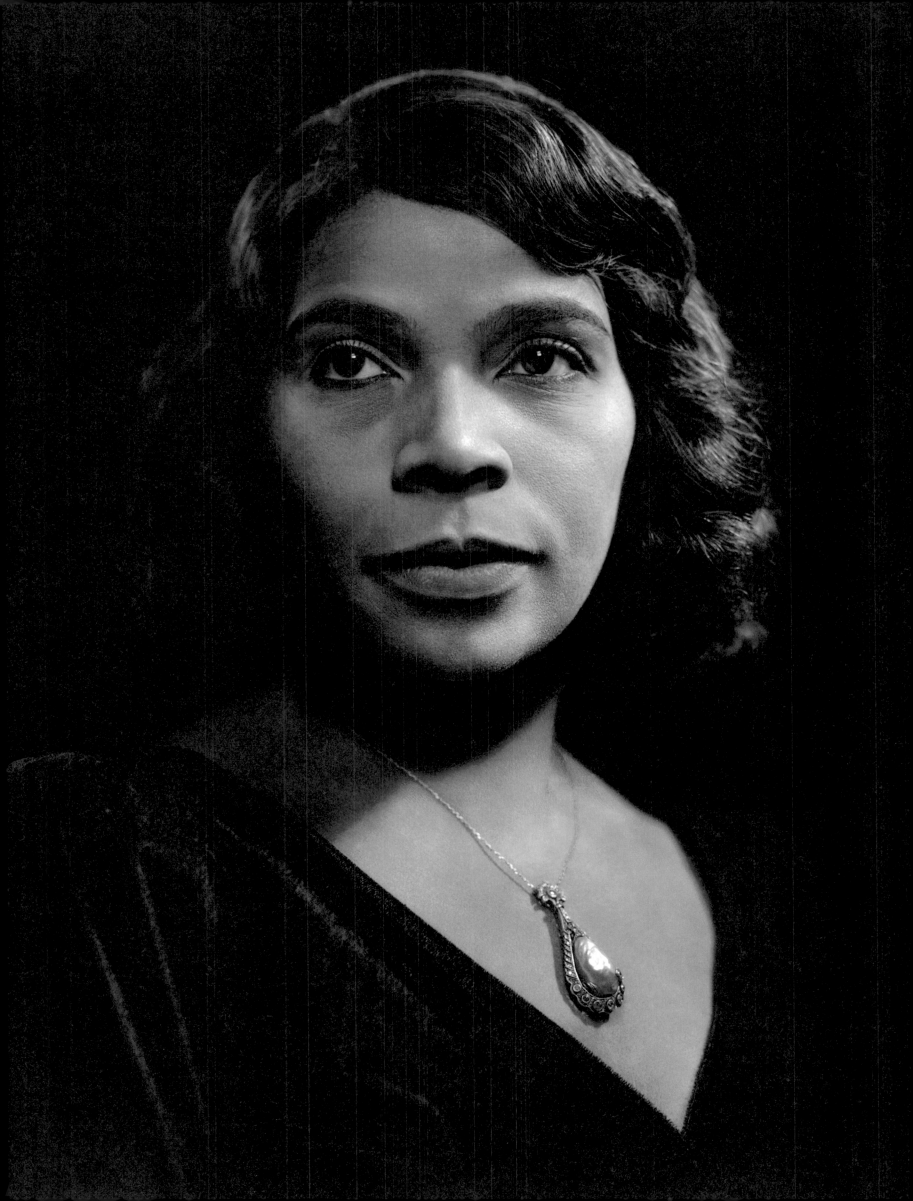

above: EDWARD STEICHEN, *1944*
64 opposite: BORIS KARLOFF, *1946*
overleaf left: HUMPHREY BOGART, *1946*
overleaf right: INGRID BERGMAN, *1946*

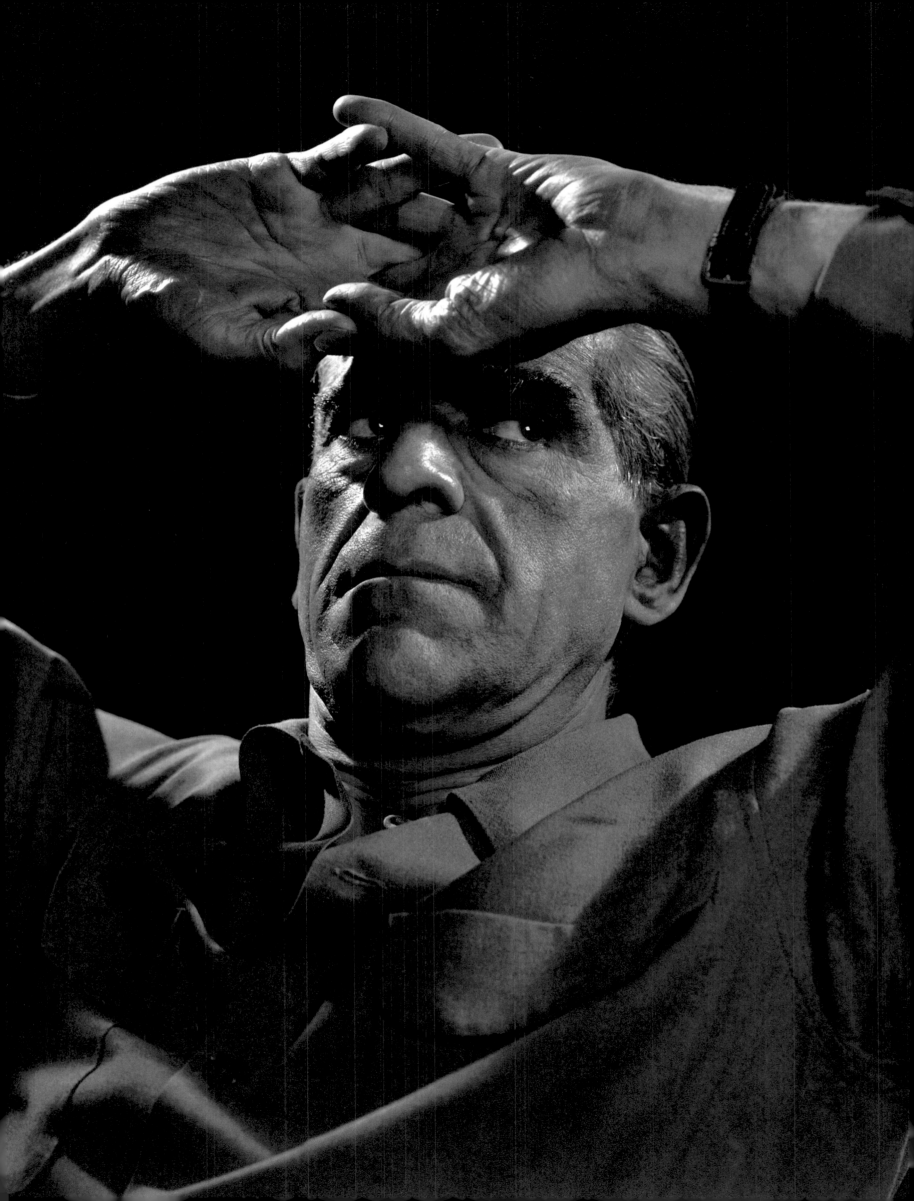

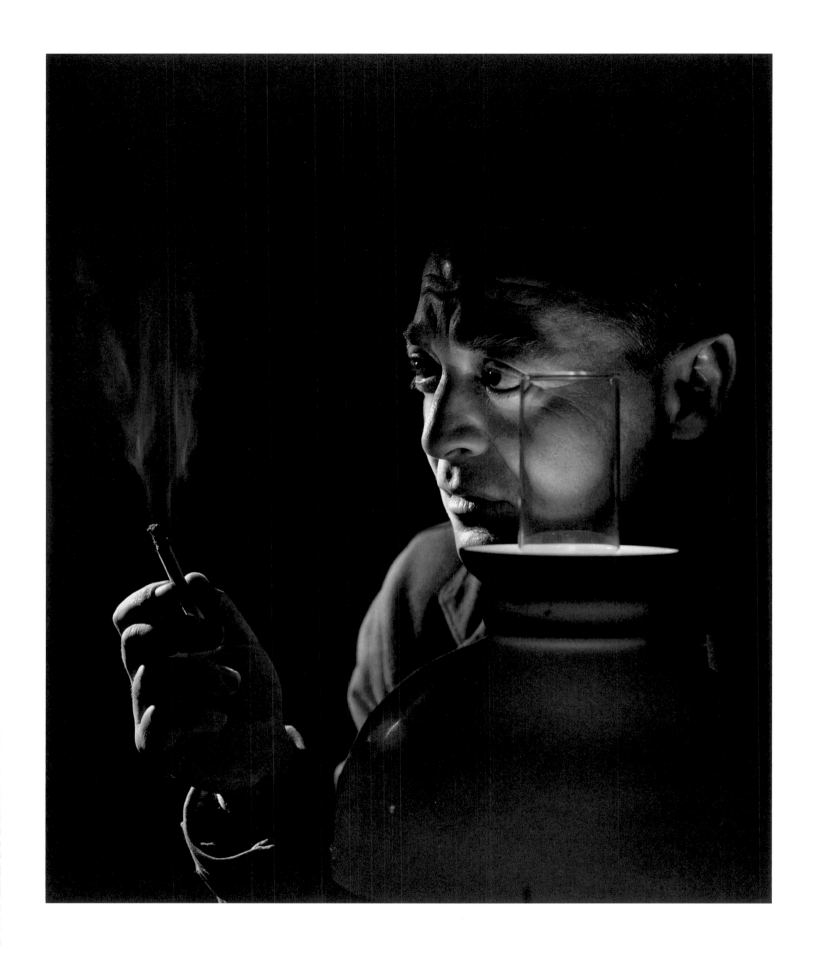

above: PETER LORRE, *1946*
opposite: JOAN CRAWFORD, *1948* 69
overleaf left: FRANK LLOYD WRIGHT, *1945*
overleaf right: CLARK GABLE, *1948*

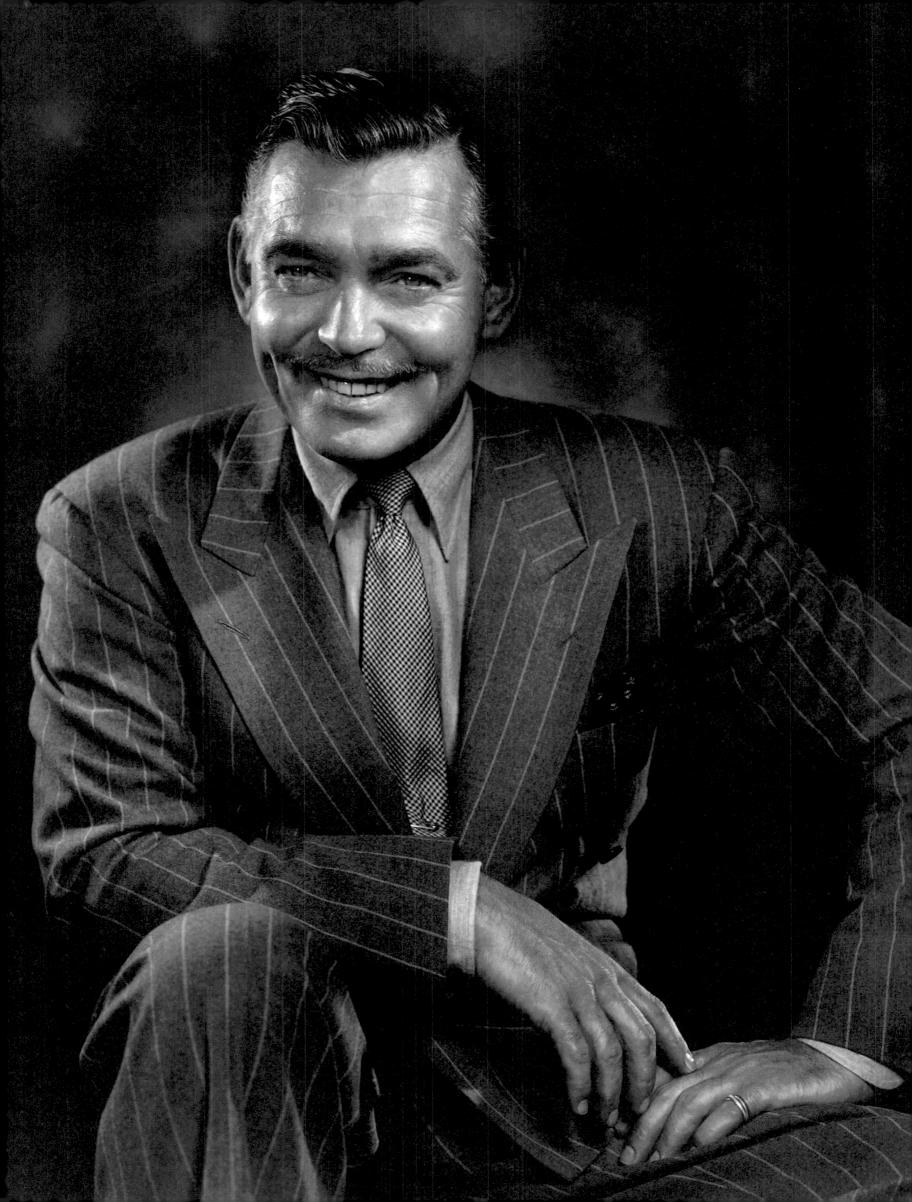

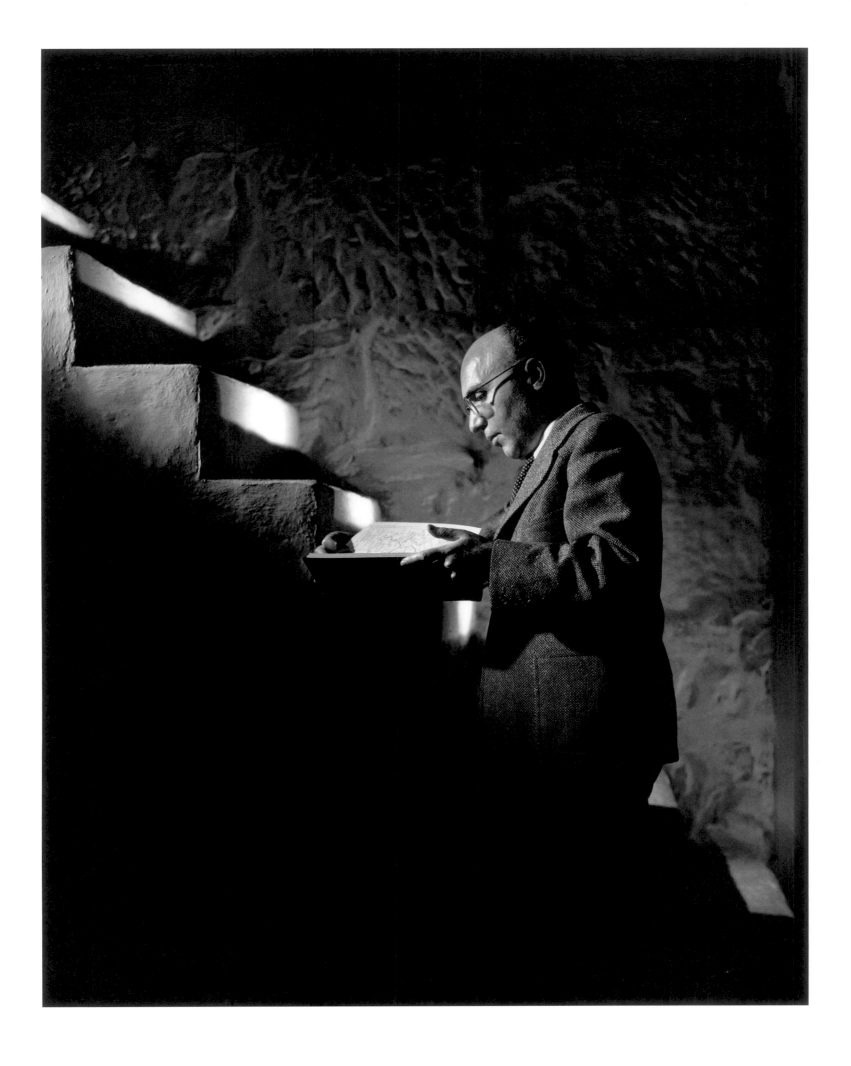

72 *above:* **KURT WEILL,** *1946*
 opposite: **THOMAS MANN,** *1946*

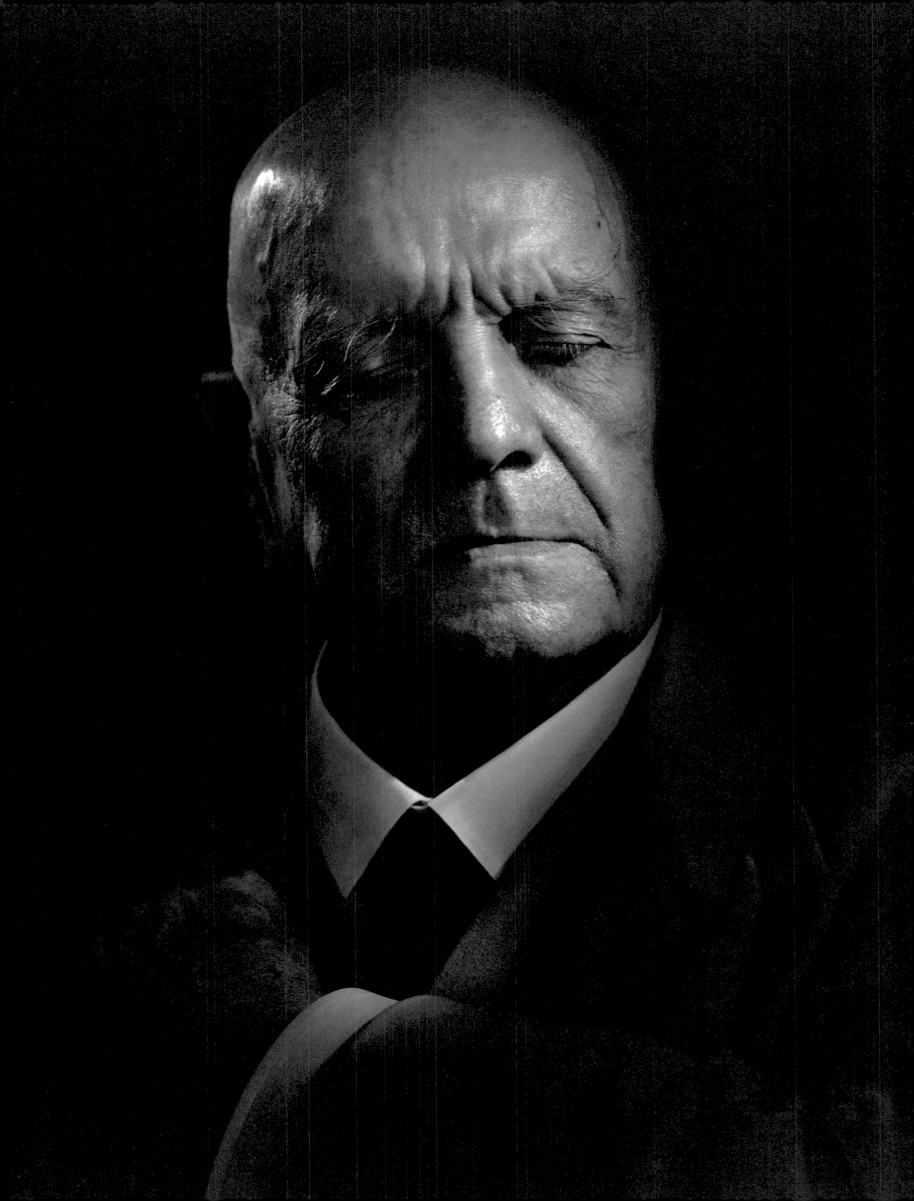

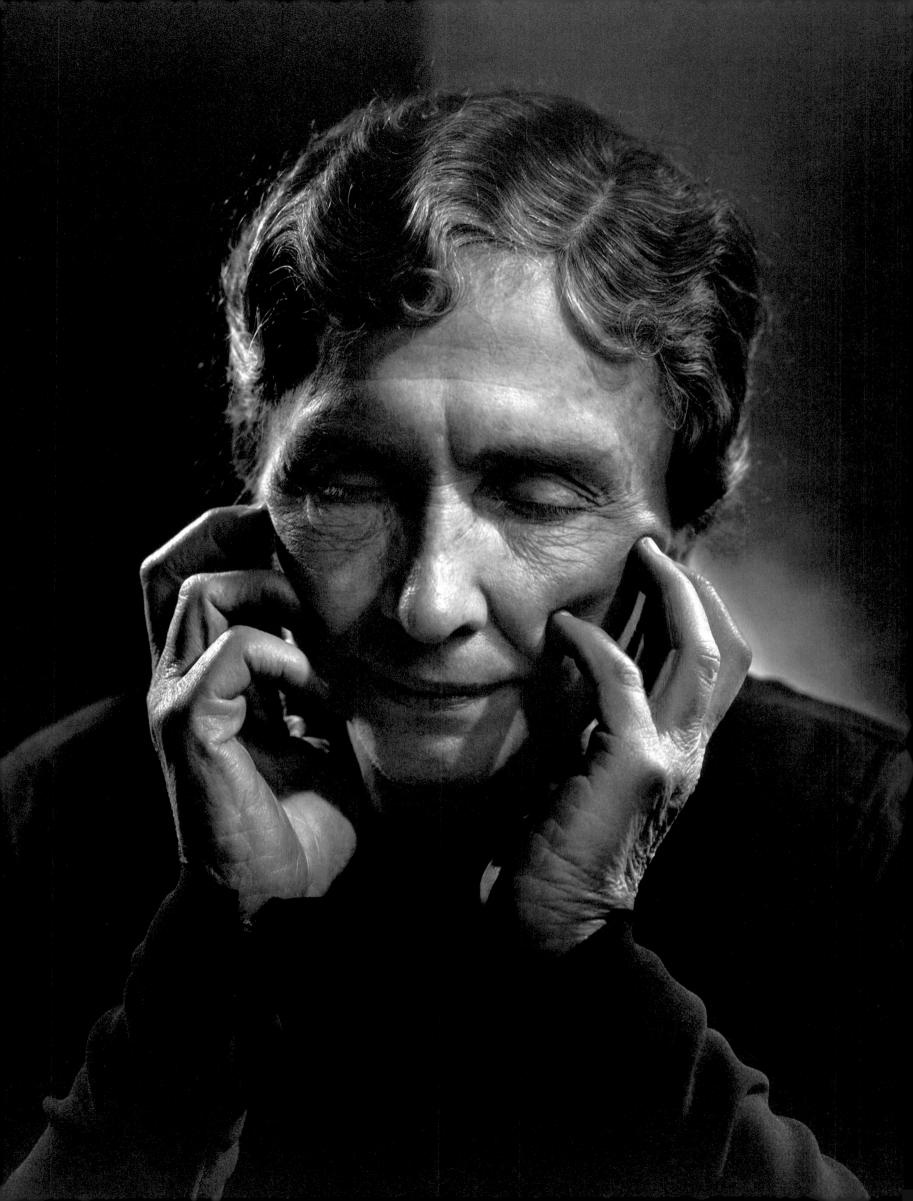

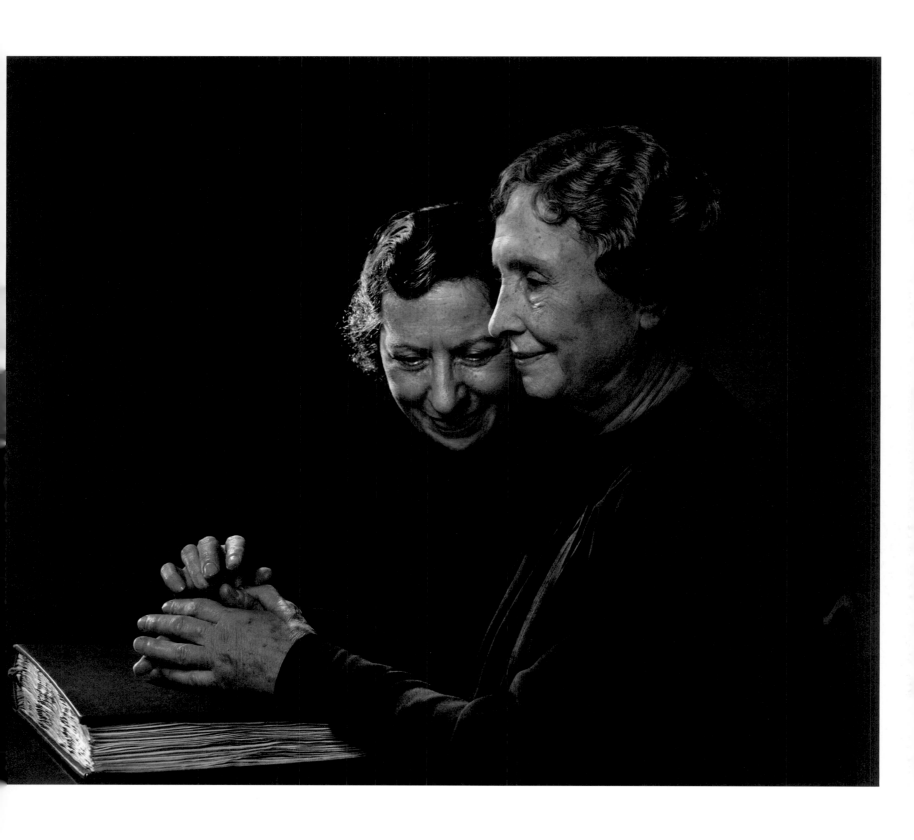

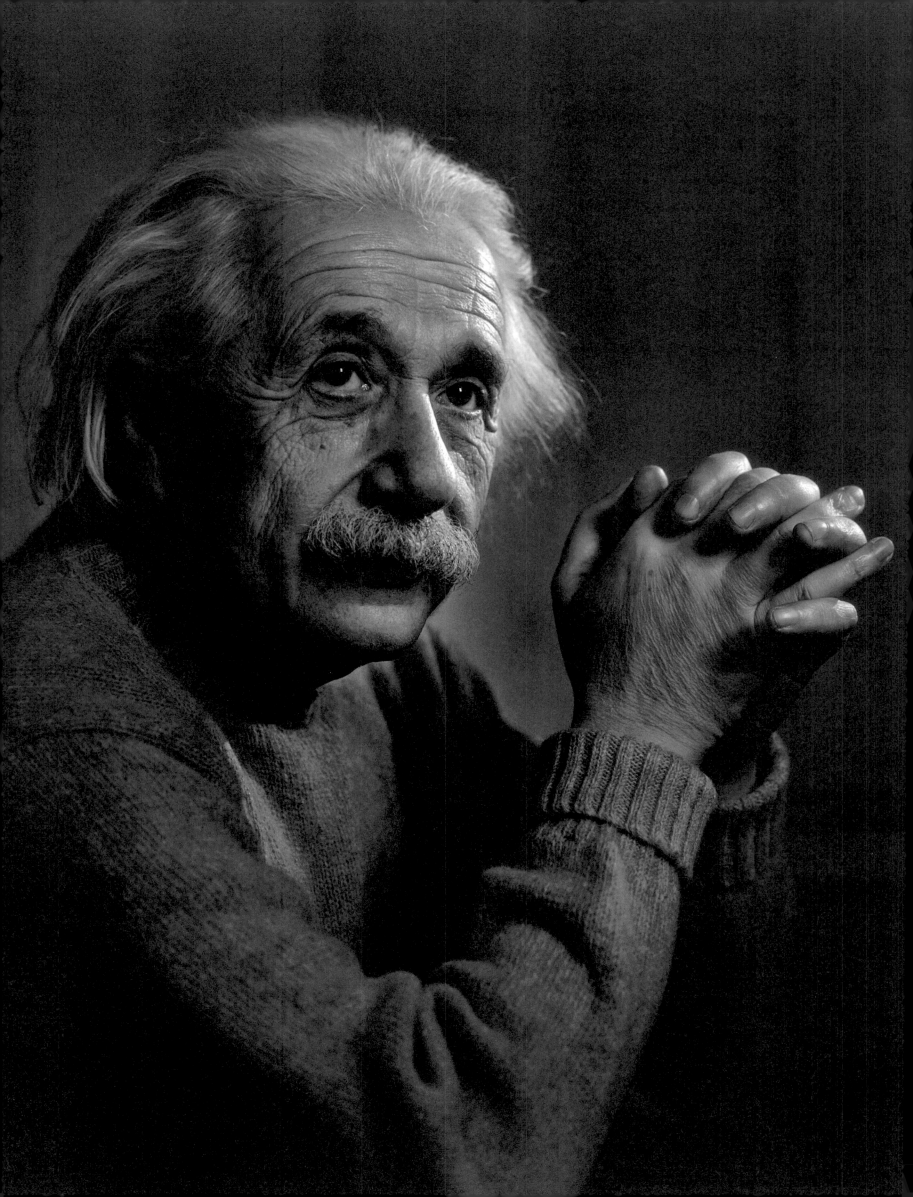

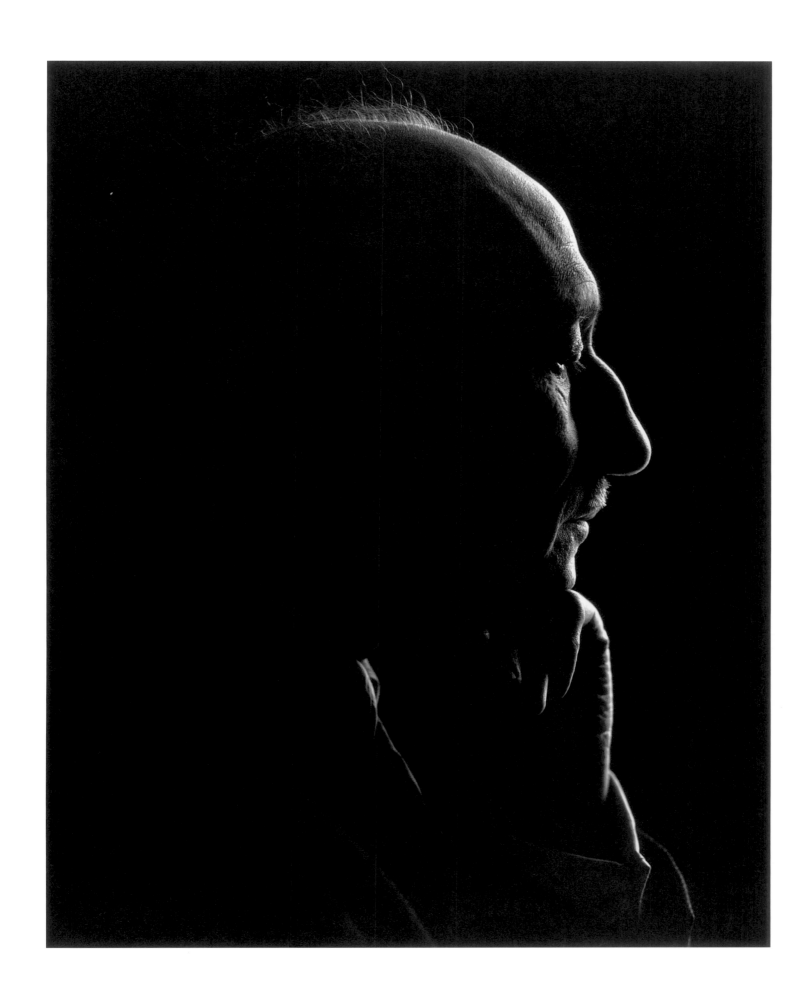

80 *above:* FRANÇOIS MAURIAC, *1949*
opposite: MARTHA GRAHAM, *1948*

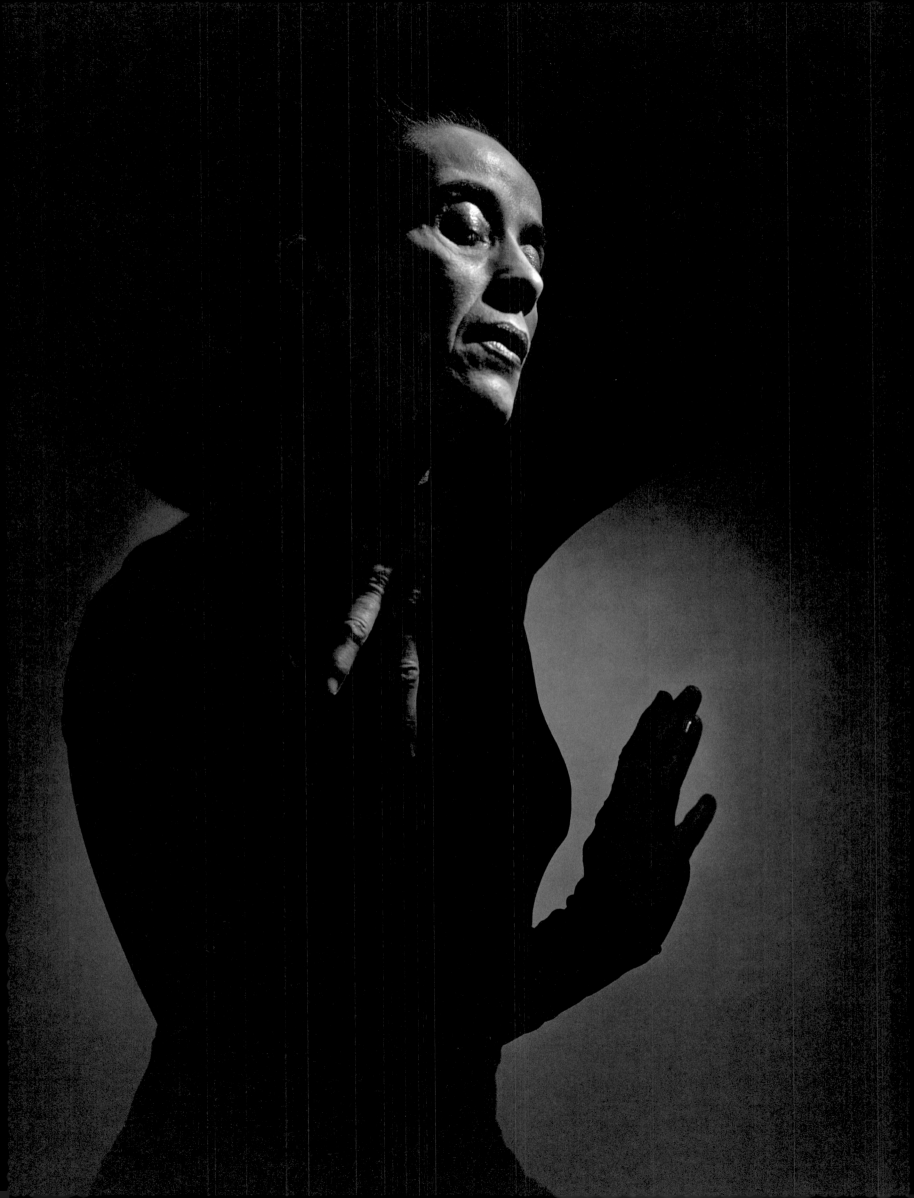

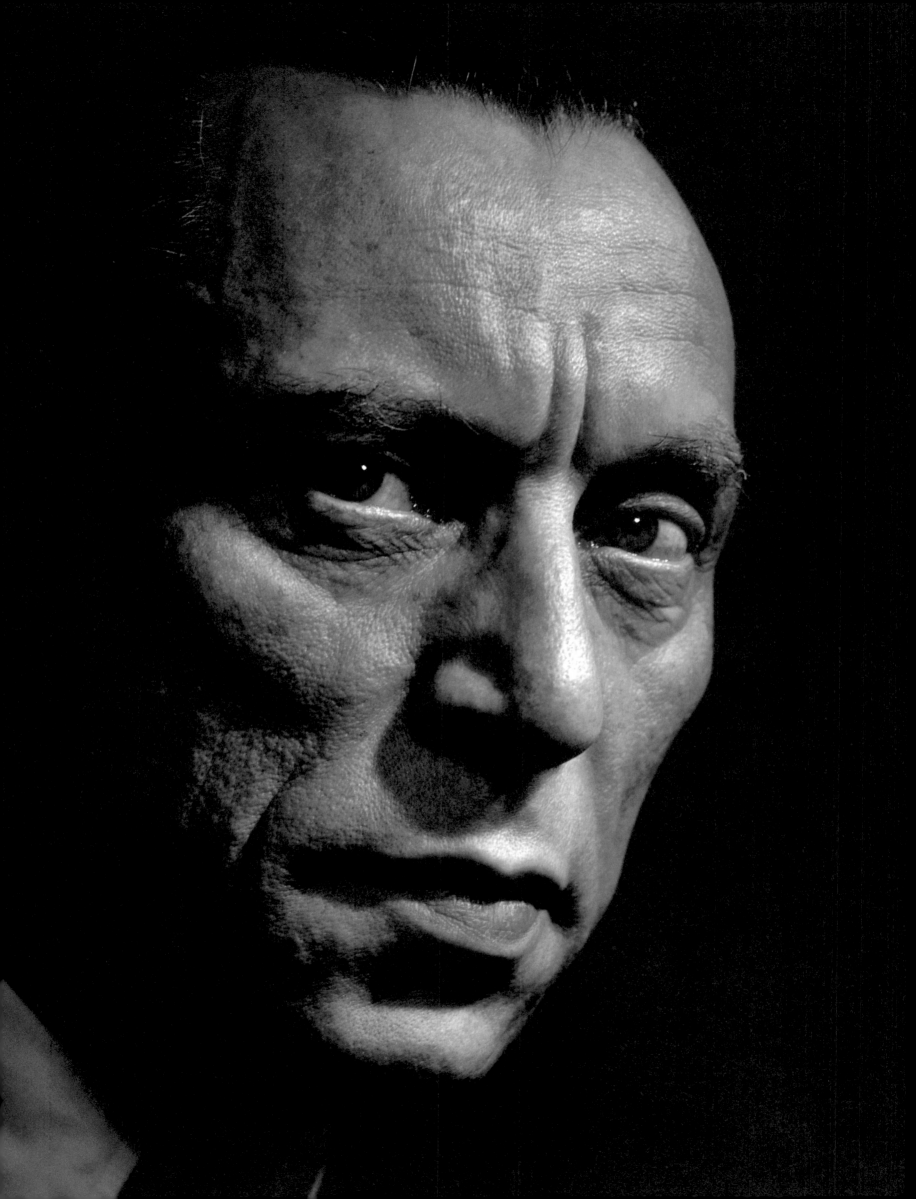

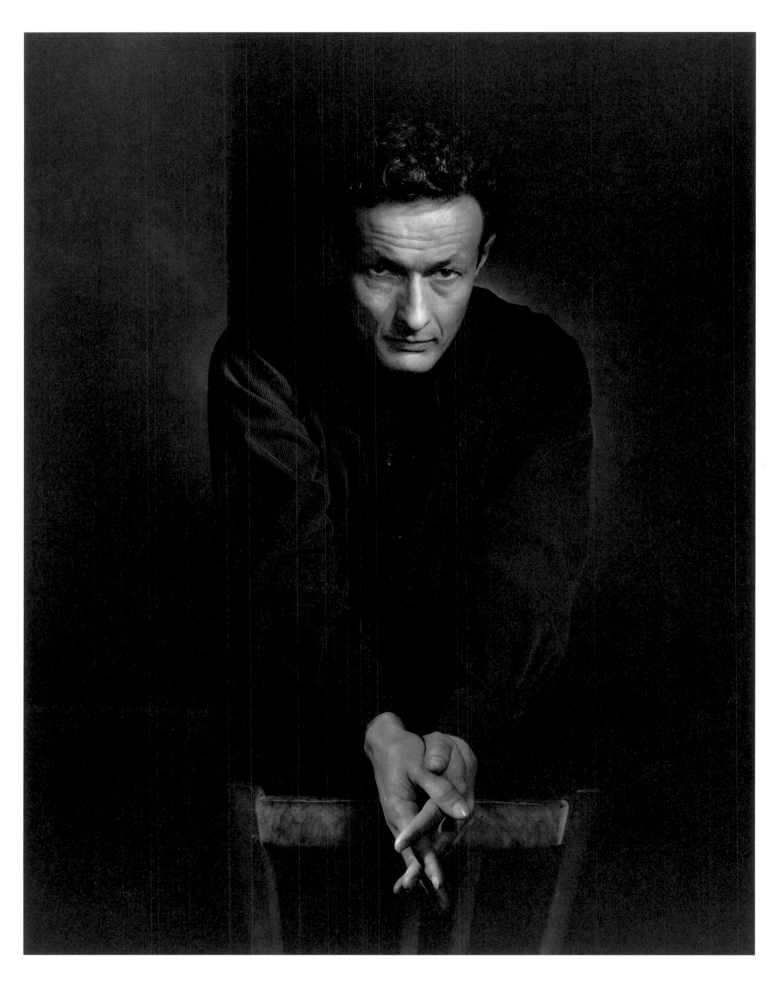

above: LOUIS JOUVET, *1949*
opposite: JEAN-LOUIS BARRAULT, *1949* 83
overleaf left: GEORGES BRAQUE, *1949*
overleaf right: HENRY MOORE, *1949*

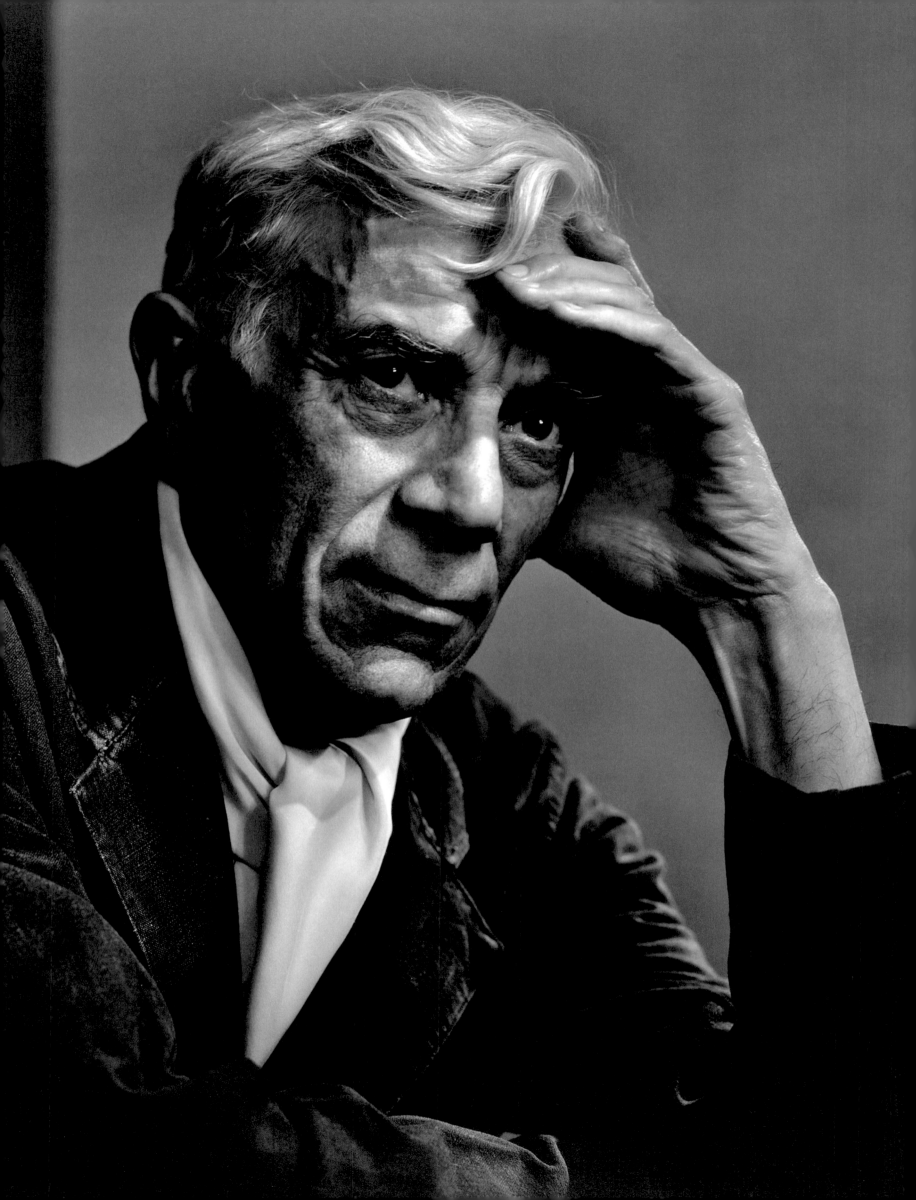

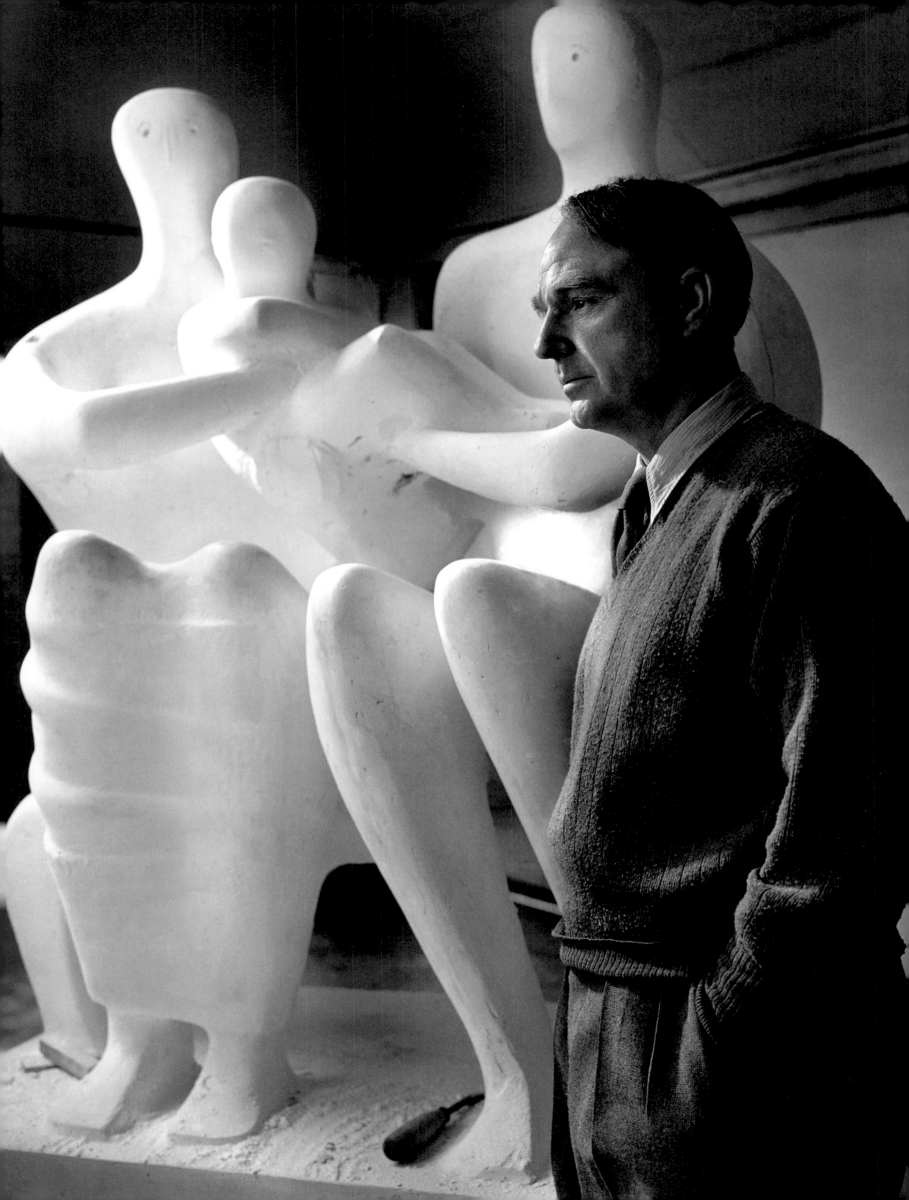

86 BENJAMIN BRITTEN, *1954*

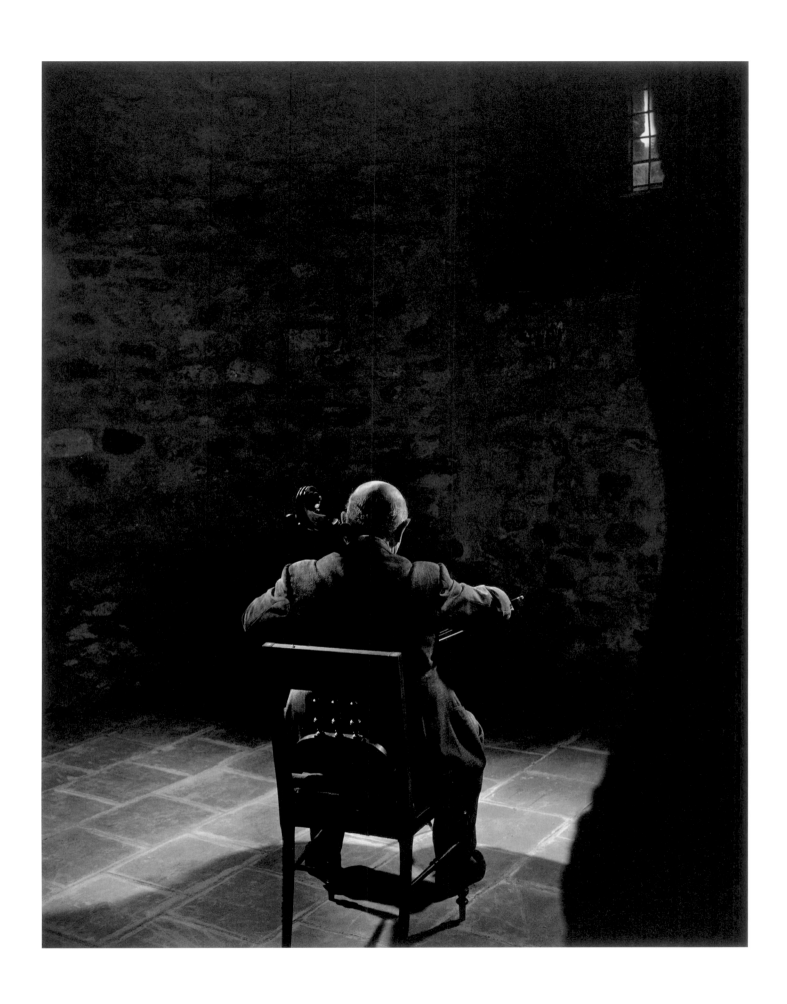

88 *above:* PABLO CASALS, *1954*
 opposite: ALBERT SCHWEITZER, *1954*

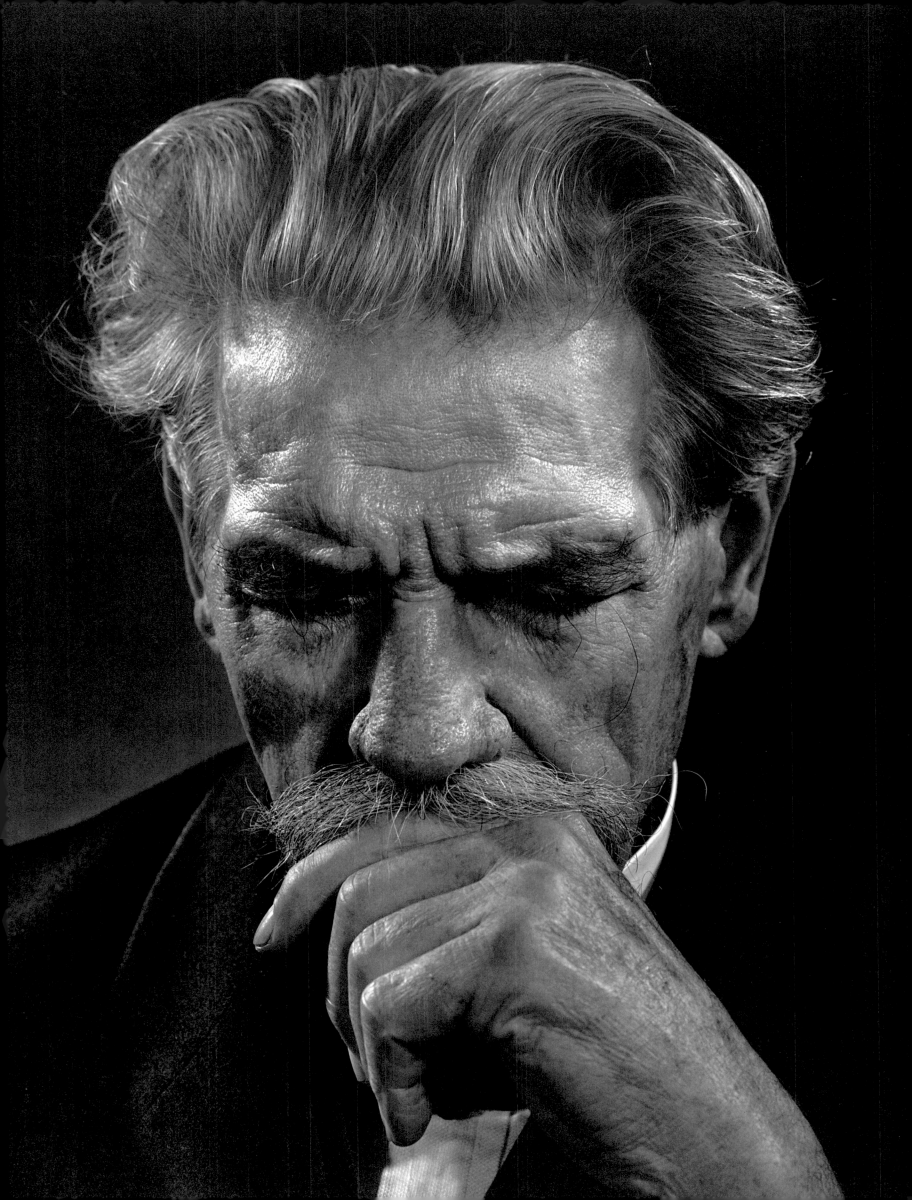

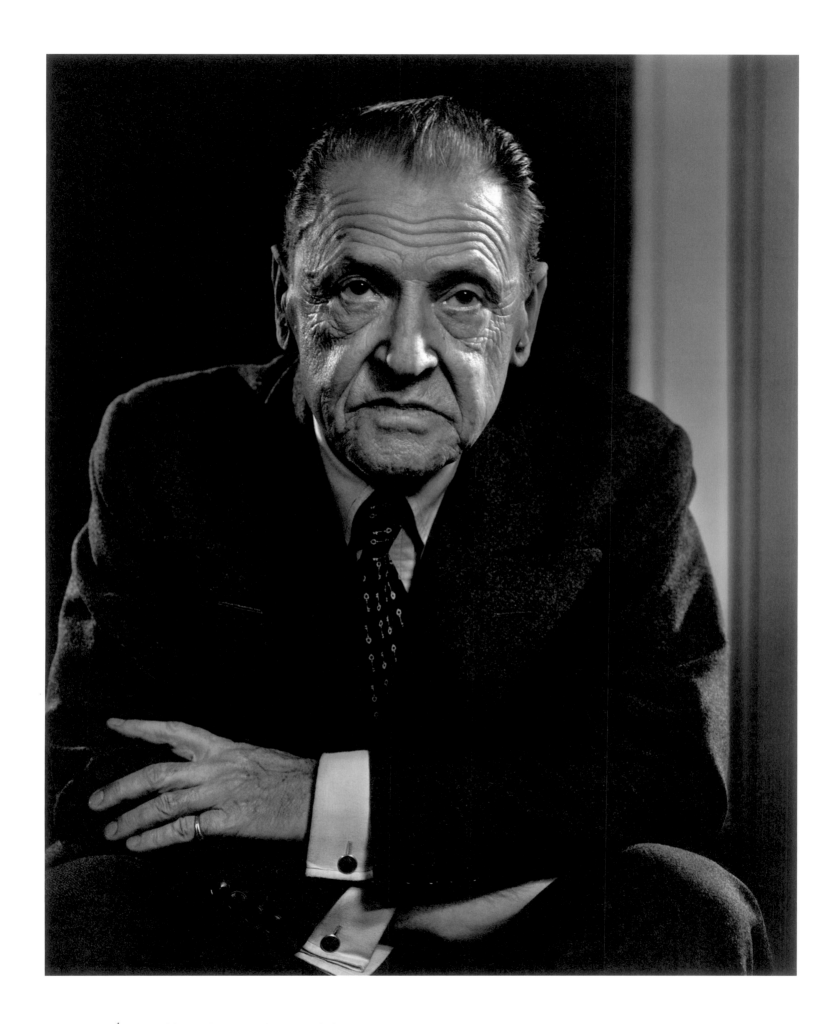

90 *above:* W. SOMERSET MAUGHAM, *1950*
 opposite: CARL SANDBURG, *1954*

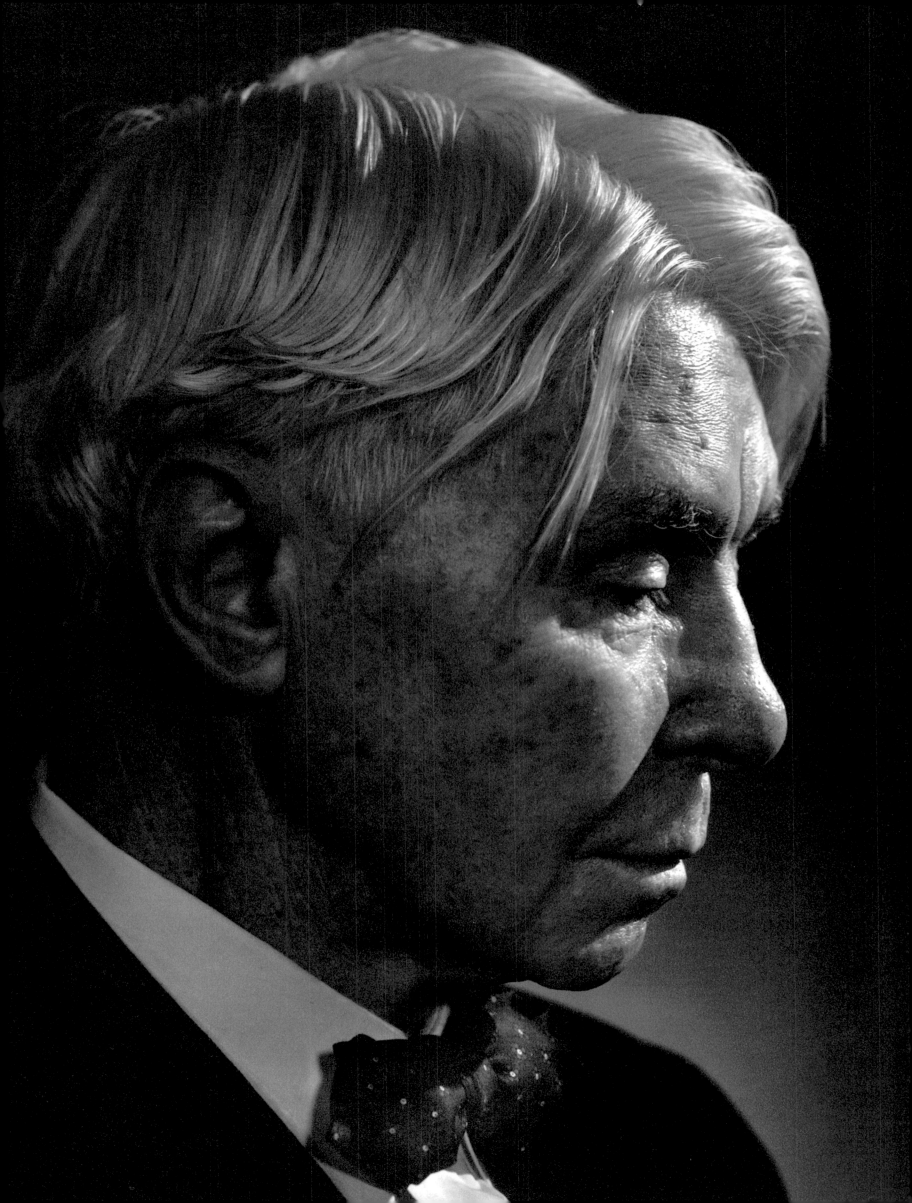

opposite: CHRISTIAN DIOR, *1954*
overleaf left: ANITA EKBERG, *1956*
overleaf right: AUDREY HEPBURN, *1956*

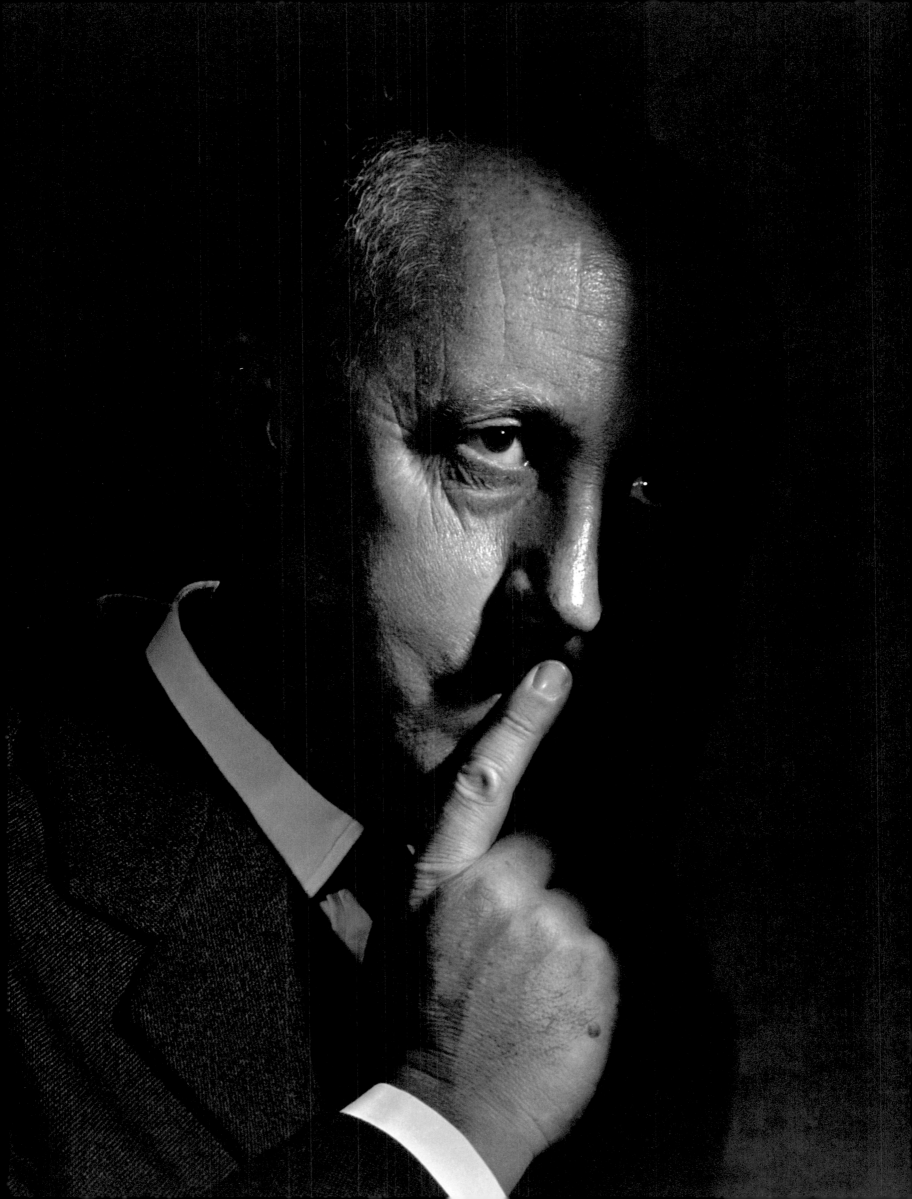

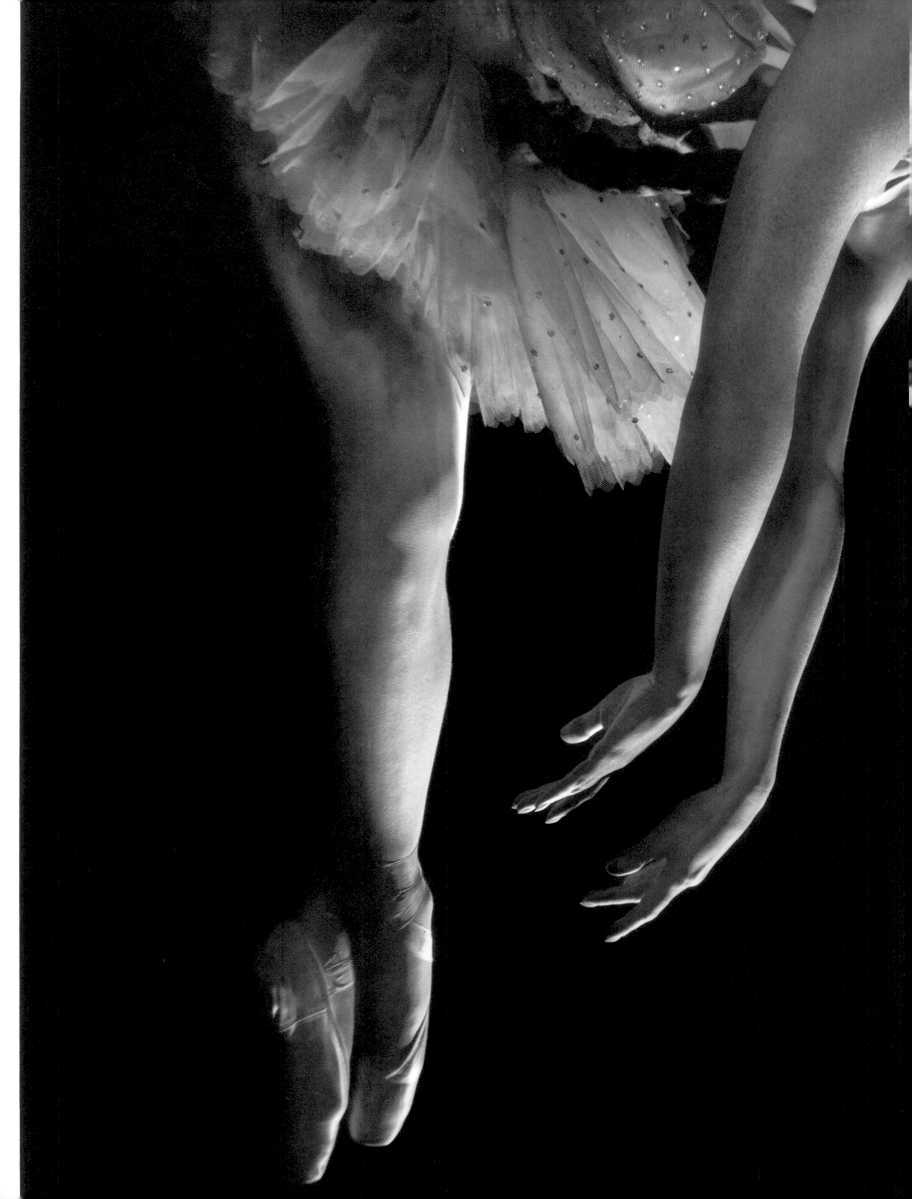

above: BRIGITTE BARDOT, *1958*
opposite: MAYA PLISETSKAYA, *1963*

above: NORMAN ROCKWELL, *1958*
opposite: WALT DISNEY, *1956*

above: **GEORGES ENESCO,** *1954*
opposite: **MARCEL MARCEAU,** *1956*

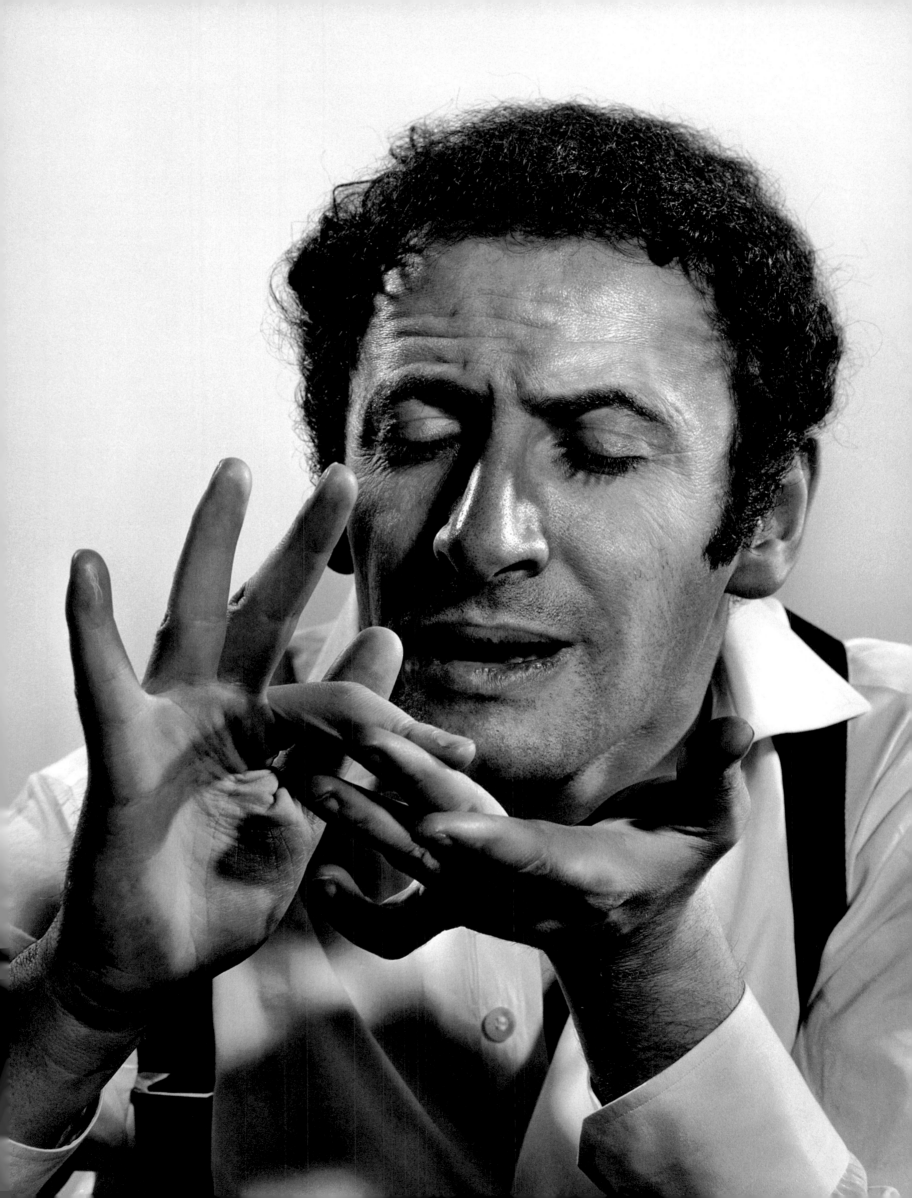

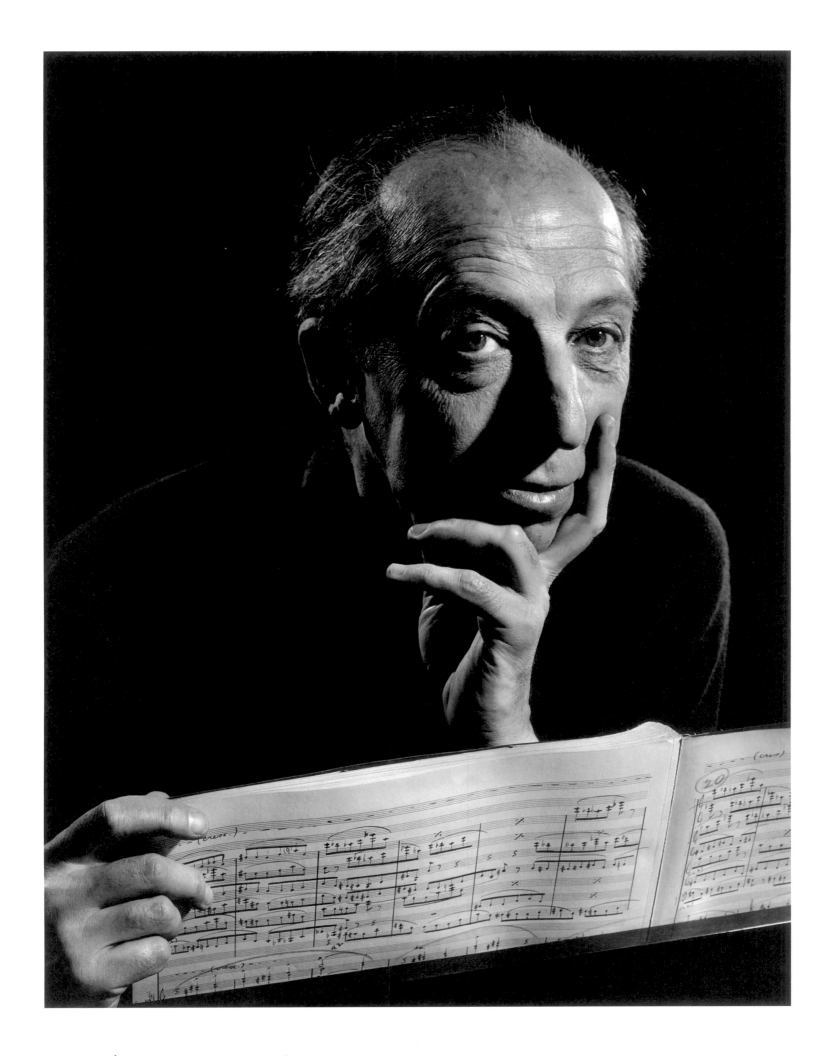

above: **AARON COPLAND,** *1956*
opposite: **PABLO PICASSO,** *1954*

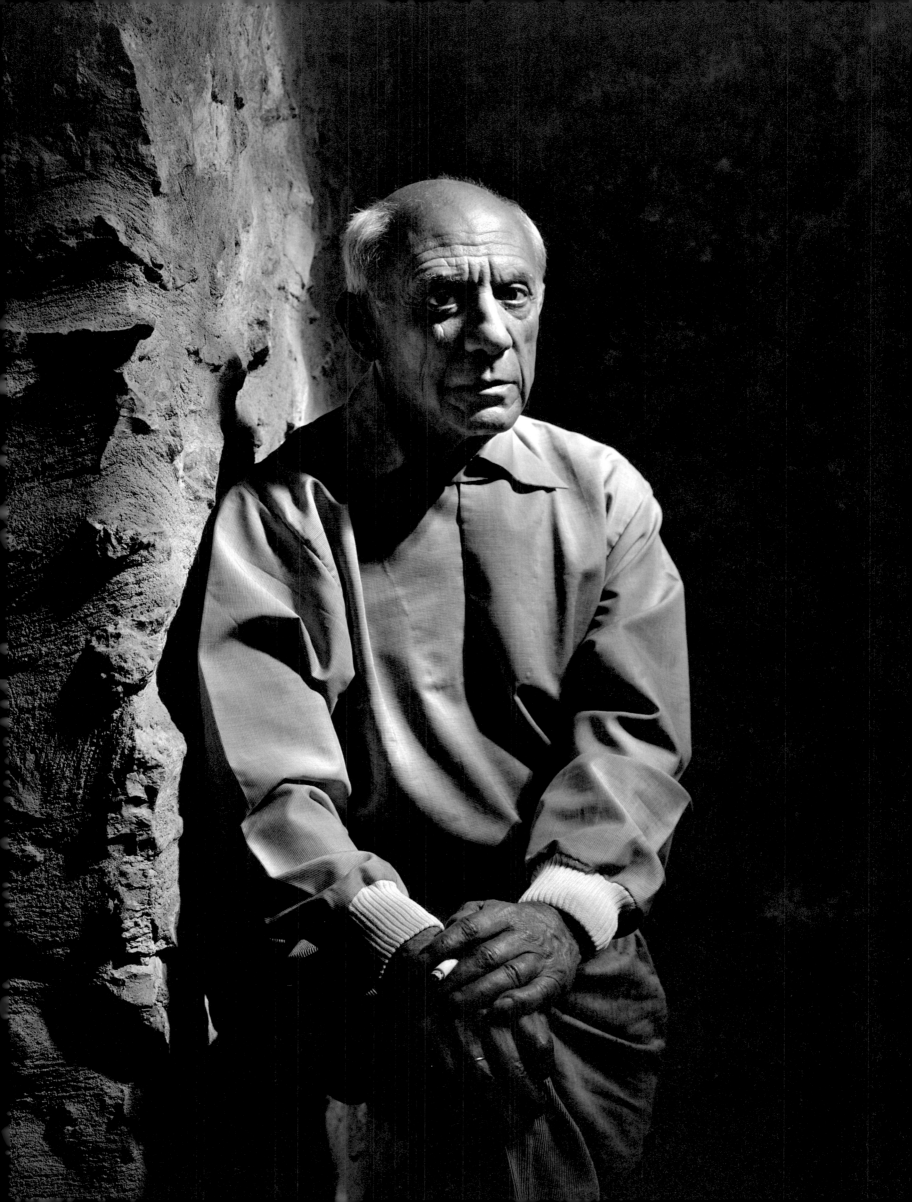

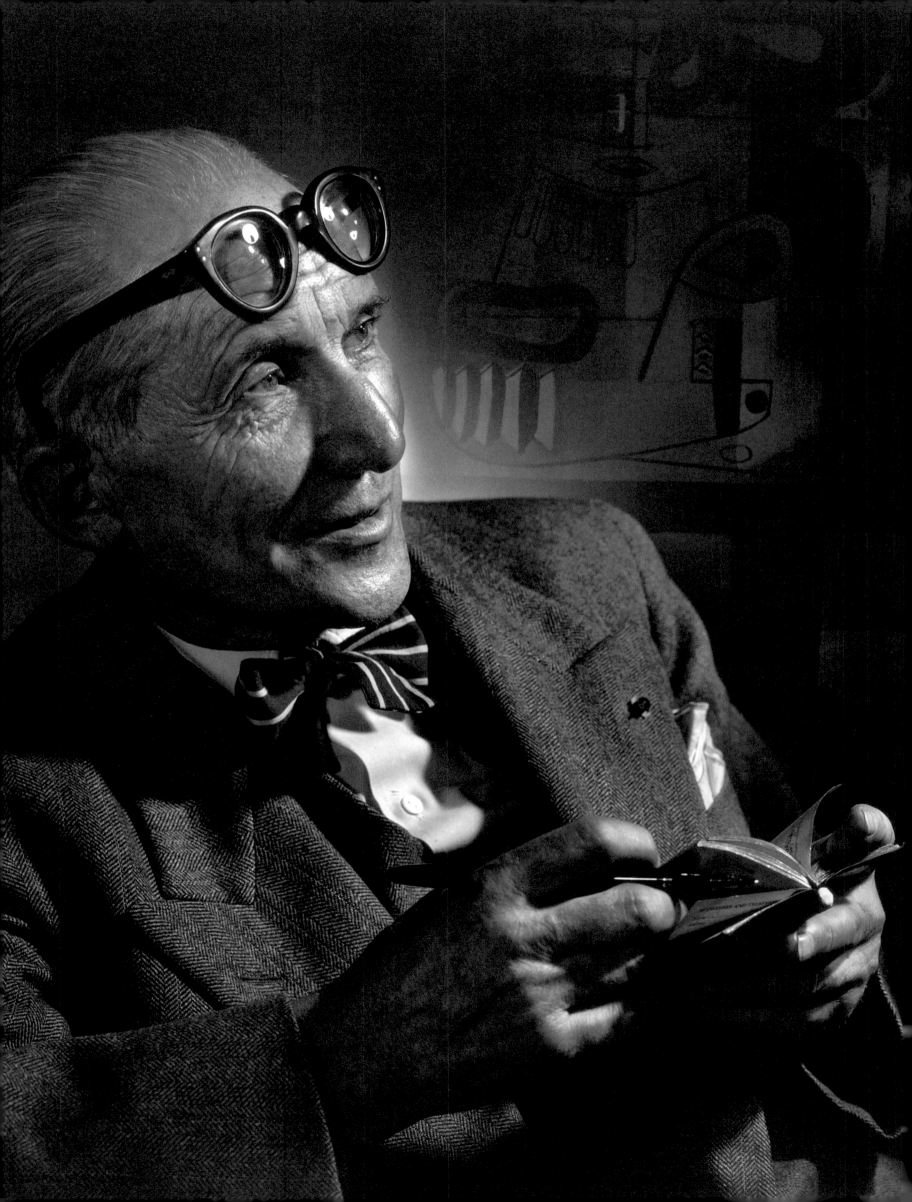

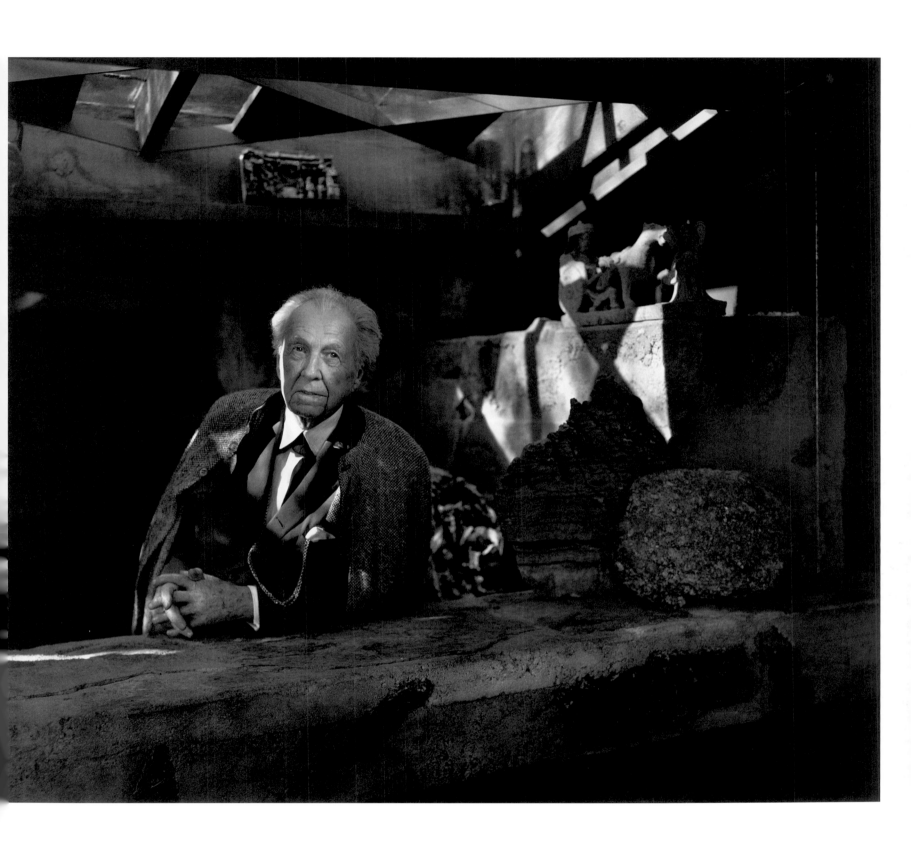

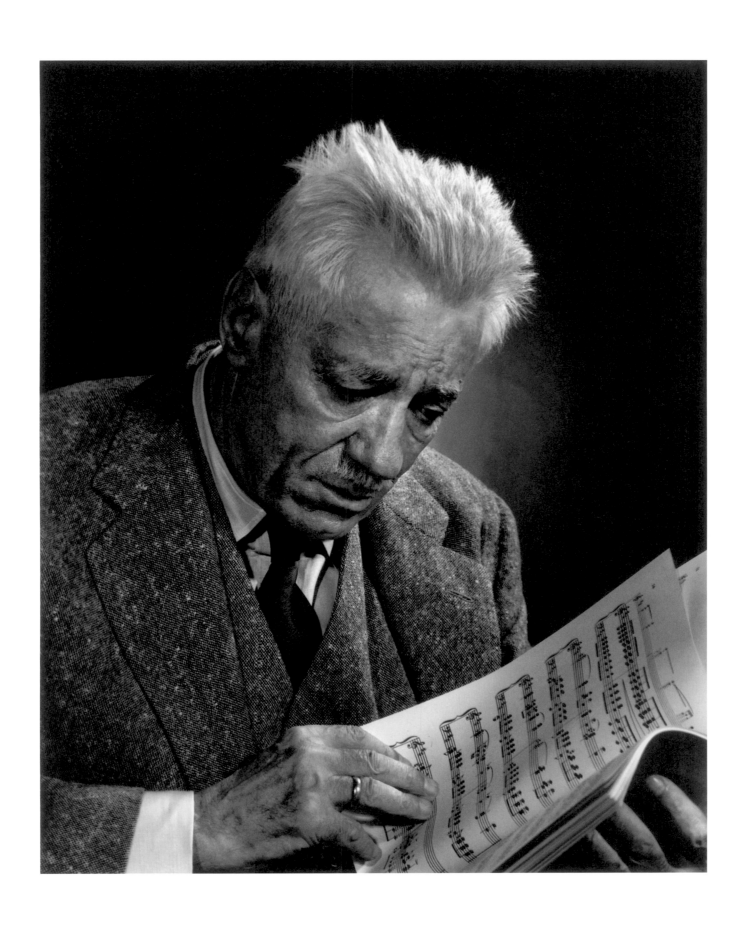

106 *above:* **FRIEDRICH KREISLER,** *1955*
 opposite: **JOHN STEINBECK,** *1954*

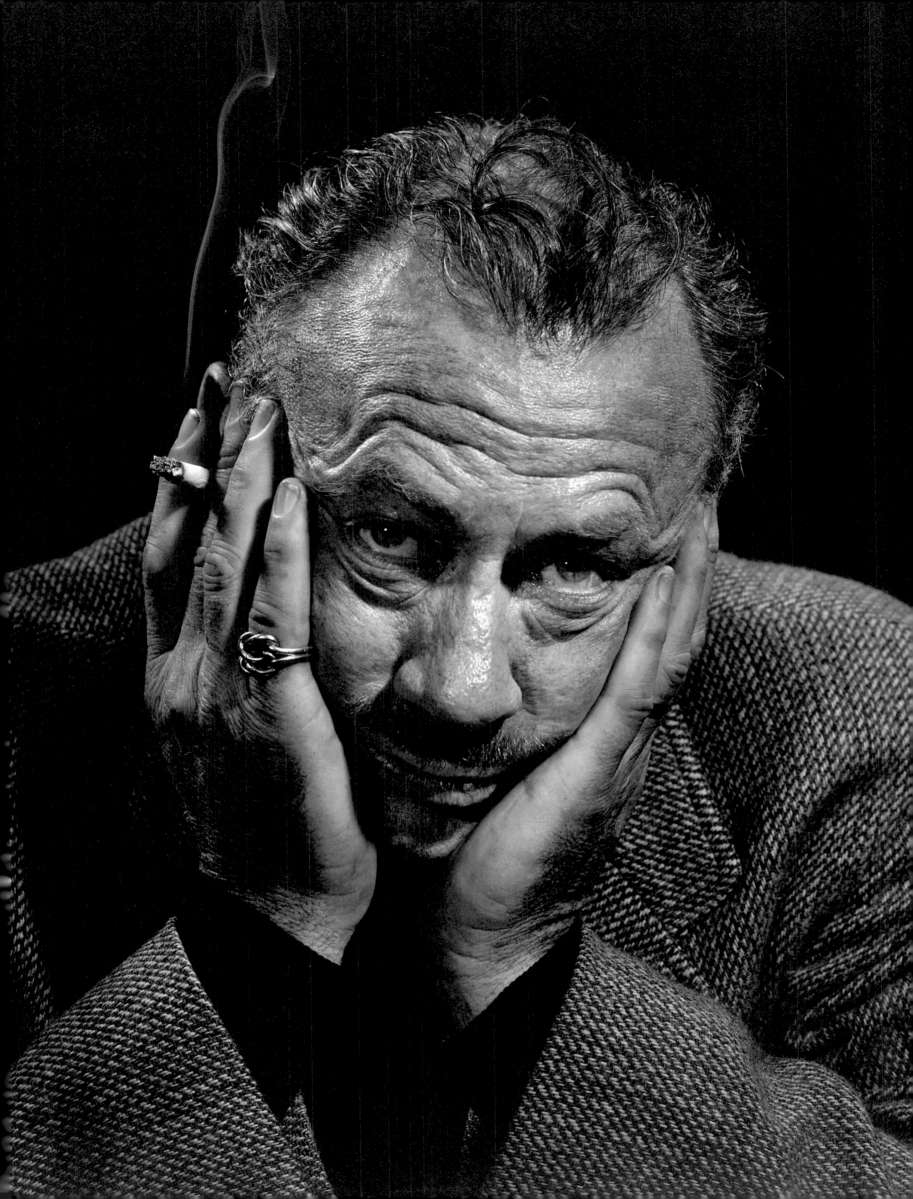

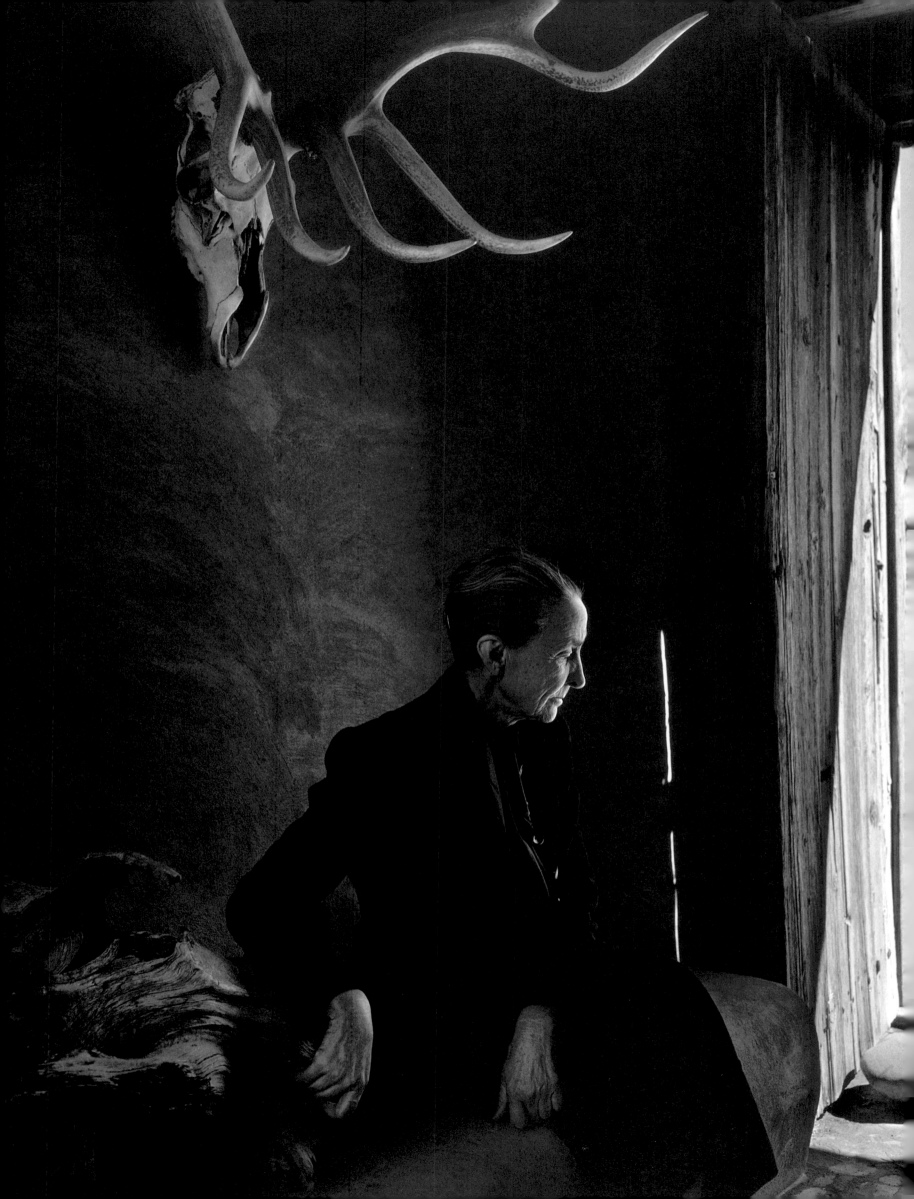

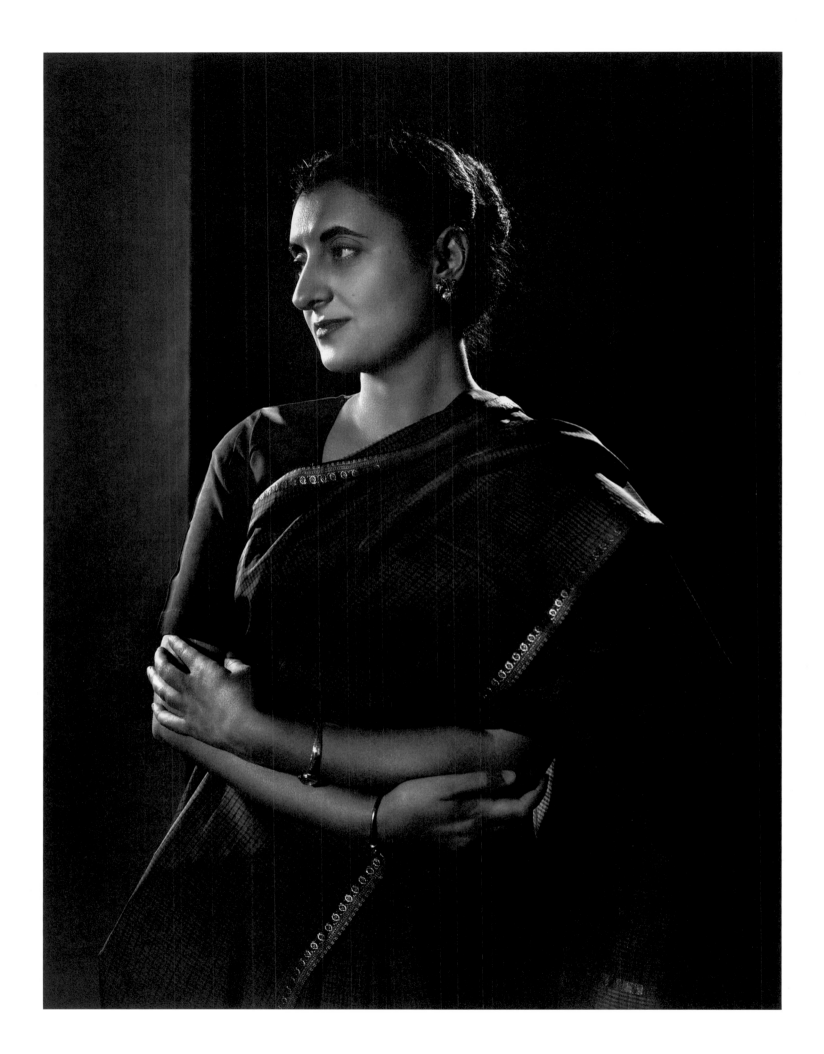

above: INDIRA GANDHI, *1956* 109
opposite: GEORGIA O'KEEFFE, *1956*

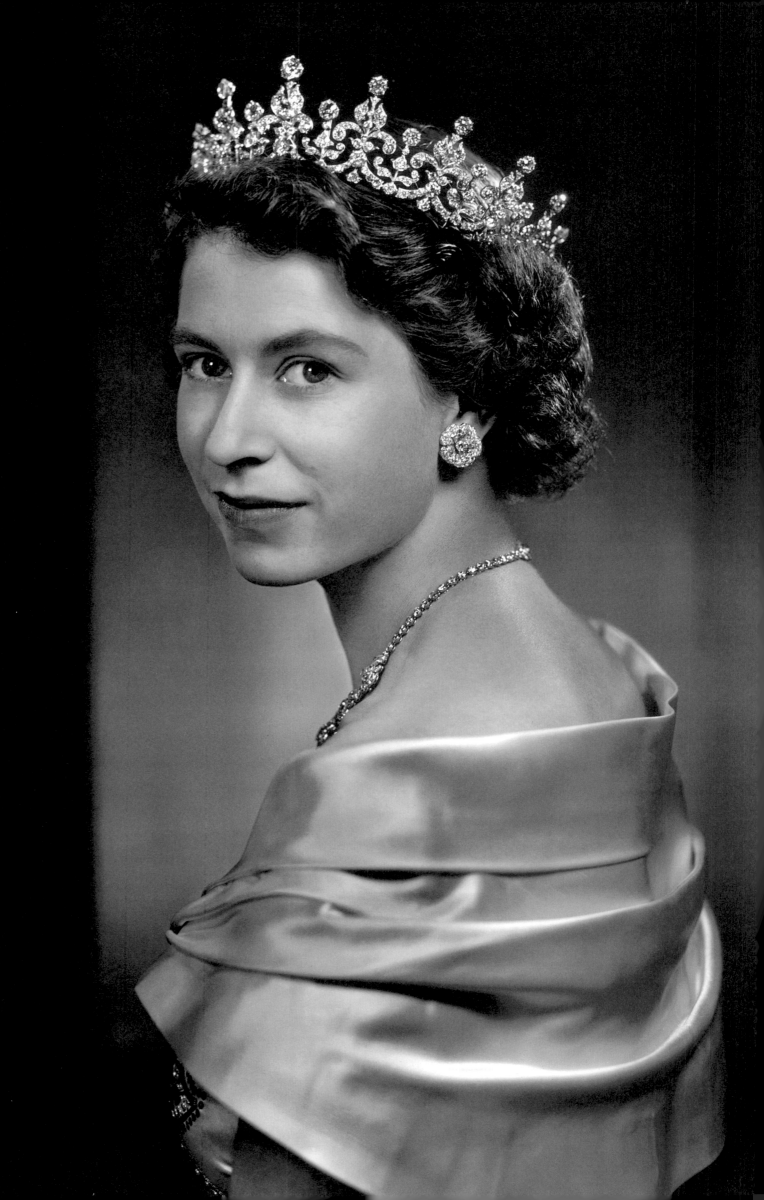

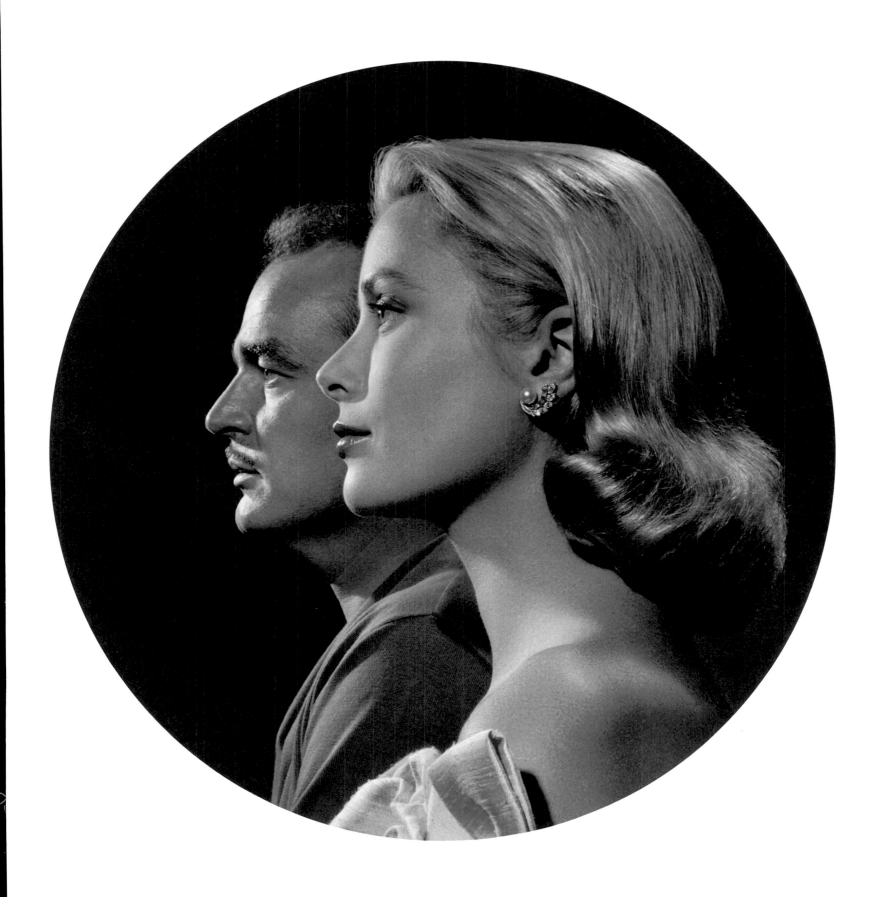

above: **PRINCE RAINIER III AND PRINCESS GRACE,** *1956* 111
opposite: **QUEEN ELIZABETH II,** *1951*

112 *above:* JOHN AND JACQUELINE KENNEDY, *1957*
 opposite: JACQUELINE KENNEDY, *1957*

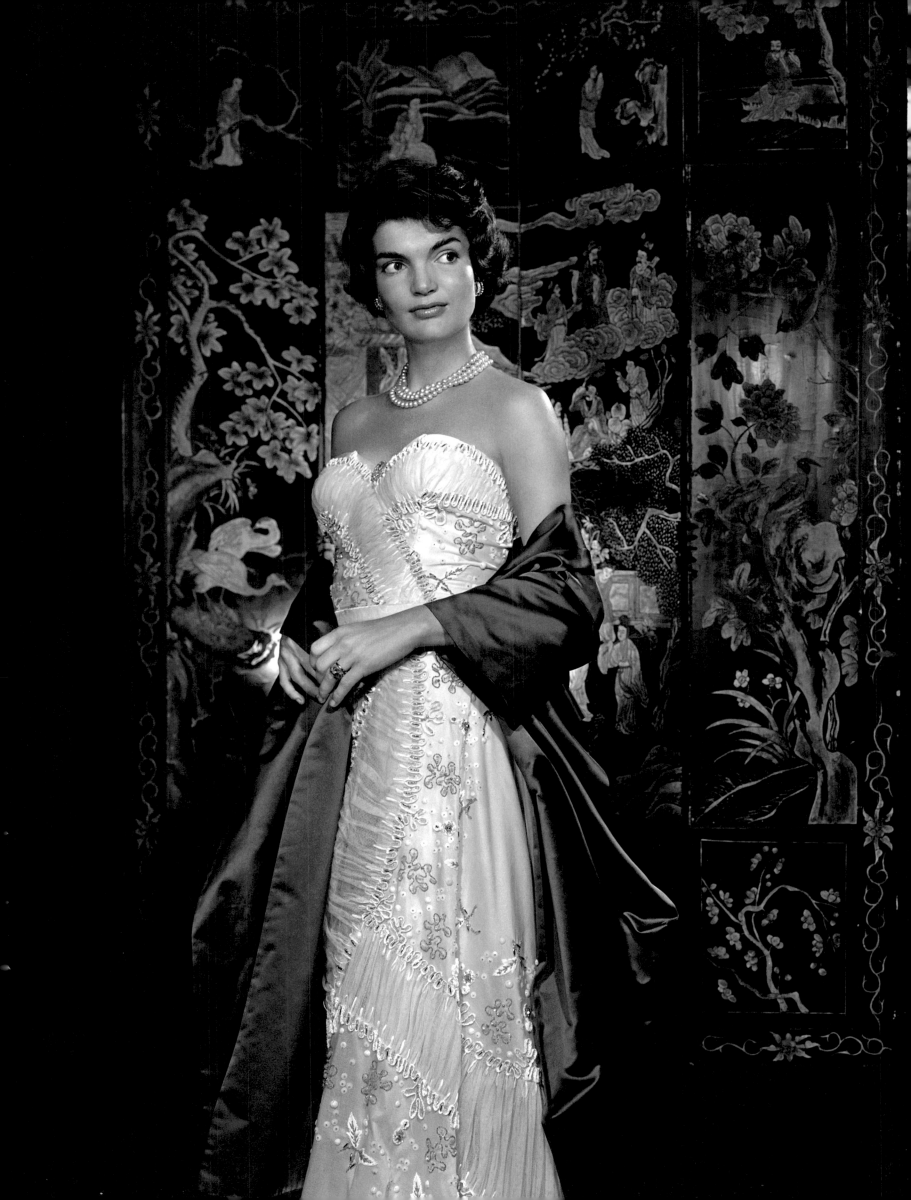

114 *opposite:* ERNEST HEMINGWAY, *1957*
 overleaf left: J. ROBERT OPPENHEIMER, *1956*
 overleaf right: EDWARD R. MURROW, *1956*

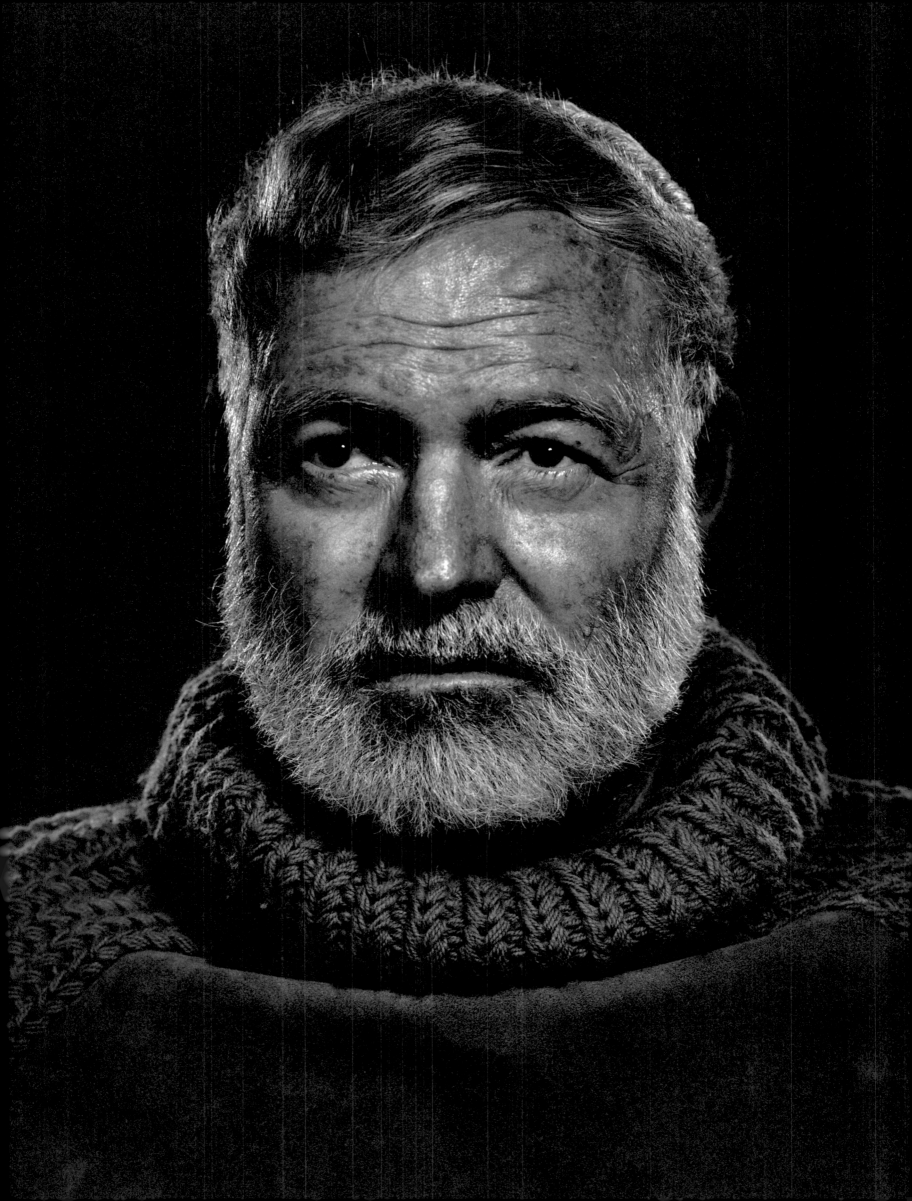

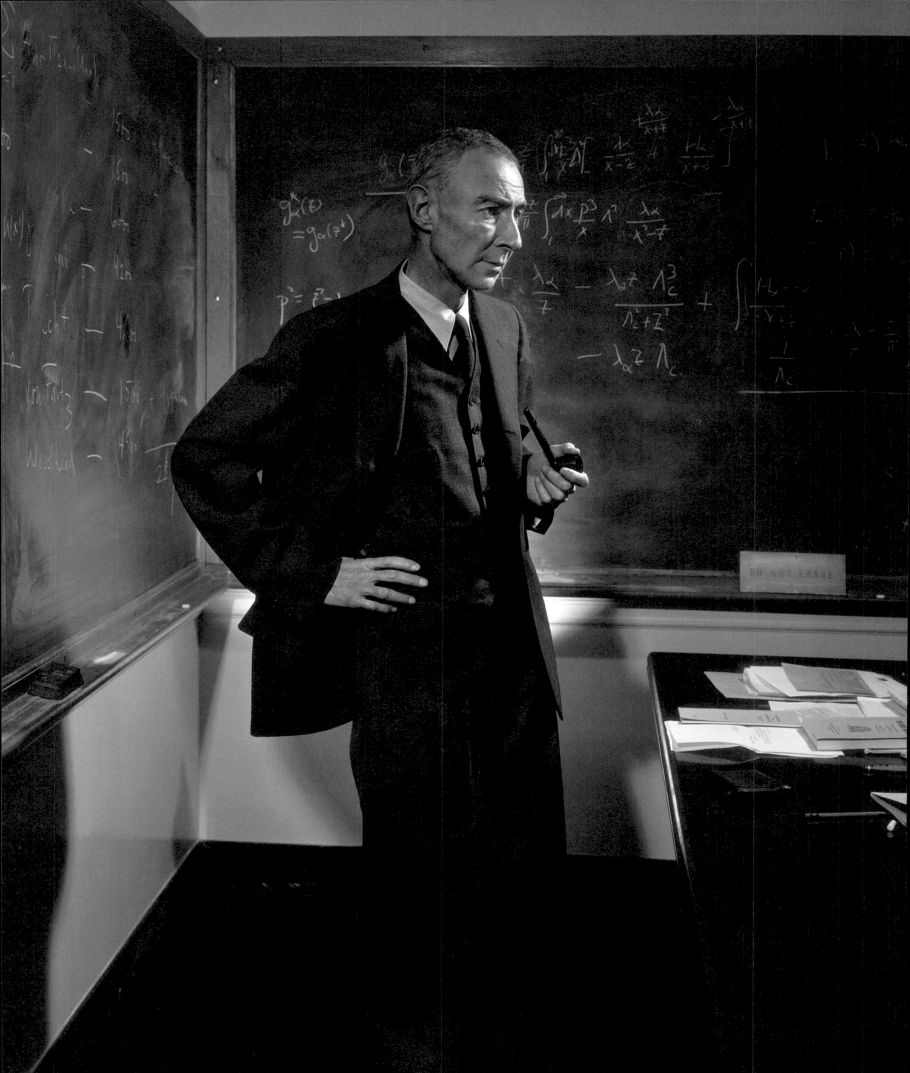

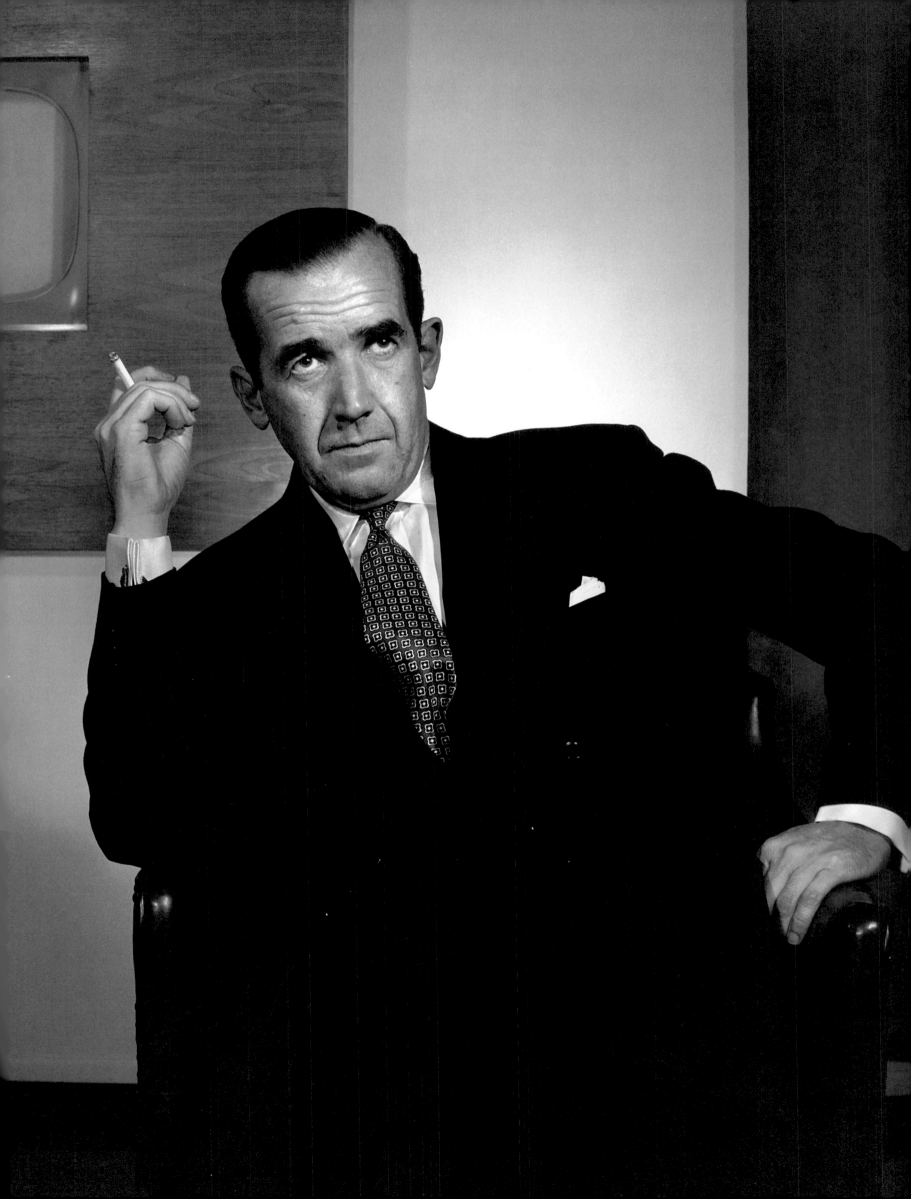

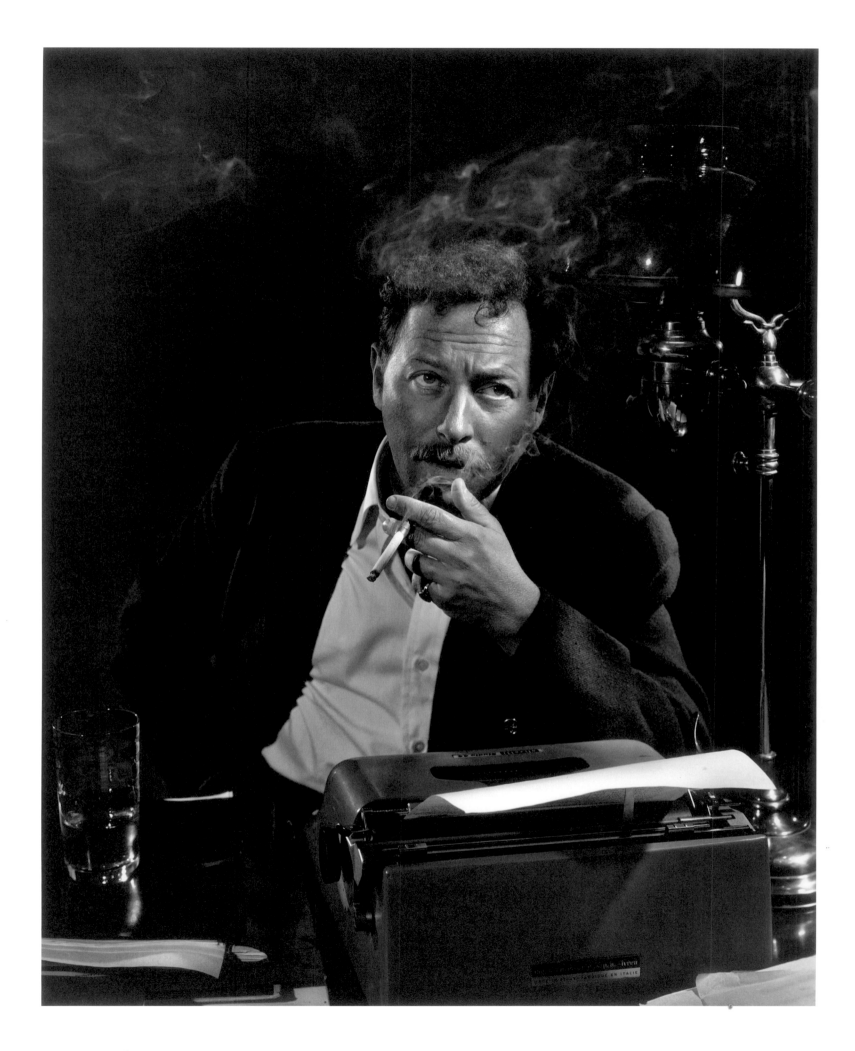

118 *above:* TENNESSEE WILLIAMS, *1956*
 opposite: ROBERT FROST, *1958*

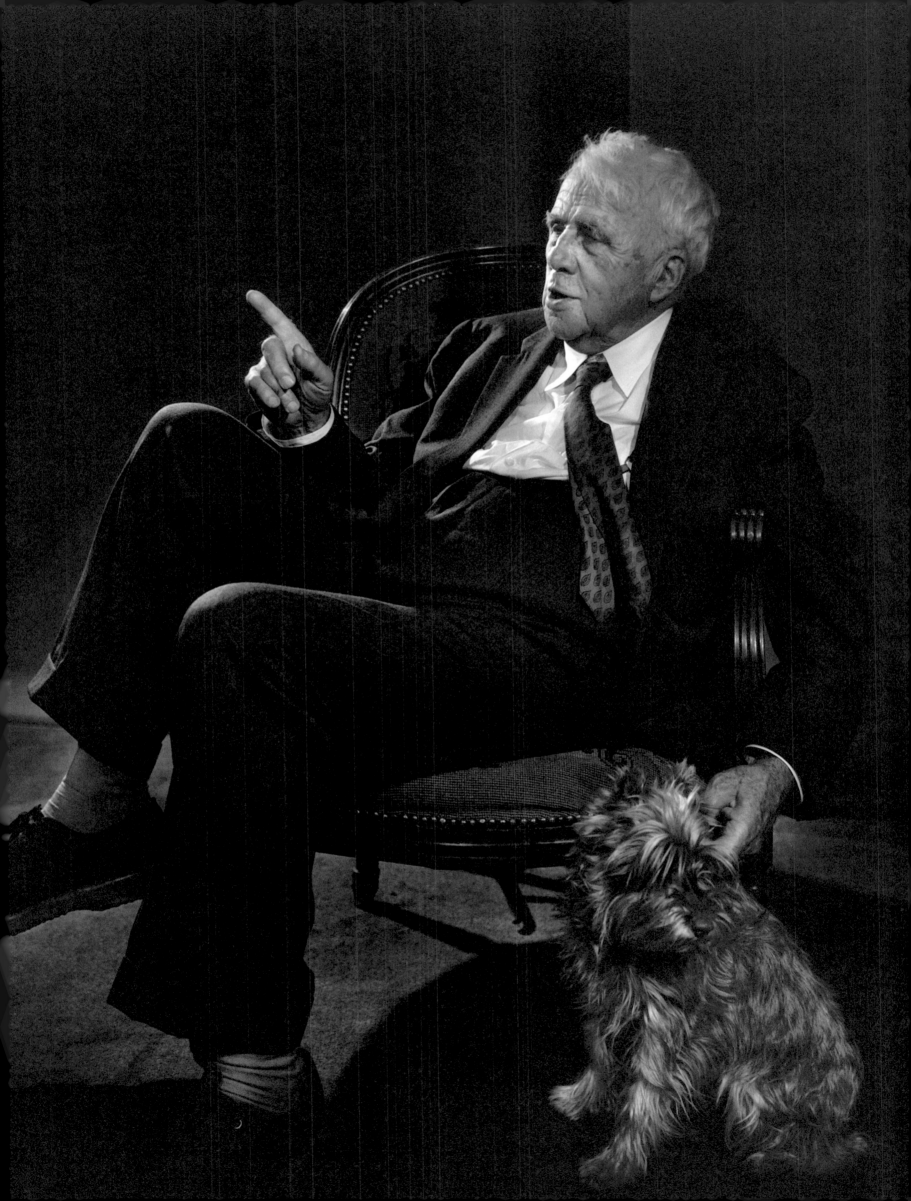

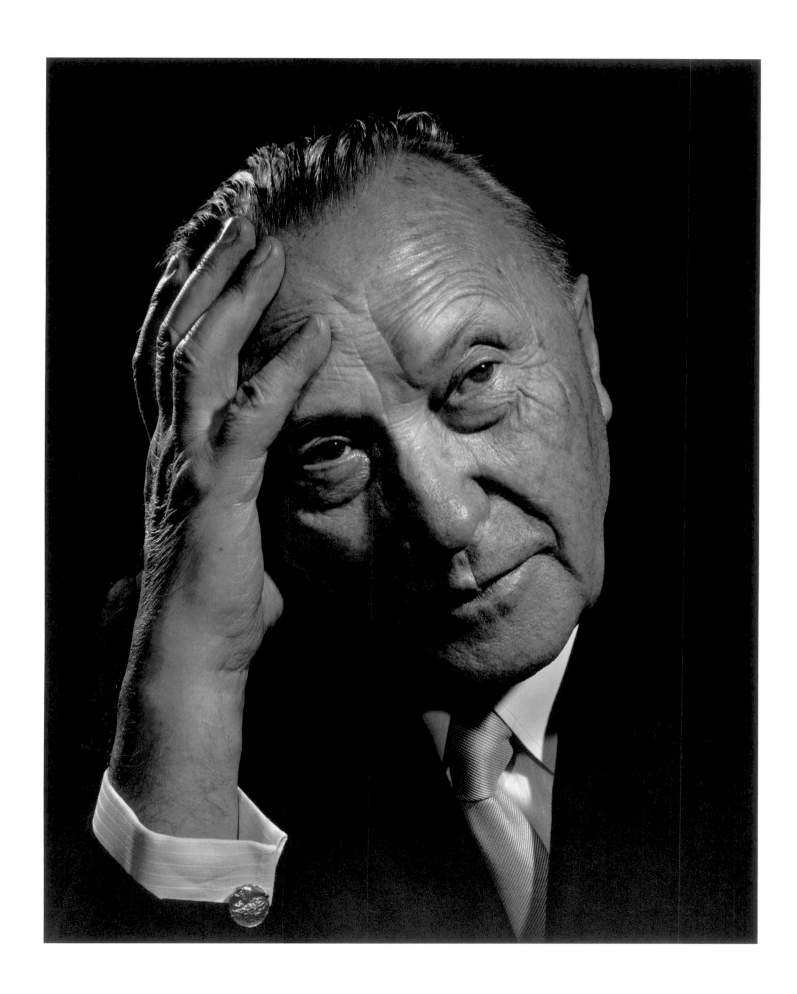

120 KONRAD ADENAUER, *1964*

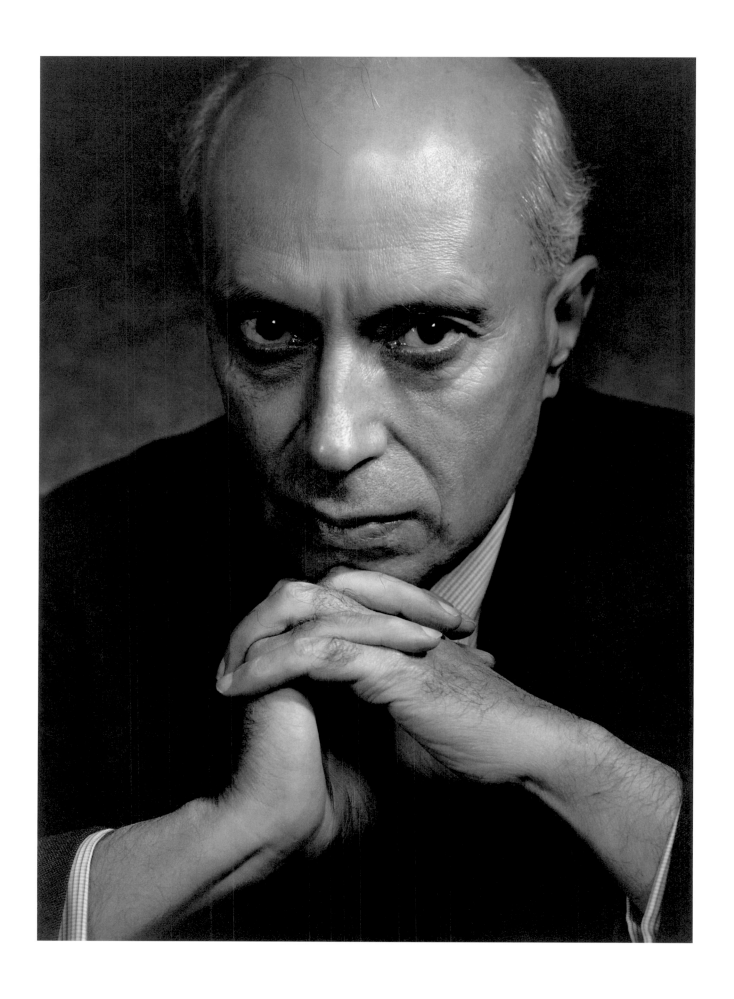

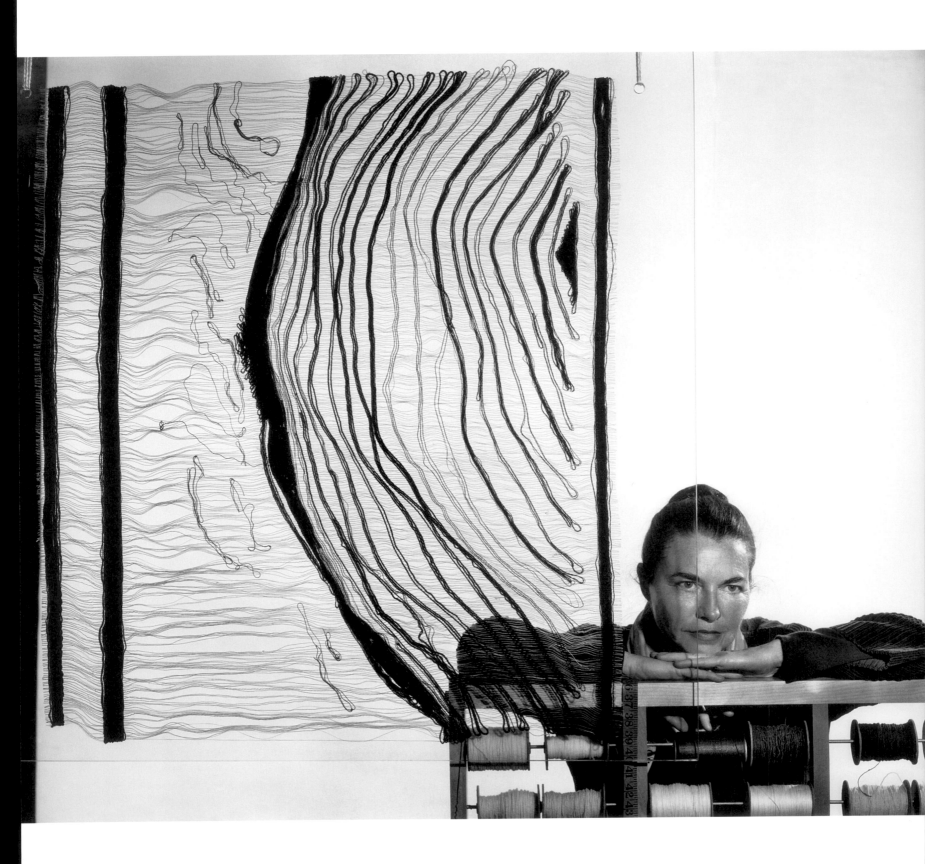

122 LENORE TAWNEY, *1959*

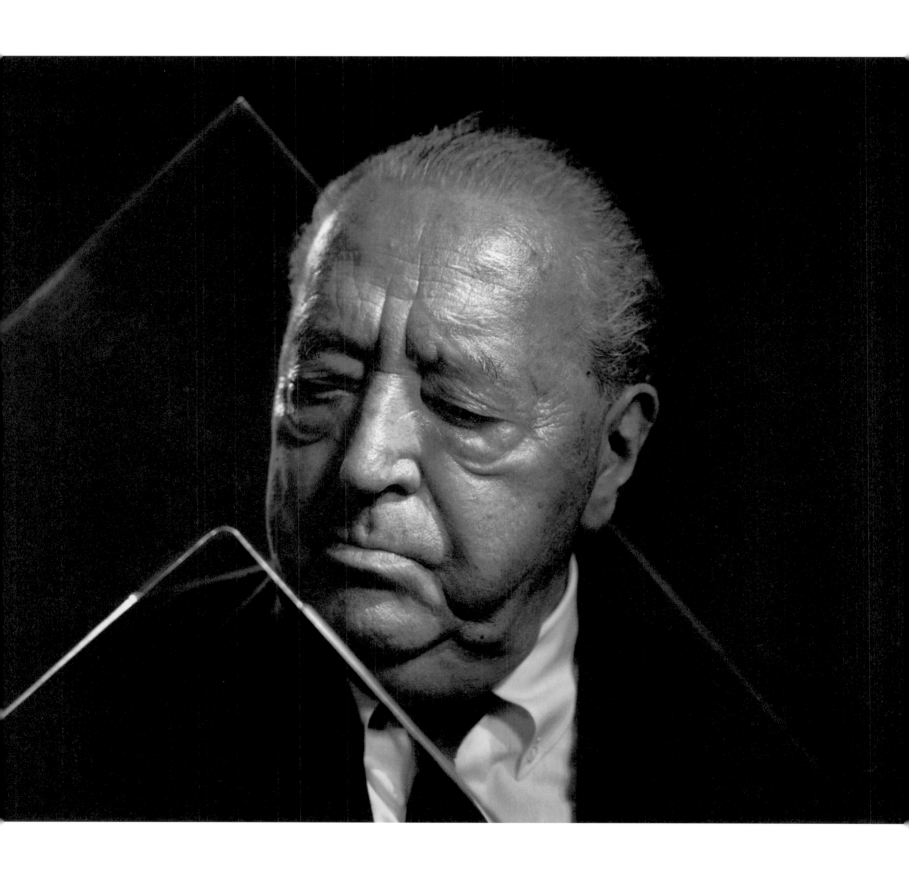

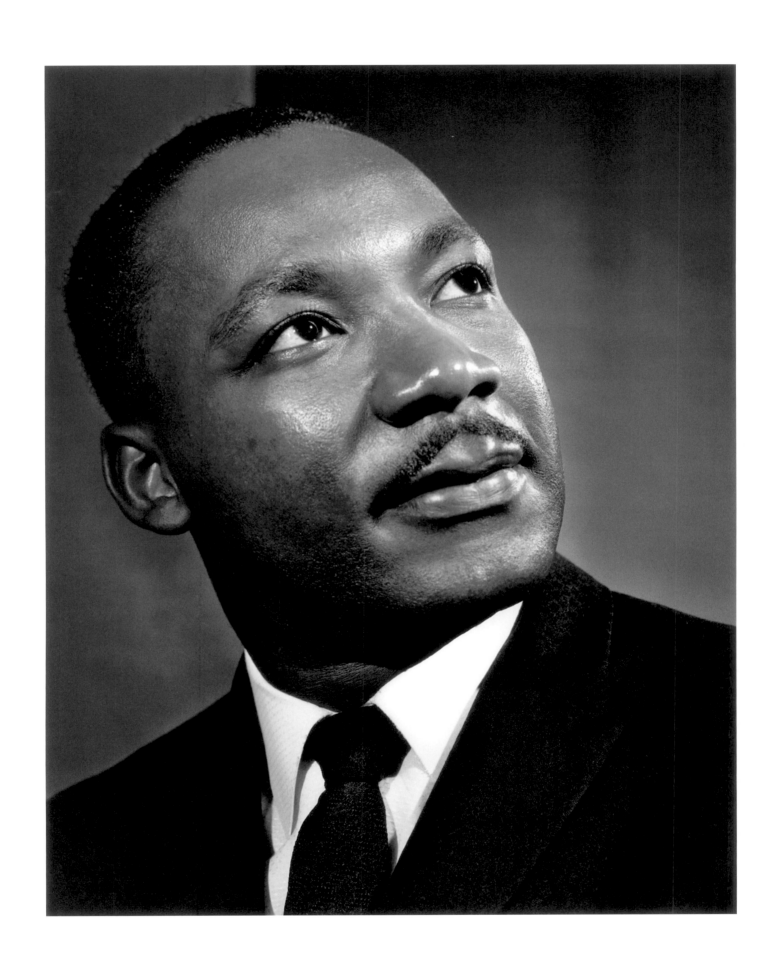

above: MARTIN LUTHER KING, JR., *1962*
124 *opposite:* NELSON ROLIHLAHLA MANDELA, *1990*
overleaf left: QUEEN ELIZABETH II AND PRINCE PHILIP, *1966*
overleaf right: GEORGES POMPIDOU, *1965*

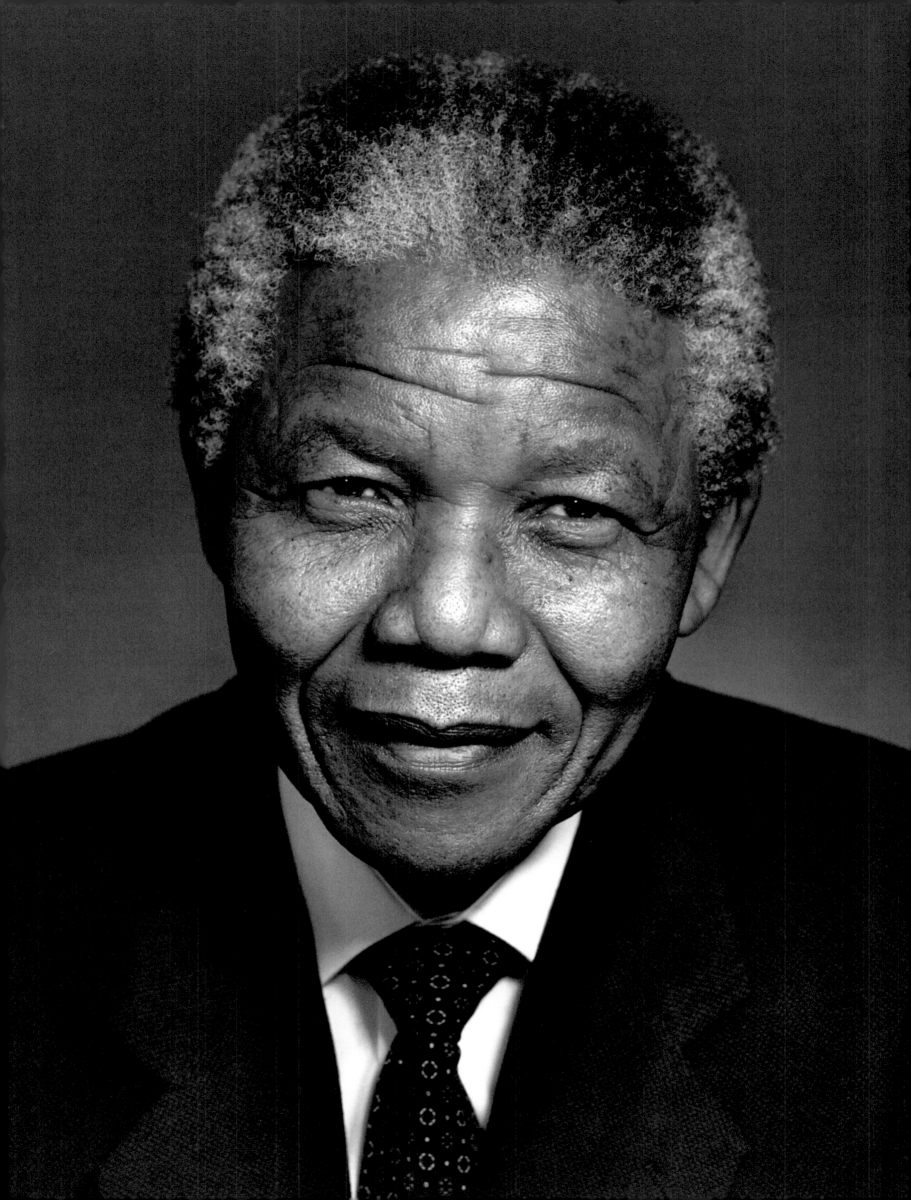

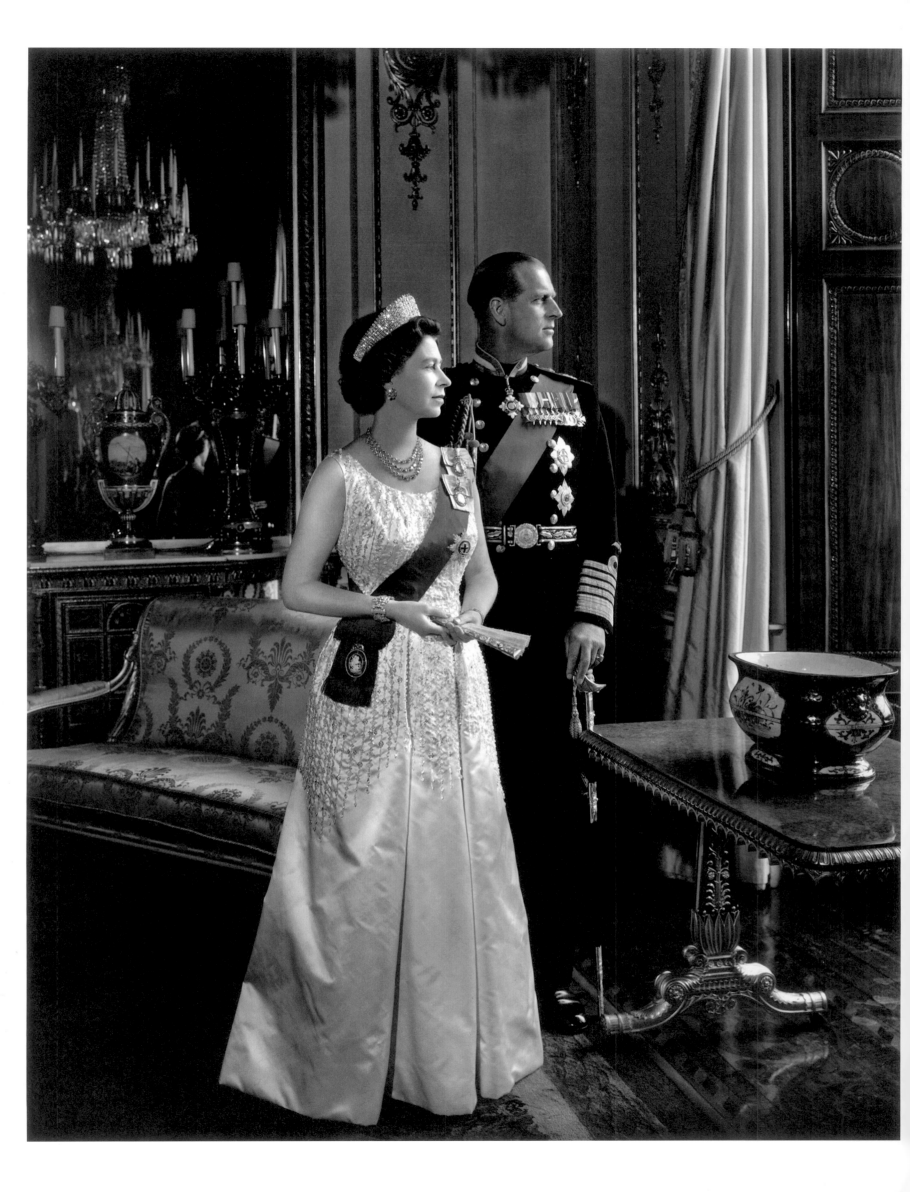

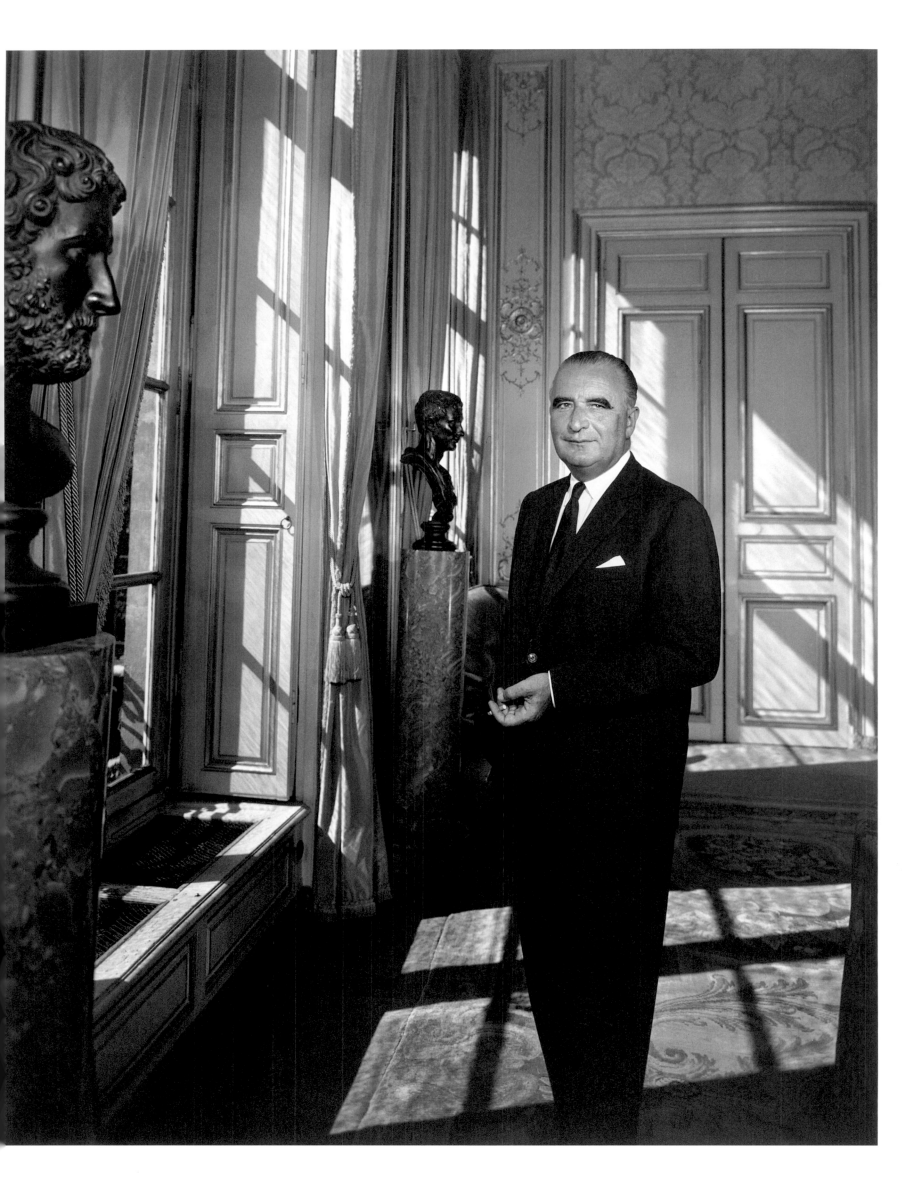

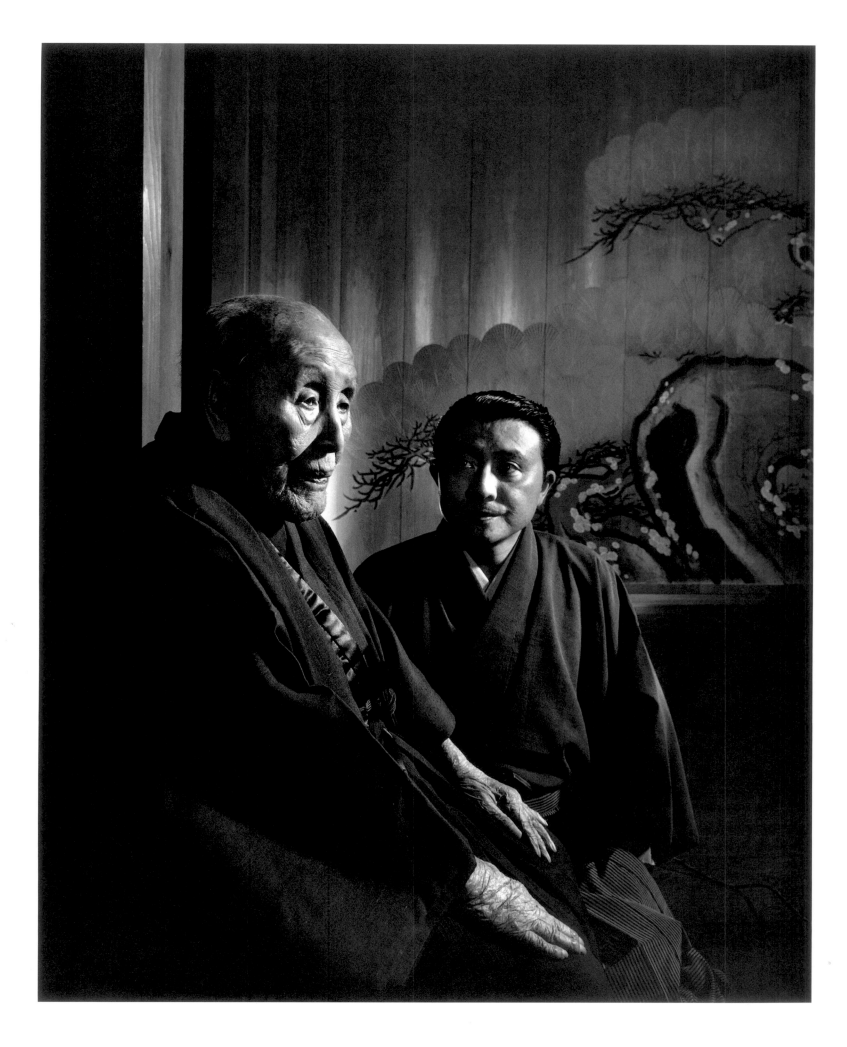

128 *above:* ROPPEITA KITA XIV, *1969*
opposite: ALBERTO GIACOMETTI, *1965*

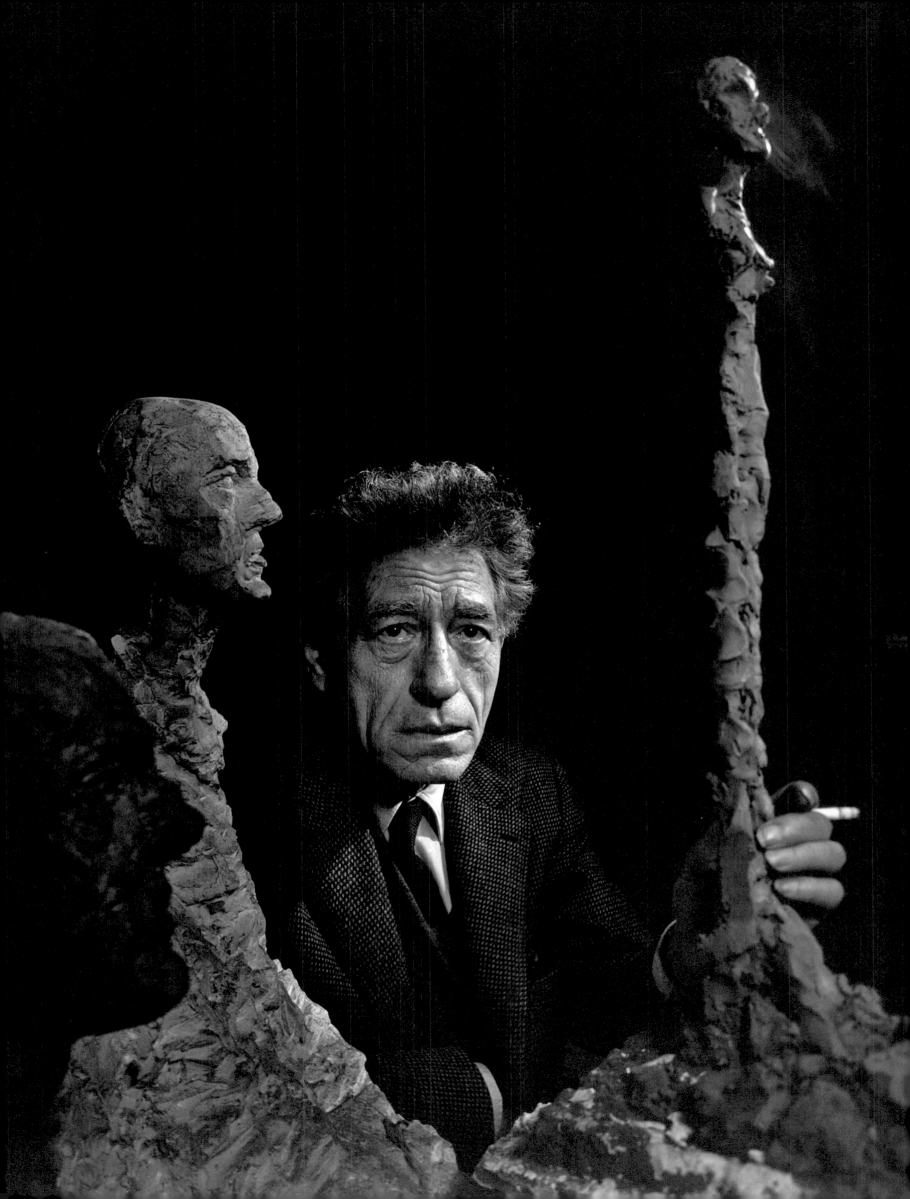

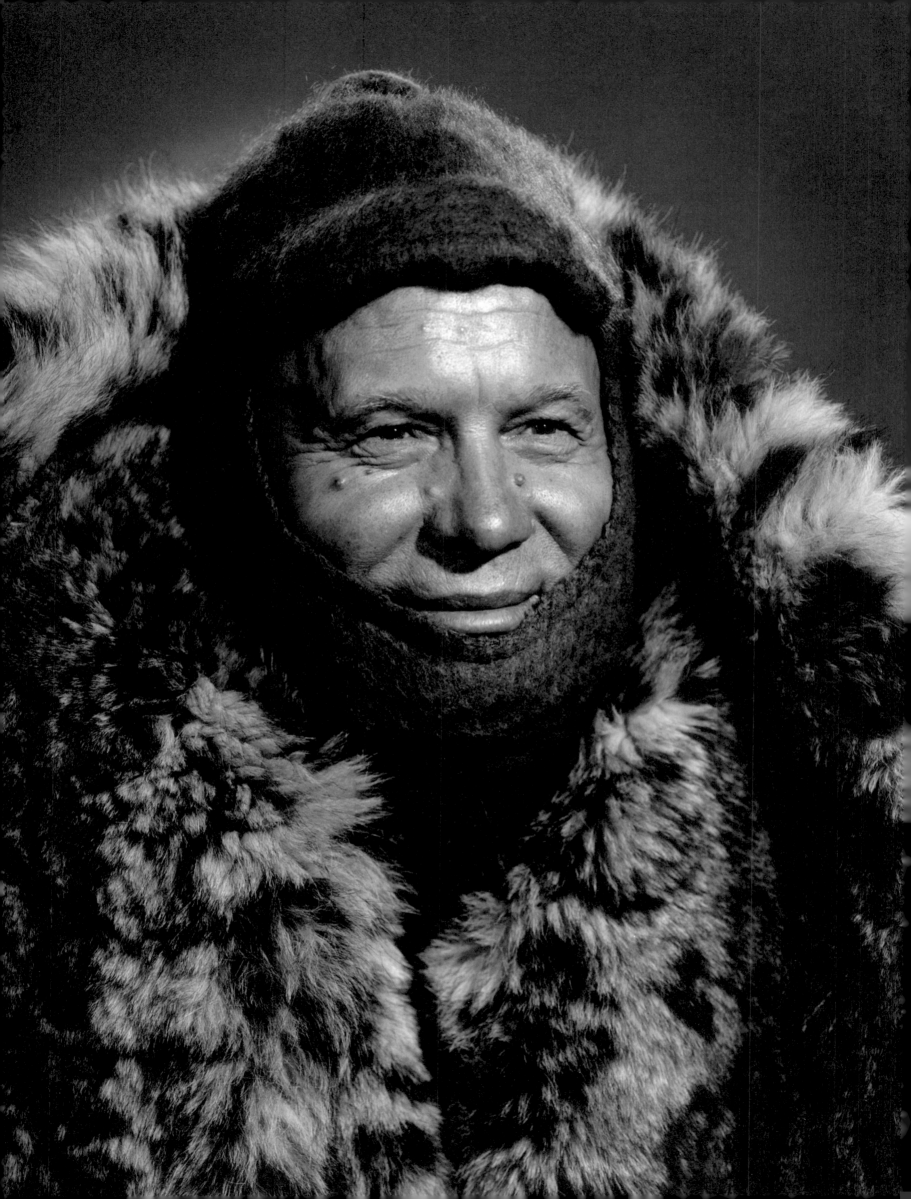

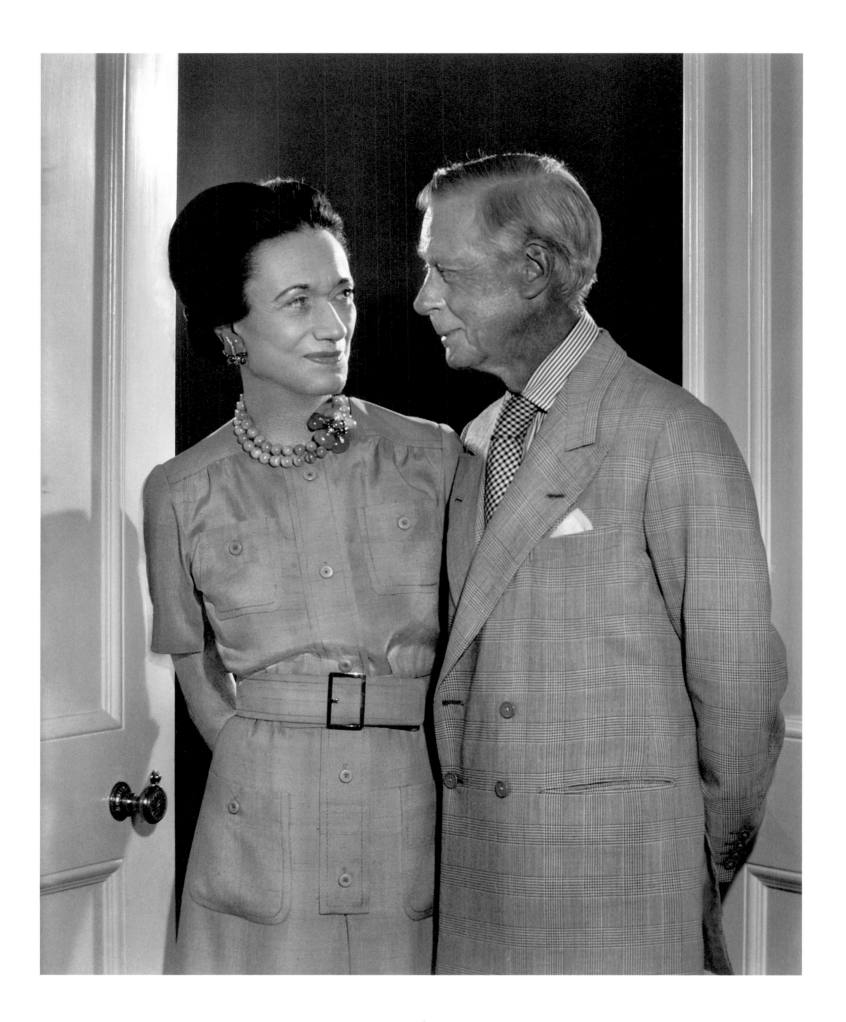

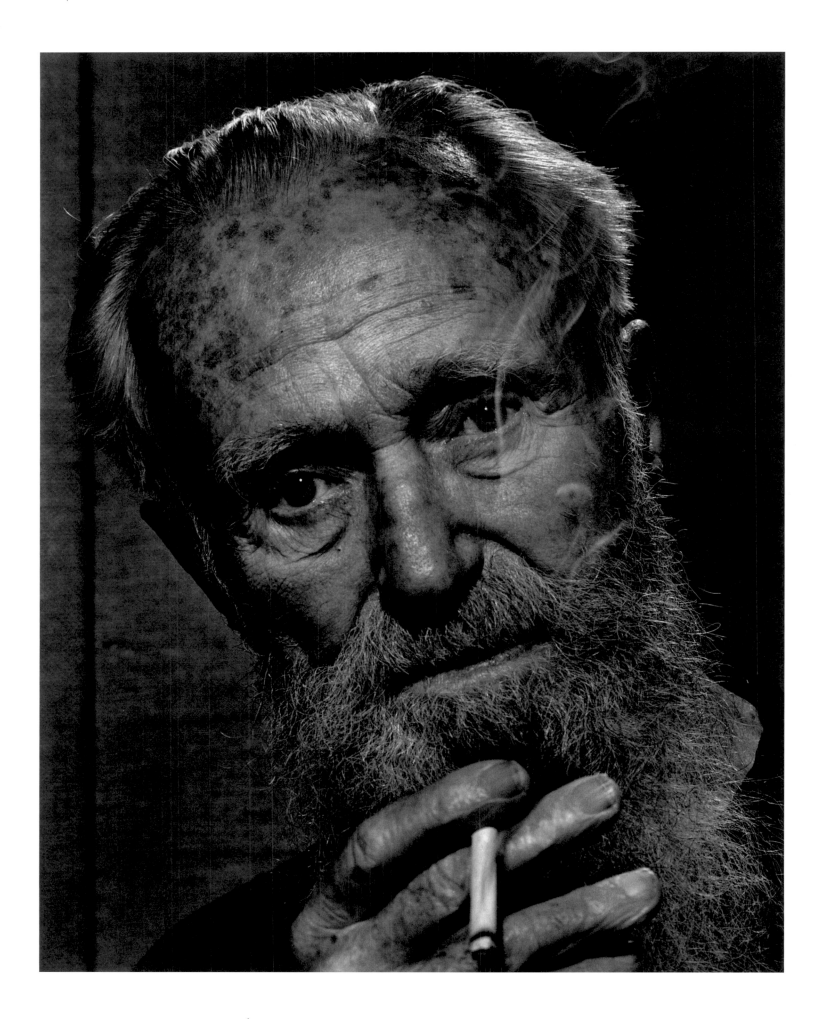

above: EDWARD STEICHEN SMOKING, *1970*
opposite: EDWARD AND JOANNA STEICHEN UNDER THE SHADBLOW TREE, *1967*

133

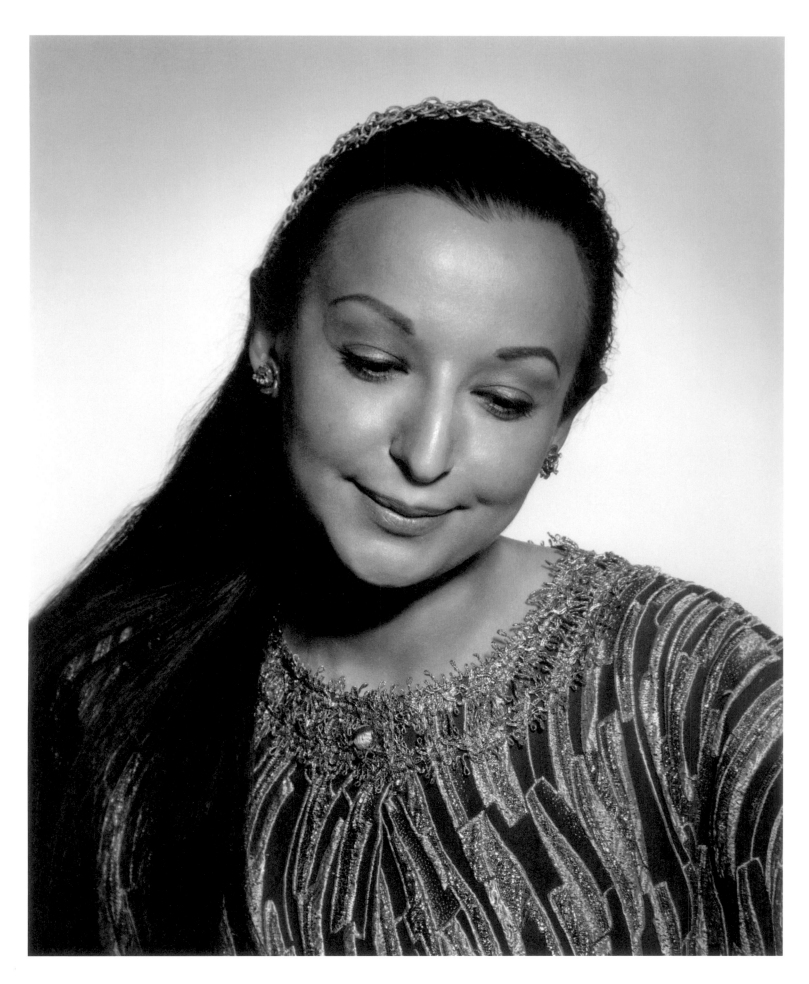

above: ESTRELLITA KARSH, *1970*
134 *opposite:* GIACOMO MANZÙ, *1970*
overleaf left: PIERRE ELLIOTT TRUDEAU, *1968*
overleaf right: FIDEL CASTRO, *1971*

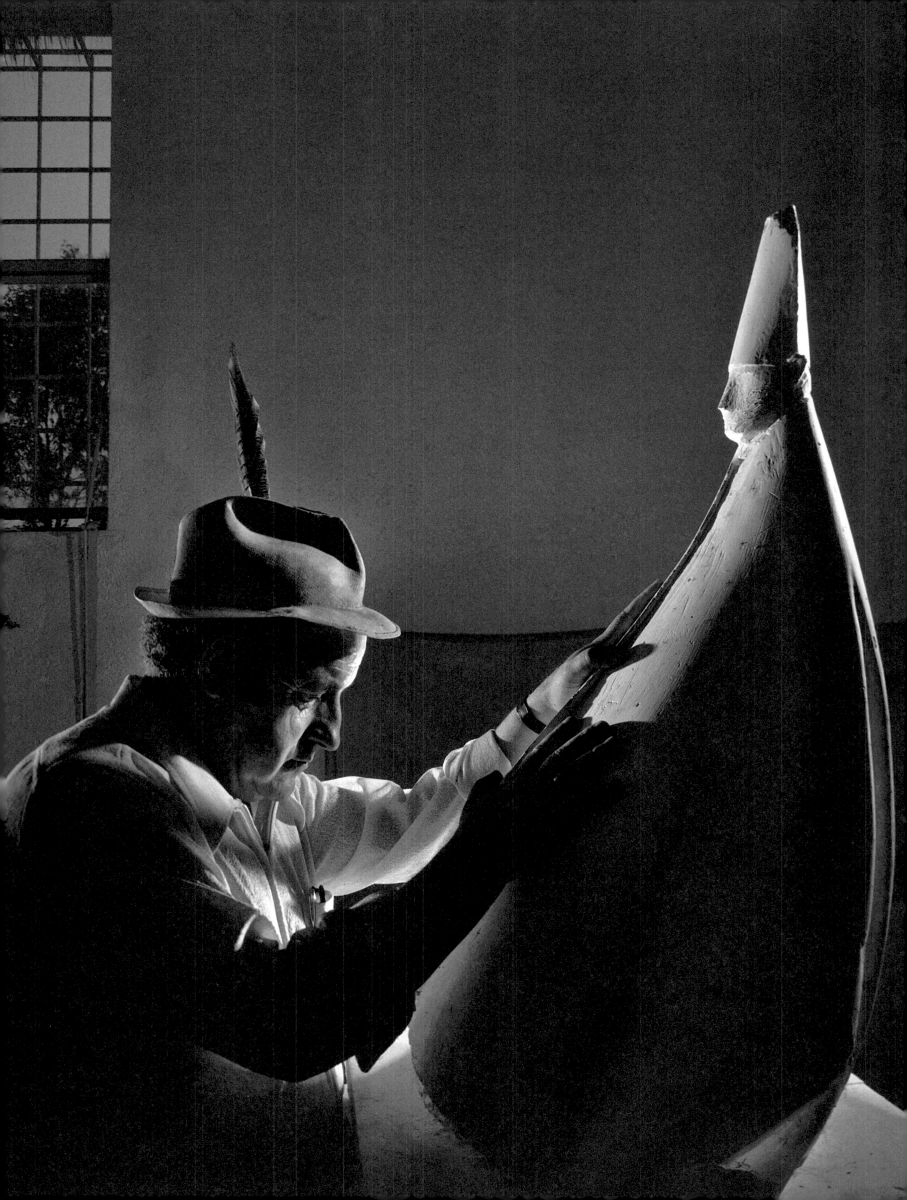

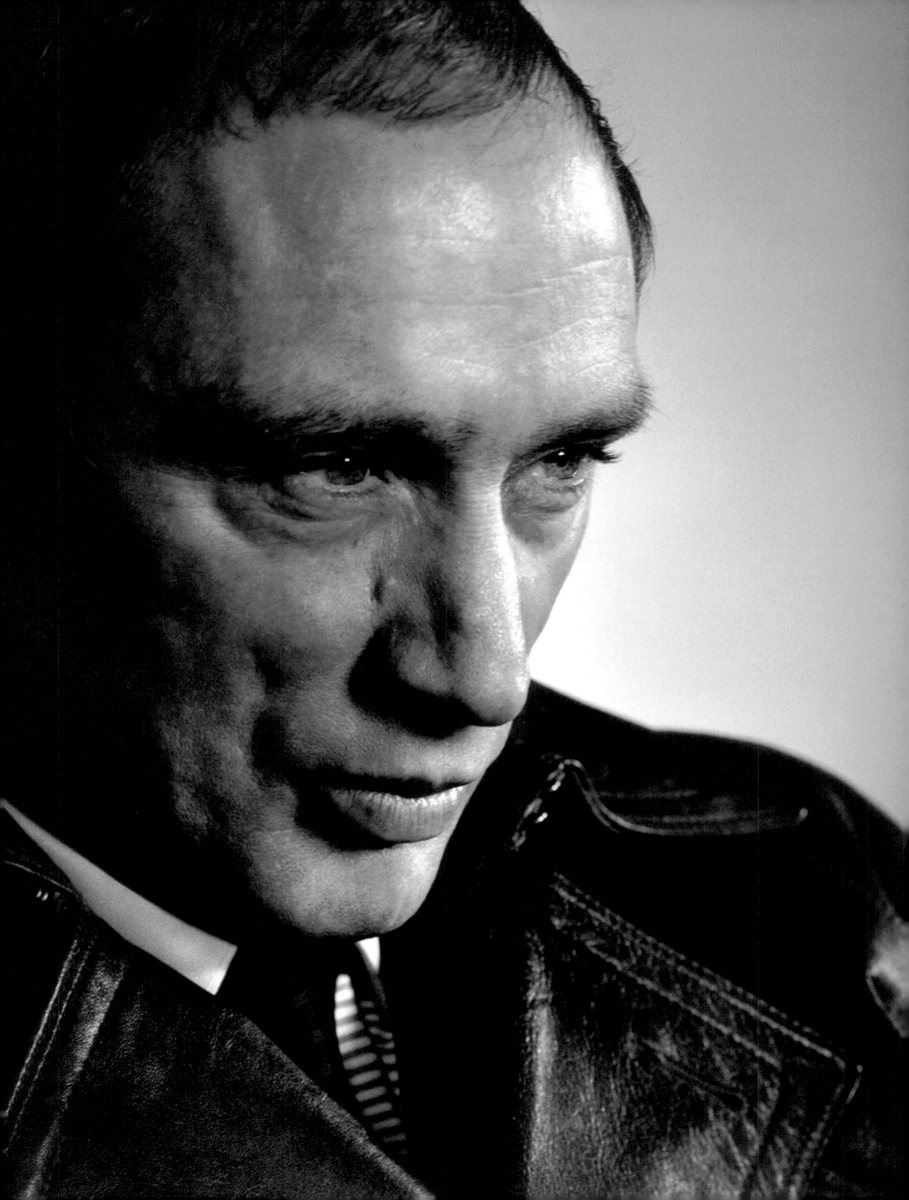

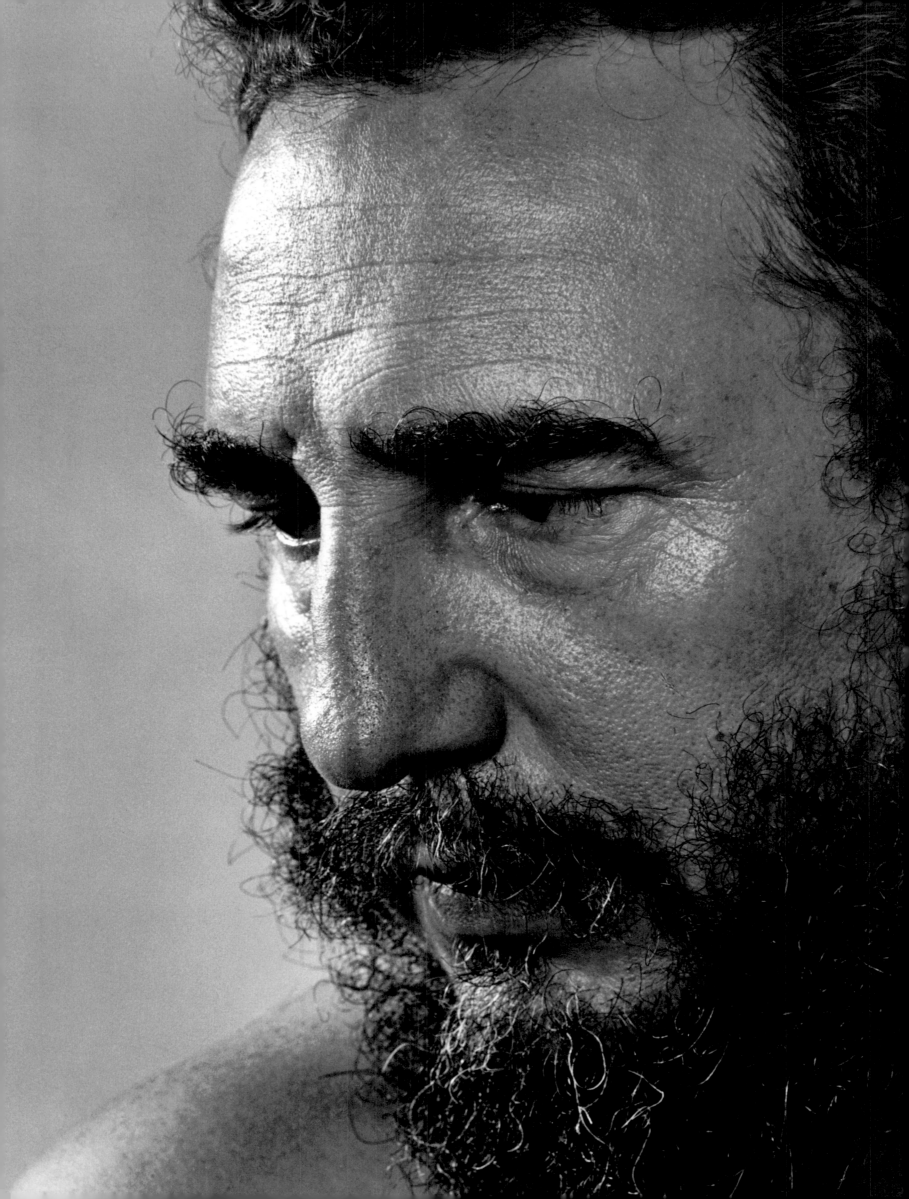

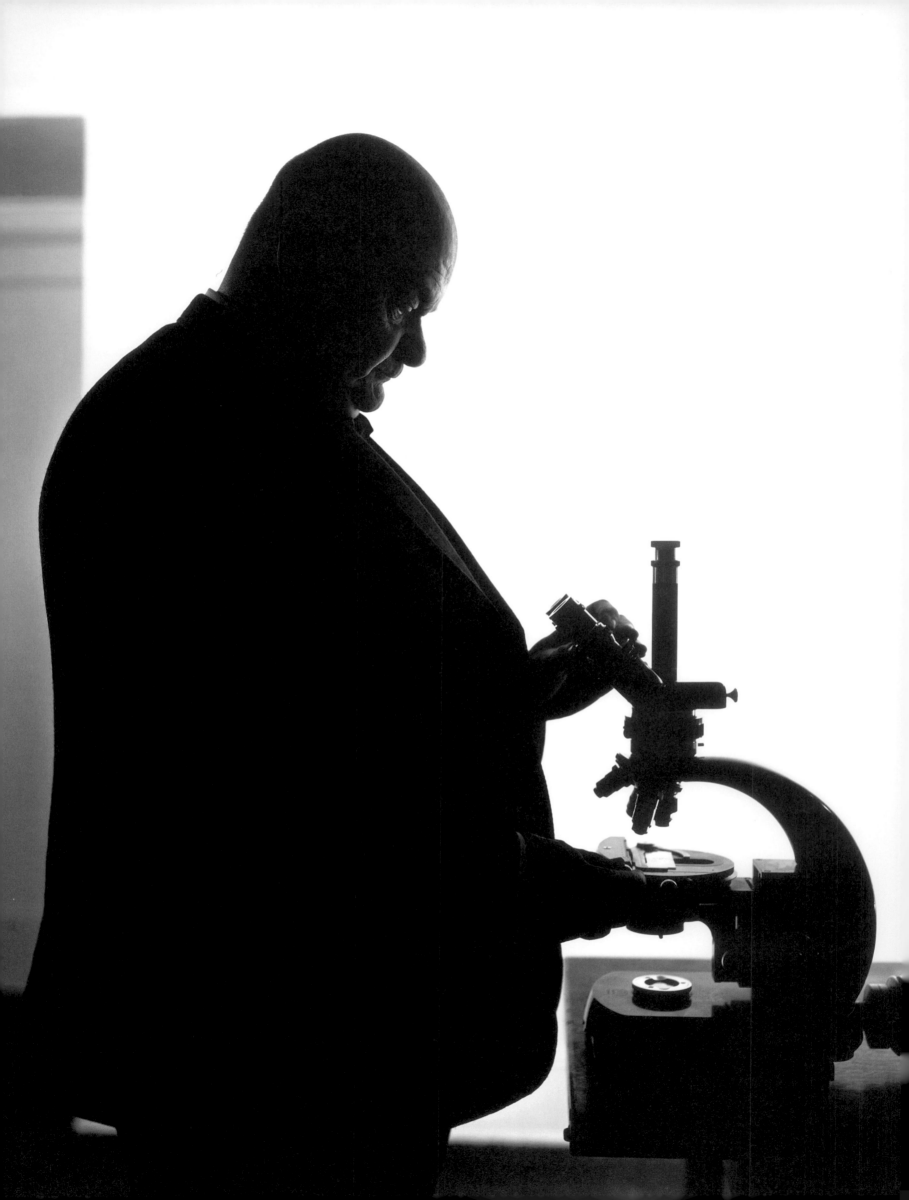

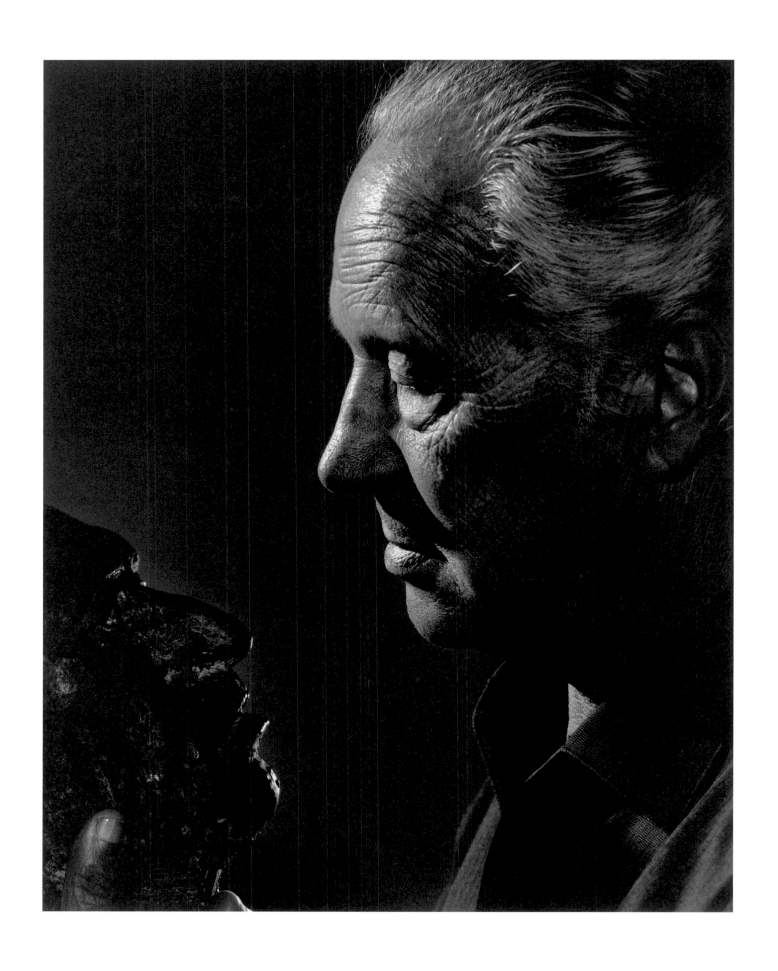

above: MARINO MARINI, *1970*
opposite: ROMAN VISHNIAC, *1971*
overleaf left: SIR EDMUND HILLARY, *1960*
overleaf right: MUHAMMAD ALI, *1970*

139

above: HENRY MOORE, *1972* 143
opposite: WYSTAN HUGH AUDEN, *1972*

above: RUDOLF NUREYEV, *1977*
opposite: JACQUES YVES COUSTEAU, *1972*
overleaf left: ANDY WARHOL, *1979*
overleaf right: JACQUES-HENRI LARTIGUE, *1981* 145
page 148: ISAMU NOGUCHI, *1980*
page 149: KURT VONNEGUT, *1990*

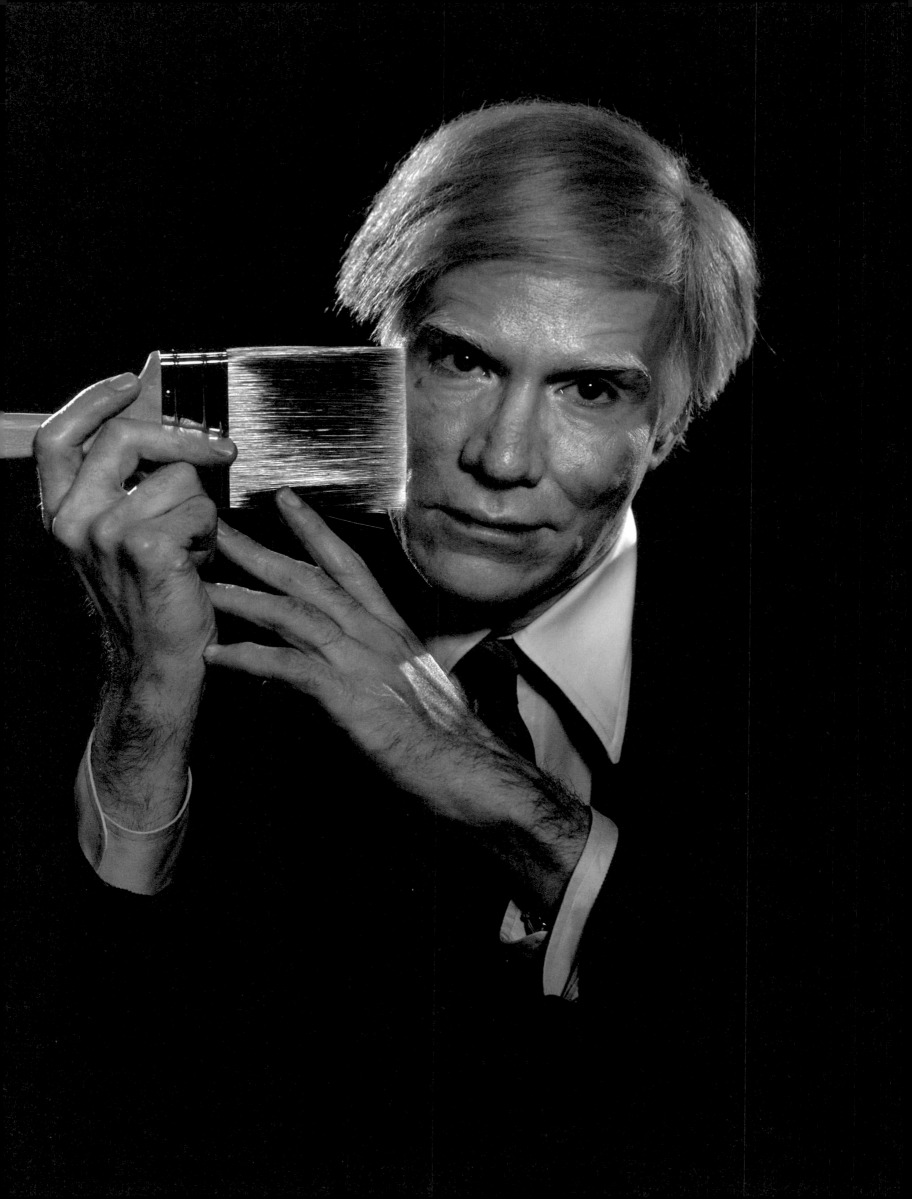

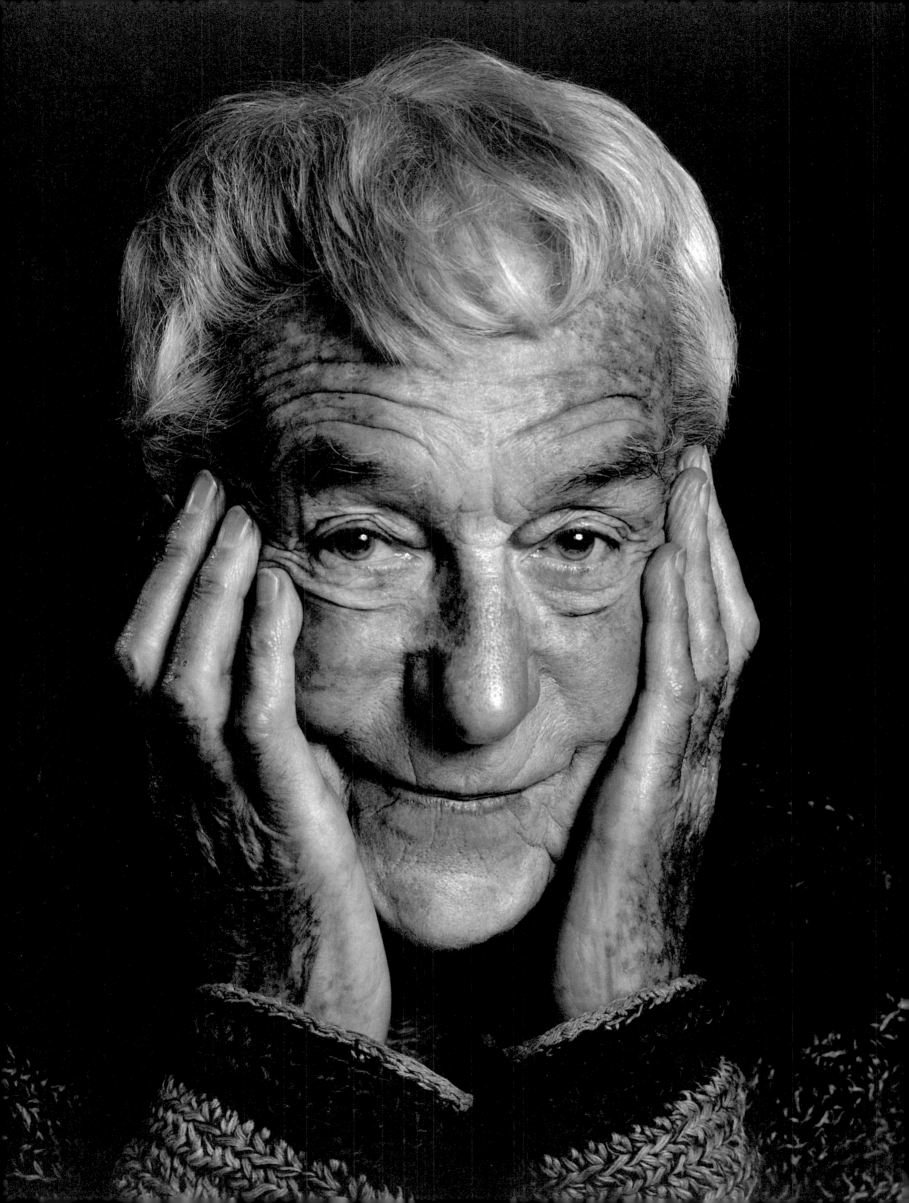

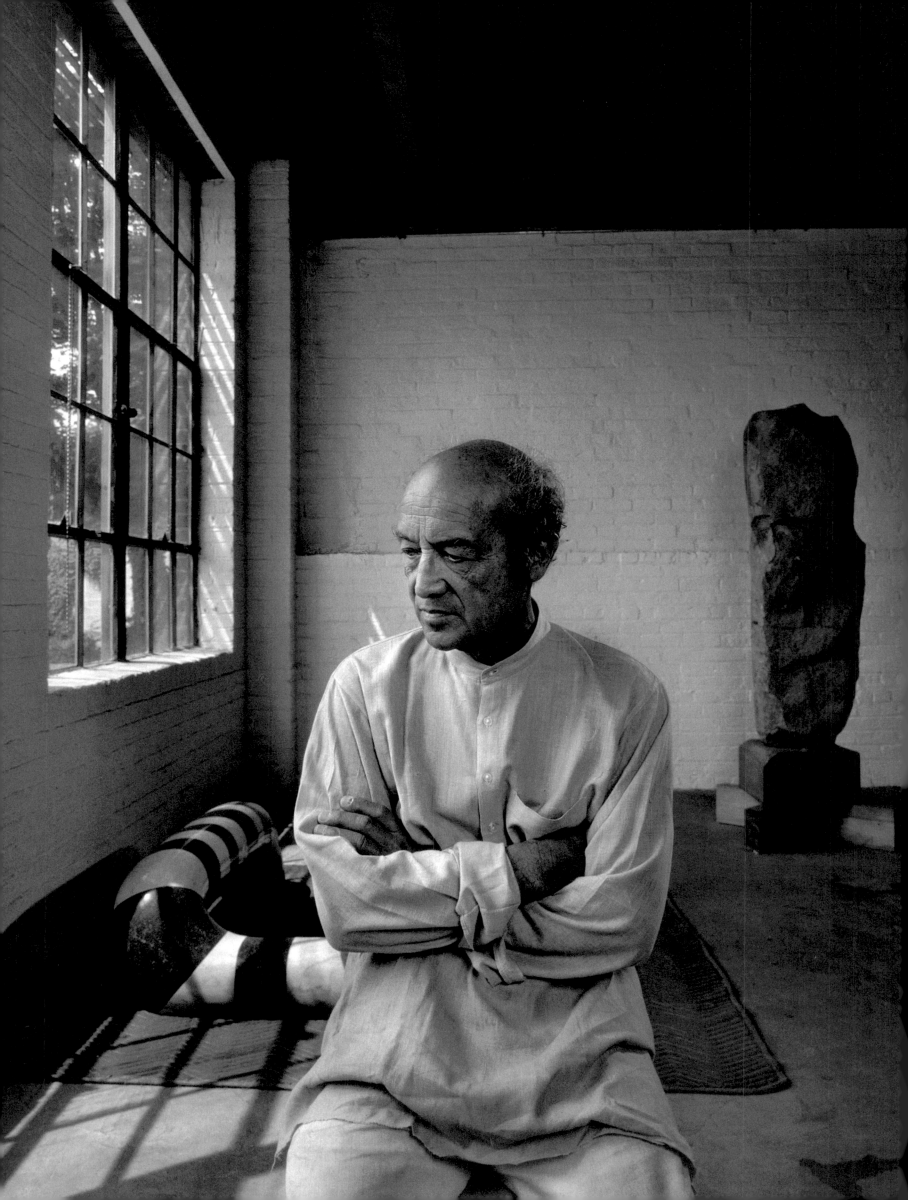

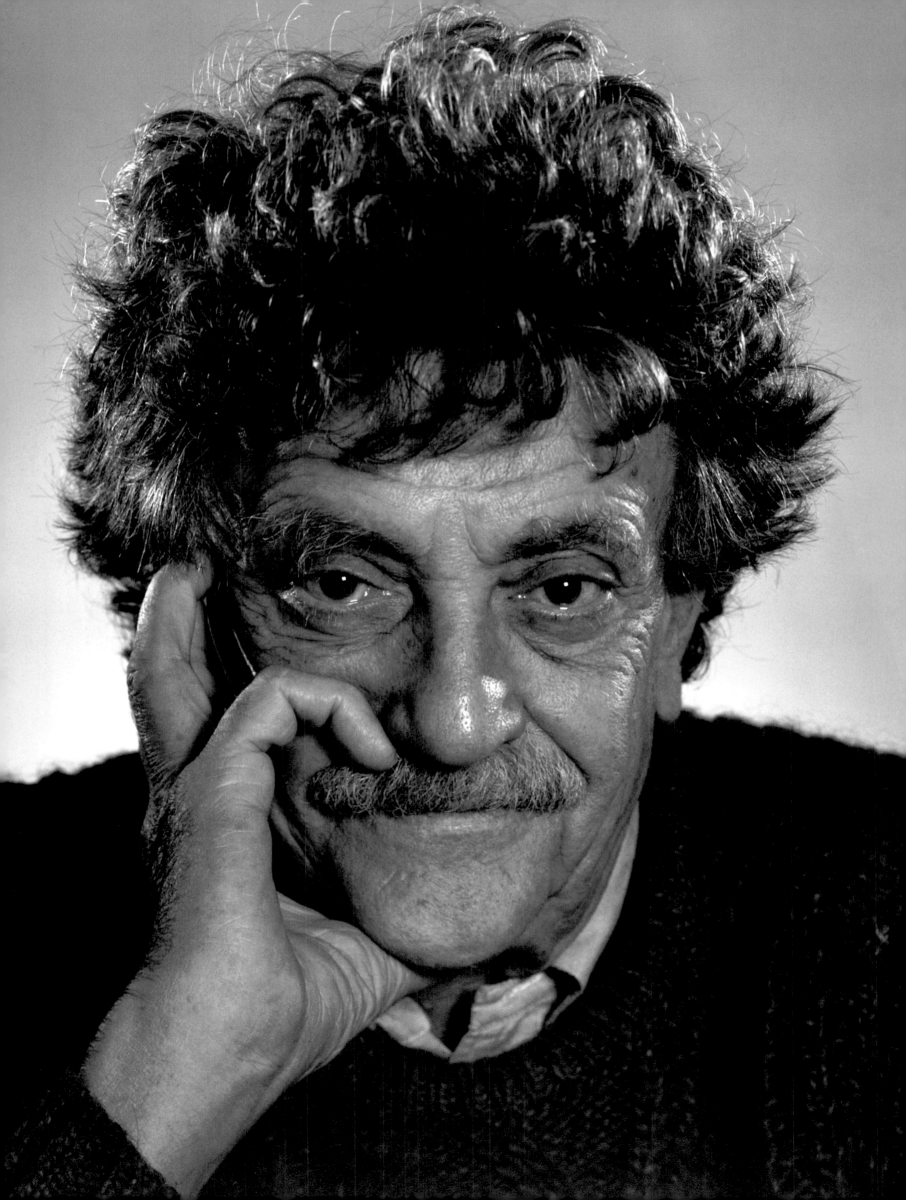

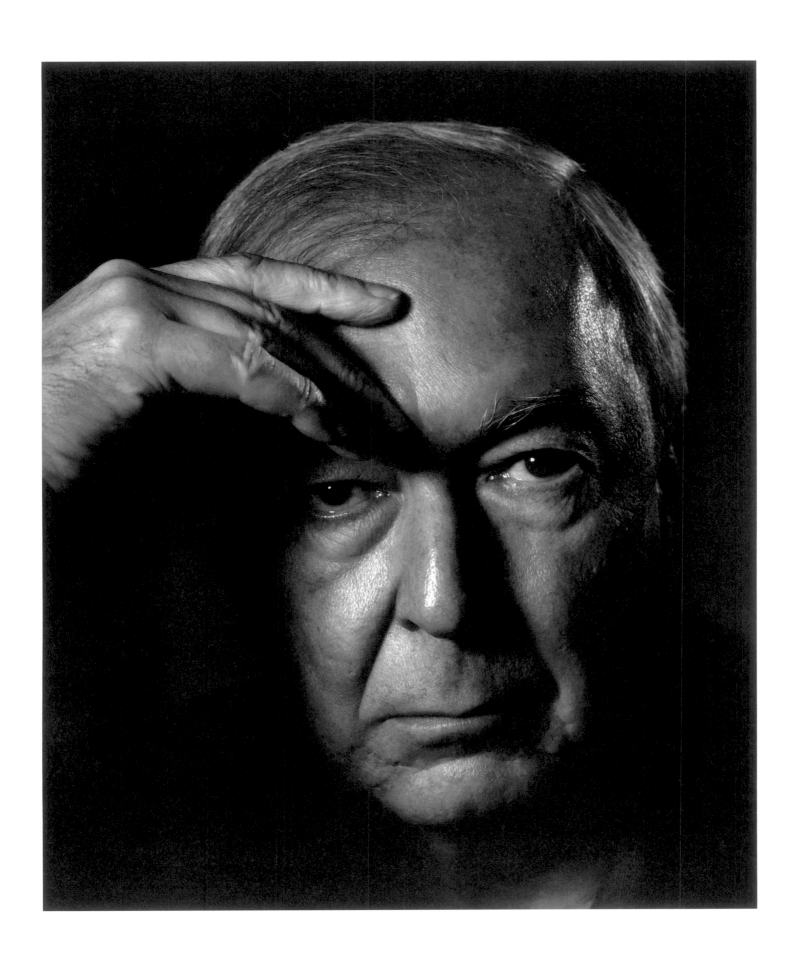

150 *above*: JASPER JOHNS, *1990*
 opposite: JESSYE NORMAN, *1990*

BIOGRAPHICAL PROFILES

Brief biographical profiles of Yousuf Karsh's subjects are organized here in alphabetical order. The corresponding page number for each portrait is listed in brackets beside the subject's name. Following a number of these profiles are (in italics) Yousuf Karsh's own recollections of the subjects.

ADENAUER, KONRAD [120] Konrad Adenauer (1876–1967) was elected the first chancellor of West Germany at age seventy-three. Commonly known as *Der Alte* (the Old Man), he was staunchly anti-Soviet, and his goal was to tie West Germany so closely to the West that no successor could sever the ties, making it vulnerable to a communist take-over. ∾ Born in Cologne, Germany, Adenauer was raised as a Roman Catholic. His father was a lawyer and civil servant, and Adenauer himself also studied law at the Universities of Freiburg, Munich, and Bonn. After school, he worked as a lawyer in Cologne. First elected to the Cologne city council in 1906, he became the city's mayor in 1917. He lost his wife in the First World War, and an automobile accident left him with facial scars. ∾ Adenauer opposed Nazism. Driven from office by Hitler, he was arrested and imprisoned in 1934 and 1944. After the end of the Second World War, Germany had become an economic force with world markets. Adenauer had gained the respect of European and U.S. leaders and was participating in councils with Western powers. The year 1953 was significant for Germany and for Adenauer. He was up for reelection, and was running against the Socialist Party on a platform for uniting Europe. Adenauer said, "Our country is at the point of tension between two world blocs.... Long ago I made a great decision: we belong to the West and not to the East.... Isolation is an idea created by fools. It would mean that the U.S. would withdraw its troops from Europe. Ladies and gentlemen, the moment that happens, Germany will become a satellite." Adenauer won by a landslide, and his victory was a harbinger for Europe and its success in the Cold War against the Soviet Union. That same year, *Time* magazine named Adenauer "Man of the Year," writing, "If the European dream does come true, Adenauer will go down in history as one of its creators. If it fails, his efforts will still have served West Germany well. He has won her respectability." ∾ By the early 1960s, *Der Alte*, then in his eighties, was out of touch with the new generation and a thaw toward the Soviet Union. He stepped down from office at the age of eighty-seven, retiring to travel and write his memoirs. The *New York Times* wrote, "He was an autocrat, his own kind of 'Iron Chancellor'; but if the democratic system that he helped to found endures, and if Germany survives in freedom, he will be remembered for as long as Bismarck and with vastly greater affection."

KONRAD ADENAUER A sense of power clung to him like a garment, and it required no utterance. The square-cut and deeply graven face, the huge body, and, above all, the somber granitic look indicated a singleness of purpose, a dedication to some inward and unshakable decision. His public decisiveness, the basis of his political career, is, of course, well known. This man had become the master of his people; he had brought them back to the family of Western nations, and he was determined to save them from a communist doctrine not only dangerous politically, but, to him, inherently anti-Christian and evil. He has, I suspect, that rare genius of common sense – the instinct for practicality in other fields had long been abandoned in international affairs, with tragic results. Yet, he is driven on by his own dream, the dream of a better Germany. He had suffered much for that dream under Hitler, and the suffering was legible on his face. It showed the firmness achieved only from suffering, the self-assurance of his undoubted success, and the subtlety and wariness of Der Alte, as his people like to call him. There was also a certain disillusionment and stark loneliness. He seemed, in short, the image, as a sculptor might have carved it in rough stone, of a lost people who were finding themselves.

ALI, MUHAMMAD [141] Muhammad Ali (1942–), a three-time heavyweight-boxing champion of the world, Olympic gold medal winner, and social activist, is known as much for his boasting and poetry as well as his boxing skills. He is a man of dedication and purpose, a leader committed to helping black Americans, particularly children. ∾ Cassius Marcellus Clay, Jr. was born in Louisville, Kentucky, in 1942. He began boxing at age twelve. As Cassius Clay, he won the Olympic gold medal in boxing in 1960 at age eighteen. However, when he returned home from the Olympics, he tried to order lunch in Louisville and was denied service. He was so disgusted that he threw his Olympic gold medal into a river and said, "I went all the way to Italy to represent my country, won a gold medal, and now I come back to America and can't even get served at a five-and-dime store.... That gold medal didn't mean a thing to me if my black brothers and sisters were treated wrong in a country I was supposed to represent." ∾ When Ali began his professional boxing career, many experts did not think much of his skills because his style was so different. Ali's first fight for the heavyweight championship was with Sonny Liston in 1964. Liston was the most intimidating fighter of his generation; Ali was only twenty-two. The two fought with opposing styles: Liston was prone to brute force, while Ali's style was to "float like a butterfly, sting like a bee." Clearly the underdog, Ali won the fight in six rounds. Two days after winning the championship, he announced his conversion to Islam and officially changed his name to Muhammad Ali. Malcolm X said, "He will mean more to his people than any athlete before him. He is more than Jackie Robinson was, because Robinson is the white man's hero. But Cassius is the black man's hero." ∾ For the next three years, Ali dominated boxing. In 1967, he was drafted by the U.S. Army to fight in Vietnam. Ali applied for an exemption, claiming he was a conscientious objector and opposed the war for religious reasons. But the war was still accepted by most Americans, and the controversy worsened when he said he *would* participate in an Islamic holy war. Stripped of his championships, he had his license suspended and was criminally indicted to serve five years in prison. Ali said in an interview, "I'm giving up my title, my wealth, maybe my future. Many great men have been tested for their religious beliefs. If I pass this test, I'll come out stronger than ever." It took four years for the Supreme Court to overturn his conviction, and he was prohibited to fight during the prime of his life. ∾ Ali's refusal to fight the war in Vietnam became a battle cry for others. Julian Bond, a noted black activist, said, "When a figure as heroic as Muhammad Ali stood up and said, 'No, I won't go,' it reverberated through the whole society." ∾ In late 1970, Ali returned to boxing. He should have retired, but he loved boxing and said it was all he wanted to do. His last fight was in 1981, and in 1982 he was diagnosed with Parkinson's disease. Some doctors called the disease "pugilistic Parkinson's," brought on by repetitive trauma to the head. His wife claimed, "Parkinson's disease has made him a more spiritual person. Muhammad believes God gave it to him to bring him to another level, to create another destiny."

MUHAMMAD ALI Probably no other person I have photographed has been subjected to so many years of such open hatred as Muhammad Ali – hatred because he was born black in the American South; hatred because of the arrogance which is one of his weapons; hatred because he was unafraid to take unpopular stands for his new religion or against a war; and hatred because, despite all this, he remained the fastest-moving, as well as the fastest-talking, heavyweight boxer in history.... ∾ "The Greatest" and I talked about his triumphs, about patent medicine, about the commercials he was making, but for me there was no real contact. The pinstriped suit he wore for our sitting was chosen not for business but to command the respect he rightly felt he deserved. Behind his movements lurked suspicion and anger, a waiting for recognition. He seemed to be saying, as he wrote later in his compelling autobiography, "I am America. Only, I'm the part you won't recognize. But get used to me. Black, confident, cocky; my name, not yours; my religion, not yours; my goals, my own – get used to me! I can make it without your approval! I won't let you beat me!"

∾

ANDERSON, MARIAN [63] A peerless contralto, Marian Anderson (1897–1993) was known for both her voice and for breaking racial barriers with dignity and grace. She was the first African American named a permanent member of the Metropolitan Opera and the first to sing at the White House. Leontyne Price said, "Her example of professionalism, uncompromising standards, overcoming obstacles, persistence, resiliency, and undaunted spirit inspired me to believe that I could achieve goals that otherwise would have been unthought of." ∾ Born in Philadelphia in 1897 and raised by her mother after her father died, Anderson was from a poor family. At six, she was singing with the choir of the Union Baptist Church, and at fifteen, she began her formal training at the Philadelphia Choral Society. With its financial help, she studied with Agnes Reifsnyder and later with Giuseppe Boghetti. In a contest in New York City in 1925, she won first prize, signed a contract, and began touring and performing, mainly for black audiences. ∾ In 1930, Anderson traveled to Europe to learn the languages of opera and study *lieder* singing. An instant success, she toured for years, performing 142 concerts in Scandinavia alone, including concerts for royalty in Sweden and Copenhagen. Singing for Jean Sibelius, he was so moved that he dedicated *Solitude* to her. Touring in Salzburg she met Arturo Toscanini who said, "A voice like yours is heard once in a hundred years." ∾ She returned to the United States at the request of Sol Hurok, who became her manager for the remainder of her career and was eager to arrange a concert in Washington's Constitution Hall, owned by the Daughters of the American Revolution (DAR). In 1939, Washington was a segregated city, and the concert hall had segregated seating. Hurok's offer was declined, and he took the rejection public. First Lady Eleanor Roosevelt resigned from the DAR and helped to arrange a free, open-air concert on the steps of the Lincoln Memorial on Easter Sunday. Attended by more than 75,000 people and broadcast to millions of radio listeners, the concert was a turning point in Anderson's career. ∾ Despite worldwide popularity, she faced racism at all levels, from hotel and restaurant rejections to her inability to participate in operatic performances. The prejudice was worse in the United States than in Europe. She said, "If I were inclined to be combative, I suppose I might insist on making an issue of these things. But that is not my nature, and I always bear in mind that my mission is to leave behind me the kind of impression that will make it easier for others to follow." At the age of fifty-seven, Marian Anderson finally made her operatic debut in Verdi's *Un ballo in maschera* at the Metropolitan Opera. ∾ Anderson continued regular concert singing until 1965, giving her last performance at Carnegie Hall. After that she made occasional appearances for benefits and special events. She received the Presidential Medal of Freedom and Kennedy Center Honors, and she was the first recipient of the Eleanor Roosevelt Human Rights Award of the City of New York.

Edward R. Murrow said, "With poise and grace she represented, abroad as at home, an evolving America, an America with problems, to be sure, but with a deep underlying sense of purpose and direction. She did so as an artist and as the holder of a deeply-felt religious position." Hurok tells the moving story of Miss Anderson, being asked by her mother what gift she might want for her successful daughter, and her reply, after much provocation, was simple and poignant: "All she wanted was that God would hold Marian Anderson in the hollow of his hand and raise up the people to be kind."

MARIAN ANDERSON The world knows the voice of Anderson. It has enriched our music, and, through it has been made eloquent the long tragedy of the Negro race and her own triumph over it. This realization is for all who hear and see her. What struck me most, however, when I photographed her at her home in Connecticut in 1945, was her simplicity and peacefulness. With her, I was convinced the harmony of music came from the harmony of her being. The Negro spirituals, which have deeply moved us all, are not merely the result of a glorious voice and long technical training, but are utterly her own nature. ∾ My problem was to capture and register that quality – not an easy problem even when she fell in with my suggestions with almost childlike obedience. None of my early shots satisfied me in the least. All of them, I felt, missed the intangible target. I began to despair. Then, towards the conclusion of the sitting, Miss Anderson's accompanist came in for a rehearsal. This seemed to be my chance. I asked him, in a whisper, to play very softly the accompaniment to The Crucifixion, *one of the singer's favorite compositions. Unaware of my innocent little plot, she began to hum to herself. Hurriedly, I snapped the camera. When I developed and printed the film I felt it contained what I had seen with my own eyes. This is the portrait of a harmonious soul revealing itself unconsciously in song.*

AUDEN, WYSTAN HUGH [142] Wystan Hugh (W. H.) Auden (1907–1973) was a poet of whom Israel Shenker of the *New York Times* wrote, "The singular voice of W. H. Auden gave resonance to a troubled age. He was often called the greatest living poet of the English language; much honored in his lifetime, he was quickly eulogized at his death." Auden wrote about social problems, politics, religion, and morals. He could write poems in every form, incorporating popular culture, current events, domestic issues, comedy, and modern-day expressions into his work. Christopher Isherwood said, "You could say to him: 'Please write me a double ballade on the virtues of a certain brand of toothpaste, which also contains at least ten anagrams on the names of well-known politicians, and of which the refrain is as follows....' Within twenty-four hours, your ballade would be ready – and it would be good." Auden was a teacher, a writer of prose essays and critical reviews, and he worked on films, plays, and a variety of performances. ∾ He was born in York, England, the son of a professor and a nurse. Both his grandfathers

were Anglican ministers, and they probably had an indirect influence on Auden, as, in some ways, his poems were modern day sermons disguised as verse or rhyme. ∾ He began writing poetry as a teenager, and by the time he was eighteen, he began establishing his own style. Stephen Spender privately printed his first book, *Poems*, in 1928 after Eliot at Faber & Faber rejected it. In 1930, Auden published a short play, *Paid on Both Sides*, in the *Criterion*, and in that same year, Auden's first collection of new poems was published by Faber. ∾ At Oxford, he formed lifelong friendships with Stephen Spender, Christopher Isherwood, and Cecil Day Lewis. ∾ They spoke out against the rise of Nazism and Fascism in Europe; Auden went to the front during the Spanish Civil War, and in 1939, he and Isherwood immigrated to the United States together. His poetry took on more religious themes. From 1939 to 1961, he taught at a number of schools and colleges, and from 1956 to 1961 he was a professor of poetry at Oxford. He received the Pulitzer Prize for *The Age of Anxiety* in 1946; the National Medal for Literature, given to living American authors for lifetime contribution; the King's Gold Medal for Poetry; and the Bollingen Prize in Poetry. ∾ Auden once wrote, "In a world of prayer, we are all equal in the sense that each of us is a unique person, with a unique perspective on the world, a member of a class of one." He died in Vienna of a heart attack in 1973.

W. H. AUDEN In Stephen Spender's garden in London, the poet W. H. Auden talked about "coming home." The Oxford University he knew, which he had longed for during bouts of deep nostalgic depression while living in New York, no longer existed for him when he returned to England. He spent two hours talking to my wife – prophetically – about friends who had died. He smoked incessantly, his conversation punctuated by wracking coughs. Meanwhile, the light was gone from the garden and I could take only a quick photograph of a beautiful and ravaged face. "Come soon, come soon," he invited, but I knew I would never see him again.

BARDOT, BRIGITTE [97] The French movie star and sex symbol, Brigitte Bardot (1934–) was best known for her "sex kitten" roles. With her striking beauty, long blond hair, alluring eyes, pouting mouth, and voluptuous figure, she was more than seductive. She was among the few European actresses to receive real recognition in the United States. Like her American counterpart, Marilyn Monroe, she represented female sexuality but also uniquely personified the French art of love. Jean Cocteau said of her magnetism, "The press is responsible for inventing people who already exist and endowing them with an imaginary life, superimposed on their own. Brigitte Bardot is a perfect example of this odd concoction. It is likely that fate set her down at the precise point where dream and morality merge. Her beauty and talent are undeniable, but she possesses some other, unknown quality which attracts idolaters in an age deprived of gods." ∾ Born in Paris, she started ballet lessons

early and was accepted into the National Superior Conservatory of Paris for Music and Dance in 1947. She began modeling for shows and magazines in 1949, and in 1950 appeared on the cover of *Elle*. She was discovered by the film director Roger Vadim, who became a major influence in her life. He launched her career as an actress and married her in 1952, when Bardot was eighteen and Vadim was twenty-four. ∾ Bardot first acted in romantic dramas and comedies, appearing in seventeen films between 1952 and 1956. In the mid-1950s, French and Italian filmmakers were successfully launching "art films," and Vadim lobbied to get Bardot a serious role in one. He directed her in *And God Created Woman*, in which she played a woman who marries to escape life in an orphanage only to fall for her husband's younger brother. Bardot's performance was considered daring; she played a young, married woman searching for sexual freedom, inciting public protests over the film. Vadim said, "I wanted to show a normal young girl whose only difference was that she behaved in the way a boy might, without any sense of guilt on a moral or sexual level." The film earned them both a permanent place in French cinematic history and is recognized for making a breakthrough in what was considered permissible on the screen. In retrospect, Vadim noted, "There was really nothing shocking in what Brigitte did, what was provocative was her natural sensuality." ∾ Bardot's film career lasted twenty-two years, and she appeared in forty-six films with actors such as Alain Delon, Jean Gabin, and Sean Connery. In 1973, before her fortieth birthday, she announced her retirement, and has devoted her life since to the protection of animals.

BRIGITTE BARDOT When I photographed Brigitte Bardot on a film set in Paris in 1958, she was then on the first crest of her success, not yet a legend. It was shortly after Roger Vadim, her then-husband, had directed the display of her charms in the film, And God Created Woman *and brought her to the world's delighted attention. ∾ Unlike many of her contemporaries in films, who rise from poverty-stricken childhoods, through nondescript jobs, to perhaps final stardom, Bardot came from a wealthy family and had had a strict, proper childhood. ∾ When she came on the set in the character's costume she was portraying I was amused. It was a rather extraordinary costume that was not overtly revealing but calculated – held together with Scotch tape. Her manner was at once professional and intelligent. Her walk had none of the provocative languidness of her films, and her face was alive with curiosity.*

BARRAULT, JEAN-LOUIS [82] Jean-Louis Barrault (1910–1994) was a French actor and director whose best-known role was the mime Baptiste Deburau in *Les enfants du paradis*. The success of this film has been said to have single-handedly revived the art of pantomime. ∾ Barrault was born the son of a pharmacist in Le Vesinet, France. He attended college at Collège Chaptal and Ecole du Louvre in Paris, and, at the age of

twenty-one, began studying theater with Charles Dullin and mime with Etienne Decroux. Barrault made his debut in the 1930 film *Vagabonds imaginaires*, and his stage debut a year later as a servant in Dullin's production of *Volpone*. He was a successful film actor, appearing in more than ten films by 1940 and going on to make more than two dozen films in all. Despite his success, however, the stage remained Barrault's true passion. ∾ In 1940, Barrault joined the Comédies Francaise. There, he met his wife, the actress Madeleine Renaud, who was ten years his senior. In 1946 the couple founded the Compagnie M. Renaud–J.L. Barrault at the Théâtre Marigny. ∾ In addition to his work as an actor and director, Barrault also wrote many articles, two books on plays, theater, and acting, and an autobiography, *Memories for Tomorrow*. Barrault's death in 1994 was a national tragedy in France. The minister of culture, Jacques Toubon, publicly praised Barrault's "unique mixture of subtlety and power, of intelligence and energy."

JEAN-LOUIS BARRAULT Barrault was a difficult man to photograph: alert, moody, puckish, and highly nervous. This most famous member of the French modern school of acting never knew, he said, what to do with his hands, although to me they seemed as eloquent as his speech. I photographed him in motion, trying especially to catch that woebegone expression of the instinctive mime, of the downtrodden but unconquerable human being. Only at the end of the sitting was I rewarded with a smile – from the world's little man who survives everything.

BELANEY, ARCHIBALD (GREY OWL) [50] A foremost Canadian conservationist, Grey Owl (1888–1938), through his writings, films, and lectures inspired millions to conserve their wilderness. Born in England to a farm family, he adopted the name Grey Owl as an adult after establishing himself a member of the First Nations, the indigenous people of Canada and the United States. Raised by his grandmother and aunts, he developed a love of nature and native culture. In 1906, at eighteen, he moved to Toronto to study, but he soon established residence in northern Ontario, learning traditional skills from the Ojibway and Chippewa people, who gave him his name. ∾ He originally earned his living as a trapper, wilderness guide and forest ranger, and married Gertrude Bernard, a Mohawk called Anahareo. After one of his traps left two beavers orphaned, she suggested they adopt the animals and abandon trapping. She also convinced him to pursue a career as an author and write about his wilderness experiences. ∾ Recognizing his work, the Dominion Parks Service hired Grey Owl as a naturalist, gave him a home in the National Parks and in 1931 he, Anahareo, and the two beavers, moved to Riding Mountain National Park, and then to Prince Albert National Park where they built Beaver Lodge. Grey Owl's career blossomed, his writing was prolific, and he expanded to film and lecture tours. Now considered classics, his two most famous books are *Pilgrims of the Wild* and the children's book *Sajo and*

the Beaver People. According to historian Bill Waiser, "They were widely acclaimed as two of his finest works on Canadian wilderness heritage and the need for conservation." ∾ In 1938, upon completing a lecture tour, Grey Owl developed pneumonia and died.

BERGMAN, INGRID [67] Murray Schumach said of Ingrid Bergman (1915–1982), "Her beauty was so remarkable that it sometimes seemed to overshadow her considerable acting talent. The expressive blue eyes, wide full-lipped mouth, high cheekbones, soft chin and broad forehead projected a quality that combined vulnerability and courage; sensitivity and earthiness, and an unending flow of compassion." ∾ Bergman was born in Stockholm to a German mother, who died when Ingrid was only three. Her father, a popular photographer and artist, died when she was thirteen, and her aunts and uncles raised her. At the age of seventeen, Bergman was accepted to the Royal Dramatic Theatre in Stockholm, and after only one year she was working full-time making films. Within seven years she was a leading movie star in Sweden. She married Peter Lindstrom at the age of twenty-one. ∾ Initially Bergman was not interested in becoming a Hollywood movie star. She told the press, "Hollywood has a queer way of taking an individual and fitting her into the American mold. I have worked hard to develop my style and I don't want anything to do with bathing suits and plucked eyebrows." Director David O. Selznick, who pursued her relentlessly for parts in his Hollywood films, was eventually successful in convincing her. Her work in *Intermezzo*, his 1939 English remake of her Swedish language film established Bergman as a star. ∾ In 1942, Bergman and Bogart costarred in the blockbuster *Casablanca*. That same year, she was nominated for best actress in a leading role in *For Whom the Bell Tolls*. In all, she was nominated for the Academy Award for best actress six times, winning the award for her roles in *Gaslight* and *Anastasia*. She also won an Oscar for best supporting actress for *Murder on the Orient Express*. ∾ She was a fan of Roberto Rossellini, the Italian film director, and to further her artistic development, approached him for work. In 1949, the two fell in love, having a child before Bergman could divorce her husband. She fell out of favor with the American public and stayed out of the United States for seven years. When she returned in 1956, she told the press, "I have had a wonderful life. I have never regretted what I did. I regret the things I didn't do. All my life I've done things at a moment's notice. Those are the things I remember. I was given courage, a sense of adventure, and little bit of humor. I don't think anyone has the right to intrude in your life, but they do. I would like people to separate the actress and the woman." By 1957, her marriage to Rossellini had ended. ∾ For the last eight years of her life, Bergman fought cancer. She pushed herself to complete her last film role, a middle-aged concert pianist in *Autumn Sonata*, which is considered her finest performance, and for which she received her last Oscar

nomination in 1978. Her final role was Golda Meir, the Israeli prime minister, in the television production of *A Woman Called Golda*, for which she won an Emmy. She said of her struggle, "Cancer victims who don't accept their fate, who don't learn to live with it, will only destroy what little time they have left.... I didn't think I had it in me. But it has been a wonderful experience, as an actress and as a human being who is getting more out of life than expected."

INGRID BERGMAN The death of this courageous woman, a sensitive and compassionate actress, brought a flood of memories. How effervescent and full of life she was! Kurt Weill asked for this photograph when the Playwrights Company was considering her for Maxwell Anderson's Joan of Lorraine.

BOGART, HUMPHREY [66] Humphrey DeForest Bogart (1899–1957) was named by the American Film Institute the greatest male star of all time. Initially cast in gangster roles, he soon transcended the stereotype. By middle age Bogart had matured into an actor who could play complex roles of smart, reckless, and often cynical characters driven by a strong moral code. He played Sam Spade in *The Maltese Falcon*, Rick Blaine in *Casablanca*, Charlie Alnutt in *The African Queen*. The academy nominated him three times, and he won the Academy Award for best actor in a leading role in 1951. ∽ Bogart was born in 1899 in New York City, New York. He was educated at Trinity School and Phillips Academy, Andover. His parents hoped he would continue his education at Yale, but in 1918 he was expelled from Phillips Academy and joined the Navy, serving during the First World War. ∽ Bogart never took acting lessons. He started his career on Broadway and moved to Hollywood in the early 1930s, initially with roles as a gangster in B movies. He received his first break when Leslie Howard recommended him for the role of the evil Duke Mantee in *The Petrified Forest* in 1935, a performance that won him a contract with Warner Brothers, the studio that produced most of the tough-guy movies at the time. In 1941, he was given the leading role in *High Sierra*, the movie that established him as a leading man. He signed a seven-year contract and began to work on films that were to become classics: *The Maltese Falcon*, *Casablanca*, *The Caine Mutiny*, *The Big Sleep*, *The Treasure of the Sierra Madre*, and *The African Queen*. ∽ He was the consummate professional; he always knew his lines, was ready to work, and was prompt. Katharine Hepburn said of Bogie, "He was one of the biggest guys I ever met. He walked straight down the center of the road. No maybes. Yes or no. He liked to drink. He drank. He liked to sail a boat. He sailed a boat. He was an actor. He was happy and proud to be an actor...." ∽ Bogart married four times, but it was his marriage to Lauren Bacall that stuck. They met on the set of *To Have and Have Not* in 1945. He was forty-five, and she was twenty. Director Howard Hawks said of the on-set romance, "When two people are falling in love with each other, they're

not that tough to get along with, I can tell you that.... Bogie fell in love with the character she played, so she had to keep playing it the rest of her life." ∽ In the late 1940s, during the height of McCarthyism, Bogart organized a delegation to Washington, D.C. to protest the unfair treatment he felt actors and writers were receiving from the House Un-American Activities Committee. ∽ Bogart's health began to fail him in the mid-1950s. He had cancer of the esophagus and refused treatment until the cancer had seriously progressed. John Huston gave the eulogy, saying, "Himself, he never took too seriously – his work most seriously. He regarded the somewhat gaudy figure of Bogart, the star, with an amused cynicism; Bogart the actor, he held in deep respect.... He is quite irreplaceable. There will never be another like him."

HUMPHREY BOGART The handsome son of a successful New York physician and his artist wife, Bogart's role model in the theater was the aristocratic Leslie Howard. As a fledgling Broadway actor, it was he who first asked that famous question, "Tennis, anyone?" But by the time I photographed him, the image of the tender-tough hero was already wrought. Bogart and his English butler had planned a thoughtful surprise to welcome me to his home: an issue of the Illustrated London News opened to my portrait of King George VI.

BRAQUE, GEORGES [84] The French government proclaimed Georges Braque (1882–1963) the "most French of all French artists of his generation." Known for his work in Fauvism and Cubism, he and Pablo Picasso were the founders of Cubism. In their six year collaboration, they worked in competitive collaboration that redefined the future of modern art. The Louvre recognized Braque's importance by making him the first living artist whose work was exhibited. ∽ Born in Argenteuil-sur-Seine, France, Braque was raised in Le Havre and learned painting by working as a decorator and house painter with his father and grandfather. He also studied at the Ecole des Beaux-Arts. Leaving for Paris in 1899 to study under a master decorator, he received his craftsman certificate in 1901. ∽ In 1904, Braque set up a Paris studio to begin painting. His original work, in the impressionist style, slowly evolved into a post-impressionist Fauve style that flourished in France from 1898 to 1908. He fell under the influence of Paul Cézanne, who said artists should treat nature "in terms of the cylinder, the sphere, and the cone." ∽ Picasso and Braque met in 1907. Both were frustrated with the current styles, both ambitious with a strong desire to create a new kind of art. They worked in a close partnership and friendship to produce work that is known today as analytical cubism. ∽ In 1914, they ceased their collaboration when Braque was drafted into the French Army. A year later he received a head wound that temporarily blinded him and left him unable to paint until 1917. When he returned to his art, he changed his style. His work became less structured and more personal. He was using a

brighter palette and a freer manner that was less angular, though elements of cubism were still present. ∽ In 1922, after an exhibition at the Salon d'Automne, he was commissioned to design the décor for two Sergei Diaghilev ballets in the mid-1920s. He remained in Paris during the Second World War, painting still lifes, designing interiors, and making lithographs, engravings, and sculptures. In 1930, Braque moved to the coast of Normandy, where he actively painted until his death. André Malraux said in his eulogy, "The painting of Braque and his friends exemplified France just as much as those of Corot, although in a more mysterious way, for Corot had overrepresented her. Braque expressed French values with such symbolic force that he was as legitimately at home in the Louvre as the Angel of Rheims in its cathedral."

GEORGES BRAQUE All his life, Georges Braque, the French painter, was preoccupied with space. With extraordinary imagination and his own unique methods, he painted space, and his work, with that of Picasso, is said to have had the greatest influence on modern painting. His house in Paris was in complete disarray when I went to photograph him in 1949, the tiny living room almost empty and its furniture heaped up as if for moving day. We went upstairs to his studio and prepared to make his portrait. M. Braque seemed a little surprised, almost disappointed, that I did not wish to portray him with some of his paintings in the background. This type of photograph, I said, had been rather overdone of late. I had come to picture the man, not his work. I did use one prop – a "casquette," a cloth cap of his own design, made for him in both black and white. It suited him well in either color. M. Braque was a delightful man, innocent of all pretense. A jovial subject, he was much more approachable for me than were his cubist pictures, which I confess I had vainly studied before I visited him. I enjoyed his company.

BRITTEN, BENJAMIN [86] Benjamin Britten (1913–1976) – whose birthday was on the feast of Saint Cecilia, the patron saint of music – achieved international fame as a composer, conductor, and musician. Born in Lowestoft, England, in 1913, he was exposed to music at an early age by his mother, an amateur singer, and began composing when he was five. At eleven, Britten was discovered by Frank Bridge, a composer who trained him and introduced him to a wide range of composers throughout Europe. Britten entered the Royal College of Music in 1930 to study piano and composition under Harold Samuel and Arthur Benjamin, but found his style was not a fit with the traditional style of music advocated at the school. Britten felt he did not learn much at the Royal College. ∽ He began composing music for films produced by the General Post Office, and met W. H. Auden while there, using his poetry in some of his work, including "Hymn to St. Celia." Britten immigrated to the United States in 1939 with tenor Peter Pears, who was a conscientious objector and his lifetime companion, and for whom Britten created many roles. Britten's anti-war feelings were expressed in his later

choral work *War Requiem*. In 1942, he returned to England and, on the journey home, he wrote *Hymn to St. Cecilia*. ☙ One possible explanation for Britten's decision to return to England was an article he read peaking his interest in the poem "The Borough" by Suffolk poet George Crabbe that formed the basis for Britten's opera *Peter Grimes*. Britten completed *War Requiem* in 1961. ☙ In 1968, Britten was diagnosed with subacute bacterial endocarditis, the same disease that killed Mahler. He recovered from the infection but had heart problems that recurred, and surgery was needed to repair a valvular heart lesion. For many years, he complained of a pain in his left arm that bothered him while conducting. His last opera was *Death in Venice*, finished in 1973. He was insistent on finishing the opera before having the surgery, but, unable to attend the opening, he died at home in 1976. ☙ Britten was named a Lord by the Queen, and he was named a Companion of Honour in 1952, and a member of the Order of Merit in 1965.

BENJAMIN BRITTEN Every circumstance conspired against my attempt to photograph Benjamin Britten in 1954. The brilliant British composer lived in a tiny kingdom of his own at Aldeburgh, in the County of Suffolk, and my driver lost his way to our appointment. Mr. Britten was irritated at my lateness, insisted he must play a regular set of tennis to exercise a lame right arm and then, when my camera was set up, leaped into the sea, which comes right up to his house. That plunge cooled him off remarkably and we got on well together after that. Some time later, in direct answer to questions, he illuminated for me aspects of contemporary music, especially his own. I remarked that he had worked a good deal with the English Opera Group and with Peter Pears in particular. When writing, did he have particular people in mind? "It's always a great inspiration," he said, "to work for particular artists. One gets stimulus from knowing their personal characteristics; though a disadvantage, it makes the artists difficult to replace." ☙ His envious dachshund would not allow me to take more than a few photographs of Britten alone in his house by the sea in Suffolk, England. The dog demanded to become part of the picture. Britten swiveled on the piano seat to make room for his canine collaborator, who leaped into the safety of his arms, while yet casting a wary eye at me.

CASALS, PABLO [88] Pablo Casals i Defilló (1876–1973), best known as Pablo Casals, the Spanish cellist, is known for the music he played and for his self-exile in protest to dictatorships. In 1946, at the height of his career, Pablo Casals put down his cello and refused to ever perform on stage again, to protest the totalitarian Franco regime. In spite of his exile, his career was legendary. The *New York Times* said in its obituary, "And so Casals lived a legend, and died a legend. And it was a real legend, one that Casals had rightly earned. In him came together a set of attributes that few musicians have matched. The man was largely responsible for modern cello playing, was instrumental in furthering the cause of chamber

music, and lived and died for music. His was an important life. And in most respects it was a beautiful life." ☙ Born in 1876 in Vendrell, Spain, Casals was surrounded by music from the time he was born. His father was the organist and choirmaster for the local parish, and gave Casals piano, violin, and organ lessons. Casals began his career performing with his father at the church. He enrolled in Escuela Municipal de Música in 1888 and studied cello and piano. He excelled in cello and was able to give his first solo recital in Barcelona at the age of fourteen. Casals began each day with an inspirational walk, followed by playing Bach. "I go immediately to the sea, and everywhere I see God, in the smallest and the largest things. I see Him in colors and designs and forms … and I see God in Bach. Every morning of my life I see nature first and then I see Bach." His life was influenced by his faith, nature, and the music of Bach. To him, "music was an affirmation of the beauty man was capable of producing." ☙ In 1890, Casals was introduced to Bach's *Six Suites* for solo cello. The suites were considered to be musical exercises useful for practice, having little artistic value. However, when Casals played the suites publicly for the first time, the sound was like nothing previously heard. Casals said, "Bach has reached the heart of every noble thought, and he has done it in the most perfect way." ☙ Casals held positions as a cellist at the Madrid and Paris Operas, and performed concerts throughout Europe and the United States. He was invited to play for heads of state and royalty, the White House, where he played for President Theodore Roosevelt. In 1939, General Franco rose to power and Casals moved to Prades, France, where he gave occasional concerts. In 1946, he renounced the stage altogether, taking a stand against all dictatorships. His self-imposed exile was the strongest statement he felt he could make against the oppression of dictators. He never returned to Spain again. ☙ In 1950, because of the Prades Festival celebration of the bicentennial of Bach's death, Casals was urged to resume his performances. While he agreed to perform again, he refused to play in any country that officially recognized the Franco government, and did not bend on his position except for a single concert he played for President Kennedy. Kennedy said, "The work of all artists – musicians, painters, designers, and architects – stands as a symbol of human freedom, and no one has enriched that freedom more singly than Pablo Casals."

PABLO CASALS As I drove along the dusty road to Prades in 1954, I had the feeling that I was on a pilgrimage. I was going to meet that great self-exile and patron saint of music, Pablo Casals. He did not disappoint me. I had never photographed a warmer or more sensitive human being. We decided to take the portraits in two sessions and against two different backgrounds. The second day, we moved to the old Abbey of St. Michel de Cuxa. Though partially restored, it was empty and dark. One electric light bulb was the only illumination available, but, hap-

pily, I secured enough current for my strobe lights. No need to pose Casals. Once he had sat down with his cello, the immediate surroundings seemed to fade from his consciousness. Soon the old abbey was throbbing with the music only he can play – music of an almost unearthly quality in this dismal chamber. I hardly dared to talk or move for fear of breaking the spell. And then, as I watched the lonely figure crouched against the rough stones, a small window high above him giving this scene the look of a prison, I suddenly decided on an unusual experiment: I would photograph the musician's back. I would record, if I could, my own vivid impression of the voluntary prisoner who, on the surge of his music, had escaped not only the prison, but also the world. The portrait printed here perhaps suggests the immense strength, intellectual, physical, and spiritual, flowing from this amazing old man.

CASTRO, FIDEL [137] On Tuesday, February 19, 2008, Fidel Castro (1926–), revolutionary and reformer, gave up the power he had held as leader of Cuba for almost fifty years. At the news of his resignation, The *Daily Telegraph* wrote, "The world may long argue whether he was a communist or a social reformer, a mad tyrant or a visionary savior, but no one will ever doubt that he was a shrewd survivor who left power just as he ruled: on his own terms…. Of his survival skills, there was no dispute. Castro withstood Mafia hit men, CIA-backed invasions, the collapse of world communism, a four-decade U.S. economic embargo, and the mortal hostility of millions of his own countrymen." ☙ Castro's father moved to Cuba from Spain to fight against the United States in the Spanish-American War. After Spain's defeat, he remained on the island to run a successful sugar plantation. Castro, always rebellious, organized a strike of sugar workers on his father's plantation at age thirteen. He was educated at a Jesuit boarding school and was recognized as an intelligent student and a gifted athlete. Castro became a lawyer in Havana, committed to defending the poor and to fighting inequality. ☙ In 1947, he joined the Cuban People's Party and by 1952 was elected the party's head, fighting corruption, injustice, poverty, unemployment, and low wages. When General Fulgencio Batista took control of Cuba in 1952, Castro believed that starting a revolution was the only way to gain power. At the same time, Castro and his party wanted to gain independence from America. ☙ Castro's frustrations provided the motivation for the Cuban Revolution of 1959. On July 26, 1956, Castro, Che Guevara, Juan Almeida, and other rebels took control of the Sierra Maestra Mountains, initiating a fight that would last for three years. On January 9, 1959, Castro became Cuba's new leader and immediately began implementing his socialist agenda. He was a strong believer in nationalizing education and health care. Property owned by the wealthy and businesses owned by American companies were seized and redistributed to the poor; rents were reduced, and utilities were nationalized. ☙ Castro was often at the center of politically contentious issues

between the United States and the Soviet Union, Angola, Afghanistan, China, and Latin America. Up until 1991, when the Soviet Union collapsed, Cuba was the beneficiary of significant economic aid. On hearing news of the collapse, Castro said, "To speak of the Soviet Union collapsing is as if to speak of the sun not shining." ✎ When asked how he would pass the revolution on to generations of Cubans sixty years from now, he responded, "At that time the U.S. and Cuba will be friends. The awareness of the need for peace will have made great strides, and the so-called embargoes by you and by us would have disappeared. . . ."

FIDEL CASTRO At the end of our host's tour of the facilities, we inspected two or three possible places for photography. I chose a simple ceremonial room with a few bookshelves and walls so stark as to suggest a barracks. It turned out to be Castro's own office. I set up my equipment and went home to the Canadian Embassy, where I was staying as a guest of the ambassador, Kenneth Brown. And then I waited to learn when Castro would see me. Days passed. They were pleasant enough: the weather was wonderful, and I was free to explore where I wished. Nowhere did I see people with sad faces, or with unhealthy, ill-fed bodies. But planes then left Cuba only once a week, and my time for departure was fast approaching. On the last day, I phoned the Protocol Office every hour: when would the prime minister be free? My frustration was not eased by the embassy phone, which periodically went out of order. ✎ Not until after six o'clock, the last evening, did word come that two cars were on their way to fetch me. Castro arrived in the room we had chosen, quietly, graciously, but looking grave and tired. He was taller than he appeared in photographs. He shook my hand and immediately removed the belt and pistol that were part of his uniform. Then he apologized for keeping me waiting so long; he had had many guests and duties during the previous days of the anniversary celebrations. As I readied the camera, I suggested that, to start, he might try to recapture the moods of our first moments together. ✎ "I'm sorry, I cannot," he replied charmingly. "I am not a good enough actor. I cannot play myself." Our session lasted three-and-a-half hours. From time to time we would stop to refresh ourselves with Cuban rum and Coke. "Tell me," he said, "about photographing Helen Keller." Then he asked about Shaw, Churchill, Camus, Cocteau, and mostly about Hemingway, whose home near Havana is a shrine. I was impressed that Castro – a revolutionary – should have made room in his life for these creative luminaries.

CHIANG KAI-SHEK, MADAME [55] Madame Chiang Kai-shek (1897–2003) was a member of the Soong family that dominated Chinese finance and politics for the first part of the century. Her American education, background, lifestyle, and fluency distinguished her, and she was the ambassador for her husband, Generalissimo Chiang. ✎ Born Soong Mei-ling to one of Shanghai's wealthiest families, her father had made his fortune as a publisher. Her mother was a devout Christian.

Educated at Wellesley College, she studied English literature and philosophy, and in her senior year, received Wellesley's highest academic honor. She graduated in 1917 and returned to China. ✎ In 1920, Mei-ling met Chiang Kai-shek, who was rising in the ranks of the Chinese military and was a leader in the Nationalist Government, which, under the leadership of Sun Yat-sen, was dominant. In 1925, Sun Yat-sen died, and Chiang Kai-shek assumed leadership of the party. He spoke almost no English, was eleven years older than Mei-ling, was a Buddhist, and was married. He divorced, converted to Christianity, and married her in 1927: a union joining a military hero with one of the nation's richest families. Madame Chiang Kai-shek became her husband's political partner for life, acting as his advisor on political and military matters and traveling with him as interpreter, spokesperson, and ambassador. Their political partnership was a stormy one. ✎ Madame Chiang came to the United States in 1943 looking for money to support the Nationalist cause against Japan. She was the second woman to address a joint session of Congress, and succeeded in raising billions of dollars in aid. ✎ Roosevelt viewed China as a powerful component in the new international world order and was anxious to contain the spread of Communism and the Soviet Union. Though he provided support to the Nationalist Party, he soon grew disenchanted with General Chiang's tyrannical and corrupt practices. At a state dinner, Mrs. Roosevelt asked Madame Chiang what could be done about striking Chinese coal miners. Madame Chiang responded with a quick movement of her forefinger across her throat. Afterward Mrs. Roosevelt commented, "She can talk beautifully about democracy, but she does not know how to live democracy." ✎ In 1949, General Chiang was forced to resign as president and fled to Taiwan, declaring Taipei the temporary capital of China. When he fled, it was said that he took with him the national art collection and stripped the treasury of at least three million U.S. dollars. He died during his fifth term in office in 1975. Following his death, Madame Chiang moved to a family estate in Long Island where she remained active until her death.

MADAME CHIANG KAI-SHEK This photograph of the First Lady of China was made in Ottawa's House of Commons. Little time could be spared from the official program so this was one of those hurried sittings that had to be finished in a few minutes. The First Lady was most gracious, but quite concerned over her appearance and felt that she had to do a little repair work before being photographed. . . . She is a person of great beauty and distinction, with all the graceful mannerisms of the Orient and many of the democratic mannerisms of the Occident. If I have made her appear more grave than needed, it is because I feel that her good looks, which have been features seen so often before, are only incidental to the great influence she wielded in her own country and in international affairs. . . .

✎

CHURCHILL, WINSTON [53] At the passing of Sir Winston Churchill (1874–1965), Queen Elizabeth wrote to his wife: "The whole world is the poorer by the loss of his many-sided genius while the survival of this country and the sister nations of the Commonwealth, in the face of the greatest danger that has ever threatened them, will be a perpetual memorial to his leadership, his vision, and his indomitable courage." A British statesman, orator, author, prime minister, military strategist, and world leader, he staunchly defied Hitler and his regime. He was as well a man of language, a historian, artist, and author, winning the Nobel Prize for Literature in 1953. ✎ Born at Blenheim Palace in 1874, the son of Lord Randolph Churchill and the former Jennie Jerome of New York, he was educated at Sandhurst Royal Military Academy and joined the fourth Hussars after graduation in 1895 as a war correspondent. He liked soldiering, serving over the next three years in Cuba, India, and Sudan. ✎ Churchill first entered Parliament in 1901 at age twenty-six as part of the Conservative Party. Switching to the Liberal Party, he was appointed to the high office of home secretary in 1910 and First Lord of Admiralty in 1911. When the First World War broke out, he was the political head of the Royal Navy and in 1915 urged the government to send a navy expedition to the Dardanelles to open a road to Russia through the Black Sea. The expedition failed, forcing Churchill's resignation and bringing his political career to a halt. Rejoining politics in 1917, when Lloyd George named him Minister of Munitions, he served as Secretary of State for War, Colonial Secretary, and Chairman of the Cabinet Committee on Irish Affairs. In 1924, he returned to the Conservative Party and was appointed Chancellor of the Exchequer. When the Conservative Government fell in 1929 and Ramsay MacDonald came to power, Churchill resigned and spent the years until 1939 as an author, journalist, and lecturer. ✎ Churchill remained vigorously involved in politics and public affairs. He spoke out aggressively against the rise of totalitarian governments, especially of Hitler and the Nazis. He believed it essential to alert the British people to the danger of another war, and when he addressed the House of Commons he stressed the importance of resisting Hitler, ". . . not only of self-preservation but also of the human and the world cause of the preservation of free governments and of Western civilization against the ever-advancing sources of authority and despotism." Taking this stand, Churchill pitted himself against the Conservative leaders promoting the appeasement of Hitler. He was also positioning himself to be Prime Minister. ✎ When France surrendered and Britain "stood alone," Churchill said, "Let us therefore brace ourselves to our duties, and so bear ourselves that, if the British Empire and its Commonwealth last for a thousand years, men will still say, 'this was their finest hour.'" Finally appointed prime minister in 1940, at age sixty-five, he declined to negotiate with Hitler, organized an air defense against him, and attacked Hitler's Italian ally, Mussolini. ✎

The war intensified and Churchill desperately tried to convince the United States to join Britain. He met President Roosevelt for the first time in 1941, and together they established the Atlantic Charter, stating, "they deem it right to make known certain common principles in the national policies of their respective countries on which they base their hopes for a better future for the world." ∾ Churchill, with FDR and Stalin, shaped the Allied strategy. In 1944, after the D-Day invasion, Germany surrendered, and Churchill proclaimed the end of European hostilities. The Tory government broke up, Churchill lost the general election and, with it, the premiership. John Keegan wrote, "His name had been made, and he stood unchallengeable as the greatest of all Britain's war leaders. It was not only his own country, though, that owed him a debt. So, too, did the world of free men and women to whom he had made a constant and inclusive appeal in his magnificent speeches from embattled Britain in 1940 and 1941. Churchill did not merely hate tyranny, he despised it. The contempt he breathed for dictators – renewed in his "Iron Curtain" speech at Fulton, Missouri, at the outset of the Cold War – strengthened the West's faith in the moral superiority of democracy and the inevitability of its triumph." ∾ Churchill spent his retirement writing and painting, and died in 1965.

WINSTON CHURCHILL This study of Britain's great wartime leader was made in the Speaker's Chambers of the Canadian House of Commons immediately following one of his memorable speeches. It is one of those rare pictures showing him without the famous cigar. This was not accidental. The Prime Minister relinquished his ubiquitous talisman in an unguarded moment, and I still wonder that I had the inspiration – or the temerity – to take it from him.... It came about in this way: because of his overloaded schedule while in the Canadian capital, permission to make a portrait was secured only with the greatest difficulty, and even then chiefly because it was to become part of Canada's National Archives. I was warned that I could have just a few moments and that I would have to catch my bird in passage between the House and the Canadian Prime Minister's private chambers where a reception was to be held.... The arrangements made it necessary for me to prepare my lights beforehand, and to study my subject as best I could from the House gallery. There, I decided how I wished to photograph him, and with a strong conviction there should be no cigar – not because I wanted to be original or different, but because Churchill was so plainly a person who did not require props.... ∾ But when his speech was finished, the great man was in no mood for photographing: he wanted to relax. Gentle persuasion induced him to grant me two minutes for one shot – "and I mean two minutes for one shot." Upon that understanding, he stuck a freshly lit cigar in the corner of his mouth and waited. I was expecting just that and had prepared for it. "Sir," I said, "here is an ash tray." He dismissed it with a disapproving frown, but there was no time for more persuasion, gentle

or otherwise. I took the cigar from him and clicked the shutter as soon as I could reach the camera.... I expected a justifiable outburst, but instead the great man genially shook my hand. "Well, you can certainly make a roaring lion stand still to be photographed." ∾ Fifteen years after the portrait [on page 53] was made, I flew the Atlantic to photograph Sir Winston again. This time, I was told, the job would be still more difficult. In fact, it might be impossible. I was warned, "the old man must not be tired. You mustn't press him. Besides, he is unpredictable. Be quick ... don't make him impatient. Remember, only one or two exposures." I awaited him at Drapers' Hall in London, and as he appeared on the stairway I saw how greatly he had changed since our Ottawa meeting. The massive strength was still there, but it had slowed down. The man of action had become a man of thought. Yet what thoughts moved behind that magnificent and battered face only Sir Winston knew. ∾ I had not time for much speculation. Only a few minutes could be spared. His frown, more alarming than ever, made me fear the worst. To my amazement, he allowed me to lead him to a chair, which he settled into with only a few friendly grunts of protest. He looked into the camera with the air of a kindly, innocent old uncle who is a little hard of hearing and finds his chair uncomfortable. I studied that incredible man for a moment and saw a face lined with wisdom and experience, eyes that observed the world with patience, knowledge, authority, and no illusions; and behind this familiar visage I detected an impish, never-failing sense of humour without which, I suppose, he could not have survived his long ordeal. Here was England incarnate. I clicked the shutter to record a Churchill, aged, tired, but immortal.

COPLAND, AARON [102] Aaron Copland was a classical composer (1900–1990) whose work ranged from ballet scores to orchestral music, choral music, and movie scores. In Copland's *New York Times* obituary, John Rockwell wrote, "Of many notable achievements, Mr. Copland's greatest gift was his ability to be both serious and popular.... In ballet scores like *Billy the Kidd, Rodeo*, and above all *Appalachian Spring*, and concert pieces like *El Salón México, Fanfare for the Common Man*, and *Lincoln Portrait*, Mr. Copland touched a chord in the American psyche reached by no other classical musician this country has produced." In addition to the contribution he made with his compositions, Copland was an important promoter of music worldwide. He lectured about American music and composition, authored many books and articles, and organized concerts to support new composers and musicians. ∾ Copland was born in Brooklyn, New York, the son of immigrants from Lithuania. He initially learned piano from his older sister, and after graduating from high school, Copland continued to study music with Rubin Goldmark. Attracted to the classical music of Europe, he pursued his studies in France, where he became part of a music community unlike anything he had seen in New York. After attending summer music school for

American students at the Palace of Fontainebleau, he met Nadia Boulanger and began to study with her. While in Paris, he also met the composer Serge Koussevitsky, who asked Copland to write a piece for the Boston Symphony Orchestra. The work, *Symphony for Organ and Orchestra*, served as Copland's introduction to the American music world. Walter Damrosch conducted the New York premiere of the symphony with the New York Symphony Society in 1925. Damrosch said, "If a young man can write a piece like that at the age of twenty-four, in five years he will be ready to commit murder!" ∾ Copland wanted to find a way to distinguish the American music sound and style from traditional European music. He said, "Composers differ greatly in their ideas about how American you ought to sound. The main thing, of course, is to write music that you feel is great and that everybody wants to hear. But I had studied in France, where the composers were all distinctively French; it was their manner of composing. We had nothing like that here, and so it became important to me to try to establish a naturally American strain of so-called serious music." He believed jazz to be the first major American musical movement, and he drew inspiration from it. Composer Virgil Thomson said, "It is as if he could see already coming into existence an organized body of modernistic American composers with himself at the head of it, taking over the art and leading it by easy stages to higher ground." ∾ In the 1940s, Copland began composing in a more popular style. He continued composing and incorporating new styles into his work until 1970, after which time he focused on conducting and lecturing. ∾ Copland was a supporter of modern music concerts featuring new composers and musicians. He established the composition department at Tanglewood, and for twenty-five years he was a faculty member at the Berkshire Music Center, where he facilitated making the festival a center for contemporary music. One of his contributions to promoting new music was the cofounding of the Copland-Sessions Concerts in New York. Copland and Sessions staged group concerts to feature young and promising composers. This mission was consistent with his lifelong goal of cultivating change in music. ∾ He was awarded the Presidential Medal of Freedom and the Kennedy Center Award for a lifetime of significant contribution to American culture in the performing arts.

AARON COPLAND Arriving at Ossining, New York, on a chilly spring morning in 1956, I saw on a hilltop a gracious and rambling house which commanded a fine view of the country for miles around. Aaron Copland was absent from his home at the moment. His secretary explained that he had been called away on an urgent matter but would return in a few minutes. Meanwhile, a huge fire was lit in the library, and I was entertained, after my cold ride, with excellent coffee. The atmosphere of that house was friendly and informal. It had once been a combination barn and carriage house, I was told, and I marveled at the skillful remodeling which had

transformed it. Immediately I began to enjoy myself, not a usual sensation when one is about to photograph a complete stranger. Presently the master of the house appeared, and there was about him a certain candor and friendliness that endeared him to me at once. As we began to talk casually about books and about his own music and that of other composers, I soon found Mr. Copland had a keen critical sense, though always a friendly one. We talked about some of our favorite musicians whom I had photographed, and he referred with affection to his great teacher, Nadia Boulanger, expressing the hope that I would also photograph her someday. Like himself, Mr. Copland's writings about music, as I later discovered, have an ease and charm, which make even the most abstruse musical question accessible and interesting to a layman.

COUSTEAU, JACQUES YVES [144] Jacques Cousteau (1910–1997) called himself an "oceanographic technician." The Frenchman was also a premier educator and spokesman for ocean life. He was a pioneer environmentalist who raised public awareness about the fragility of marine life. ❧ He had no scientific degree and insisted he was not a scientist, but he produced a television program, *The Undersea World of Jacques Cousteau*. His books were popular, and *Silent World*, his first, sold more than five million copies in twenty-two languages. His film won the Grand Prix at the Cannes Film Festival in 1956, as well as an Academy Award in 1957. Cousteau was the recipient of three Academy Awards, ten Emmys, and numerous other awards including the Medal of Freedom and membership in the French Academy. President Ronald Reagan said of him, "He will be remembered not only as a pioneer in his time, but as a dominant figure in world history." ❧ Born near Bordeaux, France, Cousteau always loved the water. As a youth, he was fascinated with cameras as well, buying a movie camera at age thirteen and taking it apart and reassembling it before shooting his first film. Upon graduation, he applied and was admitted to the French Naval Academy, joining the Navy's aviation school in 1933. An automobile accident left him seriously injured and ended his dreams of flying, though he remained in the Navy until after the war. ❧ In the early 1930s, swimming in the Mediterranean as daily rehabilitation, he began experimenting with watertight goggles and was mesmerized by what he saw. He experimented with portable breathing devices and worked with Emile Gagnon to develop the Aqua-Lung, a valve that lets air escape until the pressure is balanced, feeding it to the diver through a mouthpiece. Cousteau was free to swim like a man-fish, and the basic mechanism of scuba diving was born. ❧ In 1950, Cousteau acquired a 360-ton converted minesweeper from the British Royal Navy, named it *Calypso*, and converted it to a floating laboratory, beginning a journey of exploring, filming, documenting, publishing, and making films that lasted more than forty years. The motto of his ship *Calypso* in its glory days in the 1950s was his credo: "*Il faut aller voir*." ("We must go and see for

ourselves.") ❧ Cousteau's interest in protecting the environment grew as the sea was being exploited. By the 1970s, ocean life had diminished by forty percent in just the twenty years he had observed it. He is quoted as saying, "The oceans are in danger of dying." He founded the Cousteau Society, which is dedicated to marine conservation. ❧ In his tribute, President Jacques Chirac said, ". . . an enchanter, he represented the defense of nature, modern adventure, and the dreamy part at the heart of all of us."

JACQUES COUSTEAU At his specific request, I photographed that knight of the twentieth century, Jacques Cousteau, with his two sons, Jean-Michel and Philippe. "Here I am," he said, "happy with my own sperm." And indeed, he was supremely pleased. "Karsh," he said, "you have taken a portrait of three relative strangers [the crew of the Apollo XI] who went to the moon together. How much more wonderful it would be to photograph a father and two sons on a space mission!" He hoped that the three of them might some day, in fact, work together on a space platform. But I could not help reflecting that the undersea world that he had opened for us was as potentially rich as the vacuum beyond the atmosphere. ❧ In his wetsuit, his profile reminiscent of a thirteenth-century mystic, Jacques Cousteau reminded me of a medieval seer. As I photographed this knight of the twentieth century, I was fascinated to learn about his underwater research. "It is the key to human survival," Cousteau said. All land pollutants eventually find their way to the oceans, and "we risk poisoning the sea forever."

COWARD, NOËL [56] For more than fifty years, actor, singer, dancer, playwright, author, composer, librettist, lyricist, and director Noël Coward (1899–1973) was among the most popular entertainers of his century. He redefined the concept of Englishness and was, in turn, defined by it. Coward's generation delighted in shocking the elder Victorians, and he evolved into the theater's major spokesmen. With his wit, energy, polish, sophistication, and charm, he brought new life and excitement to the staid British theater, creating a trendsetting new style. A *Time* article in 1933 read, "Noël Coward is conceded to be the cleverest of living English dramatists. Some go further, advancing the premise that in the last hundred years, only Disraeli, Wilde, and Shaw have started from nothing and conquered England as Mr. Coward has conquered." Coward was prolific, writing twenty-seven dramas, comedies, and musicals for the stage and more than 281 songs, and often acting in and directing his own work. ❧ Noël Pierce Coward was born to a middle-class family near London where his father was an organist and piano salesman. Noël learned to play the piano by ear, and with his mother's encouragement was singing and dancing in public by age seven. He made his professional debut on the London stage at ten, becoming sought after for children's roles by many theaters. Coward later said of his childhood, "I was a brazen, odious little

prodigy, over-pleased with myself and precocious to a degree. I was a talented boy, God knows, and when washed and smarmed down a bit, passably attractive." His formal education ended at fourteen when his mother sent him to a drama school run by Italia Conti. She remembered Coward, saying, "Little Noël was a clever boy, but I never regarded him as normal, even in those days. He was very emotional, but full of brains." T. S. Eliot once criticized him for not having had a formal education, and for having no knowledge of the classics. Coward responded, "It is of little help at the first rehearsal to be able to translate Cicero." ❧ His first major stage success was *The Vortex*, written in 1923 about a neurotic drug addict and his nymphomaniac mother. Coward's new approach often dealt with off-color characters who used profanities and talked about sexual problems and drug addiction, an approach offending some and also eliciting censorship. In the postwar period, Coward reinvented himself as a cabaret singer in Las Vegas. His popularity in the United States also led to television adaptations of his work. ❧ Coward received an honorary Oscar and was knighted by Queen Elizabeth II in 1970.

NOËL COWARD Photography has definite limitations. In the case of Noël Coward, for example, it is impossible to convey any impression of one of the most beautiful speaking voices it has been my good fortune to hear. However, I was able to capture other characteristic features: his alert, intelligent face, whose expression in repose seems to verge on sadness; his remarkably fluent hands. Because he is a writer and composer, I wanted his hands particularly in his portrait, but, for some reason, we had difficulty with them. Finally, I asked him if he couldn't make them look more decorative. He smiled. "After all these years I should be able to manage that." Most people think of Noël Coward as brilliant and scintillating, but I found him rather simple and unaffected.

CRAWFORD, JOAN [68] Joan Crawford (1908–1977) rose to stardom and achieved a film career that comprised more than eighty movies during an interval when the film industry progressed from silent films to film noir. Peter B. Flint wrote in his *New York Times* obituary, "Miss Crawford was a quintessential superstar – an epitome of timeless glamour who personified for decades the dreams and disappointments of millions of American women. . . . Her career, a chlorine to Grande Dame rise with some setbacks, was largely due to determination, shrewd timing, flexibility, hard work and discipline." ❧ Crawford was born Lucille Fay LeSueur in San Antonio, Texas. Her father abandoned the family before she was born, and her mother remarried a vaudeville theater owner. As a child she loved vaudeville; her ambition was to be a dancer. From age nine forward she helped her mother work, doing laundry and other low-income jobs. In school, she was the only student who had to work, and often spoke of how she had been ridiculed and ignored at home and at school. ❧ Crawford began her career as a dancer

in Midwest dance-hall shows, soon making her way to New York City, where she danced as a chorus girl. Her film career began in 1925, first in silent films and progressing to increasingly well-known movies. In 1928, Crawford played the free-spirited flapper, Diana Medford, in *Our Dancing Daughters*, a role that established her career. Relentless in the pursuit of the roles she coveted, she hounded producers and directors with, it was said, "the diligence of a ditch digger." By the early 1930s, she joined MGM studios and, within a few years, she had established a sophisticated image for herself, and her characters were often defined as much by their glamour as their character. ❧ Crawford left MGM in 1942 to join Warner Brothers, returning to film in 1945 in *Mildred Pierce*, for which she won the Oscar for best actress in a leading role. She enjoyed being a star and cultivating her fan club. Crawford was a pop culture figure, an the American film success story, rising from poverty, reinventing herself, and succeeding in a man's world. She once said of her career, "I wanted to be famous, just to make the kids who'd laughed at me feel foolish. I wanted to be rich, so I'd never have to do the awful work my mother did and live at the bottom of the barrel. And I wanted to be a dancer because I loved to dance....Maybe the illusions, the daydreams, made life more tolerable, but I always knew, whether I was in school or working in some damned dime store, that I'd make it. (Funny, but I never had any ambition whatsoever to become an actress.)"

JOAN CRAWFORD The 1958 sitting with Joan Crawford was a prize won in a singles tennis game at the Beverly Hills Hotel. My partner challenged me with the tantalizing prospect of a kiss from "one of the most famous actresses in Hollywood" if I succeeded in winning the match. I had no other alternative but to beat him soundly! The "famous actress" we visited for cocktails and the promised kiss – both cheerfully bestowed, I might add – was Joan Crawford. Thereafter, she never failed to remember my birthday, holidays, and other important occasions with handwritten personal notes.

DIOR, CHRISTIAN [93] Christian Dior (1905–1957) was a fashion designer whose name is synonymous with glamour and good taste. He was a pioneer who revolutionized the fashion industry. Dior was the first to establish a global brand over a wide range of fashion products that included items like perfume and hosiery. He introduced high-fashion ready-to-wear stores in the United States. Dior developed what is believed to be the first royalty payment system for the use of his brand name by other manufacturers, including the support of "knock off" lines for discount store chains. His basic business premise was "to make elegant women more beautiful; to make beautiful women more elegant." ❧ Born in Granville, France, on the Normandy coast, Dior's family moved to Paris in 1910. He was interested in the arts and wanted to be an architect. Heeding his parents' urging, Dior attended École des Sciences Politiques to study political science and prepare

for a diplomatic career. After he finished his schooling, Dior pursued his own artistic goals and opened an avant-garde art gallery in Paris that featured the work of Salvador Dalí, Georges Braque, Pablo Picasso, and Jean Cocteau. ❧ He entered the fashion industry in 1931 when he became an illustrator for the *haute couture* page of *Le Figaro Illustré*. He began selling sketches to the *haute couture* houses and took a job as an assistant designer to the couturier Robert Piquet. During the war years, he served in the French Army but became a designer again in 1941 for Lucien Lelong. ❧ In 1946, with the help of cotton millionaire Marcel Boussac, Dior set up his own salon. From the start, his business was unique in the fashion industry. Employing techniques such as statistical surveys, revenue and cost controls, and programs to prevent copying, Dior's success was immediate. After the war, he recognized that the public was ready for a change in style, and he capitalized on the opportunity. He explained his designs by saying, "We are leaving a period of war, of uniforms, of soldier-women with shoulders like boxers. I turned them into flowers, with soft shoulders." Dior's first couture show was in February of 1947. His couture house was overwhelmed with orders, attracting celebrities, socialites, and royalty worldwide. His client list included Ava Gardner, Rita Hayworth, Princess Margaret, and the Duchess of Windsor, and his prestige attracted talented assistants like Pierre Cardin and Yves Saint Laurent. The company grew to become a global entity that incorporated *haute couture*, ready-to-wear and a wide variety of fashion products. At the time of Dior's death in 1957, his company had expanded to twenty-four countries and was grossing fifteen million dollars in annual sales. ❧ Dior died of a heart attack at the age of fifty-two. *Le Monde* said of him in its obituary, "He was a man identified with good taste, the art of living and refined culture that epitomizes Paris to the outside world."

CHRISTIAN DIOR Perhaps the most successful, certainly the most suave and disarming dictator of our time was a man with a gentle, oval-shaped face, pensive eyes, and an elongated nose. Christian Dior held more elegant women in abject slavery than any pasha, but he shunned publicity and was surrounded by secretaries and functionaries whose only task was to keep away photographers and journalists. Clearly I had come to Paris at the wrong time in 1954, within a few days of a Dior opening when the contents of the salon were more carefully guarded than any secret of state. Any premature inkling of the master's latest creations, I gathered, would create an international crisis. Hence the only place where Dior would be photographed was his tiny private office that guarded the designing and model room. His press attaché understood my problem, but nothing could be done: "Anywhere else there would be gowns in course of preparation or models being fitted with new creations, or sketches, or..." I understood. ❧ No room except the office could be visited even to get a more suitable chair, table, or prop of any kind. Dior could perhaps be portrayed with some sketches

of gowns, but, of course, they would be gowns of previous years. And I was reminded that my subject had little time to devote to his own portrait when, as he said, he was so desperately trying to improve the look of womankind and "save it from nature." This task was so demanding, indeed, that he seldom left his office day or night and at this critical season his food was brought to his desk. ❧ There I was compelled against my wishes to make his portrait and to arrange lights and camera – a task that was something of a feat in such a space. When Dior appeared at last, I was amazed at the contrast between the man and the feverish, conspiratorial air maintained around him. The arbiter of style, who has made skirts long or short, busts grow or fade by the flick of his pencil, was himself dressed in a very quiet business suit. Though thoroughly French, he looked exactly like the personification of an English understatement. His manner was charming, if somewhat preoccupied, and he understood, as an artist, that I wished to make a fine portrait of him. Alas, the time element.... I decided to portray him in his authentic element of mystery. I therefore placed him standing partially hidden behind a screen, only a portion of the face showing, with just one eye lighted and his finger to his lips, enjoining silence and secrecy.

DISNEY, WALT [99] Walt Disney (1901–1966) was not only the renowned pioneer of animation, but also invented the theme park. President Dwight D. Eisenhower described him as "a genius as a creator of folklore ... his sympathetic attitude toward life has helped our children develop a clean, cheerful view of humanity, with all its frailties and possibilities for good." ❧ Born in Chicago, Disney endured an impoverished childhood. His father had a hard time making a living and moved from job to job. Disney did not graduate from high school, and left home at age sixteen to join the Red Cross Ambulance Corps in the First World War. He began drawing at a very young age and continued to improve his skills in the service. After the war, he took a job as a commercial artist, and through that job discovered the world of animation. He particularly appreciated that cartoon characters constitute a world of their own, and, unlike characters in real life, they were totally in his control. ❧ Disney moved to Los Angeles to start an animation company. He partnered with his brother Roy, who took responsibility for the business side while Walt managed the creative end. In 1925, he married one of the company's first employees, Lillian Bounds. ❧ Disney continued to perfect the art of animation. In 1928, Mickey Mouse was created. He introduced Technicolor to the industry and held the patent on it for two years, giving his studio the exclusive rights to color cartoons. By 1940, Disney Studios had a staff of more than a thousand artists, animators, and technicians. In the 1950s, he was Hollywood's first to embrace television, producing *The Wonderful World of Disney*, while other studios avoided it, fearing it would put them out of business. ❧ The Disneyland theme parks consumed much of Disney's time in the 1950s and 1960s. His desire to create

a clean, well-organized amusement park that offered a never-before-seen fantasy experience was realized when Disneyland opened. Disney personally directed the development of EPCOT (Experimental Prototype Community of Tomorrow), a new concept in entertainment that incorporated amusement theme parks with a hotel, motel, resort, and vacation center. He did not live to see his masterpieces fully realized.

WALT DISNEY I journeyed one Sunday morning to Disneyland and inspected with amazement the world of wonders created by the imagination of one mind. Clearly this might be a setting for Disney's portrait, a setting of pure fantasy. We took some shots against a background of the entrance to a mammoth underground cave, which had been used in Twenty Thousand Leagues Under the Sea. *Disney sat down in front of the cave entrance, nonchalant, relaxed, and genial as he always appears with strangers, his boyish manner hiding what his associates told me was the fierce drive of the perfectionist. ∾ I gave him a copy of the Disneyland News to look at, and, eyeing me impishly, he solemnly read out: "Disneyland is being sued for two and a half million dollars." When I offered him a cigarette, he refused it. He never allowed himself to be photographed smoking, drinking; he had his large audience of children to think of. ∾ I asked him particularly about his children's motion pictures, such as* Snow White, *and found him eager to discuss them. He intended, he said, to return more and more to the use of animation in place of living actors. Already he had filled many filing cabinets with drawings for one of his next ventures. All this, I suggested, was far removed from the realities in documentary pictures such as* The Living Desert, *where cruelty in nature is revealed so starkly. ∾ "Nature," said Disney, "is concerned with the survival of the fittest. She is unlike man, who kills for the sake of killing." Under the breezy surface, this man evidently had thought a good deal about grimness. But then, only a very serious man can provide the sense of fantasy which, in the guise of pleasant madness, helps the world to keep its sanity.*

EINSTEIN, ALBERT [78] An outstanding intellect, Albert Einstein (1879–1955) was named person of the century by *Time* magazine in 1999, an honor awarded not only for his contribution to the sciences, but also his deep sense of morality and contributions as a humanitarian. The tribute by Frederic Golden read, "He was the embodiment of pure intellect, the bumbling professor with the German accent, a comic cliché in a thousand films Yet he was unfathomably profound – the genius among geniuses who discovered, merely by thinking about it, that the universe was not as it seemed Besides campaigning for a ban on nuclear weaponry, he denounced McCarthyism and pleaded for an end to bigotry and racism.... Einstein's humane and democratic instincts are an ideal political model for the twenty-first century, embodying the very best of this century as well as our highest hopes for the next. What more could we ask of a man to personify the past one hundred years?" ∾ In his tribute, fellow Nobel Prize winner in Physics, Dr. Niels Bohr, said, "Through Albert Einstein's work, the horizon of mankind has been immeasurably widened, at the same time as our world picture has attained, through Einstein's work, a unity and harmony never dreamed of before. The background for such achievement was created by preceding generations of the worldwide community of scientists, and its full consequences will only be revealed to coming generations. The gifts of Einstein to humanity are in no way confined to science. Indeed, his recognition of hitherto unheeded assumptions in even our most elementary and accustomed concepts means to all people a new encouragement in tracing and combating the deep-rooted prejudices and complacencies inherent in every national culture." ∾ Einstein's father was a salesman and engineer, and his mother had a passion for classical music, particularly the violin. His family was Jewish by tradition, but not deeply religious. In 1880, the family moved from Ulm, Germany, to Munich, where Einstein began his schooling. After the family relocated to Italy, he moved to Switzerland, finishing his secondary studies in Aarau, where he learned about Maxwell's electromagnetic theory. A pacifist, he graduated in 1896, renounced his German citizenship to avoid the war, and applied for Swiss citizenship. Admitted to the Swiss Federal Polytechnic School in Zurich, he focused on physics and mathematics. In 1901, he graduated, became a Swiss citizen, but, unable to find a teaching position, accepted a job at the Swiss Patent Office while working on his doctorate degree, which he obtained in 1905. ∾ Much of his important scientific work was conceived while at the patent office, and in 1905, his miracle year, Einstein documented his two theories of relativity that would revolutionize scientific thought. These discoveries led to professorships in Prague and Zurich. Despite his aversion to Germany's militarism, he was appointed director of the Kaiser Wilhelm Physical Institute and professor at the University of Berlin. He again became a German citizen, remaining in Berlin until 1933 when the Nazis' rise to power caused him to leave. Again renouncing his German citizenship, he emigrated to the United States, accepting the position of Professor of Theoretical Physics at Princeton and an appointment to the new Institute for Advanced Study created around his professorship. ∾ Einstein actively opposed the rise of Hitler and the Nazis in speeches and in aid to Jewish refugees seeking asylum in the United States. Upon learning the Germans might be developing an atom bomb, he wrote President Roosevelt, warning him of the possible consequences. After the Second World War, Einstein campaigned for a ban on all nuclear weapons. ∾ Albert Szent-Györgyi, Nobel Laureate in Medicine, said in his tribute, "I would be unable to picture science without him. His spirit permeates it. He makes up part of my thinking and outlook. Science, as an art of measuring, is said to have little to do with the humanities. Einstein has taught us that science is more than this. It is the art of understanding: the highest expression of man's craving to understand the universe in its entirety."

ALBERT EINSTEIN Awed before this unique intellect, I yet ventured to ask Einstein his views on human immortality. He mused for a moment and then replied, "What I believe of immortality? There are two kinds. The first lives in the imagination of people and is thus an illusion. There is a relative immortality, which may conserve the memory of an individual for some generations. But there is only one true immortality, on a cosmic scale, and that is the immortality of the cosmos itself. There is no other." ∾ He spoke of these ultimate mysteries as calmly as he might answer a student's question about mathematics – with such an air of quiet confidence, indeed, that I found his answer profoundly disturbing to one who held other views. Knowing him to be an accomplished violinist, I turned the conversation, and asked if there were any connection between music and mathematics. "In art," he said, "and in the higher ranges of science, there is a feeling of harmony which underlies all endeavour. There is no true greatness in art or science without that sense of harmony. He who lacks it can never be more than a great technician in either field." ∾ Was he optimistic about the future harmony of mankind itself? He appeared to ponder deeply and remarked in graver tones: "Optimistic? No. But if mankind fails to find a harmonious solution then there will be disaster on a dimension beyond anyone's imagination." To what source should we look for the hope of the world's future? "To ourselves," said Einstein. He spoke sadly yet serenely, as one who had looked into the universe far past mankind's small affairs. In this humor my camera caught him ... the portrait of a man who had traveled beyond hope or despair.

EISENHOWER, DWIGHT DAVID [61] Dwight David Eisenhower (1890–1969), widely known as Ike, was a five-star general, the supreme commander of the Allied Forces in Europe, the first supreme commander of NATO, and the thirty-fourth president of the United States. Felix Belair, Jr. wrote, in Eisenhower's obituary in the *New York Times*, "In all corners of the earth where the name Eisenhower was associated with victory in war and a tireless crusade for peace, great men and small were moved by the passing of the man whose rise from farm boy in Kansas to supreme Allied commander and conqueror of the Axis powers and President of the United States was devotion to duty." ∾ Eisenhower was raised in Abilene, Kansas, the third of seven sons. At a time when attending high school was considered a luxury, he and all his brothers not only attended high school but were encouraged to go to college. In 1911, Kansas Senator Bristow recommended Eisenhower for appointment to the West Point Military Academy, and he was accepted. While at West Point, Eisenhower was not known for his scholarship, but he was a natural leader who served as the junior varsity football coach. ∾ Commis-

sioned as a second lieutenant in the Army, Eisenhower excelled in his Army career, serving under Generals Pershing, MacArthur, and Krueger, and advancing through all the grades until he was appointed general of the Army in 1944. He was instrumental in commanding the Allied Forces after Pearl Harbor in 1942. Eisenhower was supreme commander of the troops at D-Day and served as the Army chief of staff from 1945 to 1948. He was president of Columbia University from 1948 to 1952, taking a two-year sabbatical to become the first supreme commander of the North Atlantic Treaty Forces in Europe from 1950 to 1952. In 1952, Eisenhower retired from active duty to run for president. ∾ The prestige and respect accorded Eisenhower allowed him to make significant progress on international issues as president. He obtained a truce in Korea and worked endlessly to maintain world peace and lessen the tensions of the Cold War. Eisenhower was able simultaneously to contain the spread of communism and improve relations with the Soviet Union. He also faced foreign policy challenges in Suez, Lebanon, Berlin, Hungary, Taiwan Straits, and Cuba. ∾ In 1955, still in his first term of office, Eisenhower suffered the first of what would be seven heart attacks. He was still reelected by a wide margin. On January 17, 1961, he gave his farewell speech on national television. Raising the issue of the ongoing Cold War, he said, "We face a hostile ideology global in scope, atheistic in character, ruthless in purpose, and insidious in method.... Only an alert and knowledgeable citizenry can compel the proper meshing of the huge industrial and military machinery of defense with our peaceful methods and goals, so that security and liberty may prosper together."

DWIGHT D. EISENHOWER *As yet, I had not made a portrait of General Eisenhower. I felt that my collection of portraits would not be complete without it – and anyhow, I had set my heart on photographing the General. But my first appointment was cancelled.... When I had called on Eisenhower's principal aide, I was greeted with, "How long will you take?" The only reply I could make was, "As long as you can give me." Finally, we settled for twenty minutes. But the next day my eye caught on the General's appointment sheet the notation: "10:00 A.M. Karsh – painter – one hour and a half." Inaccurate, but encouraging.... Once in conversation, I pointed to a globe, and, mentioning the importance to all the countries and peoples of real peace, suggested that he should be elected the first Minister of International Peace. He smiled at the title and said, "Well, that's a good start."... As a parting shot, General Eisenhower said, "You made me work as hard as you did." But I noticed that although I was perspiring freely, there was not a drop on the General's brow.*

EKBERG, ANITA [94] Stunningly gorgeous, Anita Ekberg (1931–) was said to represent timeless beauty and desire. She was known for her voluptuous physique, was enormously photogenic, and became one of the most photographed women of her time. Born the sixth of eight children, Ekberg began modeling when she was a teenager. In 1950, she entered the Miss Universe contest for Sweden and was one of the six finalists. Ekberg caught the attention of Hollywood directors such as Russ Meyer and Howard Hughes, and was soon an aspiring actress at Universal Studios. As she became better known, Ekberg was romantically linked with many celebrities. Her beauty and exotic lifestyle made her a target of gossip magazines and to the new variety of men's magazines that featured pinup girls. Her renown as a glamorous sex symbol also led to comedic roles in *Hollywood or Bust* and *Artists and Models* with Jerry Lewis and Dean Martin, where she was well-known enough to play herself, a busty sex symbol. ∾ RKO selected Ekberg for the female lead of *Back from Eternity*, which confirmed her ability to act in serious films. In 1956, she traveled to Rome to film *War and Peace*, costarring Audrey Hepburn. During the production, she met the man who changed her life and career forever, Federico Fellini. He gave Ekberg her greatest role in *La dolce vita*, in which she played the unattainable dream woman opposite Marcello Mastroianni. The movie was a tremendous success, and the scene of Ekberg dancing in the Trevi fountain became one of the most famous images in film history. Tullio Kezich said of the scene, "Anita dancing in that fountain is one of the ten great movie images of the century. Even today, advertisements still recall it – it is such a lasting moment of cinema." Fellini featured her in three more of his films: *Boccaccio*, *I clowns*, and *Intervista*. ∾ With more than fifty films to her credit, Ekberg lives in semiretirement in a villa in Rome, taking interviews and occasionally acting in small film roles.

ANITA EKBERG *The smorgasbord was already lavishly spread on the table of Anita Ekberg's California home when I arrived. Her natural behavior resembled the love goddesses she portrayed – uninhibited and seductive, and totally without guile. When changing from one gown to another, she ignored the screen her attendant had place before her. She exuded sexuality; in the garden, as she exuberantly hugged a tree trunk, it became a gesture of utmost sensuality.*

HER ROYAL MAJESTY, QUEEN ELIZABETH II [110, 126] Queen Elizabeth II (1926–), head of state to fifteen commonwealth nations, in addition to the United Kingdom, is one of the longest-reigning monarchs of the United Kingdom. She has met regularly with twelve prime ministers, each of whom have praised her wisdom, wit, impartiality, and shrewdness. She is the most traveled monarch in the world and a patron of more than six hundred charities. ∾ Born in 1926, Princess Elizabeth was the oldest daughter of King George VI and Queen Elizabeth. Her sister, Princess Margaret, was born in 1930. The family of four was very close, and their lives changed dramatically when King George V, the Princess's paternal grandfather, died. Her uncle, the oldest son, Prince Edward, ascended the throne as King Edward VIII, but abdicated soon after to marry Wallis Simpson. ∾ The family moved to Buckingham Palace, and Princess Elizabeth had become next in line to the throne. Educated at home, she began to prepare to be queen by studying politics, law, religion, and history. At the age of thirteen, Princess Elizabeth met her third cousin Prince Philip of Greece. According to the princess's nanny, Marion, it was love at first sight. He was five years older, but she remained loyal throughout her teenage years, calling him "my Viking prince." She made her first public speech at the age of fourteen, and in 1947, at age twenty-one, she made her first official overseas visit, to South Africa. During that trip, she gave a radio address dedicating her life to the Commonwealth. She said, "I declare before you that my whole life, whether it be long or short, shall be devoted to your service and the service of our great imperial Commonwealth to which we all belong, but I shall not have strength to carry out this resolution unless you join in it with me, as I now invite you to do; I know your support will be unfailingly given. God bless all of you who are willing to share it." ∾ In 1946, Princess Elizabeth became secretly engaged to Prince Philip, who had served in the British Royal Navy during the Second World War as a lieutenant. The couple faced initial resistance from her father, but the engagement was officially announced in 1947. Phillip gave up his Greek citizenship, became a British subject, and assumed the title Duke of Edinburgh. ∾ Princess Elizabeth and her husband were visiting Kenya in 1952 when King George died of cancer in his sleep. The new queen immediately assumed her duties. The long reign of Queen Elizabeth II has since overseen tremendous social and political change, including the final dissolution of the British Empire and the evolution of the Commonwealth of Nations.

QUEEN ELIZABETH II *This portrait of Princess Elizabeth (a reproduction from a Kodachrome) was taken at Buckingham Palace several months before her coming of age. Her presence had been a great help while photographing other members of the Royal Family, and each time I saw her I was more and more impressed by her wholesome charm, good humor, and entire lack of affectation. The Princess had an infectious, spontaneous laugh, and it is easy to see why she has become such a favorite with the British people.... She entirely captivated the handsome Captain of the Canadian Irish Fusiliers who had come along with me that day and who appeared dressed in full regalia, which included the kilt, the plaid, and the sporran. Her Majesty, the Queen, was present at the sitting, and was greatly amused when the Captain, in answer to a direct question, confessed that most of his Irish Fusiliers were of Scottish descent.*

ENESCO, GEORGES [100] Georges Enesco (1881–1955) was a virtuoso violinist, a pianist, a conductor, a teacher, and a composer. Pablo Casals, the cellist, said, "He is the greatest musical phenomenon since Mozart." ∾ Born in Liveni,

163

a small town in the Moldavian region of northern Romania in 1881, Enesco grew up hearing the sound of gypsy fiddlers. A child prodigy, he began taking piano lessons when he was four and began composing by age five. He played the violin, and by the time he was seven, his parents sent him to the Vienna Conservatory to study. Enesco was only the second student under age ten to be admitted. He was there four years when he won first prizes for violin and harmony. He graduated before his thirteenth birthday and became a violist with the Viennese orchestra. Enesco continued to work on composition while he was with the orchestra and also learned the skill of orchestration. While in Vienna, he met Brahms, whose style influenced his early compositions, and was influenced by Wagner's music as well. ◌ In 1895, Enesco entered the Conservatoire in Paris to study composition, but he also studied cello, organ, and piano, and became accomplished with each instrument. In 1898, Edoard Colonne, the Parisian concert manager, presented Enesco's first orchestral work, the *Poème Roumain*. His American debut came in 1923 when he appeared as a guest conductor for the Philadelphia Orchestra at Carnegie Hall. ◌ Enesco helped and encouraged young musicians, most notably Yehudi Menuhin, who he first encountered when Menuhin was a ten-year-old boy. He accepted him as a student, and they became lifelong friends. As a faculty member at Mannes College of Music, he taught a class on interpretation, and the combination of his profound knowledge, passion, and enthusiasm for the subject made it one of the most popular classes at the College. Enesco was an intense and tireless teacher, and many of his classes were five or more hours long. He once commented, "I have written relatively little because my duties as soloist and conductor haven't given me sufficient leisure." ◌ Enesco's last public appearance was at Carnegie Hall in 1950. In this concert he appeared as composer, conductor, violinist, and pianist, and played with the New York Philharmonic Symphony to honor the sixtieth anniversary of his concert debut. Enesco died in 1955 at age seventy-three after a long illness. Yehudi Menuhin said in tribute, "But quite apart from his music, which constituted his very life, it is as a human being that I would like to convey my memories of him. A more selfless, generous or noble person would be hard to find. He was at all times ready to give of himself. His talents were so vast that he could act with the largesse of a god without ever seeming to exhaust his resources."

GEORGES ENESCO The apartment of Georges Enesco in Paris was less than modest. It was poverty itself. Yet it contained certain riches and an extraordinary musician who sat amid a clutter of relics and mementos recalling for him, no doubt, the happier days of the past. I knew that he had a serious heart condition, but I also found that he was so badly crippled by arthritis that he moved as little as possible. His desk was placed so that he could turn from it to his piano without rising from his chair. He looked frail, old, and exhausted, but at times I caught in his eyes a sparkle, which seemed to illuminate his whole face with intense kindliness and unshakable courage. At this moment, in 1954, he was putting the final touches to an orchestral work, now almost ready for the publishers. I was amazed at the neatness of his musical script, written meticulously in ink. I did not like to disturb his creative thought, I knew that this photographic sitting must tire him, and I hesitated to ask many questions. But I could not refrain from inquiring his opinion of the music of modern composers. "Some of it I like," he said, "but a great deal I do not. . . ."

FROST, ROBERT [119] Robert Frost (1874–1963) was a four-time Pulitzer Prize-winning poet, lecturer, and teacher. His Associated Press obituary read, "Thus he recorded timelessly (by matching the sharpest observation with the most exact word) how the swimming buck pushed the 'crumpled' water; how the wagon's wheels 'freshly slice' the April mire; how the ice crystals from the frozen birch snapped off and went 'avalanching' on the snowy crust." ◌ Although closely associated with New England, Frost was born in San Francisco. His mother and father were both New England teachers. Frost's father, who died when he was eleven, had hoped to be buried in Lawrence, Massachusetts, where he was born. The family honored his wishes and permanently relocated to New England after his burial. Frost excelled in school, writing poetry from a young age. He and Elinor White were sweethearts and co-valedictorians who later married and had six children. ◌ For the first twenty years, Robert Frost worked odd jobs, taught, and continued his studies, all the while writing poetry and vainly trying to get it published. In 1912, he moved his family to London, where he met Ezra Pound, who was the first to write positive reviews of his work. Back in America in 1915, Frost bought a farm in Franconia, New Hampshire, and began his professional career; writing, lecturing, and teaching. From 1916 to 1938, he taught English at Amherst College, spending summers teaching at the Bread Loaf School of English at Middlebury College. ◌ Amherst College devoted a day of tribute to Frost after his death. President Kennedy took time away from his duties to participate in the occasion, delivering a lengthy speech to commemorate the poet: "'I have been one acquainted with the night.' And, because he knew the midnight as well as the high noon, because he understood the ordeal as well as the triumph of the human spirit, he gave his age strength with which to overcome despair. At bottom, he held a deep faith in the spirit of man. And it's hardly an accident that Robert Frost coupled poetry and power. For he saw poetry as the means of saving power from itself. When power leads man toward arrogance, poetry reminds him of the richness and diversity of his existence. When power corrupts, poetry cleanses."

ROBERT FROST "Don't make a saint of me," said Mr. Frost, facing my camera in 1958. "I'm a rascal. Why, they call me Scarface Frost from Chicago." This was my introduction to the crusty, beloved American poet, an old man who did precisely as he pleased. At the time, he was sitting in his littered, chaotic studio in Cambridge, Massachusetts. There he worked at what he was pleased to call his desk – a dilapidated piece of Ten-Test supported by a piece of string and a battered walking stick. Yet, I thought, out of all this bedlam comes so much beauty.

GABLE, CLARK [71] Crowned "The King of Hollywood" by the *New York Daily News* in 1936, Clark Gable (1901–1960) was ranked among the greatest male stars of all time by the American Film Institute. He was certainly one of Hollywood's most popular male leads, nominated for three best actor awards for his roles in *Gone with the Wind*, and *Mutiny on the Bounty*. Gable was the first actor to win an Oscar for a comedy, *It Happened One Night*, co-starring Claudette Colbert, and was among the few to play the lead in three films that won Academy Awards for best picture. ◌ The son of an oilman and farmer, Gable was born and raised in Cadiz, Ohio. He quit high school at sixteen to work in an Akron tire factory where he saw his first play and decided to become an actor despite his father's disapproval. First performing in regional theaters, touring companies, and as an extra in movies, he eventually made his way to Broadway. His big break came with the Los Angeles production of *The Last Mile*, where his leading role brought him to the attention of MGM, which signed him to a contract in 1932. For the most part he stayed with them for the next twenty-two years. ◌ Gable costarred with the most successful actresses of the era: Joan Crawford in eight films, Myrna Loy in seven, Jean Harlow in six, Lana Turner in four, and Norma Shearer in three. Despite his reluctance to play the role, he is probably best remembered as Rhett Butler in *Gone with the Wind*. Married five times and romantically linked to any number of stars, he said the happiest years in his life were the three he was married to Carole Lombard, who died in a plane crash in 1942. After this, Gable seemed to lose interest in life, and his later film work declined. ◌ His last film, *The Misfits*, had an all-star cast consisting of Marilyn Monroe, Montgomery Clift, and Eli Wallach, was directed by John Huston, and had a screenplay by Arthur Miller. The film was enormously difficult to produce, and involved several stunt scenes that took their toll on Gable. He suffered a heart attack and died two days after the filming was completed, at age fifty-nine. The movie world mourned his passing, and most American newspapers carried the simple four-word headline, "The King Is Dead."

CLARK GABLE "The King of the Movies," unlike Rhett Butler in Gone with the Wind, *emphatically did "give a damn" when he was late for his photographic appointment. He was stuck between floors in an elevator at a famous Wilshire Boulevard department store, causing a minor riot and boundless delight for the adoring fans with whom he was confined for the better part of an hour.*

◌

GANDHI, INDIRA [109] Indira Gandhi (1917–1984), the first woman to be elected prime minister of India, dominated Indian politics for almost two decades. Indira was the daughter of India's first prime minister, Jawaharlal Nehru, and the mother of Rajiv Gandhi, her successor. Known for her will and determination to govern an unruly country, Gandhi was one of India's most notable leaders after it gained independence from British rule in 1947, and she was a champion of her people. While Indira was of no relation to Mahatma Gandhi, she was strongly influenced by him, and often made the comment that he was always present in her life. ❧ Born the only child to a wealthy family from Allahabad, India, Indira Priyadarshini Nehru's involvment in political life was determined at a young age. Her parents joined the Indian National Congress, Mahatma Gandhi's movement against British Imperial rule, and were extremely active in the cause. Her house was a center of political activity. She was influenced by both her parents' commitment to India's independence, and by Mahatma Gandhi. At the age of twelve, Gandhi joined the Monkey Brigade, a children's group modeled after the Monkey army in the epic Indian story *Ramayana*. They worked to undermine British control by warning members of the Indian National Congress of the British plans for their arrests. Gandhi's most notable contribution to the Monkey Brigade came when she protected documents for a planned civil disobedience movement. The plans were in the trunk of a car, and she was in the backseat. She convinced the British police not to take the time to search the car, as she would be late for school. ❧ Gandhi was well-educated at Indian schools, and went on to study in Switzerland and at Oxford University. In 1936, when her mother died, Indira became the confidante and assistant to her father, traveling with him and meeting international figures. Gandhi finally joined the Indian National Congress in 1938 and married Feroze Gandhi in 1941. Her marriage to Feroze was very controversial, as she was Hindu and he was Parsee. Her father, however, defended her decision. ❧ In 1967, Indira Gandhi became the first woman ever elected to lead a democracy. She was reelected in 1971 and served until 1977. Gandhi's term in office was notable for her efforts to improve the lives of Indians; improve relations with China and the Soviet Union; progress in science, technology, and space exploration; abolish poverty; and nationalize banking. She also led India to be one of the fastest-growing economies in the world. She implemented a voluntary, but controversial, sterilization program to control population growth. She also faced enormous political problems in Punjab, East Bengal, and Pakistan. Much unrest ensued because of these political problems, and in 1975 Gandhi declared a state of emergency – unpopular because it limited freedom. Her efforts to stem the violence resulted in death threats. In 1977, she lost the election. She ran again in 1980, winning this time. Her term was preoccupied by efforts to resolve the ongoing conflict with Sikh militants in Punjab. Her second term was short-lived when her own Sikh bodyguards, seeking revenge, assassinated her at her home. ❧ The night before her death, Gandhi said, "I don't mind if my life goes in the service of the nation. If I die today, every drop of my blood will invigorate the nation."

GIACOMETTI, ALBERTO [129] Parisian sculptor and painter Alberto Giacometti (1901–1966) was an artist in the postwar Paris art scene. While Giacometti's early work was part of the Surrealist movement, his later work was closely associated with the Existential philosophical movement. He created renditions of models the way he saw them and the way he thought they should be seen. He once said he "was not sculpting the human figure, but the shadow that is cast." ❧ Born in Stampa, an Italian region in Switzerland, Giacometti's roots were grounded in art. His father, Giovanni Giacometti; his cousin, Augusto Giacometti; his godfather, Cuno Amiet; and his brother, Diego, were all modern painters. He began drawing at nine and painting at twelve. Giacometti studied painting at the Ecole des Beaux-Arts and sculpture and drawing at the Ecole des Arts et Métiers in Geneva. In 1920, he traveled to Italy, falling under the influence of the works of various artists, including Archipenko, Cézanne, Giotto, and Tintoretto, with an interest in African and Egyptian art. ❧ In 1922, he moved to Paris to study sculpture at the Académie de la Grande Chaumière in Montparnasse under Auguste Rodin's assistant Antoine Bourdelle. During this time, Giacometti began to sculpt in a cubist style. In 1927, he and his brother Diego set up an *atelier* together, with Diego acting as his assistant and model. In 1932, he had his first solo show. ❧ From 1935 until 1940, Giacometti focused on sculpting the human head, concentrating on the eyes and the subject's gaze. He was so intent on perfecting his forms that the sculpted heads became as thin as nails. One of his friends said that if Giacometti decided to sculpt someone, "he would make your head look like the blade of a knife." His elongated human figures followed and were embraced by the Parisian avant-garde. ❧ During the Second World War, he resided peacefully in Geneva, where he met Annette Arm, who in 1946 would become his wife and muse, modeling for many of his sculptures of the female form. The postwar decade was Giacometti's most productive period, during which he became close friends with Jean-Paul Sartre, who became an advocate to Giacometti and helped to advance his career by introducing him to patrons of the French literary world. ❧ In 1962, Giacometti was awarded the grand prize for sculpture at the Venice Biennale but continued to work in the same intense fashion, saying, "I refused the intrusion of success and recognition as long as I could. But maybe the best way to obtain success is to run away from it. Anyway, since the Biennale it's been much harder to resist. I've refused a lot of exhibitions, but one can't go on refusing forever. That wouldn't make any sense." ❧ He died of heart disease and chronic bronchitis in 1966.

ALBERTO GIACOMETTI My experience with Giacometti began with a surprise. He was still asleep when we arrived at his studio, in a working-class district in Paris. The sculptor and his brother, Diego, who was Giacometti's favorite and most constant model, had shared that same studio for thirty-eight years since leaving their native Switzerland. Diego continued to paint exquisite custom-made lamps for exclusive Parisian interior decorators. I did not know then that three in the afternoon was Giacometti's usual breakfast hour and that he usually worked through the night. I urged him to go to his neighborhood bistro for coffee, so that I could have time to set up my equipment in the unbelievably cluttered tiny room that served as his atelier. ❧ All around, in semi-darkness and dirt, were his characteristic elongated figures, many still uncast, in clay. They dominated the room; they pervaded the atmosphere. My wife could stand it only a short time before she rushed out to the welcome release of the open air. She told me afterward that, while she enjoyed Giacometti's attenuated figures in a museum full of light and space, to experience the sculptures in the crowded atelier was a far different matter. She felt as if she were in unredeemable hell – that here was a place without grace, without hope, without humor, without redemption – that she was among the living dead – and she grieved for the tortured sensibility that had produced this. ❧ Giacometti was still in an uncertain temper when he returned. He could not sit still for a moment; he stamped his foot impatiently like a child; he smoked constantly. His face was ashen grey and did not welcome any conversation that might bring a ray of humor. My experience should have prepared me to realize he was in excruciating pain. Soon after, when his spasm of agony somewhat subsided, he invited me to a lengthy visit with him and his New York dealer, Pierre Matisse, the son of the great French artist. We stood in the alleyway outside the studio, the passage so narrow we could touch both walls of the adjacent buildings with our fingertips, and reality seemed to right itself again as we discussed the current art scene. A few weeks later, he was dead.

GRAHAM, MARTHA [81] Known as the mother of modern dance, Martha Graham (1894–1991) transformed traditional ballet into a new form of dance with radically different movements and expressions. She was a pioneer, and her impact on dance has often been compared to the impact of Picasso on art, Stravinsky on music, and Frank Lloyd Wright on architecture. To Graham, dance needed to be a free and honest expression. She described her thinking, saying, "I wanted to begin not with characters or ideas, but with movements I wanted significant movement. I did not want it to be beautiful or fluid. I wanted it to be fraught with inner meaning, with excitement and surge." Some of the students from her company include Alvin Ailey, Twyla Tharp, Paul Taylor, and Merce Cunningham. ❧ Born in Allegheny, Pennsylvania, Martha Graham was the oldest of three girls. Her father, a doctor, saw to it that the children had a good education, as well as exposure to the arts.

In her autobiography, *Blood Memory*, Graham recalled at age sixteen seeing Ruth St. Denis dance in Los Angeles, after which she decided that she would devote her life to dance. However, her parents discouraged a career in the performing arts, considering it below her social status. Thus, Graham did not begin to study dance until after the death of her father, when she was twenty-two. In 1916, she enrolled in the Denishawn School in Los Angeles, which was the only major dance school teaching outside the classical ballet tradition. She studied under Ruth St. Denis and Ted Shawn and began to tour with the Denishawn Company. ∽ In 1923, Graham was offered the opportunity to dance in the vaudeville revue *Greenwich Village Follies*, which allowed her to begin to design and choreograph her own work. Soon after, she joined the Eastman School of Music as a teacher and director of the newly formed dance department, allowing her a greater opportunity to experiment freely with movement independent of public performances. Craving even more creative freedom, she started the Martha Graham Center of Contemporary Dance in New York in 1926. She was now able to freely choreograph and teach in her own mode. Her work was received with mixed reviews, primarily because her style was so different from traditional dance. While praised, her work was often misunderstood. She said she wanted to "give visible substance to things felt and chart the graph of the heart." One of the first pieces she choreographed for the company was *Frontier* in 1935, a solo performance about a pioneer woman. She collaborated with Isamu Noguchi, a Japanese-American sculptor who created what would be the first of many set designs for her dances. Soon after, she met Ethan Hawkins, a young ballet dancer who joined her company, and who for ten years danced in some of her most important works, including *Appalachian Spring*. They fell in love and married. The marriage did not last long, and eventually their professional relationship ended as well. Graham continued dancing until 1970, when she retired from the stage at seventy-six. ∽ While she was one of the most important choreographers in the history of modern dance, Graham preferred to think of herself as a dancer. She wrote in *Blood Memory*, "It wasn't until years after I had relinquished a ballet that I could bear to watch someone else dance it. I believe in never looking back, never indulging or reminiscing. Yet how can you avoid it when you look onstage and see a dancer made up to look as you did thirty years ago, dancing a ballet you created with someone you were then deeply in love with, your husband? I think that is a circle of hell Dante omitted." ∽ She died in 1991 at the age of ninety-six. In 1998, *Time* magazine called her "The Dancer of the Century."

MARTHA GRAHAM Upon arriving at Miss Graham's New York apartment in 1948, I was quite taken aback, though impressed, by the stark simplicity with which she had chosen to surround herself. On a modernistic table stood a grotesque piece of petrified wood, vaguely suggesting the attitude of a modern dancer. A rubber plant in one corner, a few pieces of very modern furniture, no pictures, no radio, no decorations of any sort – this, then, was to be the setting of a dancer's portrait. Then I looked up to the ceiling and it seemed only a few inches above my head. No one, not even Martha Graham, could dance in such a place. Compromise sometimes must be the stuff of which pictures are made. So, rather hopelessly, I sat Miss Graham on a low stool and asked her to assume various attitudes as if she had the space of a great stage around her. Amazingly enough, this restricted posture presented no problem, such perfect control had she over her body. She was sitting on a stool, in a low room, but she seemed to be dancing. In fact, she was dancing, and thus I recorded her. . . .

HEMINGWAY, ERNEST [115] Pulitzer and Nobel Prize-winning author, Ernest Hemingway (1899–1961), writer of novels, short stories, and essays, was a man of action drawn to battle, adventures, and blood sports of all kinds. Through both his work and lifestyle, he became a role model for a generation of writers. Archibald MacLeish paid him this tribute:

> Veteran out of the wars before he was twenty:
> Famous at twenty-five: thirty a master–
> Whittled a style for his time from a walnut stick
> In a carpenter's loft in a street of that April city

That "April city" was Paris, where Hemingway was part of an extended and talented expatriate community later known as "the Lost Generation." ∽ Hemingway was born in Oak Park, Illinois. His father was a doctor and a sportsman, and his mother had been an aspiring opera singer and music teacher. His father was rugged and taught him about the outdoor life, including how to use a rod, gun, and an axe. His mother introduced him to art and culture by taking him to operas and galleries. After graduating high school, Hemingway decided to become a writer and pursued a career in journalism. When the First World War started, he tried to enlist in the infantry, but poor eyesight kept him out of active duty, and he instead joined the ambulance service. At nineteen, Hemingway suffered a severe leg wound and was twice decorated by the Italian government for his service. This experience became the background for *A Farewell to Arms*. ∽ After the war, in 1921, Hemingway moved to Paris. He wrote articles for the *Toronto Star* and began writing short stories. Gertrude Stein and F. Scott Fitzgerald, helped him break into writing and acted as mentors. In 1926, he published *Torrents of Spring* and *The Sun Also Rises*. Other works followed, including *Men Without Women*, *A Farewell to Arms*, *Death in the Afternoon*, *The Green Hills of Africa*, *For Whom the Bell Tolls*, *The Old Man and the Sea*, and short stories including "The Snows of Kilimanjaro." ∽ Hemingway's writing style was terse but poetic. Describing it himself, he propounded "the iceberg theory" of writing prose. "If a writer of prose knows enough about what he is writing about, he may omit things The dignity of movement of an iceberg is due to only one-eighth of it being above water. A good writer does not need to reveal every detail of a character or action." Hemingway was awarded the Nobel Prize for Literature for *The Old Man and the Sea* in 1953. ∽ In his last years, the injuries, illness, and scars from his adventures and hard living took their toll, leaving him prone to more sickness after each new adventure. Some have speculated that his frustration with his health led to depression, and the medical treatment left him unable to write. The report on his death in 1961, a few weeks short of his sixty-second birthday, said he died of a gunshot wound while cleaning his gun.

ERNEST HEMINGWAY In his books and stories, Ernest Hemingway has brought to life a swarming company of characters, but he jealously concealed himself. After reading those tales of ferocity, violence, and physical suffering, I expected to meet in the author a composite image of his creations. Instead, in 1957 at his home near Havana, I found a man of peculiar gentleness, the shyest man I ever photographed. Therein, I imagine, lies the secret of his work. He has felt in his soul, with lonely anguish, the tragedy of our species, has expressed it in his writing, but for self-protection, has built around himself a wall of silence and myth. Nevertheless, I wanted him to talk, to focus his mind, and hence his face, on some subject which would arouse both; so I asked him bluntly what he thought about the large tribe of writers who try to imitate his style. Forgetting his diffidence, he gave me a ready answer. The trouble with the imitators, he said, was that they were able only to pick out the obvious faults in his work; they invariably missed his real purpose and his real method – just as many readers remembered him chiefly for his defects There was no bitterness in this remark, only a rather sad amusement. As he thought about my question I discovered that he had a wonderful smile – alive, kindly, and full of understanding. But on developing my negatives, I liked best the portrait printed here. It is, I think, a true portrait, the face of a giant cruelly battered by life, but invincible.

HEPBURN, AUDREY [95] One of America's most popular movie stars and fashion icons, Audrey Hepburn (1929–1993) won Academy, Tony, Emmy, and Grammy Awards. Active with UNICEF, she served as goodwill ambassador from 1988 until her death, traveling extensively in Africa and Latin America, crusading for children's rights. For her work in this position, Hepburn received the Presidential Medal of Freedom. Hepburn epitomized good taste; she was dignified, intensely engaging, and, like many of the characters she played, was "Cinderella-like," rising from ashes to glory. Some of her movie roles were Eliza Doolittle in *My Fair Lady*, Holly Golightly in *Breakfast at Tiffany's*, Sabrina Fairchild in *Sabrina*, Princess Ann in Roman *Holiday*, Jo Stockton in *Funny Face*, Suzy Hendrix in *Wait Until Dark*, and Joanna Wallace in *Two for the Road*. ∽ Hepburn was born in Brussels. Her father was an English banker, and

her mother was a Dutch baroness. Her father was a Nazi sympathizer, causing her parents to separate in 1935. In 1939, her family moved to the Netherlands in an attempt to escape the Nazi occupation. Hepburn studied ballet at the Arnhem Conservatory of Music. In 1940, the Germans invaded the Netherlands, making living conditions dangerous and difficult. During this time, Hepburn witnessed many atrocities, including the murder of her uncle and cousin for being part of the resistance. She suffered from malnutrition, anemia, and respiratory difficulties, and she and her family were forced into hiding. Because of her experiences, Hepburn felt an affinity for Anne Frank. She once said: "We were both ten when war broke out and fifteen when the war finished. I was given the book in Dutch, in galley form, in 1946 by a friend. I read it – and it destroyed me. It does this to many people when they first read it but I was not reading it as a book, as printed pages. This was my life. I didn't know what I was going to read. I've never been the same again, it affected me so deeply." She recalled her war experiences and her gratitude for surviving them as a reason for her deep commitment to the United Nations Children's Fund. ❧ An accomplished dancer by war's end, she and her family, briefly moved to Amsterdam, where Hepburn did modeling and continued to study ballet. Eventually relocating to London, she began working on the stage as a chorus girl, and appeared in small roles in movies. In 1953, she met the French writer Colette, who felt that Hepburn would be perfect for the title role in her Broadway show *Gigi*. She was right, and the success established Hepburn as a film actress. In her first major film role as Princess Ann in *Roman Holiday*, Hepburn won the Academy Award for best actress. This role made famous what became known as "The Hepburn Look," a recognizable fashion statement that was partially inspired by Hubert de Givenchy, who designed gowns for her films. Hepburn's last film appearance was a cameo role in Steven Spielberg's *Always*, filmed in 1988. ❧ She was appointed goodwill ambassador to the United Nations Children's Fund (UNICEF). Fluent in French, Italian, English, Spanish, and Dutch, she was a tremendous asset to the cause. She dedicated her remaining years to aiding starving children in the most impoverished and war-torn countries of the world. Remembering her own struggle against Nazi oppression, Hepburn had already often contributed to UNICEF. As an ambassador, she made a much deeper commitment. She traveled tirelessly to Africa, Turkey, Venezuela, Ecuador, and Honduras. After a trip to Ethiopia, she said, "I have a broken heart. I feel desperate. I can't stand the idea that two million people are in imminent danger of starving to death, many of them children, not because there isn't tons of food sitting in the northern port of Shoa. It can't be distributed.... I went into rebel country and saw mothers and their children who had walked for ten days, even three weeks, looking for food, settling into the desert floor into makeshift camps where they may die. Horrible. That image is too much for

me. The 'Third World' is a term I don't like much, because we're all one world. I want people to know that the largest part of humanity is suffering."

AUDREY HEPBURN I photographed Audrey Hepburn in 1956 in the Paramount Studios, Hollywood, where she was creating her starring role in Funny Face. *I had seen her in various movies, and she did not surprise me in this meeting. I had expected to find her rather brittle, extremely sensitive, and always emotionally charged. So she is. Intensity, I suppose, is her particular quality and her particular success. Beauty is combined with an insatiable appetite for life, and for work, too. Miss Hepburn was surprised and thrilled, as if I had offered her some extraordinary gift, when I said I would let her see my pictures before they were published – an unusual procedure in America. Accordingly, a few days later, I took the color and the black-and-white pictures to her dressing room while she was having her hair shampooed. She greeted them with the explosive enthusiasm which the public has seen so often on the screen. ❧ "What a relief," she cried, "to see pictures taken without foundation makeup!" ❧ I noticed then that, unlike most movie stars I had portrayed on my trip to Hollywood, Miss Hepburn was comfortable with only a line of eyebrow pencil and some lipstick. Her natural beauty required little assistance from the art of makeup.*

HILLARY, SIR EDMUND PERCIVAL [140]

The cheerful, unpretentious, heroic explorer, who was part of a team of two to first reach the summit of Mount Everest, Edmund Hillary (1919–2008) said of himself, "I was just an enthusiastic mountaineer of modest abilities. An average bloke." On May 29, 1953, Hillary, with Tenzing Norgay of Nepal, became the first known climbers to reach the highest place on earth. Their destination was five and a half vertical miles (29,035 feet) above sea level, with frigid hundred-mile-per-hour winds and air so scarce it is almost humanly impossible to function. In fact, many considered the mountain unconquerable. Prior expeditions had failed; dozens of climbers had perished, buried or lost in avalanches or sudden storms. ❧ Born to Percival and Gertrude Hillary, née Clark, in Auckland, New Zealand, Hillary's interest in climbing began at the early age of sixteen during a school trip to Mount Ruapehu. He studied at the University of Auckland and in 1939 completed his first major climb to the summit of Mount Ollivier, in the Southern Alps. After college, Hillary became a beekeeper with his brother, allowing him to work in the summers and do what he loved most in the winter: climb mountains. ❧ Hillary and Norgay were part of a Royal Geographical Society team led by Colonel Henry Hunt. The group included dozens of climbers, Sherpa guides, and 350 porters to carry 10,000 pounds of food and equipment. The base camp was established in March, and they climbed slowly, setting up the final camp at an elevation of 25,900 feet. Several team members tried unsuccessfully to make the final ascent before Hunt asked Hillary and Norgay. They pitched a tent

at 27,900 feet and attempted the final ascent wearing thirty-pound packs. The last forty feet were the most crucial and difficult, and the area was subsequently named "Hillary's Step." At 6:30 A.M. they made it to the top. Standing there, Hillary recalled, "The whole world around us lay spread out like a giant relief map. I am a lucky man. I have had a dream and it has come true, and that is not a thing that happens often to men." After spending a short time at the top in a modest celebration they began their descent. Hillary remembered, "We shook hands and then, casting Anglo-Saxon formalities aside, we thumped each other on the back until forced to stop from lack of breath." ❧ They were heroes, showered with honors. Queen Elizabeth immediately made Hillary a knight, and Norgay received the George Medal of Britain. Since the historic climb, advances in supplies, clothing, and equipment, have made the climb significantly easier, and subsequently Mount Everest has become a tourist attraction with hundreds of people able to replicate the adventure. ❧ Many have asked in retrospect what was so special about their accomplishment. Jan Morris wrote for *Time*, "Geography was not furthered by the achievement, scientific progress was scarcely hastened, and nothing new was discovered. Yet the names of Hillary and Tenzing went instantly into all languages as the names of heroes, partly because they really were men of heroic mold, but chiefly because they represented so compellingly the spirit of their time." What was perhaps most remarkable and heroic about Hillary and Norgay was the humble, straightforward, and respectful way they achieved their goal and accepted their celebrity. After the climb, both men devoted much of their lives to helping the Sherpa people of Nepal through a trust founded to develop schools and hospitals and improve the ecology.

SIR EDMUND HILLARY He had achieved the ultimate triumph in his field: to conquer the world's highest mountain and, by great good fortune, to present the feat to his queen as a gift on the very morning of her coronation day. What was left? Without hesitation he answered, "To make it scientifically as simple as possible for others to follow and benefit from the experience." He has since pursued his aim, studying not only the use of oxygen and specially designed equipment, but also the long, difficult process by which man must acclimatize himself to live in the thin, cold, dry atmosphere five miles up and higher. This portrait was taken between expeditions, in a Chicago office building. Ideally, it should have been taken on a mountain peak, but that would have required the photographer to follow his path. For Hillary, it did not matter. He is an outdoorsman wherever he may be located. I like the confidence he radiates, and the friendship too, for he is a very natural and warm human being; but particularly I am struck by the integrity of that fine face. His eyes are those of a man who has looked into distance and danger. There is infinity in them. They remind me of his passing, casual remark that mountain climbing, of itself, was never enough. ❧ "The odds," he said, "are always in favor of the

mountain." *He paused for a moment and added a curious comment on his own past adventures and the future of humankind: "There is no height, no depth that the spirit of man, guided by a higher spirit, cannot attain." Then, rather shyly: "It is an act of worship just to sit and look at high mountains." This man had seen beyond Everest.*

JOHNS, JASPER [150] Jasper Johns, Jr. (1930–) became a prominent force in American art history in the late 1950s, when his work moved the art world away from Abstract Expressionism toward a more real and concrete focus, with images of American flags, letters, and numbers. As it evolved, Johns's style helped to lay the groundwork for the Pop Art and Minimalism movements. ❧ John was born in Augusta, Georgia, and his parents divorced when he was young. His grandparents and other relatives in South Carolina raised him in a rural environment. Johns began drawing at the age of three, and he is quoted as saying of this period in his life, "In a place where I was a child, there were no artists and there was no art, so I really didn't know what it meant." He studied at the University of South Carolina for three semesters before moving to New York in the early 1950s. ❧ In New York, Johns became associated with a number of artists, including Merce Cunningham, John Cage, and, most notably, Robert Rauschenberg. Exploring the New York art scene together, Johns and Rauschenberg became companions who furthered each other's careers tremendously. In 1955, Johns began his early series of American flags, numbers, and letters, creating new impressions of commonly known forms by using techniques such as encaustation, hot wax painting, and collage on canvas. ❧ In 1959, Johns encountered Marcel Duchamp's collection called "Readymades," which were ordinary objects modified by simply repositioning, joining, or retitling, and then by signing them, signaling the creation of a work of art. It was the least amount of interaction between artist and art, perhaps the most extreme form of minimalism. Johns was moved, and it inspired his work in the 1960s. He began to affix objects such as brooms or rulers to the canvas, creating nontraditional collages, provoking deeper questions about the painting's identity, and establishing his signature style.

JASPER JOHNS While I did photograph him with his painting as background, I found the penetrating intelligence of his face alone more of a challenge. . . . In our photographic session, he was a sensitive collaborator, intuitively anticipating and aware of all the nuances of light and shadow.

JOUVET, LOUIS [83] Louis Jouvet (1887–1951), actor and director of French theater, was most well known to Americans for his famous film roles. However, his most significant contributions were to the French theater. Many of his films are classics of French cinema and serve as a lasting memory for future generations to appreciate. The *New York Times* said of Jouvet: "A character actor

who was equally at ease in the classical repertory of Molière or in the modern plays of Jean Giraudoux and Jules Romains. M. Jouvet built up a formidable troupe of actors and decorators who, with himself as producer-actor, made the Athénée one of the greatest centers of dramatic art in France." ❧ Born in Crozon, Brittany, he developed a passion for theater by the time he was eighteen. At his mother's urging, he studied pharmacy and worked briefly in the profession while devoting his spare time to theater. Jouvet applied to the Paris Conservatoire three times, but was rejected. Nonetheless he persevered, and joined a theater company in 1908, and by 1910 he made his acting debut in the Paris production of *The Brothers Karamazov*. In 1913, he accepted the position of director at the Théâtre du Vieux-Colombier in Paris. After the war, in 1924, Jouvet was appointed director of the Comédie des Champs-Elysées in Paris. The position lasted ten years until he was appointed director of Athénée, a position he held until his death. ❧ In 1932, Jouvet established himself as an actor in the film *Topaze*. By 1939 he was a celebrated actor in French cinema appearing in classic movies like *Les bas-fonds*, *Drôle de drame*, *Un carnet de bal*, *La marseillaise*, and *Hôtel du nord*. His most famous role is that of the bishop of Bedford in *Drôle de drame*. ❧ For more than three decades, Jouvet achieved theatrical success and popularity in both traditional and classical performances, including the rejuvenation of Molière, in addition to more contemporary playwrites like Cocteau, Romains, Passeur, and Giraudoux. In addition to performing in Paris, Jouvet took his troupe to both North and South America where they were also very well received. ❧ Louis Jouvet died in his theater office in Paris of a heart attack at the age of sixty-three.

KARLOFF, BORIS [65] Born William Henry Pratt, the son of a diplomat, Boris Karloff (1887–1969) was educated at London University and, as a youth, considered following the family tradition of diplomacy. Instead, in nearly forty years of acting, he became famous for his roles in horror movies, most notably his portrayal of the monster in *Frankenstein*. Though his lines were few, Karloff was not only memorable in the role, but also contributed significantly to defining the new genre. Peter Bogdanovich, one of Karloff's directors, said, "Considering most of the movies he was cast in, it is all the more remarkable that he so completely transcended his vehicles; his presence in even the worst of these lent them a measure of his talent, grace, and wit. And that was the irony of the image: it was nothing like the man. The consummate horror heavy was, in fact, a tasteful, knowledgeable British gentleman – shocked by unkindness, never less than polite, with a sense of humor about his roles and nothing but gratitude to the public for their long-lasting affection." ❧ Orphaned as a young child, Pratt was raised by his elder siblings and received a college education. Avoiding the foreign service, he immigrated to Canada in 1909, initially performing menial jobs.

Moving to Banff, he changed his name to Boris Karloff and began looking for acting work. He began his career on the stage, and for the next six years, he learned the trade by appearing in stock plays for touring companies, developing a reputation as a consummate professional. ❧ In 1917, he arrived in Los Angeles with no intention of acting in films. But times had changed, and the Hollywood theater business had reluctantly moved into movies. He made silent films for a time, but the work was irregular, so he drove a truck and did other odd jobs. Karloff got his lucky break when he acted the part of Galloway, a seemingly trustworthy convict/killer, in the play *The Criminal Code*. He was a success, and subsequently he was asked to play the same role in the film version. Director James Whale took notice, intrigued with the shape of Karloff's head and face. He felt that with appropriate make-up, Karloff would be ideal for the role of Frankenstein's monster in what was Hollwood's first major monster film. He exceeded all expectations. Karloff said of the work, "*Frankenstein* transformed not only my life, but also the film industry. It grossed approximately $12 million on a $250,000 investment and started a cycle of so-called boy-meets-ghoul horror films." Karloff appeared in three more *Frankenstein* films, and also starred in *The Mummy*. In all, his movie career lasted a decade and included films from a variety of genres. In 1941, Karloff returned to the stage in the role of the homicidal brother in *Arsenic and Old Lace*, a play that enjoyed a run of over 1400 performances. ❧ In contrast to his screen persona, Karloff was known to be a kind and generous gentleman. He was particularly fond of donating to children's charities, and even narrated the animated Dr. Seuss TV special, *How the Grinch Stole Christmas*, and played, of course, the part of the Grinch. After a long battle with emphysema, he died in 1969 at age eighty-one.

BORIS KARLOFF The monster of Frankenstein *lived a secluded existence in a modest room of the private club in which I photographed him. Gentle and scholarly, with an exquisitely modulated voice, he spoke of English gardens and growing roses.*

KARSH, ESTRELLITA [134] Estrellita Karsh (1930–) met her husband in Chicago on a portrait assignment to photograph her boss. The Newark, New Jersey native and Antioch College graduate was then editor to the renowned retired Mayo Clinic physician Dr. Walter C. Alvarez, collaborating with him on his nationally syndicated medical advice column articles and books. When Estrellita married Yousuf Karsh in 1962, *Newsweek* magazine quipped, "Something else clicked besides the shutter." ❧ Encouraged and supported by her husband, who shared her interests in art and medical history, Estrellita continued her career. She wrote for the medical supplements of the *Encyclopedia Britannica*, curated exhibitions featuring Boston physician-artists, investigated the socio-medical aspects of the Canadian Inuit (Eskimo) prints for Harvard Medical School, and helped physicians write books understandable to the

layman. She also accompanied her husband on his worldwide assignments and arranged their busy social and work schedule. ✍ Since her husband's death in 2002, Estrellita has continued to support the projects they started together: encouraging young artists with the annual Karsh Prize in Photography at the School of the Museum of Fine Arts, Boston, and introducing photographers to the public through the Karsh Annual Lecture in Photography. She has also honored his legacy by establishing endowed curatorships at the Museum of Fine Arts, Boston: the Estrellita and Yousuf Karsh Curator and Assistant Curator of Photographs. At Boston's Brigham and Women's Hospital, she has added to Karsh's 1975 gift of his portraits of medical and scientific luminaries, "Healers of Our Age," with collections in Brigham's patient and family center to alleviate anxiety and bring solace and healing "in a gallery that never closes." ✍ During what would have been Karsh's centennial year (2008–2009), Estrellita has participated in a number of tribute exhibitions worldwide honoring her husband's birth.

KARSH, SOLANGE [48, 49] Born in Tours in the Loire region of France, Solange (1900–1961) and her family immigrated to Canada when she was a young girl. She lived in convents until she was fourteen, when she began attending high school in Ottawa. There, she was introduced to drama and soon advanced to Ottawa's Little Theatre acting and directing plays in French. Though offered positions in theatre and film after graduation, she refused them because French girls from good families didn't go on stage. Instead, she worked as a secretary to a Member of Parliament. ✍ She met Yousuf Karsh in 1932, and convinced him to become the official photographer of the Ottawa Drama League, the onset of his career photographing theater, which in turn introduced him to the dramatic potential of artificial studio lighting. In 1936, she left her job, joined Karsh, and three years later they were married. Managing every aspect of the business, she supported her husband in every way. Their mutual friend Betty Low said: "He was doing his beautiful work, but it was her ideas; she was the driving force, raising him up from being a court photographer. Solange cultivated Yousuf and gave him culture." ✍ Solange was diagnosed with cancer in the late 1950s, and although the treatments weakened her physically, she endured bravely, finally succumbing in 1961.

KARSH, YOUSUF [2] Yousuf Karsh (1908–2002) is known to millions for his portraits that were extensively published in newspapers, magazines, and books. Unlike other formal portrait photographers, Karsh had the goal "to stir the emotions, and lay bare the soul of his subject," and indeed had a gift for capturing his subject's character visually. As he observed: "Within every man and woman a secret is hidden, and as a photographer it is my task to reveal it if I can. The revelation, if it comes at all, will come in a small fraction of a second with an unconscious gesture, a gleam of

the eye, a brief lifting of the mask that all humans wear to conceal their innermost selves from the world. In that fleeting interval of opportunity the photographer must act or lose his prize." Not all of his subjects were famous, but all were remarkable. ✍ Born in Mardin, a Turkish city of the Ottoman Empire, his parents were Armenian, and Karsh grew up during the Armenian genocide. At fourteen, he fled with his family to Syria to escape persecution. His parents then sent him to live with his uncle, George Nakash, a photographer in Quebec. Karsh briefly attended school and assisted in his uncle's studio, who recognizing his potential, arranged for his study with another Armenian, the portrait photographer John Garo in Boston. ✍ After his apprenticeship, Karsh returned to Canada in 1932 to establish himself. With a studio in Ottawa close to the Canadian government offices, he was discovered by Prime Minister Mackenzie King who arranged introductions with visiting dignitaries for portrait sittings. His work became known, but his place in history was assured in 1941 when he photographed Churchill after he delivered a speech to Ottawa's House of Commons. The portrait, *The Roaring Lion*, brought Karsh international celebrity and is claimed to be the most reproduced portrait in history. ✍ Karsh became a legend who captured legends. The *New York Times* said in their obituary: "He characteristically achieved a heroic monumentality in which the sitter's face, grave, thoughtful and impressive, emerged from a dark, featureless background with an almost superhuman grandeur."

KELLER, HELEN [76, 77] American author, activist, and lecturer, Helen Keller (1880–1968) was the first blind and deaf person to graduate from college. Her life's work led to advances in specialized education for the blind and deaf. In his tribute for the *New York Times*, Alden Whitman wrote, "For the first eighteen months of her life, Helen Keller was a normal infant who cooed and cried, learned to recognize the voices of her father and mother and took joy in looking at their faces and at objects about her home. 'Then,' as she recalled later, 'came the illness which closed my eyes and ears and plunged me into the unconsciousness of a newborn baby.' The illness, perhaps scarlet fever, vanished as quickly as it struck, but it erased not only the child's vision and hearing but also, as a result, her powers of articulate speech. Her life thereafter, as a girl and as a woman, became a triumph over crushing adversity and shattering affliction." ✍ She was nothing if not optimistic and determined. She said, "I have always felt I was using the five senses within me; that is why my life has been so full and complete." Able to communicate through braille, she learned to speak and dance, delivered lectures, and authored many books. She was an activist who worked tirelessly to improve the lives of other blind people. She said, "The public must learn that the blind man is neither genius nor a freak nor an idiot. He has a mind that can be educated, a hand which can be trained, ambitions which it is right for him to strive to realize, and it is the duty of the public to

help him make the best of himself so that he can win light through work." ✍ Keller was born in Tuscumbia, Alabama. Her father was a wealthy cotton plantation owner and editor of a local newspaper, her mother a Memphis belle twenty years his junior. At eighteen months, Keller fell ill and was expected to die. She recovered, but her mother soon noticed that she did not respond to noise or visual stimuli, and realized the illness had left her blind and deaf. When she was six, her mother sought the help of a specialist in Baltimore. The doctor confirmed that Keller would not hear or see again, and referred the family to Alexander Graham Bell, who was focusing his life on educating deaf children, and who referred them to the Perkins Institute and Massachusetts Asylum for the Blind to find a teacher. They hired Anne Sullivan, a former student who had lost most of her sight at age five. She became Keller's teacher and lifelong companion. The relationship was stormy at first, but Sullivan was able to break through, spelling words onto Keller's hand, teaching her about the world around her, and breaking her free of her isolation. The story of their relationship, hard work, and success was later portrayed in *The Miracle Worker*, a popular mid-twentieth century play. ✍ In 1900, Keller entered Radcliffe College, the first blind and deaf person to enroll in college and subsequently to earn a bachelor of arts degree. She graduated cum laude in English and German in 1904. During her time at Radcliffe, Keller began writing books, both in braille and on a normal typewriter. Her first book, *The Story of My Life*, was published in 1903. Writing was soon a key element in her life. She said, "Literature is my Utopia. Here I'm not disfranchised. No barrier of the senses shuts me out from the sweet, gracious discourse of my book friends. They talk to me without embarrassment or awkwardness." ✍ In 1909, Keller joined the Socialist Party in Massachusetts and became an activist for racial and gender equality. She and Sullivan traveled worldwide, giving lectures in support of the blind and deaf, with Sullivan interpreting her words. Keller died in 1968 at age eighty-seven.

HELEN KELLER On first looking into the blind but seeing eyes of perhaps the greatest woman in our world, I said to myself, "The light comes from within." And what a light of courage shines through the face from the dauntless soul of Helen Keller! Katharine Cornell, her devoted friend, had taken me to Miss Keller's apartment in New York in 1948 and explained the ritual of our meeting. The woman who has no sight or hearing shook my hand and then placed her marvelously sensitive fingers on my face. In her mind's eye, I knew, she already had me completely photographed. We were en rapport and I could make my portrait. Although I could speak to Miss Keller only through Miss Polly Thomson, her faithful companion, who dialed Braille into Miss Keller's palm, we soon developed a code of our own. At the slightest pressure of my fingers on her hand, she knew at once exactly which way I wished her to turn and at what angle I wanted her head. Her extreme sensitivity, her alert mind, her kindness

and understanding, but most of all her gaiety, kept me amazed throughout the whole sitting. Sight and hearing had passed into her hands. Therefore a portrait of the hands was as important as a portrait of her face – hands that create light out of darkness, sound out of perpetual silence, and alone bring this woman into communion with nature and her own kind. So I photographed those hands and as I looked at the result I repeated my first observation of Miss Keller: the light did indeed come from within.

KENNEDY, JACQUELINE [112, 113] Better known as Jackie, Jacqueline Lee Bouvier Kennedy Onassis (1929–1994) was born in South Hampton, New York. She was educated privately, attended Vassar for two years, and graduated from George Washington University in 1951. An accomplished horsewoman, she was also an avid writer and illustrator as well as a student of ballet. She married John F. Kennedy on September 12, 1953, becoming first lady on his inauguration in 1961. Her brother-in-law Ted Kennedy said of her, "She was a blessing to us and to the nation – and a lesson to the world on how to do things right, how to be a mother, how to appreciate history, how to be courageous. No one else looked like her, spoke like her, wrote like her, or was so original in the way she did things. No one we knew ever had a better sense of self." ∾ Much of Jackie's tenure as first lady was devoted to making the White House a museum of American history and an elegant residence. In 1961, Jackie provided a televised tour to show her work, called *A Transformation at the White House*. The program was broadcasted by three networks, and was seen by fifty-six million viewers. Hugh Sidney, White House correspondent for *Time* said of her work, "She really was the one who made over the White House into a living stage – not a museum – but a stage where American history and art were displayed." ∾ She is probably best remembered for the dignity and courage she displayed during the days following her husband's assassination on November 22, 1963. Despite her grief, she planned the funeral, including details like the riderless horse in the procession, the salute by three-year-old John, and the eternal flame by the grave. Her composure and spirit won her admiration worldwide. ∾ In 1968, she married Aristotle Onassis, a wealthy Greek businessman, twenty-three years her senior. He died in 1975, leaving her a widow for the second time at the age of forty-six. Jackie moved to New York to become a publishing professional at Doubleday. Also devoted to historic preservation, she helped save buildings in New York City. ∾ In 1994, she died of cancer at the age of sixty-three with her family by her side.

JACQUELINE KENNEDY Widowhood and adversity had not yet touched the glamorous young wife of the handsome senator from Massachusetts. Our meeting was at Hammersmith, her mother's home in Newport. I photographed her against a Coromandel screen that complemented her dark beauty. Weeks later in New York, she saw me walking down Fifth Avenue and rushed toward me to inquire breathlessly

about her photographs. Our last meeting was shortly before her untimely death, when she came to my exhibition "American Legends." She stood alone at the entrance, her quiet presence penetrating the crowd.

KENNEDY, JOHN FITZGERALD [112] John Fitzgerald Kennedy (1917–1963) was the youngest elected president of the United States. He was passionate about politics and extremely skilled at communicating. His way with people and vision for his country inspired millions to become engaged in public service. His presidency was encapsulated in the famous line from his inaugural address: "Ask not what your country can do for you – ask what you can do for your country." ∾ Born in Brookline, Massachusetts, in 1917, Kennedy was the son of a prominent businessman, politician, and leader of the Democratic Party and the Irish Catholic community. Graduating from Harvard in 1940, Kennedy entered the Navy and became skipper of a PT boat sunk in the Pacific by a Japanese destroyer during the Second World War. Despite his near-death condition and debilitating back injury, Kennedy managed not only to survive, but also to courageously lead the other survivors to safety. ∾ Kennedy's own political career started when he became a Democratic congressman for Boston in 1946. In 1952, he was elected senator, a position that he maintained until his election as president in 1960. In 1953, he married Jacqueline Bouvier. Kennedy became widely known for his popular book, *Profiles in Courage*, which describes acts of bravery and integrity by eight United States senators who defied public opinion in order to do what they felt was right, although they consequently received severe criticism and loss in popularity. He was awarded the Pulitzer Prize in history for this work in 1957. ∾ As president he promised "to get America moving again" by bringing dynamic and new programs to the country. His agenda, called "The New Frontier," provided solutions for dealing with problems at home, abroad, even in outer space. However, Kennedy's tenure in office had grave challenges, particularly with foreign affairs. Early in his term, Kennedy allowed a group of Cuban exiles to invade Cuba to overthrow Castro's communist regime. They failed, and the world seemed on the brink of war when air reconnaissance discovered that the Soviet Union had installed nuclear missiles in Cuba. A naval embargo of the island forced the removal of the missiles, and the peace that followed led to a limited test-ban treaty signed with the Soviet Union. In Europe, Kennedy enjoyed friendly and cooperative relationships with important allies and their leaders: Britain's Harold Macmillan, Germany's Konrad Adenauer, and France's Charles de Gaulle. De Gaulle said that in his long lifetime, he had met only two real statesmen: Adenauer and Kennedy. But Adenauer was too old, he said, and Kennedy was too young. ∾ Overall, in Kennedy's thousand days in office, the United States saw the beginning of new hope for both world peace and civil rights reform. He was looking forward to furthering his agenda in a second term of office when

he made the fateful trip to Dallas. On November 22, 1963, a gunman firing from the upper floor of a building assassinated the president.

JOHN FITZGERALD KENNEDY The first time I photographed John F. Kennedy in 1960 was in August, with Mrs. Kennedy, at the home of her mother, Mrs. Hugh Auchincloss. Working with these two young people was a rare experience. It is always pleasant to photograph a handsome man beside one of the world's most alluring women. They needed no coaching. Between them one sensed a wonderful intuitive understanding. The senator was under considerable pressure that morning. Several bills of real importance were pending. Every few minutes he would excuse himself to telephone for a progress report, in case he should need to rush off to vote. Yet, between these interruptions, during a session which lasted two hours, he seemed able to throw off politics completely. I was enormously impressed by his ability to live in the present, to concentrate completely on the job at hand. ∾ The next time we met was in the Senate offices, where I was to photograph both Kennedy and Lyndon Johnson. The elections were closer now. One might have expected to find the presidential candidate tired and harassed, but, like any thoroughbred, he had summoned fresh reserves as the chance of triumph approached. He was thoughtful enough to suggest that instead of my moving my photographic equipment, he would come to Johnson's office. Kennedy had not realized that the pictures would be taken in color as well as in black and white and considered his necktie unsuitable. ∾ "Well then," he said, "let me have yours." ∾ As a result, the portrait shows this most meticulous dresser wearing a tie borrowed on the spur of the moment.

KHRUSHCHEV, NIKITA [130] Nikita Sergeyevich Krushchev (1894–1971) ruled the Soviet Union in the post-Stalin era, representing a stark contrast to prior regimes and leading to his reputation as "the last great reformer" before Mikhail Gorbachev. In 1956, he delivered a report on Stalin that shocked the nation and the world with its candor. The report, "The Personality Cult and Its Consequences," outlined the atrocities suffered under Stalin and denounced his rule and policies. Khrushchev neglected to mention that he had been part of the Stalin regime. Khrushchev's stay in power represented an important transition for the Soviet Union in the reform and modernization of Russia. Under his rule, new degrees of public controversy were permitted, the secret police became less powerful, labor and concentration camps were closed, law and order were restored, and the improved economy made the future look hopeful. ∾ Unlike Lenin and most Soviet leaders, who were born in auspicious circumstances, Nikita Khrushchev was born in 1894 to a peasant family in Kalinovka near the Russia–Ukraine border. At eighteen, he began working in a factory and simultaneously began his career as an activist by joining a group of workers who organized a strike to protest working conditions. ∾ In 1917, the

Russian Revolution ousted the czar, and Khrushchev joined the Bolshevik forces of the Red Army and became a dedicated communist serving as a junior commissar. A political leader, he was soon appointed secretary of the Communist Party Committee. His career soared as Stalin rose to power and coincided with the period of "The Great Terror," during which Stalin began a series of bloody purges. When Stalin died in 1953, Khrushchev became the Communist Party's dominant figure. His leadership transitioned the country from the rule, policies, and personality of Stalin, and he was much admired for the economic growth Russia experienced, higher than most Western countries and in sharp contrast to the past. He focused military spending on a rocket-based defense, which gave the Soviet Union a lead over the United States in the space race with the success of Sputnik and the subsequent flight of the first man in space, Yuri Gagarin. ∾ In foreign matters, Khrushchev promoted policies of "peaceful coexistence" in the Cold War. Khrushchev perceived the West as a rival instead of an archenemy, but strongly supported East German plans to build the Berlin Wall, reinforcing the Cold War in Europe. His more open attitude toward the West alienated Mao Zedong of the People's Republic of China and contributed to the Sino–Soviet split. Khrushchev's relations with the United States were highlighted by his visit, the first by a Soviet leader, but were marred by the Cuban Missile Crisis. ∾ Khrushchev's demise was a result of the conservative faction of the party that was led by Leonid Brezhnev. In 1964, Khushchev was removed from power, replaced by Brezhnev, and retired to a *dacha* in rural Russia where he remained until he died in 1971.

NIKITA KHRUSHCHEV On April 21, 1963, Moscow's first real spring day, we were driven to Khrushchev's official dacha (country home) outside the capital, a large, impersonal guest house free of ornamentation. The atmosphere was very relaxed. At precisely the appointed hour, twelve noon, Khrushchev and (to my surprise and delight) his entire family strolled across the wide lawn, their faces tan and smiling. As I watched Khrushchev's portly figure approaching, suddenly I thought, "Here is a personality that I must photograph in a big fur coat." I asked the press officer for such a coat. He shook his head. "Niet." My wife asked Mrs. Khrushchev; alas, the garment was in mothballs in their Moscow apartment. ∾ After making formal portraits of the affable chairman, I switched the lights off, and, to the surprise of the interpreter, I asked Khrushchev directly. "Why not?" he replied. "Of course." Soon an aide appeared, weighed down under the most voluminous fur I have ever seen. The chairman sent the aide to his private dacha nearby to fetch a knitted woolen stocking cap to complete the costume. "You must take the picture quickly," the chairman smiled, donning the coat, "or this snow leopard will devour me." Mrs. Khrushchev, who was chatting with my wife, was astonished when the fur appeared. Of course, I could not foresee then that,

within eighteen months, this remarkable personage would be out of office. But, on hearing the news of his fall, I could not doubt that in Russian history he would always remain a formidable landmark, the agent or at least the symbol of a decisive and hopeful change in his nation's life. Here, I venture to think, is the face of the eternal peasant, perhaps the collective portrait of a great people, painted like Cromwell, warts and all.

KING, MARTIN LUTHER, JR. [124] Martin Luther King, Jr. (1929–1968) was a highly regarded and powerful leader of the American Civil Rights movement. To many, he defined it. The injustices he fought were widespread and obvious: segregation in schools, public facilities, restaurants, and hotels; the right to a fair wage; and equal access to the judicial system. Jack E. White wrote in his article for *Time* magazine, "The movement that King led swept all that away. Its victory was so complete that even though those outrages took place within the living memory of the baby boomers, they seem like ancient history. And though this revolution was the product of two centuries of agitation by thousands upon thousands of courageous men and women, King was its culmination. It is impossible to think of the movement unfolding as it did without him at its helm. He was, as the cliché has it, the right man at the right time." ∾ Born Michael Luther King, Jr. on January 15, 1929, King came from a family of pastors. His grandfather was the pastor of Atlanta's Ebenezer Baptist Church where his father served as pastor after him, and from 1960 until his death in 1968, King served with his father as copastor. He attended segregated public schools in Atlanta, receiving a bachelor of arts degree from Morehouse College in 1948. King studied for three years at Crozer Theological Seminary in Pennsylvania, where he obtained a bachelor of divinity in addition to being elected president of his predominantly white senior class and receiving a fellowship for graduate studies. He earned his doctorate degree from Boston University in 1955, and, while in Boston, he met and married Coretta Scott. ∾ In 1954, King became the pastor of Drexel Avenue Baptist Church in Montgomery, Alabama, and a member of the executive committee of the National Association for the Advancement of Colored People (NAACP). On December 1, 1955, Rosa Parks was arrested in Montgomery for refusing to comply with the Jim Crow laws requiring her to give up her bus seat to a white man. The Montgomery Bus Boycott ensued, planned by the NAACP and led by King. The boycott lasted 382 days until the Supreme Court of the United States declared the laws requiring segregation on buses unconstitutional. ∾ King was instrumental in founding the Southern Christian Leadership Conference (SCLC) in 1957, a group created to provide new leadership for the Civil Rights movement. The ideals of the SCLC were founded in Christianity and the philosophies of nonviolent civil disobedience used successfully in India by Mahatma Gandhi. In the eleven-year period between 1957 and his death

in 1968, Martin Luther King, Jr. spoke more than 2500 times, addressing the issues of injustice, protest, and action. ∾ King displayed courage and conviction in his belief in nonviolent protest. He faced hundreds of death threats, he was assaulted, his home was bombed with his family inside, and the FBI under the direction of J. Edgar Hoover bugged his phone lines and hotel rooms. ∾ He was not only a symbolic leader of American blacks, but also a powerful world leader. *Time* magazine named him "Man of the Year" in 1963, writing, "For all King did to free blacks from the yoke of segregation, whites may owe him the greatest debt, for liberating them from the burden of America's centuries-old hypocrisy about race. It is only because of King and the movement that he led that the U.S. can claim to be the leader of the 'free world' without inviting smirks of disdain and disbelief." ∾ He was the youngest man to receive the Nobel Peace Prize. Upon hearing of the prize, he chose to donate the money to further the Civil Rights Movement. On April 4, 1968, Martin Luther King, Jr. was assassinated while standing on the balcony of his motel room in Memphis, Tennessee. In his eulogy, King's friend Reverend Benjamin Mays declared, "I make bold to assert that it took more courage for King to practice nonviolence than it took his assassin to fire the fatal shot. The assassin is a coward: He committed his dastardly deed and fled. When Martin Luther disobeyed an unjust law, he accepted the consequences of his actions. He never ran away and he never begged for mercy. He returned to the Birmingham jail to serve his time."

MARTIN LUTHER KING, JR. In August 1962, I was asked to hurry down to Atlanta, Georgia, to photograph the Reverend Martin Luther King for a national publication. He had just returned home from nearby Albany, where for months he had been leading the most concentrated and sustained assault on segregation seen until then in the South. Inspired by his oratory and example, hundreds of Negroes of all ages and backgrounds had allowed themselves to be herded into jail until the cells overflowed with their protest. He himself had been vilified, attacked, arrested twice; he, too, had spent time in jail. I found him tired, but harboring no hatred, not even disapproval. He sought only justice; that he and his people should be treated as first-class citizens. This portrait was taken under the most difficult conditions. We had very little time, and the only place available was a corner of Mr. King's church. Nowhere could he relax when constantly beset by friends and aides wishing him well, commiserating on his difficulties, congratulating him upon his return, and planning new strategy. ∾ What emerged in my mind and, I trust, in the portrait was the dedication of the man and his clear vision of ultimate victory. This young minister, only thirty-three when the picture was taken, had been leading the civil rights battle since the bus boycott in Montgomery six years earlier. He had already seen many barriers fall; he had helped to engender a new spirit. ∾ "Without a movement like the one in Albany," he said, "thou-

sands of Negroes would still be walking around with their heads buried. Now they have become organized and articulate. They walk with a new sense of dignity and self-respect." What of the future? He warned of a potential new militancy. He feared that his people would depart from the nonviolent civil disobedience he had learned from Gandhi and always followed. Negroes must act, he said, but not with hatred. "Only when the people act are the rights on paper given life. But they must never use second-class methods to gain those rights. We must never succumb to the temptation to use violence."

KING, WILLIAM LYON MACKENZIE [51]

William Lyon Mackenzie King (1874–1950) was the tenth and longest-serving prime minister of Canada. His father was a lawyer, and his maternal grandfather was the first mayor of Toronto and leader of the 1837 Rebellion in Upper Canada. ∾ Mackenzie King studied economics and law at the University of Toronto and the University of Chicago, receiving a master of arts in 1897. He became a member of the Liberal Party, winning his first seat in 1908. Appointed minister of labour in Prime Minister Sir Wilfrid Laurier's Cabinet in 1909, he was elected leader of the Liberal Party in 1919 in the first leadership convention held in Canada. He remained the leader of the party until 1948. ∾ King led Canada through the Second World War. His strong relationship with both Winston Churchill and Franklin D. Roosevelt was a large part of the strength of the Allied effort. ∾ King's career is well-characterized by a statement he made in *Canada's Prime Ministers, 1867-1994: Biographies and Anecdotes*: "It is what we prevent, rather than what we do, that counts most in Government." The National Archives of Canada added, "This statement sums up best the secret of Mackenzie King's success as prime minister, and, perhaps, the key to governing Canada effectively. King's record as prime minister is sometimes difficult to assess. He had no captivating image, he gave no spellbinding speeches, he championed no radical platform. He is remembered for his mild-mannered, passive compromise and conciliation. Yet Mackenzie King led Canada for a total of twenty-two years, through half the Depression and all of the Second World War. Like every other prime minister, despite appearances, his accomplishments in that role required political acuity, decisiveness and faultless judgment." ∾ He retired from politics in 1948 and died two years later.

MACKENZIE KING Invariably, King wished me to depict the man he visualized himself to be. Like politicians everywhere, he professed humility, but he was fussy about the details of any picture, even about its composition. ∾ Above all, he was anxious to discourage the slightest animation or brightness in his personality, because, I suppose, it contradicted the gray, colorless legend of his own making, the legend of solemn wisdom, compassion, and reliability. He had a keen sense of humor and a dash of mischief, too, but at the threat of the shutter, he would struggle to retain a look of composure, his public

stage act, protesting, "Karsh, you must not take a picture now!"

KITA, ROPPEITA, XIV (NOSHIN) [128]

Roppeita Kita (1874–1971), the fourteenth head of the Kita school of Noh Theater is best known in his native Japan for having saved the school during the massive unrest of the Meiji Restoration and is remembered as a significant figure in the history of Noh during the three eras of Meiji, Taisho, and Showa. Noh, a major form of classic Japanese musical drama, has been performed since the fourteenth century. It evolved from various popular folk and art forms, and its roots can be traced back to the Tang Dynasty's Nuo. The Meiji Restoration, a revolutionary series of events that led to dramatic changes in Japan's political and social structure, changed the country from a feudal society to a capitalist economy. ∾ Roppeita Kita XIV, called Chiyozo as a child, was the second son of the Utsono family of former slaves of the shogun. As Japan recovered from the turmoil of the Meiji Restoration, some of the best disciples of Noh were eager to reconstruct the inactive Kita school. Chiyozo's family was chosen to head the school, and he was selected as its leader, as the second son, since he would not inherit his family's house. He made his debut on stage in 1882, and in 1884 he became the fourteenth head of the school at the age of ten. ∾ Roppeita Kita devoted himself to the art, collaborating with masters of other schools and learning from a wide variety of performers and teachers. He became one of the greatest Noh performers, receiving the highest honors for his work. Over his long career, Kita survived the loss of his theater twice: first due to an earthquake in 1923 and again, in the Second World War. He performed regularly until he was seventy and occasionally in his nineties, until he finally retired to teach younger generations. Kita died at the age of ninety-five in 1971.

ROPPEITA KITA Roppeita Kita is more than a legend in Japan. During his life he was a living shrine – so revered that all who entered the theater when he was on stage fell to their knees in respect. At ninety-plus, when I photographed him, he was one of the greatest actors of the Noh drama, a form of theater that has been so meticulously refined over seven centuries, so filled with subtle symbolism, that even few contemporary Japanese can fully appreciate all its nuances. To the Western eye, it is fascinating but totally alien. Kita's son, and his grandson, acted in the same Noh company. The graceful young man in the portrait is Kita's grandson; I wanted to include him to stress the continuity of tradition. He proved most helpful, as well, in conveying messages by shouting – with utmost respect – into the elder's ear. The photograph was taken on the stage of the Kita Noh Theatre in Tokyo. The painted screen in the background was the only scenery: the pine trees are symbolic of the Noh drama – and of eternity. The white post behind Kita serves a more practical purpose. Two such posts on the stage help to orient the principal actor, whose vision is restricted by the

narrow eyeholes of an elaborate wooden mask. (The second actor is not permitted to wear the mask; he must make his face as masklike as possible.) The masks worn in Noh drama represent the nature of characters portrayed. Before each performance, an actor imbues himself with that spirit, taking the mask reverently from its lacquer box, donning it, and communing with it before the mirror.... I asked whether he minded photographers, since it is absolutely forbidden to photograph the play itself. The old man admitted that once the idea of a camera portrait, particularly on stage, would have been abhorrent. But after the war, American soldiers gave him cigarettes, and in return for such treasures he felt obliged to let them take his picture. Now he was used to it.

KREISLER, FRIEDRICH (FRITZ) [106]

Fritz Kreisler (1875–1962) was an Austrian-born violinist. The *New York Times* columnist Harold Schonberg said of Kreisler, "Where he differed from all other violinists was in his charm, and in the sheer aristocracy of his musical conceptions. That aristocracy extended to his platform manner. There was something regal about Kreisler on the stage; and yet, without condescension, he could take the audience into his confidence and give each member the idea that he was playing for him and him alone." ∾ Born in Vienna in 1875, Kreisler was the son of a physician who was also a violinist. By the age of seven, Kreisler entered the Vienna Conservatory, where he studied with Joseph Hellmesberger (violin) and Anton Bruckner (theory). Kreisler gave his first performance when he was nine and subsequently studied in Paris with Joseph Massart (violin) and Léo Delibes (composition). By the age of ten, he won the first prize and gold medal for violinists at the Vienna Conservatory. Kreisler made his U.S. debut in 1888 at Steinway Hall in New York and then toured with the celebrated pianist Moriz Rosenthal. ∾ Kreisler's renown as a concert violinist was established when he appeared as a soloist with the Berlin Philharmonic in 1899. This concert and the subsequent series of American tours from 1901 to 1903 brought him worldwide acclaim. In 1902, Kreisler made his London debut with the Philharmonic Society Orchestra and was awarded its gold medal in 1904. Edward Elgar composed *Violin Concerto* for Kreisler and dedicated the work to him. Kreisler gave the premiere performance of the work under Elgar's direction in London in 1910. ∾ When the First World War began, Kreisler was inducted to serve for Austria and was ordered to fight the Russians after two weeks of training. He was severely wounded during battle and suffered a shoulder injury that threatened his career. Kreisler recovered and returned to the United States to resume his concert career but was plagued by controversy because he was considered a foreigner. He then stopped giving concerts and asked for a release from all contracts until the war was over, resuming his musical tour in 1919 when the war ended. Returning to Europe in 1924, he lived in both Berlin and France. He became a naturalized French citizen in 1938. In

1939, shortly after the outbreak of the Second World War, he settled in the U.S., becoming a naturalized American citizen in 1943. ∾ In 1941, Kreisler was injured in a near-fatal car accident, crossing Madison Avenue in New York City. Though his hearing and vision were impaired, he was able to continue playing until 1950. According to Archbishop Fulton Sheen, who visited Kreisler frequently during this part of his life, Kreisler "still radiated a gentleness and refinement not unlike his music." He died in New York City in 1962, three days short of his eighty-seventh birthday.

FRITZ KREISLER On short notice, the only locale that could be provided for photography was the cluttered Dickensian library of his agent. The violinist-composer was in the twilight of his life and could no longer hear his own compositions or his playing. Nevertheless, he retained the special charm and graciousness that the Viennese seem to possess.

LARTIGUE, JACQUES-HENRI [147] Jacques-Henri Charles Auguste Lartigue (1894–1986), the French photographer and painter, was born into an upper middle-class family near Paris in 1894. He started taking photos when he was six, assisted by his father in using both a large plate camera and a handheld Brownie No. 2. Thus began what became a lifelong photographic diary that eventually came to 120 volumes. In his early work, he took mostly candid photographs of friends and family. ∾ Lartigue's primary medium was black-and-white film, but he experimented with and produced images in a wide variety of formats and media, including glass plates and the autochrome color process. ∾ In 1915, Lartigue attended the Académie Julian in Paris. Painting remained his true vocation and professional activity. Beginning in 1922, he exhibited his art in the salons of Paris and southern France, but it was photography that made him famous. ∾ He continued photographing for the rest of his life, including venues in England and the United States. Though he was successful in selling his pictures to the press and exhibited with Brassaï, Man Ray, and Doisneau, his reputation as a photographer was not truly established until he was sixty-nine, when the Museum of Modern Art in New York organized a retrospective and issued a modest catalogue. ∾ Worldwide fame came in 1966 with the publication of his first book, *The Family Album*, followed by *Diary of a Century*, conceived by Richard Avedon. In 1975, Lartigue had his first French retrospective at the Musée des Arts Décoratifs in Paris. ∾ He died in Nice at age ninety-two.

LE CORBUSIER [105] The architect Le Corbusier (1887–1965) was a pioneer of modern architecture, urban planning, and modern design. His buildings are spread throughout Europe, India, Russia, and North and South America. Witold Rybczynski, professor of urbanism at the University of Pennsylvania, wrote in his *Time* article, "Le Corbusier was the most important architect of the twentieth century. Frank Lloyd Wright was more prolific – Le Corbusier's built oeuvre comprises about sixty buildings – and many would argue he was more gifted. But Wright was a maverick; Le Corbusier dominated the architectural world, from that halcyon year of 1920, when he started publishing his magazine *L'Esprit nouveau*, until his death in 1965. He inspired several generations of architects – including this author – not only in Europe but around the world. He was more than a mercurial innovator. Irascible, caustic, Calvinistic, Corbu was modern architecture's conscience." The Associated Press said in his obituary, "Le Corbusier was as contentious in his manner as he was influential in his architectural ideas. 'I am like a lightning conductor: I attract storms,' he said." ∾ Born Charles-Édouard Jeanneret-Gris in La Chaux-de-Fonds in northwestern Switzerland, Le Corbusier studied art at La Chaux-de-Fonds Art School, under the direction of Charles L'Eplattenier. L'Eplattenier insisted that Le Corbusier also study architecture and helped him to get his first commissions. He completed his first house in 1907 and taught classes while simultaneously studying theoretical architecture. ∾ In 1918, Le Corbusier had a vision for an affordable, prefabricated system for constructing new houses after the war's devastation of Europe. The plan was called Maison Domino, and differed from existing plans in that it featured a flat-slab floor with no exposed beams and with columns that were straight posts, freeing the walls from structural constraints. This design became the foundation for his architecture for the next ten years. ∾ At the end of the war, Le Corbusier moved to Paris and met Amédée Ozenfant. Together they developed a new design theory called Purism. They mass-produced objects from the industrial age and featured them in their new journal, *L'Esprit nouveau*. In the first issue of the journal, in 1920, Charles-Édouard Jeanneret-Gris adopted "Le Corbusier" as his professional name to distinguish his work as an architect from his work as an artist. ∾ In response to the urban housing crisis in Paris, Le Corbusier committed to developing a planned city that reintroduced nature into people's lives and offered a healthy and affordable lifestyle alternative that would raise the quality of life for the lower classes. In 1922, he presented his scheme for a *ville contemporaine* ("contemporary city") for three million inhabitants, hoping that his plan would transform society into a more efficient environment with a higher standard of living on all socioeconomic levels. ∾ Le Corbusier's 1923 book, *Vers une architecture* (*Toward an Architecture*), expressed his ideas. In it, Le Corbusier stated his belief, "A house is a machine for living in." ∾ On August 27, 1965, against his doctor's orders, Le Corbusier went for a swim in the Mediterranean. Bathers found his body in the late morning. His death rites took place in the courtyard of the Louvre.

LE CORBUSIER When I arrived at his home in Paris in 1954 to photograph him, Le Corbusier, one of Europe's greatest architects who had recently built a large new town for the government of India at a cost of millions, was leaning against a spiral staircase which, he said, had cost him only two hundred dollars. Le Corbusier was very proud of that staircase and its small cost. All his works, large or small, were evidently precious to him – so precious, indeed, that he seemed to regard them almost as personal secrets. He received me graciously and cooperated fully in the making of his portrait, but in conversation he proved depressingly reticent. The reticence was deliberate and, I concluded, habitual.... The sitting went well enough, photographically, but gave me little knowledge of the architect's mind. So I did my best and left him with his staircase and I know not what plans, for loftier works of shattering originality are certain, I imagine, to make him always a controversial figure – if a silent one.

LORRE, PETER [69] In his eulogy to his good friend Peter Lorre (1904–1964), Vincent Price said, "This man was the most identifiable actor I ever knew." Indeed, he was; there were obvious attributes that contributed to easy identification; the threatening look in his eyes, the sinister but soft voice, his stature, his amazing facial expressions, and the controlled manner that concealed the maniacal characters he played. He built his legacy playing villains. The *New York Times* wrote, "From the time of his debut in the German-produced *M* in 1931, through scores of Hollywood and television films, Mr. Lorre, a short (5 foot 5 inches) pudgy man, was able to dominate the screen with his own particular brand of evil.... Critics described him as 'one of the cinema's most versatile murderers, the gentle-fiend and a 'homicidal virtuoso.'" Vincent Price told how Lorre, a quiet man with a trademark deadpan sense of humor, attended the viewing at Bella Lugosi's funeral, and seeing Lugosi dressed in his famous Dracula cape, he asked, "Do you think we should drive a stake through his heart just in case?" Still, he was a consummate professional with a positive attitude about his sinister roles. ∾ Lorre was born Ladislav Lowenstein in Rózsahegy, Hungary (now Ružomberok, Slovakia), to Alois and Elvira Lowenstein. His family was Jewish, and when his mother died in 1908, the family moved first to Romania and then to Vienna, where he attended school. He began acting in local productions and in the late 1920s moved to Berlin to work with Bertolt Brecht. Lorre's career was blossoming when the Nazis came to power in 1933. While in no immediate danger, his faith determined a move to London where he met Alfred Hitchcock, who cast him as a villain in *The Man Who Knew Too Much*. ∾ Subsequently, Columbia Pictures offered him a contract, and Lorre moved to Hollywood, making films for the major studios. What made all of Lorre's characters memorable was the subtle and threatening edge he gave them. Even when starring in second-rate movies, he often guaranteed the performances' successes. His most productive and popular period was the early 1940s when he was featured regularly in suspense and adventure films. His most memorable roles were with Humphrey Bogart playing Joel Cairo in *The Maltese Falcon*

173

and Ugarte in *Casablanca*. ✎ While in his twenties, Lorre had been seriously ill and consequently developed an addiction to morphine, a dependency he was never able to overcome completely. By the time he was in his fifties, the dependency affected his health and his work. He died of a stroke in 1964 at the age of fifty-nine.

PETER LORRE *The large sign on the driveway outside of his home read "Beware of Ferocious Dogs." They turned out to be two frisky Pekingese. The movie legend of Peter Lorre was that of the timorous, sometimes menacing, sometimes bumbling, sidekick of the archvillain. He turned out to be a* gemütlich *Viennese gentleman of wit and culture. This photograph was taken after our dinner together. When I observed the effect of the lamp on his face, we agreed that it seemed to synthesize every character he played in American films.*

LOW, DAVID [58] The famous and influential political cartoonist, caricaturist and illustrator, David Low (1891–1963) was also most prolific. In a career spanning five decades, he produced over fourteen thousand drawings and was syndicated in over two hundred newspapers and magazines worldwide. Enormously popular, known for his wit, intelligence and political savvy, as well as for his sarcasm, Low once said, "If you are ever asked to write my epitaph, you can say 'Here lies a nuisance who was dedicated to sanity.'" The *New York Times*, in their tribute to him, wrote: "He will probably be best remembered for his more biting sarcastic cartoons. But he could be tender too in the face of tragedy. And who can measure the inspiration that some of the wartime cartoons, such as 'Very well, alone' must have been to the English people?" Low is most famous for the character Colonel Blimp, a walrus-mustachioed, stuffy character that represented everything he didn't like about British politics. ✎ Born David Alexander Cecil Low to Scottish-Irish parents in New Zealand, he attended high school, but as an artist he was self-taught, outside of a correspondence course and brief work at the Canterbury School of Art. At fifteen, Low, attracted to caricature and English comics, decided to become a cartoonist. Soon after, his drawings began to be published in magazines and newspapers, and he subsequently became a regular political cartoonist for the *New Zealand Spectator*. By eighteen, Low was working for the *Sydney Bulletin* in Australia, joining two other renowned cartoonists, Livingstone Hopkins and Norman Lindsay. His fame spread to London, and in 1919, he moved and remained there for the rest of his career. ✎ For twenty-three years, Low worked for Lord Beaverbrook at the *Evening Standard*. Beaverbrook was a staunch Conservative but had agreed to give Low complete editorial freedom to express his radical political views. Low once described his approach in caricaturing political figures he did not like, such as Hitler or Mussolini. He said, "To draw a hostile war lord as a horrific monster is to play his game. To throw a scare into simple victims is as valuable to him as a fleet of

bombers. What he doesn't like is being shown as a silly ass. . . ." ✎ Queen Elizabeth II knighted Low in 1962, and he died the next year at age seventy-two.

DAVID LOW *This is one of my favorite portraits; possibly because of the pleasure David Low's cartoons have given me; possibly because I feel that I have been successful in revealing both the in- and outwardness of the man. It was not a simple problem. Slight, with a pronounced Puckish expression, Low nevertheless looks more like a jolly, uncritical, middle-class businessman than one of the world's greatest political commentators – or the greatest master of caricature since Daumier. ✎ A portrait of him working at his desk for some reason proved unsatisfactory, but I finally made this shot which to me is the way he looks at the world and at his work. (The figure on the pedestal is Lenin.) ✎ We had a long talk together, and I discovered that his job verges on the monumental. He has to be news reporter, leader writer, artist, and caption writer all at once, and sometimes, political activity occurs so unexpectedly that a telephone call at midnight informs him of an event that he must highlight with a cartoon for the evening paper. He has built up his own network of information, on occasion better than the paper he works for. Many of his ideas, he said, come from listening to and joining conversations in London's pubs.*

MANDELA, NELSON [125] Nelson Rolihlahla Mandela (1918–) was born in Transkei, South Africa, the foster son of a Thembu chief. Raised in the traditional ancestral tribal culture, he learned at an early age the powerful oppression of apartheid and legalized racial segregation, and he dedicated his life to the fight against racial oppression. Mandela also learned from his guardian that successful leaders do not impose decisions – they help to mold them. ✎ Educated at University College of Fort Hare and the University of Witwatersrand, Mandela obtained a law degree in 1942. In 1944, he joined the African National Congress (ANC) and began resistance work against the ruling national party's apartheid policies. In 1956, he was charged with high treason, but the charges against him were eventually dropped. In 1958, he married Winnie Madikizela, who also became an activist in the campaign against apartheid. ✎ In 1960, the ANC was outlawed, and Mandela decided to go underground to continue his work and establish a military wing. Racial tensions grew, and in 1960, sixty-nine black people were killed. This marked the end of peaceful resistance as the ANC began efforts to destroy the South African economy. Mandela was arrested, charged with sabotage and attempting to overthrow the government. He used the trial to state his beliefs publicly: "I have cherished the ideal of a democratic and free society in which all persons live together in harmony and with equal opportunities. It is an ideal, which I hope to live for and to achieve. But, if needs be, it is an ideal for which I am prepared to die." ✎ In 1964, Mandela was sentenced to life in prison. During his incarceration, South Africa's black

children helped to sustain a resistance that was finally crushed, but not before hundreds were killed and thousands injured in the process. ✎ Nelson Mandela was released from prison in 1990. As a result of his efforts, pressure was put on the ruling regime, causing South Africa's president to lift the ban on the ANC. Mandela and de Klerk persisted in their negotiations, both committed to stopping the violence and killing. In 1993, both were awarded the Nobel Peace Prize. ✎ Five months later, South Africa held free and democratic elections for the first time. Nelson Mandela was elected president, and the ANC won 252 of the four-hundred seats in the National Assembly. He retired in 1997, passing on the presidency to his nominated successor, Thabo Mbeki.

MANN, THOMAS [73] German novelist Thomas Mann (1875–1955) was born in Lübek, the son of a wealthy trader and senator. Educated at the University of Munich, he prepared for a career as a journalist, studying history, economics, art history, and literature. While at the university, Mann developed an interest in the writings of Friedrich Nietzsche and Arthur Schopenhauer, and was also attracted to the music of Richard Wagner. ✎ Mann's writing career began with his contributions for *Simplicissimus*, a satirical weekly magazine. His short story "Little Herr Friedemann" was published in 1898, and his first novel, *Buddenbrooks*, was well received. In his early works, Mann focuses on the theme of creative artists challenged by the meaninglessness of existence. In 1905, he married, and his six children became literary and artistic figures in their own right. His book, *Royal Highness*, reflects his views on family obligation, duty, and sacrifice. His novella, *Death in Venice* was published in 1912, and in 1924 his novel, *The Magic Mountain*, was published after a decade of work. All of his major works were translated and published in the United States by Alfred A. Knopf. Mann was awarded the Nobel Prize for Literature in 1929. ✎ Apolitical by nature, Mann viewed politics as a diversion from his work, but the rise of the Nazis and Hitler compelled him to speak out. In 1930, he gave a talk in Berlin called "An Appeal to Reason," in which he appeals to the working class to fight against the "inhuman fanaticism of the National Socialists." The *New York Times* wrote, "With the rise of Nazism in 1933 and with the ruthless persecution that marked the Hitler regime, his political consciousness awoke. The more the Nazi movement grew, the more outspoken he became." In 1933, when Hitler assumed power, Mann and his wife moved to Switzerland and were warned by their children not to return to Germany. Mann was deprived of his German citizenship in 1936. ✎ In 1939, Princeton University appointed Mann a lecturer in the humanities, and he applied for U.S. citizenship. In 1942, the family moved to California, where they lived until after the end of the Second World War. Mann was naturalized as a U.S. citizen in 1944, but soon returned to Zurich for his remaining years, continuing to write until his death of atherosclerosis in 1955.

THOMAS MANN I had been intrigued throughout the sitting by the writer's hands. They seemed to reveal both his strength and his delicacy. I therefore made some studies of the hands alone, and eventually, when I submitted my pictures for Mann's inspection, he sent me back a letter, which is one of my most prized possessions. "The study of hands," he wrote, "is a highly remarkable piece of work and reminds me of a drawing by Albrecht Dürer." Mann, I think, would have made an excellent subject for Dürer, who admired men of power.

MANZÙ, GIACOMO [135] Giacomo Manzù (1908–1991), an Italian sculptor, was born in Bergamo. The son of a cobbler, he left school to apprentice for craftsmen who taught him to work with wood, metal, and stone. From age eleven, he worked for a woodcarver, a gilder, and a stucco worker. Manzù attended evening classes and obtained a degree in plastic art decoration from Gantoni Institute in 1927, but he remained essentially a self-taught artist. He moved to Milan in 1929 when he received a commission to decorate a chapel at Università Cattolica del Sacro Cuore. From that point on, he devoted his time entirely to sculpture. ∾ Manzù's early works were influenced by Egyptian, Etruscan, and medieval art. He then turned to a more Impressionistic style, owing much to the example of Rodin and Medardo Rosso. In 1934, he visited Rome, a trip that inspired him to concentrate on religious themes. In 1938, he sculpted his first figure of a cardinal. As an artist, Manzu said he regarded his sculptures as still lifes with no deeper significance than a plate of apples, representing "not the majesty of the church but the majesty of form." The series would ultimately comprise fifty sculptures of cardinals. ∾ Manzù was a communist, celebrated by the Soviet art world. He was also a Roman Catholic and a personal friend of Pope John XXIII, and he received liturgical commissions in St. Peter's, for which he created monumental bronze doors. In 1958, he completed a set of doors for Salzburg Cathedral, and, in 1968, another set for the church of St. Lawrence in Rotterdam. His later sculptures, such as *Dance Steps* (*Passi di danza*), *The Skaters* (*Pattinatori*), and *Lovers* (*Amanti*), included more intimate subjects. He also designed stage sets and costumes for Stravinsky's *Oedipus Rex*, Wagner's *Tristan und Isolde*, and Verdi's *Macbeth*. Manzù also worked as an etcher, lithographer, and painter. ∾ Giacomo Manzù was awarded the Lenin Peace Prize in 1965.

GIACOMO MANZÙ We discussed whether we might take some photographs of him and of his sculpture, Amici Manzù (The friends of Manzù) at a nearby museum. He adamantly refused; if he were going to be photographed, it was to be on his own soil.

MARCEAU, MARCEL [101] Marcel Marceau (1923–2007), master of mime (*l'art du silence*), transformed the genre and became its most popular representative. In 1999, Anna Kisselgoff wrote in the *New York Times*, "Mr. Marceau remains a model, not a fossil. Anyone who has never seen the staples of the repertory with which Mr. Marceau has toured the United States since 1955 should beat a path to his performances." ∾ In 1947, he created Bip, the clown who became his alter ego. Bip had a sad face, bright eyes, wore white face paint, dressed in a striped suit, and wore a battered opera hat with a red flower attached. He portrayed other characters, including a waiter, lion tamer, and an old woman knitting. Some of his works are *The Cage, Walking Against the Wind, In the Park*, and *The Mask Maker*. One of his pieces – *Youth, Maturity, Old Age, and Death* – was said to "depict more, in four minutes, the joy and pathos of life more succinctly and dramatically than many novelists and playwrights were able to do in hundreds of pages." ∾ Born Marcel Mangel in Strasbourg, Marceau and his family moved to Lille when he was young. They were forced to return to Strasbourg when France entered the Second World War. His father, a Jewish butcher, was captured by the Nazis and died at Auschwitz. Marcel escaped deportation, changing his last name to Marceau to hide his Jewish origins. He and his brother worked with the French Resistance to help save Jewish children from concentration camps. Of his father's death, he said, "Yes, I cried for him, but I thought of the others killed. Among those kids was maybe an Einstein, a Mozart, somebody who would have found a cancer drug. That is why we have a great responsibility. Let us love one another." ∾ His career began as an actor. In 1946, he studied in Paris at the Charles Dullin's School of Dramatic Art, where he met Jean-Louis Barrault and joined his company. His first acting role was that of Arelequin in the pantomime *Baptiste*, and his success led to an invitation to present his own "mimo drama." In 1949, Marceau took his art to the stage, and his mime troupe was unique in Europe. In 1955, he performed for the first time in the United States. ∾ Marceau was the author of two books for children and appeared on television and in film. He played a cameo of himself in Mel Brooks's *Silent Movie*, where, with the only speaking role, he uttered the single word "Non!"

MARCEL MARCEAU From the start, everything went badly in my attempt to photograph Marcel Marceau, the great French mime. I had arranged a sitting in Montreal in 1956, where I would stop on my way to the United States, but at the appointed hour I found that all my equipment had been shipped, by mistake, to New York. But, some weeks later, M. Marceau arrived there for further stage appearances, and a new appointment was set in my studio-apartment. I felt, after the Montreal fiasco, that I owed him unusual politeness, but, in my efforts to please him, let the situation get entirely out of hand. The actor had his own preconceived ideas about the portrait he wanted. In fact, as I was about to conclude the sitting I suddenly realized that I had been recording all those familiar poses, attitudes, and expressions that I had seen on the stage. To avoid this, I had asked him not to use his white face makeup, so that I could see the astounding mobility of his own face. In the concluding moments, I was compelled to be quite firm with him. Though he may have doubted their wisdom, he took my suggestions well. M. Marceau has definite theories of art and very particular preferences.

MARINI, MARINO [139] Marino Marini (1901–1980) began his career as a painter and sculptor. He said, "I always begin sculpting by painting. Afterward, the color image remains in my mind, so then I have to add color to the sculpture." Marini's sculptures were in clay with the finishes in bronze, wood, or terra cotta. Many of his works are brightly colored with blue and red dyes. ∾ Marini never became part of any avant-garde movement. He said, "For me Tuscany is the starting point, which is innate and is part of my being. My discovery of Etruscan art was an extraordinary event. This is why my art lies on themes from the past, as the link between man and horse, rather than on modern subjects like the man/machine relationship." ∾ Born in Pistoia, Italy, an area in Tuscany known for its Romanesque sculptors, he began his art career in Florence, studying painting and sculpture at the Accademia di Belle Arti. He painted, sculpted, and traveled to Paris to learn styles and techniques. By 1922, he was drawn to Etruscan art and sculpture and was particularly influenced by Arturo Martini. In 1929, Marini left Florence for Milan, succeeding Martini as a professor of sculpture at the Scuola d'Arte di Villa Reale, in Monza, near Milan. Marini observed, "Milan is the Italian city most closely tied to Europe. It has the same color as Europe, the same way of life, the same way of working. For me to be in Milan is to live in the heart of Europe." He remained in this position until 1940, teaching, but he also continued to sculpt, travel, and exhibit his own work. ∾ In 1988, the Marino Marini Museum was opened in Florence. The museum is housed in the restored ancient church, S. Pancrazio, which was established before the year 1000 and contains 180 of Marini's works.

MAUGHAM, WILLIAM SOMERSET [90] William Somerset Maugham (1874–1965), a well-known and prolific British writer of novels, plays, and short stories, was widely recognized for his literary achievements. While his writing was based on real-life events and experiences, some critics viewed his style as being unromantic and slightly cynical. Those who knew him best said he was a keen observer of human behavior. ∾ Born in France, his father was a solicitor to the British Embassy in Paris. He lost his parents at an early age and came to live in England with his uncle. Maugham attended The King's School, Canterbury, and Heidelberg University, where he studied literature and philosophy; he began to study medicine at St. Thomas' Hospital in London, becoming a doctor in 1897. Maugham felt that the years he dedicated to medicine were well spent. He said, "I saw how men died. I saw how they bore pain. I saw what hope looked like, fear and relief." He believed that his experiences and observations of

the full range of human emotion were critical to his success in literature. ∾ His first novel, *Liza of Lambeth*, published in 1897, was based on experiences he had attending women in childbirth while he was a medical student doing midwifery work in the slums of London. The novel was so successful that the first printing sold out in weeks. The successes with his first book and *Mrs. Craddock* in 1902 made him decide to follow a literary career and forgo medicine. *Of Human Bondage* was published in 1915. It is an autobiographical story of a club-footed young man who is orphaned, raised by his aunt and uncle, and becomes a doctor. ∾ In 1917, Maugham married his mistress, Maud Gwedolen Syrie Barnardo, an interior decorator. That year, he was sent to Russia as an agent of the British Intelligence. During this tour of duty he met Gerald Haxton, who became his partner until Haxton's death in 1944. Maugham and Haxton traveled together across Asia, the Pacific Islands, and Mexico until 1926, when Maugham settled in the French Riviera and spent most of his days there. In his later years, he traveled and wrote *The Art of Fiction: An Introduction to Ten Novels and Their Authors*. In 1947, he started the Somerset Maugham Award, dedicated to celebrate young British authors.

SOMERSET MAUGHAM The face of Somerset Maugham – a deeply lined, wise, and almost ageless face – is as familiar to the world as are the writer's teeming works. Yet the man I discovered in the grand suite of a New York hotel in 1950 entirely surprised me. He was quite unlike the man I had expected from reading his stories and many articles about him. Apparently he had kept his appointment with me by interrupting his customary afternoon nap. The black eye-shield he wore at such times still dangled from his hand. Though he obviously would have preferred to rest (for he was, by then, an "old party," as he always told reporters), he gave me his whole attention and almost charmed me away from the business of the sitting. To begin with, his face was arresting – not handsome – in any conventional sense, but impressive, rather like the carved, wooden image of some tribal god in the South Seas where he roamed so often. The eyes were penetrating, almost hypnotic and intensely alive. That well-known expression of starkness (often taken for cynicism) broke frequently into the most engaging smile. To my surprise, Maugham, the realist, the hard-boiled skeptic, possessed an irresistible warmth. This made the work of the camera easy but did not help my other purpose. I wanted to ask him a thousand questions about his methods, his life, and his views, but after half an hour I realized that I, not he, was being interviewed.... I had the sudden vivid feeling that he viewed the human comedy with the objectivity of my camera.

MAURIAC, FRANÇOIS [80] French Nobel Prize-winning novelist, essayist, poet, playwright, and journalist François Mauriac (1885–1970) said, "I am a novelist who is a Catholic. With the aid of a certain gift for creating atmosphere, I have tried to make the Catholic universe of evil palpable, tangible, and odorous. If theologians provided an abstract idea of the sinner, I gave him flesh and blood." While Mauriac did not always agree with Sartre and Gide, the leading French intellectuals of the time, he was on good personal terms with them. After his death, Mauriac remarked, "I don't know whether Gide is in heaven or hell. But wherever he is, it must be very interesting." Of Sartre he said, "We got along like a cat and a dog, but he is a very fine man, nonetheless." ∾ Mauriac was born in Bordeaux, France, into a wealthy family, and his father died when he was eighteen months old. His devoutly Catholic mother, who emphasized the tenets of original sin, human weakness, immorality, the necessity of grace, and fate, raised him. Mauriac studied literature at the University of Bordeaux, graduating with a master's degree. He then went to Paris to study at the Ecole des Chartes, leaving school after a few months to pursue a literary career. His initial work was in poetry. When the First World War broke out, he stopped writing to serve in the Balkans for the Red Cross. ∾ After the war, Mauriac resumed writing and in 1922 published *A Kiss for the Leper*. In 1933, he was elected the Académie Française, the ruling scholarly body on matters pertaining to the French language. He wrote almost one hundred books, of which twenty-three were novels dealing with the problem of evil. In 1952, he was awarded the Nobel Prize in Literature and in 1958, the Grand Cross Legion of Honor. ∾ For the last thirty years of his life, Mauriac turned to journalism to communicate his political and personal views, and his writing was well-received. In his weekly opinion column, "Bloc-Notes," he expressed strong opinions, maligning whatever and whomever he found disagreeable. Some of his most passionately-held positions were his anti-Vietnam War stance, his strong support of Charles de Gaulle, and Algerian independence, and his condemnation of the use of torture by the French Army. His last novel was *An Adolescent from a Time Gone By*, written in 1970 at age eighty-three. ∾ Mauriac said, "I was brought up and lived in another world. As a child I did not know the cinema or electricity. I knew the old values. This is not my age. I am here as a stranger in this new world of the atomic bomb. We live in a polluted world now. It is time for me to go. The future is very, very black because these times sin against nature. Man should turn back to simple values."

FRANÇOIS MAURIAC It is quite absurd – I speak with strong conviction and somewhat bitter experience – to say that the French are a decadent race. How can they be when so many of them climb six flights of stairs several times a day? Indeed, most of the great Frenchmen I have photographed chose to live on the sixth floor, or higher, without an elevator – François Mauriac, the eminent and devout Catholic writer, for example. Such stamina and asceticism would be unthinkable in the vigorous New World. Since M. Mauriac could not be asked to come down from his Olympian heights, I and

my assistant were compelled to ascend, with all our heavy photographic equipment, in several breath-taking climbs. And then, after all the wires had been connected, there was no electricity! So we waited hopefully, on that day in 1949, for the Paris power. Since he lives by choice under such difficult conditions, I was not entirely surprised to find M. Mauriac sunk in profound pessimism. Apparently he saw nothing to encourage him in the state of the world and was entirely convinced that civilization must ultimately face a third, devastating war.... We had been talking for a long time, but still there was no electricity, and I was on the point of despair. Yet after climbing those endless stairs with all my photographic paraphernalia I did not intend to leave empty-handed and undergo the same ordeal a second time. On the off chance of success, I placed my subject before an open French door and against the grayest of Parisian skies. My assistant removed a sheet from the bed and held it up as a reflector. The resulting profile portrait, I feel, conveys François Mauriac's Gallic charm and perhaps something of his dark despondency about human affairs.

MIES VAN DER ROHE, LUDWIG [123] With no academic architectural education, Ludwig Mies van der Rohe (1886–1969) became one of the great architects of his age. Mies said that a building "should be a clear and true statement of its times." ∾ Born in Aachen, Germany, in 1886, he worked in his family's stone carving business before joining the design office of Peter Behrens, the most progressive architect in Germany. Beginning as an apprentice and exposed to modern design theories, he worked with the firm until 1912, while developing an approach to design based on advanced structural techniques. ∾ Mies worked independently after leaving Peter Behrens's firm, and he specialized in designing upper-class homes and projects, including the German Pavilion for the Barcelona Exhibition and Villa Tugendhat in Brno, Czechoslovakia. He became director of architecture for the Bauhaus design school. Opportunities for commissions dwindled with the worldwide depression after 1929. Nazi political pressure forced Mies to close the Bauhaus. ∾ He summed up his work with the dictum, "Less is more." He liked to see the elements of construction in his buildings, so rather than obscure the steel, brick, glass, and concrete with ornamentation, he let the elements be exposed. In 1922, he invented the concept of the Ribbon Window, a band of glass between two slabs of concrete on the face of a building, which became the basis for many commercial structures. His ultimate vision was what he called "skin and bones architecture," and he committed his life's work to achieving this ultimate degree of simplicity. Of his work he said, "The long path through function to creative work has only a single goal: to create order out of the desperate confusion of our time." ∾ By the time Mies came to the United States in 1937, his designs were famous. The postwar building boom combined with his move to Chicago helped to establish his worldwide reputation. ∾ As a teacher, Mies supported

a back-to-basics education. He insisted that architecture students learn to draw first, gain a thorough knowledge of the character and use of materials, and then tackle the principles of design and construction. He was quoted to have said, "First you have to learn something; then you can go out and do it." After twenty years as director of architecture at the Illinois Institute of Technology, Mies resigned his position in 1958. He received the Presidential Freedom Medal and the gold medals of the Royal Institute of British Architects and of the American Institute of Architects. The architect Eero Saarinen said of Mies, "Great architecture is both universal and individual ... the universality comes because there is an architecture expressive of its time. But the individuality comes as the expression of one man's unique combination of faith and honesty and devotion and belief in architecture."

LUDWIG MIES VAN DER ROHE His Chicago apartment was, paradoxically, in a most traditional building. Adorned with oil paintings by his friend Paul Klee and rows of Kurt Schwitters collages, his apartment was reminiscent of his Bauhaus background, a setting as pure and structural as [Mies] van der Rohe's revolutionary buildings of glass and concrete.

MOORE, HENRY [85, 143] Sculptor Henry Spencer Moore (1898–1986) preferred to see his work displayed as part of a landscape. Toward the end of his career, Moore was the artist most often requested when public artworks were required, and his sculptures are in more public places than any other sculptor in history. ❧ John Russell wrote in the *New York Times*, "In a world at odds with itself, Moore's sculptures got through to an enormous constituency as something that stood for breadth and generosity of feeling. They also suggested that the human body could be the measure of all things, for it was in terms of head, shoulder, breast, pelvis, thigh, elbow, and knee that Mr. Moore set the imagination free to roam across a vast repertory of connotations in myth and symbol.... Henry Moore also had a personal radiance to which few people – regardless of age, sex, race or language – were immune." ❧ Henry Spencer Moore was born in Castleford, Yorkshire, England. His father was a coal miner who read widely and escaped working in the mines by acquiring the skills necessary to become an engineer. His parents were determined that their children be well-educated so as to avoid working the mines of Castleford. Moore developed an interest in sculpting in elementary school, where he began to carve in wood and clay. After learning about Michelangelo, he decided to become a sculptor, though he initially trained to become a teacher. He served in France during the First World War and received a veteran's scholarship after the war. Moore studied art at Leeds School of Art and then pursued graduate courses at the Royal College of Art in London. He began studying artists and sculptors through their work in museums and galleries, traveling to Italy and Paris. He taught sculpture at the Chelsea School of Art to support himself and Irina Radetzky, a fellow student at the Royal College of Art whom he had married in 1929. He was thirty when he had his first solo show in London. ❧ In 1946, Moore made his first visit to the United States for a traveling exhibition that began at the Museum of Modern Art in New York. From 1950 on, he received countless commissions and produced almost a thousand sculptures and more than five thousand drawings and graphics. ❧ Moore worked until he was nearly eighty years old. His honors and awards included the Order of Merit and the Companionship of Honor from the Queen of England. In 1977, the Henry Moore Foundation was established to conserve his work and promote sculpture. At the news of his death, the *Daily Telegraph* wrote, "Since the death of Winston Churchill, Henry Moore has been the most internationally acclaimed of Englishmen, honoured by every civilized country in the world."

HENRY MOORE We went together over spacious lawns and hillocks populated by his monumental bronzes, photographing Moore with his sculptures. He commented frequently on the play of natural light on his work – a fascination he had adapted to the indoor Centre in Toronto. It was designed under his supervision to provide an easy flow of overhead light. ❧ Only after an aperitif, as we were sitting down to Irina Moore's delectable lunch, did we learn that their daughter Mary had been much in their thoughts all morning. The night before, on their way back from London, she and a friend had been victims of a hit-and-run driver. ❧ The Moores had been awakened at three a.m. to learn that Mary was in the hospital, with a severe gash in her forehead. With typical thoughtfulness, they withheld the news until our photographic session was over. As we were finishing dessert, Mary arrived home. To witness the Moores' concern for her friend and for Mary – the gift of their marriage, born only after seventeen years together, and the most important person in their lives – was a genuinely touching experience.

MOUNTBATTEN, LOUIS [54] Lord Louis Mountbatten (1900–1979), British naval officer and hero of modern British history, was best known for overseeing the defeat of the Japanese aggression toward India in the Second World War. The last viceroy of British India and first governor general of independent India, Mountbatten was born to nobility in Windsor. The German son of Prince Louis of Battenberg and Princess Victoria of Hesse was by blood and marriage related to many royal families in Europe, including Queen Victoria, who was his great grandmother. In 1917, the family changed their name from Battenberg to the less Germanic and more British-sounding Mountbatten. ❧ Mountbatten was primarily educated at home until 1914 when he attended the Royal Naval College at Dartmouth. He joined the British Navy in 1916, and participated briefly in the First World War before attending Cambridge University. ❧ At the start of the Second World War, Mountbatten was the captain in charge of the fifth flotilla destroyer and saw a great deal of action in the war. In 1941, his ship *Kelly* was damaged and repaired twice before being sunk by German dive bombers. Half the crew was lost. ❧ In 1941, Winston Churchill appointed Mountbatten head of Combined Operations Command, which launched a series of commando raids in Europe including the unsuccessful Dieppe Raid that resulted in thousand of casualties. In 1943, Churchill appointed Mountbatten the supreme allied commander of Southeast Asia Command where he worked with General Slim to defeat the Japanese offensive towards India and recapture of Burma, resulting in the Japanese surrender in 1945. ❧ In 1947, Mountbatten became viceroy of India. His orders were to oversee the British withdrawal from India and help to persuade Muslim leaders of the benefits of an independent country. Despite his good relationship with Nehru, Mountbatten was unable to unite the country, and British India was divided into India and Pakistan. Significant unrest followed in Punjab which comprised East India and West Pakistan, and, to this day, the area remains tense. In commemoration of his services during the war and in India, he was created Viscount and Earl Mountbatten of Burma. ❧ In 1953, Mountbatten returned to the Royal Navy as fourth sea lord commander of the new NATO Mediterranean fleet, and subsequently first sea lord, and chief of the defense staff. ❧ In 1979, Mountbatten and members of his immediate family were killed when his fishing boat was blown up near his summer home off the coast of County Sligo. The Irish Republican Army issued a statement taking responsibility for the execution, vowing to keep British intruders out of Ireland.

LOUIS MOUNTBATTEN This was among my first photographs during my wartime London trip. (I was to photograph Lord Mountbatten again in Canada and England.) During our session, Lord Mountbatten told me of his elation when a long-awaited prototype model of a new aircraft carrier was finally produced. Nothing would do but to show it immediately to the prime minister. To Mountbatten's question, "Where is the old man?" the reply was, "Old Man is in his bath." Rushing past Churchill's astonished valet, he came upon a soaking Churchill, understandably taken aback. But Mountbatten floated the little model in the bathwater, exclaiming, "We've got it at last, sir! This might well be the turning point of the war!" Churchill was all smiles. He proceeded to play with the floating model with childlike abandon, "as if it were a rubber duck."

MURROW, EDWARD R. [117] Edward R. Murrow (1908–1965) was, and remains, the symbol of courage and integrity in broadcasting. His career with the Columbia Broadcasting System (CBS) began in 1925 in radio and extended through the beginning of television in the 1950s. In his book *Edward R. Murrow: An American Original*, Joseph E. Persico wrote, "Murrow had talent, drive, intelligence, personality, and vision. Add to those qualities the power of his good looks – that piercing

177

gaze, those heavy furrowed brows, and that voice that seemed to resound from some inner sanctum. In sum, he added up to more than most of us." Joan Konner of CBS said of his reporting, "The power of his reporting was not the clue to his accomplishment. It was that he, in this and countless other situations, questioned the rules, challenged hypotheses, and followed his instincts to explore beyond the boundaries of broadcast journalism and to increase public knowledge and understanding." ❧ Born Egbert Roscoe Murrow in Greensboro, North Carolina, Murrow was poor and lived in a log cabin without electricity or plumbing. His family moved to Blanchard, Washington, when he was six, where his father worked on the railroad for the logging industry. Murrow was popular, did well in school, was president of the student body in his senior year, and excelled on the debating team. He attended the University of Washington, where he changed his name from Egbert to Edward and married. ❧ Murrow's radio career began during the Second World War, reporting from London. His first popular programs were rooftop radio broadcasts during the Battle of Britain in 1940. The *New York Times* described him as such: "Mr. Murrow, never fevered or high-blown, had the gift of dramatizing whatever he reported. He did so by understatement and by a calm, terse, highly descriptive radio style. Sometimes there was a sort of metallic poetry in his words." ❧ Murrow's first television program was *See It Now*, adapted from his radio program, *Hear It Now*. The program averaged three million viewers, was quickly moved to prime time, and was awarded four Emmys for best news or public service. Murrow's career took a turn when he challenged Senator Joseph R. McCarthy, the Wisconsin Republican who was conducting a mission against Communist sympathizers. On Tuesday, March 9, 1954, Murrow, in collaboration with his longtime friend and producer Fred Friendly, aired actual film clips of McCarthy in action, showing him as the demagogue he was. The reviews were favorable, and the program added to Murrow's status, as well as to McCarthy's demise. As the years went on, Murrow's style fell out of favor at CBS. He was moved to the less-confrontational position of host of the talk show, "Person to Person." In 1961, he left CBS to become director of the United States Information Agency for President Kennedy. He held this position until he died of lung cancer in 1965. ❧ David Halberstam wrote in *The Powers That Be*, "Murrow was one of those rare legendary figures who was as good as his myth." NBC's eulogy said, "His accomplishments as a reporter, his courageous devotion to duty so often at such great personal risk, and his loyalty to his ideals can never be forgotten by his friends, his colleagues, and his associates and his competitors."

EDWARD R. MURROW Not many men of our time are as familiar to the public of North America as Edward R. Murrow. We have all seen him, heard him, and made up our minds about him. Yet the man who sat before my camera was not, it seemed to me, the well-known figure of the television screen. To begin with, Murrow looks rather frail on television, invariably harassed and wrinkled with thought; his tall, athletic figure is usually lost in his public appearances because he slouches deeply in his chair, and his eyes are puckered not by anxiety or by stage fright, but by the glaring studio light. In life he is over six feet tall, an outdoor man who was brought up in the West Coast woods and hates big cities. Exceedingly modest, his idiom in private conversation is relaxed and easy. Still, there is earnestness about him.

NEHRU, JAWAHARLAL [121] An accomplished politician, orator, and author, Jawaharlal Nehru (1889–1964) was a world leader known worldwide as a peacemaker, but, most importantly, as the foremost leader of India and the patriarch of the Nehru-Gandhi family, the most influential force in Indian politics. He was a key figure in postwar international politics, a pivotal figure in the Indian independence movement, and the first prime minister of an independent India. ❧ Born in the city of Allahabad, along the banks of the Ganges River, his father, Motilal Nehru, was a member of the self-rule movement and a leader of the Indian National Congress Party, a national party committed to India's independence from British rule. Graduating from Cambridge University in England, Jawaharlal Nehru qualified as a barrister after two years and returned to India in 1912. ❧ In 1916, he married Kamala Kaul, and their only daughter, Indira Priyadarshini (Indira Gandhi), was born in 1917. Nehru met Mahatma Gandhi for the first time at the annual meeting of the Indian National Congress Party in Lucknow. Attracted to Gandhi's philosophies of peaceful civil disobedience, Nehru soon became Gandhi's ally and protégé. Traveling by train in 1919, Nehru overheard the British General Dyer dismissively comment on the massacre of Indians in Jallianwala Bagh. Nehru vowed to fight the British rule and in 1920 joined Gandhi's nonviolent noncooperation movement. ❧ Nehru was arrested for the first time in 1921 by the British and imprisoned. Over the next twenty-four years, Nehru spent more than nine years in jail. During this time he wrote several major works: *Glimpses of World History* (1934), *An Autobiography* (1936), and *The Discovery of India* (1946). The campaign of civil disobedience met with continued resistance from the British. Limited self-rule was eventually attained when the British Parliament passed the Government of India Act in 1935. In 1937, elections were held and the Congress carried seven of the eleven provinces. At this point, the leader of the Muslim League asked to form a coalition of Congress-Muslim League governments in some of the provinces. His request was denied, inaugurating the beginning of a long and hardened conflict between the Hindus and the Muslims, leading to the segmenting of India and the eventual formation of Pakistan. ❧ The Second World War exacerbated the division between India and Pakistan. The British declared that India would participate on the side of the Allies. The conflicts with the British continued, and in 1942 Gandhi resigned and designated Nehru as his political heir. In 1944, the British government agreed to an independent India, providing the Congress Party and the Muslim Party settled their differences. The House of Commons passed the India Independence Act in 1947, dividing Pakistan into east and west portions on both sides of India. Pakistan was declared independent, and India became a sovereign state later that year. ❧ In 1950, Nehru became India's first prime minister. He had ambitious plans to help India develop into an industrialized nation, and he played a major role in shaping its government and politics. ❧ Also active in international affairs, he promoted policies of nationalism, anticolonialism, internationalism, and positive neutrality, arguing for the admission of China to the United Nations. He also called for a détente between the U.S. and the Soviet Union. ❧ In 1964, Nehru died in office in New Delhi.

JAWAHARLAL NEHRU Seven years elapsed between my first portrait of Jawaharlal Nehru in 1949, and the second, in 1956. In that period, despite the cares of office and the Indian statesman's extraordinary schedule of daily work, he had changed little. The slight figure remained athletic, the delicate, ascetic features alert with sensitivity and yet with an iron determination. Few men among the great of this age have impressed me so much as this interpreter of the Western and Asiatic worlds. If Mr. Nehru is philosopher, statesman, and practical politician by turns, and no doubt a giant in history, his mood is often playful. He knows how to relax. If he did not, he would have collapsed long ago from his customary timetable of eighteen hours' work a day. Before he starts the day's business, he told me, he invariably performs the traditional exercises of yoga. ❧ At our second meeting he greeted me in the Government House, Ottawa, with mischievous severity. "Mr. Karsh," he said, "you have not kept your promise to visit India. I am disappointed in you." ❧ "Mr. Prime Minister," I replied, "as soon as I can afford the luxury of putting aside six months of my time, I shall avail myself of the opportunity to see your colorful land. It does not take long to know the leaders; it takes much longer to know the common man." ❧ "You are right," he replied, "With all my experience I cannot claim to know India myself." When I recalled his ready answers at a recent grueling press interview in Washington, he remarked, "All political questions are the same. They don't require any clairvoyance."

NOGUCHI, ISAMU [148] Isamu Noguchi (1904–1988) was a Japanese-American sculptor. He created a variety of work: stage sets, lighting, furniture, public architecture and sculpture, and gardens. In the 1930s, when artistic disciplines were divided, Noguchi's interdisciplinary work was trend-setting and radical. Ian Buruma said of Noguchi's work, "It was not a matter of superficial resemblances to traditional styles: it was in the spirit of his work: artisanal, utilitarian, and always

in search of simplicity." ∽ Isamu Noguchi was born to a Japanese father, a poet, and an Irish-American mother, a teacher and editor. They never married, as Noguchi's father had strong nationalistic feelings, rejecting both the American mother and her son. His mother raised him in Omori, Japan, until he turned thirteen, when he was sent to the United States to study. He graduated high school as "Sam Gilmour" and was accepted to study medicine at Columbia University. Noguchi realized that medicine was not his future and won a Guggenheim Fellowship to pursue sculpture in Paris where he studied with Constantin Brancusi. ∽ He returned to Japan to reunite with his father but was not well-accepted because of his half-American heritage. While there, he met and married a Japanese film star, Yamaguchi Yoshiko. In 1932, he returned to New York, working as a sculptor and portrait artist, commissioned by wealthy collectors. In 1930, he began to design stage sets for Martha Graham, leading to a collaboration and friendship that lasted for many years. This association brought about work developing stage sets for John Cage and Merce Cunningham's production of *The Seasons*. ∽ Noguchi's sculpture *Kouros* was first shown in a September 1946 exhibition in New York, and its popularity led him to win commissions for memorials, monuments, and a variety of industrial designs. Buckminster Fuller collaborated with him to investigate the ways people live in their environments, an approach that provided the basis for his outdoor work. ∽ Working for the Herman Miller furniture company, Noguchi collaborated with George Nelson, Paul László, and Charles Eames, to produce a furniture catalog. He created lamp designs for both Herman and Knoll. After the war, Noguchi participated with the Japanese paper lantern industry to create designs that allowed traditional lantern makers to make electrified versions of the traditional lanterns. ∽ As a landscape architect, Noguchi developed parks, playgrounds, and gardens, and a memorial garden to his father at Keio University. His large-scale works are in many cities, and include the ceilings of the Time-Life headquarters in New York. ∽ Noguchi continued to work until his death in 1988.

ISAMU NOGUCHI Whether the subject of America's best-known sculptor is a children's playground, a lamp, a chair, or a fountain, all partake of whimsical inventiveness. Prior to his death, Noguchi spent half the year in Japan and the other half in the United States, reinforcing his ties with both traditions of his Japanese and Irish-American heritage.

NORMAN, JESSYE [151] Jessye Mae Norman (1946–) was born into a family of amateur musicians. She started piano lessons at eight and developed her vocal skills by singing gospel songs at her church. She heard opera for the first time on radio and was immediately attracted to it, crediting Marian Anderson and Leontyne Price for being her inspirations. Earning a scholarship at Howard University, she graduated with a degree in music,

continued her studies at the Peabody Conservatory, and earned a master's degree from the University of Michigan. ∽ Norman moved to Europe to establish her career, making her operatic debut with the Berlin State Opera. The *New York Times* describes her as having "an amazing voice, a catalogue of all that is virtuous in singing." The *Jerusalem Post* wrote, "The immensity of her voice struck like a thunderbolt ... it was like an eruption of primal power." ∽ Her early years were spent establishing herself at opera houses in Germany, Italy, and London, with roles including Selica in Leyerbeer's *L'Africaine*, Countess Almaviva in Mozart's *Le nozze di Figaro*, Verdi's *Aïda*, and Cassandra in Berlioz's *Les Troyens*. In 1972, she made her U.S. debut with a concert version of *Aïda* at the Hollywood Bowl. In 1975, she moved to London and had no stage appearances for five years, saying she needed to fully develop her voice. ∽ In 1980, Norman returned to opera and sang in performances in both Europe and the United States. Since the early 1990s, she has made her home in New York and has accepted invitations to perform at important events, including the sixtieth birthday celebration of Queen Elizabeth II, the second inauguration of President Bill Clinton, and the funeral of Jacqueline Kennedy Onassis. ∽ Norman has received four Grammy Awards and the Kennedy Center Honor. In 2003, she opened the Jessye Norman School of the Arts in Augusta, Georgia, to provide a tuition-free program for talented middle school students to study music performance, drama, dance, and art, and a fellowship was established in her name at the University of Michigan. Norman was awarded the French Légion d'Honneur by President Mitterand, and was named honorary ambassador to the United Nations. She received the Eleanor Roosevelt Medal in recognition of her many humanitarian and civic contributions.

JESSYE NORMAN One moment she was a disciplined goddess and diva, adept at creating before my camera the illusion of imposing majesty befitting the operatic heroines she portrays. The next, relaxed and at rest between photographs, she was disarmingly girlish, enthusiastic, and free of prima donna pretense. She spoke of her magnificent voice almost as a separate entity – a unique God-given gift – to be cared for, protected, and, when necessary, mollified.

NUREYEV, RUDOLF [145] Rudolf Khametovich Nureyev (1938–1993) was probably the greatest male dancer since Vaslav Nijinsky. For thirty years he performed nearly every night. Jack Anderson of the *New York Times* wrote, "If the standard of male dancing rose so visibly in the West after the 1960s, it was largely because of Mr. Nureyev's inspirations. He showed dancers how to jump an extra measure higher and not to be afraid of the grand manner. The public flocked to see him and he was often compared with rock stars." ∽ Born on a train in Siberia, Nureyev was the only son in a Tatar family in a village near Ufa in Bashkiria, Russia. He was interested in dance and ballet as a

child, but did not enroll in ballet school until he was seventeen. In 1955, he was accepted at the Vaganova Choreographic Institute associated with the Kirov Ballet. When he graduated and signed with the Kirov, he became one of the Soviet Union's most popular dancers. In 1961, replacing a Kirov leading male dancer on a European tour, he was well received, his esteem becoming a concern for the KGB, who were afraid he might defect. Their fears were not misplaced: while in Paris, Nureyev claimed political asylum. ∽ After defection, Nureyev danced with the Grand Ballet du Marquis de Cuevas and made his American debut in 1962, appearing on American television and with Ruth Page's Chicago Opera Ballet. Nureyev joined the Royal Ballet of London as a permanent guest artist, leaving his options open to work with a variety of companies. Dancing with the Royal Ballet, Nureyev became Dame Margot Fonteyn's partner and danced with her in many roles in ballets such as *Swan Lake* and *Giselle*. They formed a lifetime friendship. ∽ Nureyev spent significant time on original choreography and on reviving nineteenth-century ballets from his days with the Kirov. His celebrity made him a fashionable choice for Hollywood film directors, and he appeared in several movies, including *La Sylphide*, *Don Quixote*, and *Valentino*. From 1983 to 1989, Nureyev was the artistic director of the Paris Opera Ballet. ∽ Rudolf Nureyev contracted HIV in the 1980s but denied that anything was wrong. Life and ballet were the same for him, and he refused to announce his retirement. He said, "The main thing is dancing, and, before it withers away from my body, I will keep dancing till the last moment, the last drop." In early 1990, he became visibly ill and had to face the fact that he was dying. He died soon afterward in 1993.

RUDOLF NUREYEV The celebrated dancer/choreographer was guest artist with the National Ballet of Canada and would shortly venture into his first film role, that of the great screen lover Rudolph Valentino. During our photographic session we cajoled each other about great lovers. "Let me see those sensuous lips of yours," I playfully suggested. Puckishly, mischievously, he covered his mouth, and smiled with his eyes.

O'KEEFFE, GEORGIA [108] Georgia O'Keeffe (1887–1986) is known for her abstract paintings of flowers, rocks, shells, animal bones, and landscapes. She was born in 1887 in a large farmhouse outside of Sun Prairie, Wisconsin, where her parents were dairy farmers who placed a high value on women's education. O'Keeffe loved art and took lessons as a young girl. Her talents were recognized and encouraged, and by the time she graduated from high school, she was committed to becoming an artist. ∽ Pursuing art studies at the Art Institute in Chicago from 1905 to 1906 and the Art Students League in New York from 1907 to 1908, O'Keeffe learned the formal approach to art, known as "imitative realism." Though she was successful and won the League's William Merritt Chase still-

life prize for her oil painting, she became discouraged, as she felt that she would never be able to succeed using this style. O'Keeffe quit painting and returned to Chicago to find work as a commercial artist. ◌ Returning to art four years later, she took a summer course at the University of Virginia, and found inspiration from Arthur Wesley Dow. His ideas offered her an alternative style to imitative realism. ◌ In 1916, Anita Pollitzer took some of O'Keeffe's drawings to Alfred Stieglitz's 291 Gallery in New York. Stieglitz was an internationally known photographer and art critic. He said, "At last, a woman on paper! The drawings were the purest, finest, and sincerest things that had entered 291 in a long time." Stieglitz and O'Keeffe began corresponding, and a relationship developed. In 1917, he offered her his gallery space for her first solo show, and in the following year he offered her a year's financial support to paint in New York. She accepted and moved there in 1918. Stieglitz decided to close 291 due to financial constraints. He said, "Well, I'm through ... but I have given the world a woman." O'Keeffe and Stieglitz fell in love in spite of the fact that he was twenty-three years older and married. Stieglitz divorced and married O'Keeffe. ◌ After moving to New York, O'Keeffe began painting primarily in oil. She said of her work, "Most people in the city rush around, so they have no time to look at a flower. I want them to see it whether they want to or not." During the twenties, she focused on painting both natural and architectural forms. Stieglitz would organize annual exhibitions of her work from 1923 until his death in 1946. ◌ In 1929, seeking new inspiration for her painting, O'Keeffe visited Taos, New Mexico. The trip changed her. In 1934, O'Keeffe visited Ghost Ranch and decided to buy the ranch, which became a popular guest retreat for her contemporaries. In 1945, she bought a hacienda in Abiquiú, which became the setting for much of her later work. ◌ In 1946, Stieglitz died of a stroke. O'Keeffe buried his ashes at the foot of a pine tree near Lake George and moved to New Mexico permanently in 1949, living at Ghost Ranch and the hacienda in Abiquiú. She continued to work in oil until the 1970s, when her failing eyesight forced her to abandon her painting.

GEORGIA O'KEEFFE As though to concentrate her vision inwardly, Miss O'Keeffe banished color from her surroundings. Her adobe home, with wide windows on every side overlooking the mountains, and almost completely empty of ornament, seemed stark to me, but when I asked Miss O'Keeffe why she chose to live in such a remote area, she replied, "What other place is there?" In the end I decided to photograph her as yet another friend had described her: "Georgia, her pure profile against the dark wood of the paneling, calm, clear; her sleek black hair drawn swiftly back into a tight knot at the nape of her neck; the strong white hands, touching and lifting everything, even the boiled eggs, as if they were living things – sensitive, slow-moving hands, coming out of the black and white, always this black and white."

OPPENHEIMER, J. ROBERT [116] J. Robert Oppenheimer (1904–1967), theoretical physicist, scholar, and linguist, was the director of the Manhattan Project, the Second World War effort to develop the first nuclear weapons. He was concerned about the power of the weapons and the problem scientists face when public interest and their own conscience conflict. From the time the test bomb exploded, Oppenheimer was haunted by the moral implications, saying it "dramatized so mercilessly the inhumanity and evil of modern war. In some sort of crude sense which no vulgarity, no humor, no overstatements can quite extinguish, the physicists have known sin; and this is a knowledge which they cannot lose." ◌ Oppenheimer was born in New York City; his parents were wealthy German textile merchants. He entered Harvard intending to study chemistry but changed to physics. In 1926, he went to the University of Gottingen to study under Max Born, and at twenty-two he obtained his doctorate. Together, Oppenheimer and Born helped lay the foundation for the modern theory of quantum behavior of molecules, or the study of atoms. ◌ In 1928, Oppenheimer entered a research program at the California Institute of Technology and then accepted an assistant professorship at the University of California, Berkeley. For the next thirteen years, he worked jointly at the universities. His work predicted the neutron, positron, meson, and neutron stars, and his research encompassed astrophysics, nuclear physics, spectroscopy, and quantum field theory. He studied the theory of cosmic ray showers and was the first to write papers suggesting the existence of "black holes." ◌ Though he was totally consumed with his scientific work, the rise of fascism in the 1930s frightened him, and he took a political stand against it. In 1939, the Germans split the atom, creating the possibility the Nazis could develop nuclear weapons. ◌ President Roosevelt established the Manhattan Project in 1941 to create the atomic bomb, and Oppenheimer was appointed its director. On July 16, 1945, the first atomic bomb was successfully tested in the New Mexico desert. Oppenheimer said, "We knew the world would never be the same." ◌ At the end of the war, he was appointed chairman of the United States Atomic Energy Commission, and he recommended against developing a hydrogen bomb, which he believed was morally wrong. When President Truman overruled the committee and approved the development of the hydrogen bomb, Oppenheimer complied, but because of his reluctance and the heightening of anticommunist feelings in the U.S., the political climate turned against him. Accused of having communist sympathies, his security clearance was revoked, ending his influence on national science policy. He took a position at Princeton's Institute of Advanced Study, where he wrote extensively on the dilemma of intellectual ethics and morality. ◌ In 1962, President Kennedy offered Oppenheimer recognition for his contributions by inviting him to a dinner of Nobel Prize winners at the White House. And in 1963, President Johnson awarded him the highest award of the Atomic Energy Commission, the Fermi Award. In his acceptance speech, Oppenheimer said to President Johnson, "I think it is just possible, Mr. President, that it has taken some charity and some courage for you to make this award today."

J. ROBERT OPPENHEIMER The atmosphere of that sitting was not all somber. For I had noticed with fascination an oddly shaped pork-pie hat hanging on a peg, the last sort of hat you would expect to see on the head of a sober scientist. The story of that hat tells us something of the other Oppenheimer. He had been presented, he told me, with one of those huge ten-gallon cowboy hats from Texas and, thinking the brim far too wide, had cut it down with a pair of scissors. The result could hardly be called a sartorial triumph. I was happy to see, however, that this scientist, harassed by personal difficulties and, by his knowledge of mankind's peril from the discoveries of science, could make a joke of his own. Indeed, I asked him to wear this whimsical headpiece. He did so with a laugh, and I photographed him thus to record the thinker's lighter side. But I was aware, of course, that the world of Oppenheimer, behind the genial smile and schoolboy joke, was something like a hundred light years away from my world, or that of any layman.

PICASSO, PABLO [103] Pablo Ruíz Picasso (1881–1973) had a career that spanned seventy-five years, during which he created tens of thousands of paintings, prints, sculptures, and ceramics. Ann Morrison wrote in *Time*, "For most of his life, Pablo Picasso was an international, media-magnified celebrity – 'the world's greatest painter.' He was charming (women loved him; he mistreated them), controversial (in his personal life as well as his art) and enormously productive (creating more than 20,000 paintings, drawings and sculptures). In short, said critic Robert Hughes, Picasso was 'the artist with whom virtually every other artist had to reckon.'" ◌ Picasso was born in 1881 in Málaga, Spain. His father was an art and drawing teacher who recognized his son's talent at a very young age. Picasso entered the Barcelona School of Fine Arts at the age of fourteen, but his father was his primary artistic influence. He attended college at the Academy of Arts in Madrid but left after one year. He moved to Paris in 1904 and became part of the community of famous artists, such as Henri Matisse, Joan Miró, and Georges Braque. His circle of friends also included two art dealers, Ambroise Vollard and Berthe Weill. ◌ Picasso's style and work developed constantly over many decades and is often divided into periods: the blue period (1901–1904), rose period (1905–1907), African-influenced period (1908–1909), analytical cubism period (1909–1912), synthetic cubism period (1912–1919), neoclassical period (early 1920s), and surrealism period (mid-1920s–1930s). ◌ The Spanish Civil War had a profound effect on Picasso. His feelings about the war culminated in *Guernica*, a large canvas painting that embodies the inhumanity, brutality, and hopeless-

ness of war. *Guernica* hung in New York's Museum of Modern Art until 1981, when it was transferred to the Prado Museum in Madrid. Picasso would not allow the return of *Guernica* to Spain until the end of the rule of fascism under Franco. ∾ In 1965, Picasso underwent a surgery that weakened him, though he continued his work in painting, drawing, prints, ceramics, and sculpture, until his death in 1973. At the news of his passing, Henry Geldzahler, Metropolitan Museum of Art curator, said, "His work will live on and cast its spell on younger artists. The implications of what he's done haven't been worked out. His greatness was in throwing out ideas, in never repeating himself."

PABLO PICASSO A remarkable artist who has kept the world of art on tiptoes and in a state of nervous exhaustion for years, he had the rare quality of simply not caring. Especially about appointments. My own experience was different. When I reached his home in time for our arranged appointment in 1954, I found him out, but he had been delayed by the arrival of relatives at the airport. When he arrived, we made a new appointment, at a local gallery where his ceramics were on display. At the gallery, I found everybody skeptical about my appointment: they assured me that it would be futile to set up my equipment since Picasso so seldom kept his engagements. However, I stood firm, and, to everyone's amazement, the man whose every act is sensational caused yet another sensation by arriving exactly on time. Moreover, he had dressed up for the occasion. His magnificent new shirt made the attendants shake their heads in wonderment: whatever had come over the old lion? A final surprise was in store. Picasso declared that he had seen my work, and it interested him greatly. I would have taken this for mere flattery, in atonement for the previous day's delay, if he had not cited many of my portraits, which evidently he had remembered. The sitting went smoothly, yet I am sure that such normality on his part was highly abnormal. ∾ During a talk about his work, Picasso argued that the true norm of art must vary with every artist. Each has his own laws. For this reason he objected strenuously to the legend of his artistic anarchy. His work was constructive, not destructive. He was a builder, not a destroyer. If people thought differently, that was because they didn't understand what he was trying to do. He was, in fact, trying to express his vision of reality, and if it differed from other men's visions, that was because any reality was real only to one man. It differed, for better or worse, in every human mind. Art, he said, began with the individual. Without him, there could be no art. With countless individuals there would be countless versions of art, of reality.

PLISETSKAYA, MAYA [96] The Bolshoi Ballet star Maya Mikhailovna Plisetskaya (1925–) was highly recognizable. Offstage, her red hair and stunning beauty generated instant glamour. On stage, she possessed a passion and fierceness that, combined with her long limbs, high jumps, ability to suspend in the air, extreme flexibility and strength, made her special indeed. Plisetskaya's

signature pieces were *The Dying Swan*, Odette-Odile in *Swan Lake*, and Aurora in *Sleeping Beauty*. Her long arms had a fluidity that to this day remains unmatched. She changed the world of ballet by raising the standard of technical ability and stage presence. In celebration of her eightieth birthday, the *Financial Times* wrote in tribute: "She was, and still is, a star, ballet's *monstre sacre*, the final statement about theatrical glamour, a flaring, flaming beacon in a world of dimly twinkling talents, a beauty in the world of prettiness." ∾ Born in Moscow to a well-known Jewish family of artists, Plisetskaya's father was an engineer, and her mother was a silent-film actress. Her father was executed as a traitor during one of Stalin's purges, and her mother and younger brother were sent to a labor camp. Plisetskaya was raised by her maternal aunt, the classical ballerina and choreographer Sulamith Messerer. She studied with the famous ballerina, Elizaveta Gerdt, first performing at the Bolshoi Theater when she was eleven. She joined the Bolshoi in 1943 and remained there until 1990. ∾ Despite her fame, Plisetskaya was not permitted to travel outside Russia for years after joining the Bolshoi. As the daughter of a "traitor," she was never free from the scrutiny of the KGB. In 1959, Khrushchev granted her permission to make her first trip, and the outside world had the chance to see and appreciate her performances. ∾ Plisetskaya married the composer Rodion Shchedrin in 1958, and the couple spent most of the 1980s abroad. She worked as the artistic director of the Rome Opera Ballet and the Spanish National Ballet of Madrid, retiring from the Bolshoi at age sixty-five and presiding over international ballet competitions. She was also named president of the Imperial Russian Ballet.

MAYA PLISETSKAYA Plisetskaya was often asked why, in the face of so much humiliation, she never defected. Her answer: the Bolshoi stage. She said, "I awaited my music, my cue with a shiver of joy, a feeling of incomparable happiness spreading throughout my body. Three more bars. Two more. One more. There. My music. I step out onto my stage. It was a familiar creature, a relative, an animate partner. I spoke to it, thanked it. Every board, every crack I had mastered and danced on. The stage of the Bolshoi made me feel protected; it was a domestic hearth."

POMPIDOU, GEORGES [127] Georges Jean Raymond Pompidou (1911–1974) was a French statesman, political leader, prime minister, and president. Born in Montboudif, France, he was the son of a schoolteacher. He graduated from Ecole Normale Supérieure and then taught literature in Marseilles and Paris. He served in the Second World War until 1940, when he returned to teaching. In 1944, he served on the staff of General de Gaulle. ∾ De Gaulle remained in touch with Pompidou and in 1958 asked Pompidou to be his personal assistant. In this capacity, he worked to prepare France's economic recovery and to draft the constitution of the Fifth Republic, which replaced

the parliamentary government with a semi-presidential system. ∾ During the Algerian crisis, Pompidou led a mission to conduct secret negotiations that led to the cease-fire. After this, de Gaulle appointed Pompidou prime minister, a continual nomination as he was not a member of the National Assembly. It was initially defeated until de Gaulle dissolved the Assembly. The Gaullists won the election, and Pompidou was reappointed prime minister, a position he held under de Gaulle from 1962 to 1968. ∾ Pompidou helped resolve the French student-worker revolt of May 1968, participating in negotiations that ended the strikes and restored law and order. His success contributed to the election of the Gaullist majority in the National Assembly in 1968. After the election, Pompidou resigned due to strained relations with de Gaulle. When de Gaulle resigned abruptly in 1969, Pompidou announced his candidacy and won the election. ∾ During his term as president, Pompidou devalued the franc and implemented a price freeze. He had plans to modernize cities, develop industrialization, and build a new museum for contemporary art. He helped the United Kingdom join the European community (EEC) in 1973 and strengthened economic ties with Arab states. ∾ Despite rumors about his health, Pompidou remained in office until his death by cancer in 1974.

GEORGES POMPIDOU With its elegant furnishings and spacious interiors, the Élysée Palace has always been one of my favorite settings in which to photograph French officials. Georges Pompidou, who was then president of France, proudly displayed in the Élyseé the work of contemporary French artists alongside traditional eighteenth-century paintings and sculptures. I was delighted when the new museum of modern art was named the Pompidou Center in his honor.

THEIR SERENE HIGHNESSES, PRINCE RAINIER III AND PRINCESS GRACE OF MONACO [111] For fifty-five years, Prince Rainier III (Rainier Louis Henri Maxence Bertrand Grimaldi, 1923–2005) reigned as Prince of Monaco, though he may be better known for marrying Grace Kelly. Rainier's family, the Grimaldis, had ruled Monaco since 1297. During Rainier's reign, Monaco enjoyed considerable prosperity, evolving into a vacation destination and a tax haven. He was responsible for reforms to the constitution and for economic expansion. The *New York Times* wrote, "Rainier ran his country with an iron hand and police surveillance. There was virtually no crime and no unemployment. The Monaco that Somerset Maugham described as 'a sunny place for shady people' became a place where suspicious-looking characters were not welcome." ∾ Educated in England, Switzerland, and France, he obtained a bachelor of arts degree from the University of Montpellier. During the Second World War, he served as an artillery officer, winning the Croix de Guerre and Bronze Star, and he was given the rank of Chevalier in the Légion d'Honneur. In 1949, he succeeded to the throne

when his mother renounced it in his favor. ❧ He was determined to restore Monaco's ruined financial position, made more desperate by the war, to make it attractive and accessible to the middle class. Rainier's health progressively declined for the last three years of his life, and he died at the age of eighty-one. ❧ Princess Grace (1929–1982) was born Grace Patricia Kelly in Philadelphia. She was an Academy Award-winning film and stage actress, beloved in her own country, who married Prince Rainier in 1956 to become Her Serene Highness The Princess of Monaco. ❧ She attended the American Academy of Dramatic Arts in New York City, and her first major role was in *High Noon*, starring opposite Gary Cooper. Kelly met Alfred Hitchcock in the early 1950s, and with him as her mentor, she starred in *Dial M for Murder* and *Rear Window*. She was nominated for best actress in a supporting role for *Mogambo* in 1953 and was awarded an Oscar for best actress in a leading role for *The Country Girl* in 1954. ❧ In 1955, while she was in Cannes at the film festival, she met Prince Rainier. They had a very short and highly publicized courtship and engagement. The 1956 wedding was called "The Wedding of the Century." Alfred Hitchcock remarked he was "very happy Grace has found herself such a good part." ❧ Princess Grace never returned to the screen after her marriage, but she brought charm and elegance to her royal role. Vincent Weylan, editor of *Point de Vue*, said, "The day Prince Rainier married Princess Grace – one of the world's most famous and beautiful women – was the day Monaco was born on the international stage."

PRINCE RAINIER AND PRINCESS GRACE
To the world public, I judge, Their Serene Highnesses of Monaco represented the latest and most vivid version of Prince Charming and Cinderella.... This photograph was made in their New York apartment in 1956. The Princess herself took me there ahead of time, and together we selected the background for the sitting. The dining room was chosen because it offered the most space. We inspected the Princess's wardrobe, and she obligingly wore the gown I liked best. Her charm and loveliness were not immediately apparent the morning of the sitting, for she had her hair in pin curls. Unconcerned, she went about her business until I asked her to go before my lights. Then, quickly removing the pins, she brushed out her hair with a few strong strokes. I have never seen anything so fresh and alluring. It was like a cool breeze. The Prince talked freely and, to my surprise, was completely at home with American English. The happiness of this couple, who have become the symbol of romance the world over, was evident. This portrait shows, I think, the radiant beauty of the woman, the strong, clean-cut profile of the man.... The Prince and Princess seem to like it as well and asked permission to use it as a stamp in their little country ... the stamp, you might say, of domestic felicity.

ROCKWELL, NORMAN [98] Norman Rockwell (1894–1978) characterized himself as a commercial illustrator and was hesitant to call his work art.

Rockwell had the ability to create visual stories that told of America's desires and captured the heart of the American spirit. As he once said, "I paint life as I would like it to be." ❧ Born in New York, Rockwell left high school to attend art school, graduating from the Art Students League. After graduation, he was as an illustrator for *Boys' Life* magazine. Soon after that, he began to design covers for the *Saturday Evening Post*. During the forty-seven years that he worked for the *Post*, he created 321 covers portraying American life and values. In 1920, he began painting the calendar for the Boy Scouts of America and continued to do so for the rest of his life. ❧ Rockwell enlisted in the Navy during the First World War and was given the job of military artist. In 1942, in response to a speech given by President Franklin Roosevelt, Rockwell painted the *Four Freedoms* series: *Freedom of Speech, Freedom to Worship, Freedom from Want,* and *Freedom from Fear*. Throughout the 1940s, the paintings traveled around the country and were exhibited in conjunction with the sale of bonds. ❧ His painting from the 1960s called *The Problem We All Live With* depicts an African American schoolgirl being escorted to school by police officers. In the background is a wall smeared with tomatoes that had been thrown at her. ❧ In 1963, Rockwell left *The Saturday Evening Post* and took a position with *Look* magazine. During his ten-year career at *Look*, he expressed his views about civil rights and the war on poverty. Rockwell said, "For forty-seven years, I portrayed the best of all possible worlds – grandfathers, puppy dogs – things like that. That kind of stuff is dead now, and I think it's about time." *Southern Justice*, which portrays the horrors endured by three young civil rights workers in Mississippi who were fighting for equality, was painted during that stage of his career. ❧ In 1976, Rockwell published his last work for the cover of *American Artist*. He painted himself draping a happy birthday flag on the Liberty Bell in honor of the two hundreth anniversary of the Declaration of Independence. In 1977, President Gerald Ford awarded Rockwell the Presidential Medal of Freedom, citing his "vivid and affectionate portraits of our country." During his time, Rockwell was commissioned to paint the portraits of Presidents Eisenhower, Kennedy, Johnson, and Nixon. ❧ Norman Rockwell died of emphysema at age eighty-four, with an unfinished work on his easel.

NORMAN ROCKWELL He was enthusiastic in 1956 on hearing that I wished to photograph him and sent a car from Stockbridge, Massachusetts, to fetch me from New York. On reaching his studio, I found a note on the door telling me: "Please come in and make yourself at home. I will be back at one." My host arrived shortly afterwards, took me to lunch with some of his friends, and then we got down to work. I wanted to emphasize one of his famous Four Freedom *paintings as originally published in the* Saturday Evening Post, *and we chose* Freedom of Religion *[sic] to appear in the background of my portrait. ❧ Mr. Rockwell seemed intensely interested in my methods, and I soon realized that pho-*

tography is an essential ingredient of his own art. He told me he employed a regular photographer who, upon his instructions, took pictures of suitable candidates for his paintings. These pictures, blown up to the right size, are pasted over one another or placed in juxtaposition until the painter has exactly the joint effect he wants – a kind of collective model, I suppose. The characters distilled by his brush follow no particular tradition, he told me, but only "human interest" and a very cheerful realism. The artist should be an entertainer, not a crusader. ❧ For himself, he had very pleasant views on life, which his work reflected. In short, he painted people as he saw them. "I'm no Goya," he added. Was art endangered by commercialization? "It's part of the age," he replied. "Everything is commercialized." There was danger, he admitted, when an artist was pressured into repeating his successful subjects, but, he said, "I do just what I like to do and people seem to like it also. I don't think I'm selling myself down the river." I asked him if technique could be exalted over integrity. "Technique," he retorted, "is a matter of self-expression. If integrity goes, technique alone cannot save it."

RODGERS, RICHARD AND HAMMERSTEIN, OSCAR [87] *Oklahoma!* opened on Broadway in 1943, the first collaboration between composer Richard Charles Rodgers (1902–1979) and librettist Oscar Hammerstein II (1895–1960). The two maintained a creative partnership for seventeen years, writing nine musicals, one musical for film, *State Fair*, and the television special *Cinderella*, starring Julie Andrews. Their work resulted in thirty-five Tony Awards, fifteen Oscars, two Grammys, two Pulitzer Prizes, and two Emmys. ❧ Richard Rodgers was born on Long Island, New York, in 1902, and grew up admiring the musicals of Jerome Kern. Rodgers attended Columbia in 1919 and developed a partnership with Lorenz Hart, writing the music to Hart's lyrics. Their first show, in 1920, was *Fly Me*. In 1925, Rodgers and Hart had their first major hit with *The Garrick Gaieties*. Based on this success, they continued to work together for twenty years until Hart died in 1943 at the age of forty-eight. ❧ Oscar Hammerstein was born in New York City in 1895. His father was a theater manager, his grandfather a famous opera producer. He was drawn to the stage at a very young age. Hammerstein attended Columbia and produced a variety show as an undergraduate. After attending law school for a year, he went on to become a lyricist for operettas, collaborating with Jerome Kern on eight musicals, including *Show Boat*. ❧ Rodgers and Hammerstein's partnership began after their success with *Oklahoma!* The combination of Rodgers's musical comedy and Hammerstein's operatic background led to a long string of musicals. Andrew Lloyd Webber said, "What sets the great Rodgers and Hammerstein musicals apart for me is their directness and their awareness of the importance of construction in musical theater. Years ago, I played through the piano score of *South Pacific*. It is staggering how skillfully reprises are used as scene-change music that sets up a following number or underlines a

previous point. It could only be the product of a hugely close relationship in which each partner sensed organically where the other, and the show, was going." *The Sound of Music* won the Oscar for best picture in 1965. ∽ Oscar Hammerstein died in 1960, and Richard Rodgers continued to compose for the stage. He died in 1979. In 1999, they were jointly commemorated on a United States postage stamp.

RICHARD RODGERS & OSCAR HAMMERSTEIN
We spent some pleasant minutes chatting about their work, and, since I am one of their admirers, conversation was easy. I must say, though, that when Mr. Hammerstein arrived, I was a little taken aback. How could two such men so utterly different in physical appearance and in bent of mind possibly combine their talents – and without any of those private feuds and public brawls that unhappily disfigured the partnership of Gilbert and Sullivan? The sitting had not been under way long, however, before I realized that the two diverse characters complemented each other. Their unlikeness fit together perfectly and produced the complete results that have given so much pleasure throughout the world. But you would not think, at first, to look at them, that these men could write the haunting music now almost their trademark, or the lyrics illuminating with wit or a touch of tears the foibles, sometimes the heroism, and always the wistfulness of our time. The harmony of their work together appears, I hope, in their joint portrait – the portrait of a musician and of a writer. . . .

RUSSELL, BERTRAND [79] Bertrand Arthur William Russell, Third Earl Russell(1872–1970), a British author, philosopher, logician, social critic, mathematician, and teacher, was among the founders of analytic philosophy and symbolic logic. He was also a social activist, championing causes such as pacifism, free trade, anti-imperialism, and nuclear disarmament. ∽ Born in 1872 and orphaned at the age of three, Russell was raised by his grandmother and educated at home. In 1890, he entered Trinity College, Cambridge, earning degrees in both mathematics and moral science. In 1900, while doing research, Russell became acquainted with the Italian mathematician Peano, whose work inspired him to write *The Principles of Mathematics*. ∽ Russell was a moralist and a rationalist from the school of classical British empiricism, in the tradition of Locke and Hume. They posited that the mind is a *tabula rasa*, or clean slate, on which experiences develop knowledge. ∽ After the First World War broke out, Russell was terminated at Trinity College for siding with conscientious objectors. Harvard offered him a post, but he was denied a passport for political reasons. Initially prevented from publishing *Political Ideals* by military authorities, he was sentenced to prison for writing a pacifist article in 1918. He campaigned for free trade and women's suffrage, ran for Parliament in 1907, 1922, and 1923, but was never elected. In 1938, he traveled to the United States, where he taught for several

years. He was offered an appointment at City College of New York, but it was revoked after a judicial decision found him morally unfit to teach because of his controversial writing. ∽ In 1949, Russell was awarded the Order of Merit for Distinguished Service. He was awarded the 1950 Nobel Prize for literature "in recognition of his varied and significant writings in which he champions humanitarian ideals and freedom of thought." During the 1950s and 1960s, Russell inspired war objectors. He and Albert Einstein wrote the Russell-Einstein Manifesto that demanded a reduction of nuclear weapons. He remained socially and intellectually active until his death at the age of ninety-seven.

BERTRAND RUSSELL "Happiness," *said the most controversial and certainly the most impish of modern philosophers, "comes from pandering to one's self-esteem." I judged from the gleam of mischief in Lord Russell's eye that this was likely to prove a controversial sitting. I was wrong. My subject delighted in tilting with intellectual giants, and expressed a profound and almost terrifying pessimism, but was quite amenable before the camera. Still, to be with Bertrand Russell was disconcerting. He distracted me with his dark thoughts when my mind should have been on my work.*

SANDBURG, CARL [91] A poet, historian, novelist, and writer of folklore, Carl Sandburg (1878–1967) was called "the singing bard." H. L. Mencken called Sandburg "indubitably American in every pulse beat." ∽ Born in Galesburg, Illinois, a child of Swedish immigrants, Sandburg worked from the time he was thirteen. His father was a blacksmith for the railroad. Sandburg quit school after his eighth-grade graduation, taking odd jobs to help support his family. In 1898, the Spanish-American War broke out, and Sandburg enlisted. He entered Lombard College in Galesburg after returning home from the war and majored in the classics. ∽ Concerned with the problems of the American worker, he began to adopt socialist views. Sandburg moved to Wisconsin and worked as a journalist for the *Milwaukee Leader* and as an organizer for the Wisconsin Social Democratic Party. In 1908, he married Lillian Steichen, a socialist, teacher, and sister of the photographer Edward Steichen. In 1913, they moved to the Chicago suburbs, where Sandburg worked as an editor for a business magazine and a socialist journal. ∽ Sandburg's *Chicago Poems* was published in 1916. In 1919, he joined the staff of the *Chicago Daily News*, where he worked as a journalist for thirteen years. In 1922, he wrote and published *The Rootabaga Stories*, a book of children's stories originally written for his own daughters. A collector of folklore and songs, he published a collection of folk songs that he had learned from his jobs with railroad workers, lumberjacks, hobos, convicts, and farm workers. Sandburg's two-volume biography of Abraham Lincoln, *Abraham Lincoln: The Prairie Years*, was published in 1926. He followed it with a four-volume series, *Abraham Lincoln: The War Years*, and he spent thirty years document-

ing Lincoln's life. ∽ Sandburg won *Poetry* magazine's Levinson Prize as well as three Pulitzer Prizes, for *Abraham Lincoln: The War Years*, and for his poetry collections *Cornhuskers* and *The Complete Poems of Carl Sandburg*. In 1945, Sandburg moved to North Carolina, working as a farmer, writer, and folksinger. His ashes are buried at a memorial in Galesburg, Illinois.

CARL SANDBURG The sitting for this portrait of Carl Sandburg was brief, for he could spare only a few minutes in 1954 in my New York studio apartment for a portrait, and less for conversation. Still, the tall, broad figure, the massive, roughcast face, the clear eyes, and the mane of white hair falling across the forehead must delight any photographer. One might be photographing a more-than-life size statue carved by a sculptor. I knew something of the life which had produced this impressive personage and I deeply admired it. Sandburg is, and looks, a self-made man. The poverty of his childhood – he left school at thirteen to help support his family – the years of labor as a dishwasher, bricklayer, harvester, and jack-of-all-trades are written clearly on his face and are expressed in his speech. He was blunt to me but friendly. He placed himself completely at my disposal. "I'm your puppet," he said. He didn't like my electric lights, however. They hurt his eyes. On the street, he told me, he often wore sunglasses. I asked the poet what he thought of the public reading of poetry. "Nothing much," he said crisply. "Few can deliver it effectively. Some can't read, but some can, and they can even make bad poetry sound good."

SCHWEITZER, ALBERT [89] Albert Schweitzer (1875–1965) was a theologian, physician, surgeon, scholar, philosopher, musician, author, lecturer, missionary, and 1952 Nobel Peace Prize recipient. He practiced what he preached. Albert Einstein said, "There, in this sorry world of ours, is a great man." One of the greatest authorities on Bach, Schweitzer was also an advocate of Goethe, and committed his own life to both thought and action as Goethe professed. For sixty years, Schweitzer dedicated himself to medical and spiritual care of the native people of French Equatorial Africa, in Lambarene, on the Ogooue River just a few miles from the equator. Diseases like yellow fever, dysentery, malaria, leprosy, and sleeping sickness were rampant. Schweitzer healed thousands, and, in doing so, brought the perils of life in Africa to the attention of the world. ∽ Schweitzer was born into an Alsatian family that for generations had been committed to religion, music, and education, and his father and maternal grandfather were both ministers. Both of his grandfathers were organists. Schweitzer began to play the church organ at eight, and he studied piano as well. He was thought to be a child prodigy. Schweitzer entered the theological studies program at the University of Strasbourg and obtained a doctorate in philosophy in 1899. Ordained in 1900, he began to preach and teach, working at the University for twelve years. During this time, he wrote *The Quest of the Historical Jesus*, a reconstruction of Jesus' life, and a study of the

life and art of Johann Sebastian Bach, *J. S. Bach*. At the age of twenty-one, he vowed to spend his next nine years studying science and art, after which he would devote his life to healing those who were suffering most, through medicine and ministry. ✑ In 1905, Schweitzer began to study medicine at the University of Strasbourg. He married Helene Bresslau, a scholar and trained nurse, and in 1913 they left for Africa together and founded his hospital in Lambarene. However, in 1917, the First World War erupted, and the Schweitzers were sent to a French internment camp as prisoners of war. They were released in 1918 and returned to Europe, where for six years Schweitzer preached, wrote, lectured, and performed concerts to raise money to go back to Africa. Schweitzer returned to Lambarene in 1924, and, except for short periods of time, he remained there for the rest of his life. He built a hospital from jungle materials, constructing many of the facilities himself. By the time of his death, it had grown to more than seventy buildings and 350 beds, with a leper village that supported two hundred. The staff consisted of three physicians, seven nurses, and volunteers. ✑ Schweitzer's strong code of ethics was a persistent topic in his books, as well as in his lectures and sermons. He wrote, "A man is ethical only when life, as such, is sacred to him, that of plants and animals as that of his fellow men, and when he devotes himself helpfully to all life that is in need of help." ✑ Schweitzer received the British Order of Merit and the Nobel Peace Prize, and he was elected as a member to the French Academy. On the occasion of his ninetieth birthday, President Johnson sent this message: "In your commitment to truth and service, you have touched and deepened the lives of millions you have never met." Albert Schweitzer died in 1965 at the age of ninety. His ashes are buried with his wife's in a grave on the banks of the Ogooue River, marked by a cross he made himself. The administration and direction of the hospital was passed on to Schweitzer's daughter, Rhena Eckert.

ALBERT SCHWEITZER What struck me from the beginning was this man's power to concentrate his mind totally on the business at hand. While the equipment was being prepared, he went back to his writing as if he were alone in the room, and then, when I was ready, he gave me his full attention. Of course, a thousand questions were on my tongue, and it was tantalizing to realize that I would not have time to ask a fraction of them. While we talked, I watched Dr. Schweitzer closely, especially his hands. They were the fine hands of a musician and a healer. I wished to photograph him holding some books, preferably an album of Bach, but he protested that to use Bach's music for this purpose would be like "choucroute garnie." Accordingly, with a shy smile, he brought out some of his own books. And then he revealed a very human side, by declining to be photographed while wearing his spectacles. "They make me look too old," he said. It was, of course, my hope not so much to make the portrait that Schweitzer might desire, but to catch him, if possible, at an un-

conscious moment when perhaps my camera might seize something of those qualities which made him great as a doctor, musician, philosopher, humanitarian, theologian, and writer. The picture printed here was taken in a moment of meditation.

SHAW, GEORGE BERNARD [57] Nobel Prize-winning dramatist, journalist, critic, and socialist spokesman George Bernard Shaw (1856–1950) based his writing on contemporary social issues, presenting contemporary social problems as paradoxes. ✑ Shaw was born in Dublin, Ireland, to a family that lived in what Shaw described as "genteel poverty." His father was an alcoholic who died in 1885, and Shaw left school at the age of fourteen to take a job as a clerk. The family moved to London in 1876, and he continued educating himself at the British Museum, showing a strong interest in cultural studies. ✑ Shaw was an advocate of Karl Marx, and he credited Marx with having changed his life. Reading *Das Kapital* convinced him to convert to socialism. In 1884, he joined the Fabian Society, whose purpose was to advance the socialist cause by reform rather than revolution. Shaw served on the executive committee for more than fifteen years, and he was passionate about many causes, including the abolition of private property, women's rights, equality of income, radical changes to the voting system, and reform of the English alphabet. For twelve years, he delivered an average of three lectures per week. ✑ In 1885, Shaw began his career as a journalist. His first position was art critic for *The World* and he later became the drama critic for *The Saturday Review*. While employed as a journalist, he began writing plays, which often turned the stage into a vehicle for communicating his political and social ideas. Publishing his plays for popular consumption was a new innovation at the time. He continued both journalism and playwriting until 1898, when a breakdown caused him to focus exclusively on drama. *Pygmalion* provided the basis for the film and musical, *My Fair Lady*. ✑ In 1925, Shaw won the Nobel Prize for literature, "for his work which is marked by both idealism and humanity, its stimulating satire often being infused with a singular poetic beauty." His complete works appeared in thirty-six volumes between 1930 and 1950, the year of his death.

GEORGE BERNARD SHAW Every obstacle was in my way when I first met George Bernard Shaw in 1943. To begin with, his secretary laid down drastic and quite impossible terms. I was to have five minutes only with the great man. There were to be no lights. I could use nothing but a "miniature camera." While I was arguing vainly, Shaw himself came bursting into the room with the energy of a young man, though he was then almost ninety years old. His manner, his penetrating old eyes, his bristling beard and crisp speech were all designed to awe me, and, in the beginning, they succeeded. Shaw said he could see no reason why I should photograph him anyway. I explained that the Government of Canada wished to have a good portrait of him in the National Archives at Ottawa. "Since when," he retorted, "does the Cana-

dian Government know a good picture when it sees one? And in any case why did they not commission Augustus John at a thousand guineas and make sure of the job? If John did it, the job would be good – or at any rate everybody would think so." Plucking up my courage, I suggested that perhaps I had been assigned to take the portrait for that same reason. ✑ In the end, I had all the time I wanted and I think Shaw enjoyed himself. For he was a better actor than many who appeared in his plays, and he obviously loved to act. His favorite role seemed to be that of a sort of harmless Mephistopheles, or the grumpy wicked uncle with a heart of gold. After testing me with preliminary terror, we got along beautifully. He said I might make a good picture of him, but none as good as the picture he had seen at a recent dinner party. There he had glimpsed, over the shoulder of his hostess, what he took to be a perfect portrait of himself – cruel, you understand, a diabolical caricature but absolutely true. He pushed by the lady, approached that living image to find that he was looking into a mirror! ✑ The old man peered at me quizzically to see if I appreciated his little joke. It was then that I caught him in my portrait. Later on, a noted British journalist asked me to prepare a copy of this picture, which he proposed to have autographed by Shaw. To his chagrin, he received the picture with Shaw's signature scrawled on the back of it. When asked for an explanation, Shaw replied: "I was careful to make sure that my signature should not distract from my face." Nothing, I think, could distract from that face.

SIBELIUS, JEAN JULIUS [75] Jean Sibelius (1865–1957), composer of chamber music, music for the piano and violin, and orchestral work, was born in Hämeenlinna in south-central Finland near Helsinki. He began violin lessons at an early age, continued his studies at the Helsinki Music Institute and then in Berlin and Vienna. In 1892, his first symphony, *Kullervo*, was composed and produced. While conceived in Vienna, it demonstrated nationalistic feelings and was immediately popular in Finland. *The Karelia Suite* and *Finlandia* followed, the latter identifying with the deepest nationalistic feelings of Finland and establishing Sibelius as the country's leading composer. In 1897, he was awarded a lifetime grant allowing him to devote his career to composing. ✑ First popular in Germany, he quickly became known in England when the conductor Sir Henry Wood included the *King Christian II Suite* at a Promenade Concert. His first two symphonies and violin concerto clearly established him as a composer central to the development of the symphony in Europe. ✑ In 1909, Sibelius was experiencing pain in his throat, and doctors suspected throat cancer. After undergoing treatment, he wrote his third and fourth symphonies, which took on a different tone. In all, he composed seven symphonies and more than two hundred songs. ✑ The *New York Times* wrote, "From the romantic color of his early tone poems to the abstract drama of his late symphonies, particularly the Fifth and Seventh, Sibelius expressed the fundamental thought of this age, but

in a highly individual way. That way was often lonely. It was often ridiculed. It remained controversial. But it made him, while still in his twenties, a spiritual leader in his country's struggle for independence. And it raised him, after the First World War, to a position of tremendous popularity at home and in the United States, where many musicians ranked him as the greatest symphonist since Johannes Brahms."

JEAN SIBELIUS *We spent a leisurely day of photography punctuated, at intervals, with a break for coffee, cakes, and brandy. Sibelius would call for a toast and then raise an empty glass. "You see," he explained, "I never drink before dinner." He seemed to be a happy man full of infectious laughter. His little jokes were uttered in French, since I had no Finnish and he little English, but sometimes, stuck for a word, he appealed to one of his daughters, who translated for him. Towards the end of the day, when Sibelius appeared fatigued, I told him a little story. During the Russo-Finnish war, I said, there were many Finns cutting timber in the Canadian North and, hearing the dire news from home, they brooded and slackened in their work. Production in the camps began to drop. The foreman, with sudden inspiration, acquired a recording of Finlandia and piped it to the loggers in the woods. Immediately, the output of timber doubled. Sibelius rocked with mirth. "You're fantastic!" he cried "One never gets tired of working with you." I was not satisfied with that day's work, however, and suggested another sitting. He agreed, and I returned next morning when the portrait printed here was made.*

STEICHEN, EDWARD [64, 132, 133] The photographer Edward Steichen (1879–1973) once said, "To photograph what has never been photographed before does not in itself denote originality. It has no more creativity than finding a pearl in an oyster." What distinguished Steichen most was his sensitivity and vision. ❧ Edward Steichen was born in Luxembourg, and his family moved to the United States when he was three, settling in Hancock, Michigan. Steichen's mother was a dominant woman with a significant impact on his life. He said about his mother's reaction to hearing him call another child by a derogatory name, "She talked to me quietly and earnestly for a long, long time, explaining that all people were alike regardless of race, creed, or color. She talked about the evils of bigotry and intolerance. This was possibly the most important single moment in my growth toward manhood, and it was certainly on that day the seed was sown that sixty-six years later grew into an exhibition called *The Family of Man*." ❧ Leaving school at age fifteen, he began a lithography apprenticeship in Milwaukee. He was initially interested in painting, but he taught himself photography. ❧ In 1899, his photgraphs were exhibited at a Philadelphia gallery, and Alfred Stieglitz purchased three. In 1905, Steichen and Stieglitz established the Little Galleries of the Photo-Secession, where art of all mediums was displayed. Steichen traveled to Europe and brought back

work by Cézanne, Picasso, Rodin, and Matisse, as well as work by European photographers, for exhibition. ❧ When the First World War began, Steichen became commander of the photographic division of the American Expeditionary Forces, where he learned the art of aerial photography. After the First World War, he began his career as a commercial photographer, eventually becoming the country's most highly paid photographer. In 1923, he began his career as photography director for Condé Nast Publications, where he worked on fashion photography for *Vogue* and *Vanity Fair*. ❧ During the Second World War, he served as the director of the United States Naval Photographic Institute, where he was responsible for the publication of the Navy's combat photography. After the Second World War, Steichen became the director of photography at the Museum of Modern Art, a position he held for fifteen years. ❧ Steichen received the Presidential Medal of Freedom for lifetime acheivement, presented by President Kennedy.

EDWARD STEICHEN *The first time I photographed this giant, during the Second World War, I was very nervous, and Steichen, understanding this, was especially encouraging. During the intervening years, Steichen's face took on the quality of an Old Testament prophet, and I was anxious to record what endless, restless experimentation, deep thought, and photographic innovation had etched. The patriarch of American photography was nearing his ninetieth year when this portrait was taken in 1967 at his home in West Reading, Connecticut. He was still erect and vital, and he walked all the way to his greenhouses of prize-winning delphiniums to greet us. Steichen stopped frequently to pet his two beloved dogs, a soulful three-legged beagle appropriately named Tripod, and an enormous bumptious Irish wolfhound, Fintan.*

STEINBECK, JOHN [107] John Steinbeck (1902–1968) wrote novels, short stories, plays, and essays, and won both the Pulitzer and Nobel Prize. ❧ Steinbeck was born and raised in Salinas, California. His father was county treasurer, and his mother was a teacher. Steinbeck once said of his family, "We were poor people with a hell of a lot of land, which made us think we were rich people." He worked to put himself through school and took jobs as a hired hand on the farms and ranches of the Salinas Valley. He knew at a young age that he wanted to be a writer. After high school, he attended Stanford University. ❧ His first successful novel, *Tortilla Flat*, a humorous story about Mexican-Americans, was written in 1935. Steinbeck sold the movie rights to this story and, in 1937, wrote *Of Mice and Men*, which he then adapted into a play. Seventeen of his works, including *Cannery Row*, *The Pearl*, and *East of Eden*, went on to become Hollywood films. ❧ In 1943, Steinbeck went to Europe as a war correspondent for the *New York Herald Tribune*. After the war, he traveled extensively, writing articles, essays, and reports for many magazines and newspapers. His last two books were *Travels with Charley: In Search of America*

and *The Winter of Our Discontent*. ❧ In 1962, he won the Nobel Prize for literature for his "realistic and imaginative writing, combining as it does sympathetic humour and keen social perception," and for his "instinct for what is genuinely American. . . ." In his Nobel Prize acceptance speech, Steinbeck said, "Literature is as old as speech. It grew out of human need for it and it has not changed except to become more needed. The skalds, the bards, the writers are not separate and exclusive. From the beginning, their functions, their duties, their responsibilities have been decreed by our species. . . . The writer is delegated to declare and to celebrate man's proven capacity for greatness of heart and spirit – for gallantry in defeat, for courage, compassion, and love. In the endless war against weakness and despair, these are the bright rally flags of hope and of emulation. I hold that a writer who does not passionately believe in the perfectibility of man has no dedication nor any membership in literature."

JOHN STEINBECK *The American author who writes of exceedingly earthy characters maintained in Paris a very elegant address. The gate was opened for me in 1954 by a butler in black coat and striped trousers. There were, however, difficulties in this impressive setting. Sunshine poured into the room, curtains had to be changed, and the electricity supply, as usual in the eccentric power system of France, proved insufficient. Moreover, a continuous stream of people poured through the room – the author's wife, his children one after the other, and his secretary. When the procession was interrupted for a moment, I seized the chance, abandoned the French current, and took this portrait with electronic lights. Mr. Steinbeck had talked little during the sitting. His mind was on his own business and on the many urgent questions brought by his secretary. It seemed that a craftsman skilled in revealing the character of other people guarded himself jealously from prying eyes – that here was a courteous but reticent man who did not wear his heart on his sleeve.*

TAWNEY, LENORE [122] Lenore Tawney (1907–2007) was an artist who united the genres of sculpting and weaving by mixing a variety of weave types into large, abstract, and free-standing sculptural forms. ❧ Born in Lorain, Ohio, as Lenore Agnes Gallagher, she moved to Chicago in 1927. Working as a court proofreader, she took night classes at the Art Institute and at the Institute of Design. She studied sculpture with Alexander Archipenko, drawing with László Moholy-Nagy, and weaving with Marli Ehrman. In 1941, she married George Tawney, who died eighteen months later. After her schooling and marriage ended, she traveled through Europe, the Middle East, South America, and India, and briefly studied tapestry with Martta Taipale at Penland School of Crafts in North Carolina. ❧ In 1955, Tawney began her work in what she called her "woven forms." Inventing new devices that allowed her to create massive sculptures, she also developed the use of slits in the weave to allow light to be incorporated

into the compositions. In 1957, she moved to New York City. ❧ Holland Cotter wrote in the *New York Times*, "Traditionalists on both sides of the art-craft divide found fault, but she persisted in work that came to assume a grand architectural scale. Her *Waters Above the Firmament* (1976), the last work she made on the loom, was 12 feet by 12 feet. The 1983 *Cloud Sculpture*, a suspended environment made of thousands of knotted blue threads, was three times as large, an ethereal Niagara." Roberta Smith, who reviewed the retrospective of Tawney's work at the Museum of Arts and Design in 1990, said, "In the late 1950s and early 1960s, she invented open-wrap weaving and the open reed-techniques that enabled weavers to open up their woven field and to abandon the previously strict rectilinearity. In many ways, these developments precipitated the transition from textiles to what is often called fiber art." ❧ Tawney had more than two dozen solo exhibitions in galleries and museums, participated in dozens of group exhibitions, and her work is included in countless museums, universities, and private art collections. She worked until her ninth decade when her vision failed her.

TRUDEAU, PIERRE ELLIOTT [136] Pierre Trudeau (1919–2000) was prime minister of Canada for sixteen years, serving for two terms from 1968 to 1984 and dominating the Canadian political scene. A passionate leader who fought hard for his ideals, he was highly praised for his intellect and vision. Among his most important contributions to the Canadian people are the preservation of national unity and the repatriating of the constitution from the British Parliament. ❧ Born in Montreal, Quebec, to a wealthy French-Canadian businessman and lawyer, Trudeau attended elite French Roman Catholic schools and was educated by the Jesuits. He left Canada to study in the United States, France, and England, and broke away from the Jesuit tradition, studying philosophers such as Locke and Hume. In the early 1940s, he entered the Université de Montréal, refusing to enlist to fight in the Second World War. He said of his decision, "If you were a French-Canadian in Montreal in the early 1940s, you did not automatically believe that this was a just war. We still knew nothing of the Holocaust, and we tended to think of this war as a settling of scores among the superpowers." Trudeau earned a law degree from the Université de Montréal in 1943, and a master's degree in political economy from Harvard. Later he studied at the Ecole Libre des Sciences Politiques in Paris and the London School of Economics. Trudeau ultimately came to understand how important the war had been and how isolated his life had been in Quebec. ❧ In 1961, he returned to Canada, became a law professor at the Université de Montréal, and by 1965 he had joined the Liberal Party, winning election to the House of Commons. Prime Minister Lester Pearson named him to the cabinet positions of minister of justice and attorney general. Trudeau sponsored popular legislation to broaden welfare, support gun control, and liberalize laws regarding divorce,

abortion, and homosexuality. When Pearson stepped down, Trudeau ran for election and, in 1968, won by a landslide. His surging popularity was called "Trudeaumania." ❧ Trudeau was a federalist who did not support the movement for Quebec independence. He said, "French-Canadians must refuse to be enclosed within Quebec. The die is cast in Canada: there are two main ethnic and linguistic groups; each is too strong and too deeply rooted in the past, too firmly bound to a mother culture to engulf the other. But if the two will collaborate at the hub of a truly pluralistic state, Canada could become the envied seat of a form of federalism that belongs to tomorrow's world." ❧ His personal life was tabloid fodder. He was dashing, drove sports cars, attended discos, and dated celebrities. In 1970, Trudeau met Margaret Sinclair, the daughter of a politician from British Columbia, at Club Med in Tahiti. She was twenty-one, and he was fifty-one, and they married in 1971. Margaret was not happy being the wife of the prime minister, becoming a photographer and member of the "jet set." They separated in 1974 and were divorced in 1984.

PIERRE ELLIOTT TRUDEAU Before our photographic session at this official Ottawa residence, 24 Sussex Drive, we lingered and talked over dessert and coffee. The new head of government was very relaxed, very natural, and, above all, candid. Seldom had I met a politician who spoke so freely, yet he weighed his words as they pertained to national affairs. He also had a lively sense of humor, an ironic wit, a sharp memory for persons and events. If he spoke directly to you, the force, as well as the charm, of his personality helped to explain his place in current politics.... ❧ The portrait reproduced here seems to capture both sides of him: his celebrated fondness for logical argument and flashing repartee is almost belied by the introspective cerebral quality of his features, suggesting perhaps more than cool detachment. Underneath his smiling public appeal or sudden gusts of anger, Pierre Trudeau must be one of the most private men who ever played so great a part in the nation's life.

VISHNIAC, ROMAN [138] Roman Vishniac (1897–1990) is widely famous for the photographs he took of Jews in prewar Eastern Europe and Nazi Berlin. Edward Steichen said, "Roman Vishniac came back from his trips to Eastern Europe in the 1930s with a collection of photographs that has become an important historical document, for it gives a last-minute look at the human beings he photographed just before the fury of Nazi brutality exterminated them. The resulting photographs are among photography's finest documents of a time and place." ❧ Born in Pavlovsk, Russia, near St. Petersburg, Vishniac was raised in Moscow, received a doctorate degree in zoology, and was an assistant professor of biology. In 1920, he moved to Berlin to escape growing Russian anti-Semitism. There in Berlin he worked as an endocrinologist and a photojournalist. In the early 1930s, anti-Semitism was also growing in Germany. Between 1933 and 1939, Vishniac began a project to document the

daily life in the *shtetls* (small communities) of Central and Eastern Europe. He photographed Nazi demonstrations and Jewish victims in Germany. He took over 16,000 images, often assuming the identity of a Nazi, as Jews were not permitted to have cameras. He was imprisoned eleven times and forced to do hard labor in two concentration camps. Only 2,000 of the photographs survived, the rest presumably confiscated and destroyed by the Nazis. ❧ Gene Thornton, in the *New York Times*, wrote, "There is barely a hint of a smile on any of the faces. The eyes peer at us suspiciously from behind ancient casement windows and over a peddler's tray, from crowded schoolrooms and desolate street corners ... somber with poverty and with the gray light of European winter." ❧ In 1940, Vishniac immigrated to the United States. Appointed a research associate at Yeshiva University, he went on to become a professor of biology at Albert Einstein College of Medicine in 1961. During this time, Vishniac pioneered time-lapse cinematography and color photo microscopy of living organisms. He was the director of the Living Biology film series sponsored by the National Science Foundation, and went on to become a professor at Pratt Institute and the author of many books.

ROMAN VISHNIAC In his art-filled West Side New York apartment, this Russian-American scientist and photographer showed me early microphotographs of different cells of the body. They resembled the most avant-garde modern art of a strange and extravagant beauty. The human body," he said, quoting the scriptures, "is indeed fearfully, wonderfully made."

VONNEGUT, KURT [149] The American author and literary celebrity Kurt Vonnegut (1922–2007) created a following of readers who eagerly anticipated each new work of his for more than fifty years. Vonnegut's humor was dark, his philosophy was existential, and in his writing he combined both of those elements with an interest in science fiction, resulting in a unique and compelling vision of morality. Dinitia Smith writes for the *New York Times*, "His novels – fourteen in all – were alternate universes, filled with topsy-turvy images and populated by races of his own creation, like the Tralfamadorians and the Mercurian Harmoniums. He invented phenomena like chron-synclastic infundibula (places in the universe where all truths fit neatly together) as well as religions like the Church of God the Utterly Indifferent and Bokonism." The best-selling author is most well-known for his novels: *Slaughterhouse Five, Cat's Cradle, Mother Night*, and *God Bless You, Mr. Rosewater*. Vonnegut was also a playwright, whose most famous work was the Broadway play, *Happy Birthday, Wanda June*. ❧ Vonnegut was born in Indianapolis, Indiana, to fourth-generation German-American parents. His father and grandfather were architects, and his mother, Edith Lieber Vonnegut, was a writer. While attending high school, Vonnegut worked on the nation's first daily high school newspaper, the *Daily Echo*, after which he attended Cornell University for a short time, serving

as assistant managing editor of the *Cornell Daily Sun*. In 1942, during the heat of the Second World War, Vonnegut was drafted into the Army. Shortly after his induction, he experienced two life-altering events that caused him great despair and resulted in a disillusionment with humanity that lasted the rest of his life. In 1944, on Mother's Day, his mother committed suicide, and later that year, he was sent to Dresden as a prisoner of war. Dresden was brutally bombed in early 1945, killing 130,000 people, but Vonnegut survived by hiding in the basement of a slaughterhouse. ❧ Vonnegut became a pessimist, and his expectations for human nature were very low. His characters included society's rejects who no longer had a stake in community. He scorned customary wisdom and was irreverent to social norms. Yet while Vonnegut was known to be cynical and dark, he was also sentimental and generous in spirit. Lev Grossman said in his obituary for *Time*, "He could easily have become a crank, but he was too smart; he could have become a cynic, but there was something tender in his nature that he could never quite suppress; he could have become a bore, but even at his most despairing he had an endless willingness to entertain his readers: with drawings, jokes, sex, bizarre plot twists, science fiction, whatever it took.... He died a literary celebrity lionized by the culture of which he was so unsparing." ❧ Vonnegut had two marriages. He married his high school sweetheart, Jane Marie Cox, in 1945, and they had three children and adopted three more upon the death of his sister and her husband. They divorced in 1970, and Vonnegut married the photographer and author Jill Krementz in 1979, having one child with her. He is survived by his second wife and seven children.

WARHOL, ANDY [146] A founder of the Pop Art movement, Andy Warhol (1928–1987) was one of the most famous and enduring American artists of the twentieth century. Known for his paintings and silk-screen prints of soup cans, presidents, celebrities, and other symbols of the culture of his time, Warhol's work was groundbreaking and provided inspiration and leadership for other artists. He was, however, a controversial figure during his lifetime, and his work was often ridiculed by critics to be a joke. However, Leo Castelli, Warhol's dealer for twenty-three years, said of his influence in retrospect, "Of all the painters of his generation he's still the one most influential on the younger artists – a real guru." In addition to his work as a visual artist, Warhol was also a filmmaker and the founder of *Interview* magazine. ❧ Born Andrew Warhola in Pittsburg to a working class family, Warhol suffered from a nervous disorder which accounted for his pallor. His talent for art was obvious at a young age, and he began taking art classes at Carnegie Museum in the fifth grade. He moved to New York after his schooling at Carnegie Institute of Technology and was then able to capitalize on his unique image, turning it into his trademark. He began his career as a commercial artist, getting his first big break in

1949 when *Glamour* magazine asked him to illustrate an article. Working for Tiffany & Co., Bonwit Teller, *Vogue*, and the *New York Times*, his reputation grew quickly, and by 1955 Warhol had set a trend that commercial artists all over New York were copying. ❧ By the late 1950s, having earned numerous prizes and awards, Warhol began to make paintings and prints of celebrities and objects of consumer culture. His first show, in Los Angeles, exhibited the famous Campbell's soup cans and included other pop artists like Roy Lichtenstein and James Rosenquist. Warhol's popularity grew, and he was able to attract a large following of energetic young artists who worked for him and help in the mass-production of his work. They gathered in his studio, called The Factory, which was famous not only for art, but also for being the hip hangout for artists and for the superstars who graced Warhol's famous silk-screens, lithographs, and acted in his films. ❧ At the time, there was a controversy over whether copying brand images from popular culture should be considered art. Critics attacked Warhol for caving into consumerism and were offended by his embrace of commercialism. Over time, it became clear that there had been a profound change in the art world, and Warhol was at the center of it. Critic Robert Hughes wrote, "Painting a soup can is not in itself a radical act, but what was radical in Warhol was that he adapted the means of production of soup cans to the way he produced paintings, turning them out *en masse*, consumer art mimicking the process as well as the early look of consumer culture." ❧ Though he died at the age of fifty-eight, Warhol's legacy survives. His work is still in demand and remains a major force in American art. Referring to the fleeting nature of celebrity and the limited attention span of the modern public, Warhol once said, "In the future, everyone will be world-famous for fifteen minutes." His much-quoted phrase has endured far longer than the anticipated fifteen minutes.

WEILL, KURT [72] Kurt Weill (1900–1950), a German and later German-American composer of musicals and concert works, collaborated with Ira Gershwin, Alan Lerner, Maxwell Anderson, and others to help create the modern American musical as we know it today. ❧ Born in Dessau, Germany, the son of a cantor, he was composing by the time he was twelve. By twenty, he had composed an orchestral work called *Ofrahs Lieder*, writing his first symphony shortly thereafter. In 1924, Weill married the famous actress and singer Lotte Lenya, who remained the foremost interpreter of his songs throughout her life. In 1925, he had a series of performances in Berlin, and the next year made his theatrical debut in Dresden with his first opera, *Der Protagonist*. ❧ In 1927, he received a commission from the Baden-Baden Music Festival to create *Ein Songspiel* (*Mahagonny*) in collaboration with Bertolt Brecht, whose poetry fascinated Weill. A success, it led to other commissions, including a full-length opera. Brecht and Weill's association ended for political reasons in 1930; Lotte Lenya remembers Weill commenting that he "was unable

to set the communist party manifesto to music." Condemned by the Nazis, Weill left Germany in 1933, going to Paris, where he completed his Second Symphony, and collaborated again with Brecht for *Die Sieben Todsunden*, a ballet for Balanchine's company, Les Ballets Russes. After spending time in London for his operetta, *A Kingdom for a Cow*, he emigrated to the United States in 1935 to work with Franz Werfel on *The Eternal Road*, a biblical drama commissioned by the New York Jewish community, and became a U.S. citizen in 1943. ❧ During the 1940s, Weill changed his musical style, working with popular dramatists like Maxwell Anderson and Ira Gershwin to create music that would be commercially and artistically successful. ❧ Michael Feingold, music critic for *The Village Voice*, wrote, "Weill wasn't classical. He used modern tactics, but he wasn't conventionally modern. He wrote operetta-like melodies, employed jazz rhythms and blue notes, ventured into pop idioms but he wasn't writing operetta, or jazz, or pop. He was writing Weill's music and nobody else's. Prickly and tender, complexly compassionate and critical in its worldview, his work puts people off, even those who fall deeply under its spell." His friend Maxwell Anderson characterized Weill's importance to musical theater in his eulogy saying, "It takes decades and scores of years and centuries to sift things out, but it's done in time – and Kurt will emerge as one of the very few who wrote great music."

KURT WEILL The brilliant, iconoclastic German composer came to America with his wife, Lotte Lenya, in 1935, and his work soon became part of the American musical idiom. Classically trained, he carved out a new career in the United States, writing innovative scores for some notable American musicals. His Threepenny Opera, One Touch of Venus, *and* Lady in the Dark *were all certified triumphs when I photographed him at this country home in Rockland County outside New York, where, for the first time, he was enjoying financial success. "It is lots of fun to have a smash hit," he remarked happily. ❧ The farmhouse was near a running trout stream which we both could hear and see as this photograph was being taken. The session was sometimes boisterously interrupted by his sheep dog, Wooly (pronounced with a V), a gift of his collaborator Moss Hart. His close friend and neighbor, the playwright Maxwell Anderson, ran interference whenever "Vooly" tried to get in front of the camera.*

WELLS, H.G. [59] A prolific writer whose work covered a wide variety of genres, including history and sociology, Herbert George Wells (1866–1946) was an English novelist, journalist, sociologist, futurist, and historian. Along with George Orwell's *1984* and Aldous Huxley's *Brave New World*, Wells's novels are among the classic dystopian works that envisioned a future foreboding and sinister. ❧ Wells was born in 1866 in Kent, England, to parents who were, respectively, a maid and a professional cricket player. Growing up before radio and television, Wells was a passionate reader, and, while he liked to write, it was

some time before his talent for it was recognized. He earned a scholarship to the Normal School of Science. He studied biology and Darwinism under Thomas Huxley, Aldous Huxley's grandfather. He founded the school's newspaper and actively participated in the debating society ◐ By 1893, Wells was entirely devoted to his writing. His first successful 1901 novel, *Anticipations*, imagines what the world would be like in the year 2000. *The Time Machine*, a parody of English class division and a discussion of theories of time travel, was published in 1895. Considered by many the greatest single work of science fiction, it was subsequently made into at least two films, a TV program, and a comic book. *The Invisible Man*, the story of a scientist who tampers with nature to achieve superhuman powers, was published as a novel in 1897. *The War of the Worlds*, published in 1898, is the earliest and best-known depiction of an alien invasion of earth, foreshadowing other developments, including robots, world wars, aerial bombing, chemical weapons, and nuclear power; it subsequently was the basis for two movies. ◐ Politics and social reform were Wells's passions, and he was a well-known socialist and a member of the Fabian Society, an institution advocating a series of reforms for a more equitable social system. Often at odds with other socialists, Wells eventually left the society to create an organization with a more radical commitment to change. He believed people should advance on merit, not birthright, and proposed his own political ideal for a World State, a society promoting science and merit, and eliminating nationalism. He helped form the League of Nations and was disappointed when the organization was unable to prevent the Second World War. It has been said that the outbreak of the war increased his innate pessimism. ◐ In his preface to the 1941 edition of *The War in the Air*, Wells stated that his epitaph should be: "I told you so. You damned fools."

H. G. WELLS This is the way Wells greeted me: "I hear that you have been photographing Shaw. It's a great mistake. When future generations go through the ruins of London, they will find Shaw, more Shaw, and still more Shaw photographs, and the unfortunate thing is that they will take him to be the typical Englishman."... I smiled. "There's nothing funny about it," said Wells. "It's horrible, and true." I hastened to explain that my smile was due to another reason: his remark reminded me of two American radio comedians, Fred Allen and Jack Benny. "I know them," retorted Mr. Wells, "and don't imagine they originated public feuding. Shaw and I have been at it almost fifty years." ◐ Unlike Shaw, Wells engaged in no preliminary fencing; like Shaw, he was a most cooperative subject. He had an amazingly comprehensive knowledge of photography, and, unlike Shaw, he seemed to cooperate more because he wanted to help me get what I wanted than because of any concern with the final outcome.... There was, too, a marked difference in the apartments of these two men who, in their time, have wielded so much influence on the world's thinking. The arrangements in Shaw's flat

seemed oblivious to the contemporary crisis apparent everywhere in London. In Wells' apartment, chairs in the drawing room had been pushed in front of objets d'art and little figurines so the precious treasures might be protected to some extent from bomb blast.

WILLIAMS, TENNESSEE [118] American author of plays, screenplays, novels, short stories, and poems, Tennessee Williams (1911–1983) was one of America's most influential playwrights. Born Thomas Lanier Williams in Columbus, Mississippi, his father was an aggressive and domineering shoe salesman, and his mother was the puritanical daughter of an Episcopal pastor. His father traveled constantly, and the marriage was not a happy one. Williams' plays were not autobiographical, but they did draw from his family experiences. In *The Glass Menagerie*, the character Amanda Wingfield was modeled after his mother, and Big Daddy in *Cat on a Hot Tin Roof* was modeled after his father. His sister is memorialized in the character Laura in *The Glass Menagerie*. ◐ Williams began writing at an early age but had to work odd jobs to support himself through college. In all, it took him nine years to graduate, earning a degree from the University of Iowa in 1938. In 1939, Williams moved to New Orleans, where his life and work changed dramatically. He officially changed his name to Tennessee, attributing the change to three things: it distinguished his new work from his earlier work published under his birth name, his father was from Tennessee, and it was distinctive. ◐ *The Glass Menagerie*, his first big success when it opened on Broadway in 1945, was followed by *A Streetcar Named Desire*, which won both a Drama Critics' Award and a Pulitzer Prize. For years there seemed to be a new Williams play on Broadway every season, followed shortly by a movie version. ◐ At a time when it was not socially acceptable, Williams was an admitted homosexual. In 1947, he met and fell in love with Frank Merlo, a second generation Sicilian American. In 1948, he wrote *The Rose Tattoo*, a comedy about the life of a family of Sicilian immigrants following his own experience with Merlo. It is his only play with a happy ending. Merlo was a stabilizing influence on Williams, staying with him for fourteen years. ◐ For most of his life, Williams struggled with depression. He acknowledged problems with alcoholism and addiction to prescription medications. Finding it more difficult to write, he turned to caffeine, cigarettes, drugs, and alcohol. *The Night of the Iguana* in 1961, his last major success, won him his fourth Drama Critics' Award. ◐ After the death of Merlo, Williams went into a deep depression that lasted for nearly ten years, during which he did not write. In the 1970s, he began writing

again. In an article published in the *New York Times* in 1977, Williams wrote, "I am widely regarded as a ghost of a writer, a ghost still visible, excessively solid of flesh and perhaps too ambulatory, but a writer remembered mostly for works which were staged between 1944 and 1961."

TENNESSEE WILLIAMS Tennessee Williams's reply to my desire to photograph him was enthusiastic and spontaneous, like his plays. We met in his small New York apartment in 1956 and decided that the portrait should be made in his own environment, and I came to realize that this jovial, homespun man contained a tumultuous talent and a soul seldom at peace. Superficially, the plot for this sitting – a sort of minor play rather on the comic side, with Mr. Williams as the comedian and the photographer as his foil – was quite perfect. I had found the master in the scene of his work, surrounded by his typewriter, his manuscript, and his ever-present glass of scotch. Moreover, he seemed to be surrounded by invisible friends. His telephone was constantly ringing as if for the deliberate purpose of distracting me. His obvious desire to cooperate with me and the feigned calm I can sometimes command in a pinch enabled us, however, to deal with invisible friends – and some visible ones – and to get on with the portrait.... ◐ At last the portrait was done, and when I showed it to some of my friends, they remarked that it looked exactly like Williams's plays. Perhaps. At any rate, the playwright's deceptive ease of manner, his informal speech, and carefree air reminded me of his various characters – ordinary-looking men hiding an unsuspected fury that invariably erupts on stage, often ending in tragedy.

THE DUKE AND DUCHESS OF WINDSOR [131] The Duke of Windsor (1894–1972) was the oldest child of the Duke of York. His full name was Edward Albert Christian George Andrew Patrick David. In 1910, his father became King George V, and Edward the Prince of Wales, heir apparent to the throne. ◐ The Duchess of Windsor (1896–1986) was born Bessie Wallis Warfield of Baltimore. Her family traced their lineage to William the Conqueror, but they were never wealthy. Wallis's father died when she was just a few months old. She married her first husband in 1916, and they divorced in 1927. In 1928, she married Ernest Simpson, a British shipping executive, becoming part of London's social elite. ◐ In 1930, Edward met Wallis and Ernest Simpson through Edward's mistress, Lady Furness, and he and Wallis soon became romantically involved. Since divorced people were not accepted at court, or by the Church of England, the king and queen hardly approved of the relationship. ◐ King George V died in 1936, and Edward ascended the throne as Edward VIII. Wallis Simpson obtained a divorce, making marriage a possibility with Edward VIII. But when the king announced his intention to marry her, it became a national crisis. The Church of England and the prime minister, concerned that a twice-divorced American might become queen of England, put up massive resistance, citing religious, legal, political, and moral reasons for their objection. Attempts at resolution failed, and Edward voluntarily abdicated the throne in favor of his brother, who became King George VI. In a radio address, he declared, "You must believe me when I tell you that I have found it impossible to carry the heavy burden of responsibility and

discharge my duties as King, as I would wish to do, without the help and support of the woman I love." ∾ In 1937, Edward and Wallis married. They were given the titles of Duke and Duchess of Windsor and moved to the European mainland, traveled the international social circuit, and became trendsetters and standard-bearers of fashion. The duchess was among the most talked about women in the world. She became the *Times'* "Woman of the Year" (their first), and was sought after by fashion designers and doted on by gossip columnists and tabloid. While denied royal status, the couple still lived like royalty and provided the world with a romantic fantasy of splendor and elegance. ∾ The duke died in 1972 and was buried at Windsor, and Queen Elizabeth invited the Duchess to stay at Buckingham Palace for the funeral and for four days of mourning. The duchess lived her remaining days as a recluse and, at her death, was buried beside her husband in Windsor Castle's Home Park.

THE DUKE AND DUCHESS OF WINDSOR
By the time I photographed the Duke and Duchess of Windsor in their New York suite, they had been royal wanderers since their marriage, following the Duke's abdication in 1938 as King of England "for the woman I love." They were surrounded by their beloved pug dogs and by some of their personal effects, yet an air of transient sadness seemed to envelope them. The Duchess spoke wistfully of "The Mill," their home in France, and of her admiration for the classic artistry of Madame Grès, one of her favorite couturiers, whose Grecian-inspired gown she wore for this sitting. Her gracious demeanor was tempered by an habitual wariness. She later wrote to tell me that the photographs I took of her and the Duke were the "truest" of their thirty-four years of marriage.

WRIGHT, FRANK LLOYD [70, 104] In 1991, the American Institute of Architects named Frank Lloyd Wright (1867–1959) the greatest American architect of all time. He was, as well, a writer, educator, philosopher, and iconoclast, almost as famous for his outspoken, independent, and controversial personality as for his architecture. He established himself by designing innovative, unconventional, Prairie-style homes. ∾ Born in Richland Center, Wisconsin, Wright had a father who was a musician and composer and a mother who taught school. Wright credits his mother with making his career choice for him: she wanted him to grow up and design beautiful buildings. He attended high school in Madison, then studied civil engineering at the University of Wisconsin for two years as a special student. Moving to Chicago, he joined the design firm of Adler & Sullivan. Louis Sullivan, who rebelled against the classic school of architecture as taught in France and at the Massachusetts Institute of Technology, took Wright on as his apprentice and schooled him in the basics of architecture. The firm's commissions for private homes were given to Wright. ∾ Extending the work of Sullivan, Wright practiced what he called "organic architecture." Louis Sullivan's motto was "form

follows function," soon a mantra of modern design. Wright changed this to read "form and function are one." His goal was to integrate spaces into a coherent whole, creating a union between site and structure, between context and construction. He believed a building was a product of its place and time, not of an imposed style. He felt a strong connection to nature, saying, "Man takes a positive hand in creation whenever he puts a building upon the earth beneath the sun." ∾ In 1883, Wright married Catherine Tobin and built a home for her and their six children in Oak Park. In 1893, when Sullivan and Wright parted company, Wright opened his own office, where over the next decade, he would transform residential design, building almost one hundred houses in the Midwest. In 1909, he left his wife and traveled to Europe with Mamah Cheney, a former client and his new companion. When they returned from Europe in 1911, Wright designed their home in Spring Green, Wisconsin, which he called Taliesin. Two years later, a servant burned the house to the ground, killing Mamah, her two children, and four others who lived there. In 1915, Wright rebuilt it.

FRANK LLOYD WRIGHT My session with the dean of modern architects reminded me very much of my session with George Bernard Shaw in London two years earlier. Not because Wright was as coy as Shaw – the American architect was unguarded and expansive from the outset – but because both men are brilliant, iconoclastic, and magnificent egocentrics. How each admires himself in the most disarming way imaginable, and what two men have a better right to! ∾ I had always considered Frank Lloyd Wright among the greats of his generation and looked forward to photographing him with keen anticipation. I wasn't disappointed. Although seventy-three, he breezed into my hotel suite, radiating vitality and charm and dressed like a fashion plate. "Don't judge me by this outfit," he quickly said. "This is the Fifth Avenue edition of Frank Lloyd Wright. Someday you must come to my home, Taliesin, in Wisconsin, and learn what I'm really like." His aureole of silver hair and mobile features made him a delight to photograph, and while I worked, he talked – about art, architecture, photography, the new museum he was designing (he said that it would look like a washing machine), the war, and the world in general. He disapproved violently of almost everything; I disagreed with almost everything he said, but he was nevertheless entrancing. ∾ He had said something about a doctor's appointment, but the camera must have exerted its spell, for he cancelled the engagement and I was able to have most of the morning with him. He was completely self-satisfied and self-assured and seemed willing to render final opinions on any subject under the sun. He reminded me of someone, but for some time I couldn't place whom. I remember now, however: an American version of Houdon's Voltaire.

WRIGHT, RUSSEL [60] An American industrial designer, Russel Wright (1904–1976), the first designer to successfully market his name as

a well-defined brand, was best known for his colorful American Modern dinnerware. His line included furniture, accessories, dishes, glassware, table linens, art pottery, and more. ∾ Born to a Quaker family in Lebanon, Ohio, he studied law at Princeton but soon left to work on theater productions for Norman Bel Geddes in New York City, and later for George Cukor in Rochester. In 1927, he married Mary Small Einstein, a designer and sculptor, who became his business partner. Together they started Wright Accessories, a home accessories and design business; Mary did the marketing, Russel the designs. ∾ Their first living and working space was a converted horse stable, and their serving accessories succeeded because of their interesting, informal design, modern material, and affordable prices. He pioneered the use of aluminum, discovering it could go from refrigerator to stove to dinner table without damage. ∾ Wright's 1937 design for American Modern dinnerware was groundbreaking. Using market surveys, he discovered informal dining was becoming more popular. Using materials cast, glazed, and signed by hand, he developed an informal dinnerware line that offered lively, unique colors that could be mixed and matched to the occasion. It was affordable, available as open stock, and widely marketed. Wright signed each piece, selling over two hundred and fifty million in twenty years. ∾ In 1951, Mary and Russel compiled their ideas about modern living in *The Guide to Easier Living.* Proposing hundreds of ways to improve efficiency, it also challenged conventional etiquette and manners. Among the ideas they promoted were buffets and outdoor entertainment. Casual lifestyles, promoted in popular magazines, made their guide the handbook for a new lifestyle. ∾ In 1941, the Wrights began to restore, redesign, and develop the land they'd bought in Garrison, New York, into an eco-friendly modern home and studio that blended into the landscape. Their woodland garden, Manitoga, was designated a National Historic Landmark by the U.S. Department of the Interior in 2006 and is open to the public. ∾ Wright scholars consider Manitoga his most important achievement, and Wright agreed. "I am more interested in nature than any other subject. I left the theater because it was so ephemeral. The product there may only live a few days after months of work. So I was exhilarated to design products that lasted longer . . . yet, basically, they, too, are ephemeral. But not nature. With careful planning and design, that will last forever." ∾ His influence reached dinner tables, where his stark white or multi-colored Fiestaware was all the rage. In the fifties, this innovator's name became synonymous with the clean contemporary line that made overstuffed furniture seem ponderous and outmoded.

YOUSUF KARSH: REGARDING HEROES

has been set in Minion, a type designed by Robert Slimbach in 1990. An offshoot of the designer's researches during the development of Adobe Garamond, Minion hybridized the characteristics of numerous Renaissance sources into a single calligraphic hand. Unlike many faces designed for digital typesetting, drawings for Minion were transferred to the computer early in the design phase, preserving much of the freshness of the original concept. Conceived with an eye toward overall harmony, its capitals, lower case, and numerals were carefully balanced to maintain a well-groomed "family" appearance – both between roman and italic and across the full range of weights. A decidedly contemporary face, Minion makes free use of the qualities the designer found most appealing in the types of the fifteenth and sixteenth centuries. Crisp drawing and a narrow set width make Minion an economical and easygoing book type, and even its name reflects its adaptable, affable, and almost self-effacing nature, referring as it does to a small size of type, a faithful or devoted servant, and a variety of peach.

DESIGN BY SARA EISENMAN

PRINTED IN SWITZERLAND BY
ENTREPRISE D´ARTS GRAPHIQUES JEAN GENOUD SA